Teaching Artist Handbook

Teaching Artist Handbook

VOLUME 1: TOOLS, TECHNIQUES AND IDEAS TO HELP ANY ARTIST TEACH

By Nick Jaffe,
Becca Barniskis,
and Barbara Hackett Cox

With a Historical Essay by
G. James Daichendt

Series Editor: Nick Jaffe

The University of Chicago Press, Chicago 60637
The University of Chicago Press, Ltd., London
© 2013 Columbia College Chicago Press

Originally published in 2013 by Columbia College Chicago Press
University of Chicago Press edition 2014
Printed in the United States of America

22 21 20 19 18 17 16 15 14 1 2 3 4 5

ISBN-13: 978-0-226-25688-7 (paper)
ISBN-13: 978-0-226-25691-7 (e-book)
DOI: 10.7208/chicago/9780226256917.001.0001

The following essays were adapted from material previously published in the *Teaching Artist Journal*, a print quarterly published by Routledge (Taylor & Francis) under the auspices of Columbia College Chicago (print ISSN 1541-1796, online ISSN 1541-180X): "Steak and Rice"; "All Culture for All People"; "Steal Your Students' Ideas"; "No Irony, No Revolution"; "A Story About a 'Problem Student' Who is Also an Excellent Artist"; "A Story About a Student Who Didn't Want to Make Art"; "Opinionated"; and "6 Ways to Shake up Your Teaching Artist Work."

Library of Congress Control Number: 2014954364

♾ This paper meets the requirements of ANSI/NISO Z39.48–1992 (Permanence of Paper).

Contents

Acknowledgments

THE AUTHORS would like to thank our readers without whom this manuscript would not have been possible: Debra Ingram, Amara Hark-Weber, Laura Reeder, Cynthia Weiss, Maia Morgan, Corinne Rose, Courtney C. Weida, Bettine Hermanson, Kate Adams, Tish Jones, Alina Campana, Calvin Keasling, Lori Brink, Suzie Makol, Vanessa Valliere, Mary Hark, Carol Lee Chase, Eric Booth and Malke Rosenfeld.

We would also want to thank our many amazing colleagues in the field; many of the ideas in this book have been drawn from and inspired by their work and the wonderful collaborative work we have had the privilege of doing with them. Among these colleagues are the members of the Artist to Artist Network in Minnesota and the Upper Midwest; Kate Adams and the staff and teaching artists of Marwen; Antonia Contro; Cynthia Weiss; Maia Morgan; Nicole Losurdo; Nick Rabkin; Laura Reeder; Leo Park; Arnie Aprill, Amy Rasmussen, Scott Sikkema and the staff, teaching artists and partner teachers of CAPE; Jordan Lasalle; Jill Lecesne Potter and the staff and teaching artists of Urban Gateways; Dale Davis; Keidra Chaney; Judith Tannenbaum, Malke Rosenfeld and Suzi Makol.

We would like to thank our brilliant and wonderfully collaborative colleague G. James Daichendt for his generous contribution of the uniquely valuable historical essay in this volume; Tish Jones for contributing her expertise to the section on work in prisons; Corinne Rose for her invaluable input on the historical essay and the sections on the practical questions of getting gigs and pay rates; Shannon Crawford Barniskis for her expertise on teaching artist work in libraries; and Nirmala Rajasekar, Peyton Scott Russell and Kristine Sorensen for contributing their stories about why they teach.

We are particularly grateful for the support, help and guidance of our editor at Columbia College Chicago Press, Brandy Savarese, and the press's Business Manager, Jason Stauter.

We would like to thank the many students with whom we have had the pleasure of working over the years—it is their work and ideas that have made our work so interesting and fulfilling.

Teaching Artist Handbook
Series Introduction

NICK JAFFE

THE TEACHING ARTIST Handbook Series is about presenting ideas, models and experiences that we hope will be useful to you as you create original teaching artist work that flows from your unique expertise, interests, and questions as an artist and as a person. This series is not about presenting a specific approach to, or methodology of, teaching artist work. If teaching artist work is but a dimension of arts practice, then it should be as inventive and idiosyncratic as art-making. Just as art compels us in its combination of what is specific to one artist, or to a group of artists' experience and vision, and what is common to all humans, so too can your own way of teaching be exciting to you and your students as something specific to you, and also freeing to your students as they make an artistic medium, or many mediums, their own.

Future volumes in this series will be discipline specific or will deal with particular questions of teaching artist work, integrating academic study with work in the arts, or working across arts disciplines. This first volume is intended as a tool kit that we hope will be useful to any artist who wishes to teach in any context. It is not rhetorical or abstract; it is written from the personal experience of its three authors in the spirit of engaging the reader in a real dialog.

I became a teaching artist because I wanted to hear some new music. More specifically, I wanted to hear what it would sound like if a group of elementary school students got their hands on a digital recording studio. One day I packed up my Corolla with a 16-track digital audio workstation (top of the line at the time!), a bunch of mic stands and mics, and some worksheets I'd made up about signal path and the physics of sound waves. I drove through the snow on a Tuesday afternoon to a public elementary school on 46th Street on the South Side of Chicago. I didn't know what to expect, and though I was a little scared

I had a hunch that this was going to be fun—that kids, being the strange little people they are, would make some interesting music. But I had no idea what my role would be. What would I have to teach them? What would I teach them? Would they be interested? Would they listen to me? Would I listen to them?

Six 1-hour sessions later I had in my hands a CD with a single four-minute-and-22-second opus on it—a bizarre and entirely coherent amalgam of hip hop, R&B, soul, polyrhythmic percussion, comical streetwise posturing, Pikachu references and reverb-drenched cymbal crashes. It sounded fresh and entirely unlike anything I could have imagined or predicted. It was funny, interesting, moving, grooving, and thematically complex. It also sounded like the young musicians who made it *meant it.* I was hooked.

I'd played music as a kid—flute. In high school I decided I wanted to be a funk and soul guitar player like Jimmy Nolen, Steve Cropper and Nile Rogers. I played in a band, worked a bit in recording studios and made endless sound-on-sound recordings at home using two cassette decks that, maddeningly, ran at slightly different speeds—I had to retune for each take. In college I studied history and played some music but somehow never really felt I was good enough to be a "real musician." After college I continued playing guitar on my own but after a brief stint teaching ESL and then working at an academic publisher, I went back to school to be an aircraft mechanic. I liked airplanes and airports and at the time it seemed like it would be a steady job with lots of variety to the work. In the eleven years I spent working on airplanes I played music only informally, mostly at home.

In the wake of 9/11 I was laid off from my job as an aircraft mechanic and avionics instructor at a major airline. I had free time on my hands. I'd already attended a taping of Jenny Jones, blown an entire unemployment check on an espresso machine—basically I'd hit rock bottom—and after a few months freelancing as an audio engineer in studios and in my home studio I was getting a little bored. If you've worked in a studio you know there's a lot of down time—rock dudes eating pizza and watching cable while waiting for "inspiration"—that sort of thing. I was doing some playing as a guitarist in an instrumental funk/post-rock project, but mostly my plan was to go back to school, get certified to teach elementary school and get a job.

I liked teaching. I'd started teaching ESL to adults as a volunteer when I was in college and would probably have stuck with it after college if I'd been able to make a living. There was something about the environment of shared learning that seemed fun and interesting to me. When you teach, you meet all kinds of people and get to know them in a unique way. You get to know them as thinkers and makers.

At the airline I was teaching a month-long course aimed at improving the fundamental knowledge and skills of mechanics working with aircraft electronics. I was getting to know my students as thinkers and makers, and that is

also how they were getting to know me. I had recently bought an eight-track digital recorder. This was in the late nineties, when recording technology took a sudden leap that made it possible to buy a box for less than a thousand dollars that would allow you to accomplish what previously had required a million-dollar studio. I would rush home every day from the airport and spend hours working out technical and musical ideas I'd had bouncing around in my head for over a decade. My recordings were uneven, but I was having a blast and learning and relearning many things all at once—musical things and technical things. I would bring my recordings into our hangar-classroom and my mechanic students would critique them. I'd babble enthusiastically about various things I was learning about acoustics and audio electronics, many of which related to our study of aircraft systems. One day a fellow mechanic said, "You should take this to a school. Kids would learn a lot and I bet they'd love it."

I became obsessed with this idea, though I can't say exactly why. It seemed fun to me, and maybe useful. I imagined that kids, being perhaps more inclined to spontaneity and experimentation than adults, might make some very surprising music with the same technology that I was finding to be so powerful and flexible. And I liked the idea that one could learn some very basic and important principles of physics and electronics by making music, and that one might learn them in a way that was different from formal study. The idea also felt like a way of connecting with others through music. In November 2001, the airline industry was in shambles, or at least acted as if it was, and mass layoffs hit. I wasn't entirely unhappy with the change, because I sensed that I might have a chance to try something new.

I was fortunate enough to know a musician with whom I was playing in a band and who worked in an after-school mentorship program that was connected with an elementary school—the one I mentioned at the beginning of this essay. It was with his help and collaboration that I connected with the school's curriculum director, proposed a six-session workshop with a mixed group of 1st–6th-graders that would combine music and science learning with music making, and ended up working with a group of students to produce their recording. I was not surprised by the musicality of this group of students. Although only two of them had formal musical training (they sang in a church choir) they all had plenty of informal training as listeners and fans of music. Often they had other musical experiences to draw on: relatives who were musicians or DJs; parents who were enthusiasts of various genres; live performances; and videos and television and film depictions of musicians, studios and the music industry. All these combined in the way these students approached the work of music making.

What surprised me was how little direct "teaching" it took to make the music happen. The students quickly developed a vision: a recorded song that would combine a number of different raps and interpretations of some fragments of popular radio hits with a simple vocal harmony part running through

the entire piece. Once they had that vision a natural and highly collaborative division of labor emerged, and they enthusiastically studied and learned on the fly what they needed to know to make the music and recording real. Each one-hour session was, for me, both exhausting and effortless. Exhausting because elementary school kids work with huge energy and enthusiasm and have many questions. Effortless because the students pulled from me exactly what they needed in terms of knowledge and support. In spite of my careful, highly structured plans, it was ultimately the requirements of the music making that shaped the hour. This was not a class after all, although we learned a lot. It was a studio.

After the project was over I met with the curriculum director who was very complimentary and who said that the kids seemed to have really enjoyed the project and to have learned many things. Then she said, "Umm, you know you can get paid for this type of thing, right?" I didn't know that. In fact, it hadn't even occurred to me that what I'd just experienced was a "type of thing." I certainly hadn't heard the term "teaching artist," and it would be some years of doing this kind of work before I'd consider myself one. In fact, I still feel more like just a musician and audio engineer collaborating with or assisting other musicians and audio engineers who happen to be kids, or adults, in studios that just happen to be in schools or other places. The consistent thread for me, through dozens of student-run studios, residencies of various kinds, and collective music projects of all kinds, has been the simple excitement of seeing and hearing new ideas and visions become new sounds and new music. I know I've learned a lot, and I suspect the students I worked with have learned some things—I'm fortunate to hear from many of them years later. But the music making was and is, for me, what it's all about.

And the odd thing is, now that I look back on the last decade of my life, I see that it was teaching artist work that led me back to working as a musician, recording engineer and producer. I've had the great good fortune to play music in a wide variety of contexts, to collaborate with, record and produce with many amazingly original musicians, and to have the time and space to make music of my own also. All the usual frustrations of the "music industry" were present: low pay, random and not so random crookedness, musical priorities trumped by economic ones. But in the little musical universes I got to experience with students in teaching artist work, we weren't apart from music as a business—kids are very conscious of the broader cultural and economic meanings of music—but it was easy to put the making of music at the center of everything in a way that not only felt liberating but actually liberated new sounds and ideas. And it was also easy to carry this feeling and way of working back into my work as a musician. Perhaps even more importantly, I was able to carry some of the new ideas and sounds into my work, too—I make no secret that one of my main motives as a teaching artist is theft. Kids and adult "beginners" often have excellent musical ideas and a spontaneity in realizing them that is both generative and provocative to me as a musician.

So here I am, and perhaps here you are too, as something called a "teaching artist." If we bring something specific to teaching and art-making in this particular time and place, perhaps it's that we are simply artists. We teach as artists and relate to our students as fellow artists—which is to say we put the work at the center: the joy and excitement of making things, the experience of making an idea real, and learning many things in the process in a way that is different and complementary to other ways of learning. If there is something beyond that which we bring to our work, perhaps it's a kind of resourcefulness and flexibility that allows us to create a context in which others can work as artists, whoever they may be and whatever the context may be. We turn classrooms into recording studios, prison rec rooms into writers' colonies, hospital wards into printmaking ateliers, and in every case we become artists among artists.

A young teaching artist friend of mine, the photographer Suzie Makol, recently told me that she aspires to be the "physics teacher of art." She described her high school physics teacher, who combined great knowledge and love for his subject with enthusiasm for learning in his discipline and a highly idiosyncratic teaching style. She recounted, among other things, how he'd include stick figure diagrams as part of test questions. The questions required that students also draw stick figures to complete the diagrams. Part of his grading routine involved gruesomely "killing" the students' stick figures: arrow through head, sword through heart, etc. Somehow this small, and slightly bizarre expression of self actually augmented the learning atmosphere in a real and memorable way.

I had a similarly idiosyncratic high school physics teacher. He believed that he could teach his cat to speak English and played us many cassette recordings on which he would say, in a strange high-pitched voice, "Liiiiivvvvverrrr," and the cat would meow. "You can hear him forming syllables!" he'd exclaim to the class. This teacher was also an excellent and highly trained physicist who built harpsichords as a hobby and had a policy of never proceeding to a new topic until every single person in the room fully understood the current one. The first day of class he said, "If we only cover one topic this whole term, that's just fine as long as everyone understands it." As it turned out, we covered the whole textbook and more, and we all really did understand it.

What I think these physics teachers might have in common is a depth of knowledge that enables them to be flexible and spontaneous; an enthusiasm for teaching and learning in their discipline; a dynamic understanding of the inseparability of theory and practice; a commitment to putting the actual work of physics above lesser concerns like "coverage," grades and classroom norms; and a willingness to teach as their peculiar selves. Almost magically, this combination allowed my physics teacher to help everyone in that room, including students whom many would have written off as incapable, to make some fundamental concepts and practices of physics their own. What I learned about wave mechanics in Dr. C's class I've been able to use in working on airplanes,

teaching acoustics and making music. Perhaps most important, just knowing the things I learned in that class has made life more interesting and fun. So if that's what physics teachers do, then I too aspire to be a physics teacher of art.

I like to think that we are also the Special Forces of art—we parachute into all manner of places and work with whomever we find to help them make their own work. All people are talented, inventive and artistic, and it seems that all people like to make and experience art. We often come from the outside of schools and other places not because people can't make art without us—they can and do, always and everywhere—but because we can help them make it better and enjoy the making and sharing of the work more fully, and because they can help us in the same ways. If we have something to offer, it is adaptability and flexibility—the ability to create art-making spaces, literal and metaphorical, technical and aesthetic, anywhere with anyone.

Making and experiencing art is one of the main ways in which humans have always communicated with each other and enjoyed their lives. It is a fundamental human activity. Yet in our American culture, with its profound oppressions and inequalities, there are many places and institutions in which people are not ever respected as artists. In many schools, prisons, hospitals and communities there are fewer resources and opportunities for art-making than ever. What opportunities and resources are afforded often have demeaning and alienating strings attached. One is allowed to make art only in order to improve one's math abilities, self-esteem, or social and emotional well-being, or to fulfill some other goal that does not originate with the person making the art and often is about institutional needs and priorities. So if we are Special Forces, diehard allies of all who would make art, then it is our job to fight for time and space in which people can work not as students, inmates and patients, but as artists who are free to make their own work to serve their own purposes.

About This Volume

THIS BOOK IS a collection of essays, stories, lists, examples, ideas, techniques and opinions. All of them are offered in the hope of helping any artist to think about, create and implement teaching that reflects her specific interests, expertise, experience and personality. This book is not a method, or a collection of recipes or formulas to apply uncritically, or a set of models to be duplicated or emulated. We believe that the great strength of teaching artists is their ability to create original and innovative practice that can engage all students in work in the arts. Although we do reference some theoretical ideas and frames, this book is centered on practice—the actual doing and making of teaching artist work.

The materials in this book are offered as part of what we hope will be a conversation that we are having with you, and perhaps that you are having with yourself or your friends and colleagues, about the work. We hope that it's a fun, candid and slightly irreverent discussion that reflects who you are and who we are as artists and teaching artists. We hope it is a conversation that will lead to new ideas and approaches to your teaching that you and your students will find satisfying and interesting and that will lead to art-making that is equally satisfying and interesting in both its process and products.

Here is a partial list of ways one might use this book:

1. Read it cover to cover.
2. Read it cover to cover starting from the historical essay at the end and working backwards.
3. Browse through it for ideas.

4. Use it as a reference to help you think about specific questions or problems.
5. Use parts or all of it as the basis for informal or formal discussions with other artists, teaching artists, arts educators, students or anyone else who is interested.
6. Argue with it in your head, or out loud to others.
7. Read it just for fun.

You will undoubtedly find gaps, flaws and biases in this book. It reflects our own personal experience and views and our own particular focus and interests as artists and teaching artists. We hope at least that we have expressed ourselves clearly enough that where you disagree or find the book lacking or even maddening, you will be moved to respond to it in your own work or writing. We really do want to hear from you. We'd love to know what you think of this book and the ideas in it, and we'd also like to hear about your work as a teaching artist. You can post responses and questions, and also reach all three of us, at teachingartisthandbook.com.

HOW THIS BOOK IS ORGANIZED

This book is organized around three simple questions:
What will I teach?
How will I teach it?
How will I know if my teaching is working?

The core of the book is the three sections that address these three questions. Each section includes a wide range of ways of writing and thinking about these questions, from critical essays to model procedures, lists of questions or answers and personal narratives. We've grouped all of these as thematically as we can so that if, for instance, you want to think about the question of "classroom management," you will have access to a variety of ideas and frames about this question in one section of the book. Inevitably there is some overlap and even repetition in different parts of the book—the questions are simple, but the answers are often complex and intertwined.

In addition to the three core sections there is also a series introduction, an extended essay that explores the many contexts of teaching artist work, and an historical essay about the deep roots of teaching artist work. We hope that together these sections put the more concrete core of the book in a broader and usefully thought-provoking context.

WHO WE ARE

Becca Barniskis works as a teaching artist of poetry and as a freelance writer and consultant in arts education for a range of schools, arts organizations and public agencies across the upper Midwest, such as Minneapolis Public Schools, the Ordway Center for the Performing Arts, the Walker Art Center, Forecast Public Arts, and the North Dakota Council on the Arts, to name a few. She specializes in developing and facilitating peer-to-peer professional development opportunities for teaching artists and educators. She has helped launch and develop Artist to Artist, a growing network of artists and educators who meet regularly to develop and share their teaching practice. She helped write the *Artful Teaching and Learning Handbook: Student Achievement Through the Arts*, a joint project of Minneapolis Public Schools and the Perpich Center for Arts Education and is the editor of the Resource Exchange section of the *Teaching Artist Journal*.

Becca has a BA in History with minors in French and Chinese from the University of Minnesota and an MFA in Creative Writing from the University of Oregon. She has taught writing and poetry to students ranging in age from pre-Kindergarten to undergraduates. She has read and performed her work for live audiences, and her poetry has appeared in numerous journals, among them the *Mid-American Review, burntdistrict, Conduit, Prairie Schooner, Blackbird* and the *Northwest Review*. Her chapbook of poems, *Mimi and Xavier Star in a Museum That Fits Entirely in One's Pocket* will be published in 2013.

▼

Barbara Hackett Cox is Arts Education Partnership Coordinator for the Perpich Center for Arts Education (PCAE), a Minnesota state agency. She has been working in this capacity since 1998. She has a BA in Humanities/Fine Arts from San Francisco State University and earned a Clear Multiple Subject Teaching Credential through the Masters Program in Media & Technology at California State University Los Angeles. Since then she has worked as a classroom teacher and arts coordinator (she started in 1977 in Los Angeles and Oakland, CA) and eventually merged her teaching and jazz broadcasting experiences to create a curriculum-based jazz history program that brought in jazz musicians as teaching artists to provide the authentic voice of jazz in the classroom setting. In addition to taking "Jazz in the Classroom" national for various arts agencies, organizations and schools around the United States, she also worked with New York City programs, arts organizations, schools and senior centers coordinating collaborations between teaching artists, teachers,

and administrators in an intergenerational program focused on social studies, visual art and theater.

Barbara has worked alongside and mentored teaching artists in various ways over the course of her tenure at PCAE. She was originally hired by a program that was created by Twin Cities' arts organizations (*Partners: Arts and Schools for Students*, or the PASS program) with three different school districts. She was there to transition PASS into a state agency structure. It evolved into a K–12 statewide network that included independent teaching artists or teaching artists hired by or affiliated with an arts organization. Over the past fourteen years she has created and supported new networks to promote professional development of teaching artists, specifically Artist to Artist. She also helped launch and develop Artful Online, an online professional development resource for artists and educators and was a major contributor to the *Artful Teaching and Learning Handbook: Student Achievement Through the Arts*, a joint project of Minneapolis Public Schools and the Perpich Center for Arts Education.

Over the years in her work as a classroom teacher and program coordinator Barbara has continually emphasized developing multicultural resources. Her efforts have resulted in the development of the Multicultural Voices Initiative (MCV), a unique and growing network of artists, educators, skilled facilitators and print and electronic resources created to help people uncover their own assumptions about race and raise questions about multicultural issues. With MCV, Barbara has been able to offer arts integration and multicultural education resources to a range of people and organizations with a particular emphasis on raising awareness of hidden racial bias and negative cultural stereotypes within program structures and curriculum. Barbara is a member of the Editorial Board at the *Teaching Artist Journal* and with Becca helps coordinate the ongoing design team meetings of the Resource Exchange section of the journal.

Nick Jaffe is a teaching artist, curriculum designer, writer, musician, audio engineer, Illinois certified K–8 teacher and the Chief Editor of *The Teaching Artist Journal,* a print and online quarterly published by Routledge and edited under the auspices of Columbia College Chicago. As a teaching artist Nick has focused on the development of student-run recording studios in elementary schools. Nick has worked as a teaching artist in a wide variety of in-school and other contexts. He has also designed and implemented programming, curriculum and professional development for Urban Gateways, Chicago Arts Partnerships in Education (CAPE), Columbia College Chicago, Marwen Foundation, Lyric Opera of Chicago and a variety of other schools and organizations. Nick's teaching artist expertise is in music and technology integration and in collaborative assessment and evaluation of teaching, curriculum and programs.

Nick received a BA in History from Yale University and an MS in Education and Social Policy from Northwestern University. Nick has taught a wide variety of subjects to people of all ages, including English as a Second Language, Judo, and Aircraft Maintenance. He spent 10 years working as an aircraft mechanic and avionics instructor for a number of major U.S. and international airlines.

Nick is also the guitarist for Soul People, Slowbots, H2O Soul, Super Moon, and 727 Generator, and has performed with a wide variety of artists, including Common, Ice Cube, Bobby Brown, Estelle, Bilal, Jaguar Wright, Renee Neufville, Dwele and Syleena Johnson. Nick's studio credits include national TV campaigns for Kraft and sessions as a guitarist and producer for many local, national and international hip hop, soul and R&B artists. Nick's recent solo album *Sputnik 1* is a musical history of the first artificial satellite.

G. James Daichendt, Ed.D., is an art critic, historian, and art teacher. He serves as professor of art history, Exhibitions Director, and Director of the MA in Modern Art History at Azusa Pacific University in southern California and is the author of the books *Artist-Teacher: A Philosophy for Creating and Teaching* and *Artist Scholar: Reflections on Writing and Research*, both published by Intellect Books. He is currently working on a third book that focuses on street art in Los Angeles. Daichendt is the Principal Editor of the academic journal *Visual Inquiry: Learning and Teaching Art* and is the Arts and Culture Editor for the magazine *Beverly Hills Lifestyle*. Daichendt holds a doctorate from Columbia University and graduate degrees from Harvard and Boston University.

WHY WE WROTE THIS BOOK

We wrote this book because we are teaching artists and arts educators and we really like the making, doing, thinking, talking and writing that makes up teaching artist work. Most of all we like the doing: the fun, fascination and discoveries of working alongside all kinds of people in all kinds of contexts to help make art happen. It seems to us that not enough of the writing about teaching artist work and arts education is written from the perspective of teaching artists. What brings many of us teaching artists to the work is the art-making. We teach our disciplines first and foremost because we love making work, and helping others to make their work is so satisfying. We also think that the love of art-making is what makes students want to work with teaching artists and what makes art-making especially educative. We hope that the ideas in this book serve to further that simple truth that is at the center of teaching artist work.

part I

TOOLS, TECHNIQUES & IDEAS

What Will I Teach?

AT ITS BEST, teaching artist work is similar to art-making in that it is inventive, improvisational and flexible. To teach in such ways we need to know our medium and any other areas we wish to teach in combination with our medium. We also need to have an attitude of curiosity about both the areas with which we are familiar and areas we wish to know more about. This combination of knowledge and curiosity about what we teach is what enables teaching artists (and all good teachers) to engage students in dynamic and exciting learning and art-making and to encourage students to develop and pursue original ideas.

Teaching and art-making also share another characteristic: they are largely about identifying what is essential in a given context. An artist's power resides partly in the ability to identify what is essential to an idea, vision, association or functional characteristic so that it can be communicated, embodied or designed in a medium. Similarly a teaching artist, or any good teacher, must identify what techniques, concepts and processes in a discipline are essential to teach in a given context so that students can better make original work that successfully applies and extends past practice and knowledge.

What you decide to teach matters. It is the single most important decision that you can make as a teaching artist. It informs every other aspect of your teaching and is the place to begin, always, when you are heading into a new teaching situation. It is also worthwhile to return again and again to this question and reexamine what matters to you as you develop your practice as artist and teacher. Maintaining clarity on what you want to teach is essential to improving not only your own teaching practice but also the practice of others—students in your classroom, teachers and other artists and the field of arts education in general.

This chapter is about deciding what you want to teach through a process of discovering (or re-discovering) and naming the skills and concepts in your medium that you think are most important and interesting to teach and finding new areas that you'd like to investigate. Ultimately the question of what to teach is intertwined with that of how to teach, so you will find some overlap between this chapter and Chapter 2. You may even wish to flip back and forth between the chapters as you develop curriculum ideas and experiment with planning.

This chapter includes a critical essay that aims to place the question of what to teach in a larger context, as well as specific prompts and questions designed to help you think about your art form in very concrete ways. It also includes a series of exercises/tools and a range of examples to help you do the following:

- Identify your own expertise and experience in your discipline.
- Identify what skills and concepts you view as essential to teach in your discipline/medium.
- Identify areas you'd like to study more within your discipline.
- Identify areas of knowledge and experience outside your discipline that you would like to incorporate in your teaching.

Throughout this chapter we offer ideas and pose questions that we have found helpful in our practice. There is no single way to do this kind of inquiry; we want to share some useful entry points that have helped us and other teaching artists to begin.

We've divided the chapter into two parts: "Ideas and Context" and "Concrete Steps." If you are in the mood to consider some more general questions before getting to work on actual curriculum design, you may wish to keep reading. If you want to get right to work, you may want to skip to "Concrete Steps."

WHAT TO TEACH: IDEAS AND CONTEXT

Who are teaching artists?

Teaching in an art form makes you a teaching artist. Practicing artists can be teaching artists; arts specialists (visual arts, music, dance, theater, media arts, etc.) can be teaching artists. For the purposes of this book we are defining teachers, administrators and facilitators who introduce and contextualize art and artists for learners as arts educators—that is, people who can both understand an art form on a deep and meaningful level and break it down for learners. Arts educators usually understand how teaching artists work, and they often support the work of teaching artists in meaningful ways. But the focus

of this book is on those who create work regularly in an artistic discipline and who also teach in that discipline.

In a sense, what distinguishes teaching artists as a type of artist and educator has mainly to do with how education is organized in the United States. Working in an art form and sharing one's knowledge, ways of thinking, and responses concerning art is often separated out as an experience distinct from educational experiences normally associated with schools and other institutions. This handbook is focused specifically on the concerns of the teaching artist, but any type of educator, from a Kindergarten teacher to a professor of mathematics at the college level, must teach from a deep well of knowledge and experience in one or more content areas in order to teach well. It is that knowledge and the confidence that springs from a strong grasp of one's discipline that allow a teacher to reach students effectively, to teach what is most essential, and to engage students as individual and unique thinkers and makers. One need not be an experienced teacher and pedagogue to be an effective teaching artist. One need only be entirely grounded in one's medium and be able to break it down in useful ways.

We also have a certain luxury as teaching artists that most educators do not. Although we are sometimes asked to engage existing curriculum and educational priorities and standards, our primary role is to teach from our own practice and experience as artists. This approach is what creates an art-making context in schools, community centers, prisons and other places that is different from what already exists there. This approach also potentially expands upon what people learn and ordinarily experience in such places. Most educators should design curriculum based on the question "What is currently known in the field I am teaching and how can I prepare students to use and extend that knowledge?" Teaching artists design curriculum based on the question "What do I know in my medium and how can I equip students to use that knowledge to make their own art?"

Closely examining the "what" of your teaching is an excellent and focused way to improve your practice as a teaching artist and is also potentially artistically liberating and enlightening. Thinking about your medium as a teaching artist can generate all kinds of new ideas for and about your own art-making. This is one reason why so many teaching artists find their teaching work such an integral and stimulating part of their life as artists. If you articulate what matters to you in your discipline, you are both creating curriculum and thinking as an artist. This first step in teaching artist work goes right to the heart of what makes the work so exciting—it is simultaneously teaching, learning, and *making*.

You are a teaching artist *NOW*

There are established methodologies in arts education, and arguably even in teaching artist work. One organization or group of teaching artists might

teach according to a specific type of arts integration. Another might approach teaching from the point of view of a specific methodology or theory of art, like Aesthetic Education. The Reggio Emilia approach to arts teaching has been very influential in many American arts education circles in recent years. The pioneering work of the German Bauhaus and the Soviet *Vkhutemas* design and architecture schools of the 1920s through their practice developed some of the most important insights in modern arts education theory. Any of these approaches, philosophies or methodologies undoubtedly has useful insights to offer a teaching artist, even if in the form of negative examples or provocations to further research. Some of these approaches incorporate significant theoretical work and have important and interesting historical roots. All are potentially worthy of study. And it *is* useful and interesting to think theoretically and historically about teaching artist work. If you are looking for precedents and ideas as a teaching artist, why not investigate what has already been done?

However, a premise of this book and this series is that applying overly general methodologies and too formulaic an approach to teaching artist work is limiting. Teaching artist work is not a science; it is an art. It may have scientific elements to it, just as science has many artistic dimensions. But to attempt to reduce the great variety of teaching artists, contexts and students to a single methodology seems to work against two central strengths of the teaching artist field: variety and flexibility. Precedent and methodology are necessary in art-making; no art-making is completely "new." But too much deference to precedent and methodology inevitably leads to sterile and unoriginal art. The same goes for teaching artist work. You may have to translate what you do into the methodologies or rhetoric of an organization because the gig calls for it. That's fine. But translate what *you* do; don't paint by numbers. Not only will your students learn more, you'll have a lot more fun.

It makes no more sense to speak of "experts" or "masters" in teaching artist work than it does to speak of "expert" or "master" artists. Yes, there are artists who have tremendous mastery of the techniques of their medium. This does not guarantee that their art is original, interesting or compelling. Similarly there are teaching artists who are very good at many specific aspects of teaching, but this is not what guarantees that they will teach well, or that their students will do good work. The prerequisite for good teaching artist work is that one have some solid knowledge in one's discipline (have something to teach), and have some enthusiasm and ideas about how to bring this knowledge to students in ways that will encourage original work. Wherever you are in this work, however new or experienced, young or old, you can make great teaching and learning happen with your students and contribute important insights to the field—the rest of us—right now.

You can't "teach art" but you *can* help people make art

A defining characteristic of art is that it expresses, investigates and communicates ideas, emotions, associations and processes, and even solves creative and technical problems, that require the medium of an art form for their fullest expression. Many of these things are partly or wholly unconscious or intuitive in origin; others defy expression in language. Even in the case of literature, where language is the medium, the various forms of poetry and prose become the extra-linguistic dimensions that convey what cannot be conveyed in ordinary language.

It is therefore not possible to directly teach much of what is essential in art. Much, maybe even most, of the knowledge and experience necessary for effective expression in a medium can be assimilated only by *working in the medium*. It is through dynamic interaction with the medium—art-making!—that any artist ("student" or otherwise) develops the ability to engage key elements of powerful and interesting art: specificity and efficiency.

All humans experience the same emotions and ultimately face the same basic dilemmas. What makes art original or compelling is specific and surprising expression of these emotions or dilemmas that derive from a particular artist's or group of artists' experience, context and vision. In a sense, art is the means by which humans simultaneously mediate between subjective and objective reality and also between what is universal experience and what is unique to each person. We cannot "teach" an artistic vision or viewpoint; we can only encourage and support students in honing it and extending it in their work. To have the privilege of observing firsthand the development and expression of such individual viewpoints is one of the most exciting and fulfilling things about teaching artist work. In order for such viewpoints to emerge we must put art-making at the center of our work, and we should see our role as creating and protecting time and space for work in a medium as perhaps the most important thing we have to offer as teaching artists.

Curriculum design as an artistic process

What do we actually mean by "curriculum"? And why bother with it? Curriculum is foremost identifying what you know and plan to teach, usually in a sequence (See Chapter 2 of this book for a suggested framework). It also can include naming what successful teaching and learning looks like to you and how you might determine the scope and depth of that success. One thing to keep in mind is that just as one develops and changes one's art-making over time, so too does one have the opportunity to develop and change one's curriculum over time. Curriculum is alive, and just because you document it in

some way does not necessarily mean that you are obligated to implement it that way forever.

Some teaching artists go cold when someone suggests that they write down their curriculum. They might be protective of their practice—afraid of others' co-opting it and teaching them out of a gig. Others simply find the suggestion utterly incomprehensible. For still others such a task feels like a hoop that they must jump through in order to get a gig, a hoop that seems completely disconnected from making art and having students make art. To teaching artists who teach more intuitively, the idea of documenting curriculum can seem deadening, superfluous, boring, or worse. It's true that there are a lot of boring and superfluous arts education curricula out there—all the more reason to be inventing and writing curricula that reflect your own knowledge and ideas.

As you make new curriculum or make changes to existing curriculum as you adopt new ideas, you will be constantly considering how to make these ideas intelligible to others. The form, conventions, language and labels that educators use in writing curriculum may in some cases be relevant to teaching artist practice, although they can sometimes seem like a foreign language (What is an "essential question"? How is it different from a regular question? What is the difference between evaluation and assessment and simple testing? What is "inquiry-based learning"? How big should a Big Idea be?, etc.). But although this language is sometimes useful, it is also often vapid and faddish and it is not in itself curriculum. Curriculum writing must begin in *your* language, the language of your discipline and your experience in it.

Often teaching artists are able to describe what they plan to do (activities) when they meet with a teacher or administrator or even the students and learners themselves. The gap that we sometimes see is between what people talk about doing and what they actually are able to do—for instance, a gap between the stated outcomes ("I want everyone in this after-school group to participate in the play we are writing") and the level and depth of what happens in real time (Students helped write a play, memorized lines, worked on blocking and stage design, figured out how to stage a final performance for other after-school students, and so on.). If one never takes the time to write down what happened, and thus what *could* happen again, then it becomes hard to focus on what worked and why, and what could be better or just different next time. Also, the depth and rigor of what students are learning along the way in terms of essential concepts or techniques in a medium gets overlooked or is sometimes compressed into a superficial reflection on the final product or performance. Inattention to stated outcomes can also negatively affect learners who might be confused about why an artist is asking them to come up with a specific idea, or why they have to collaborate with a new partner each time, etc. Learners who do not know where things are headed, even in a general way, can sometimes be less motivated or even less creative in their work—that is, they might miss opportunities to reach the desired outcome in a new way or

their own way because the teaching artist never clearly articulated the overall vision and goal at any point. Of course, there are many ways to teach one's curriculum, and how and when one chooses to explain where things are headed, for example, depends entirely on you, your teaching style and your aims. Even if you choose not to disclose your goals or even the structure of the lesson to students before you begin, *you* still need to have a firm grasp of what you are teaching and why it matters in order for effective art-making to happen.

Curriculum also allows the teaching artist, learners and others to reflect in ways that are essential to improving practice; for some artists curriculum can also be a way to better understand what they do in their art form. Having a strong grasp of the skills, techniques and central concepts that one employs most readily and most enjoys in one's discipline—and what's more, being able to describe them to others who are outside of one's discipline or who simply have less experience—can lead to more intentional experimentation and mindful artistic practice.

For example, Becca's curriculum planning has made it clearer to her that, as a poet, she is obsessed with finding the right and equivalent metaphor to amplify an idea or emotion. The process of such searching is a core practice that she wishes to impart to learners no matter what their age. Recognizing this has allowed her to examine her own poetry in new ways: What sorts of metaphorical terrain does *she* typically stray into? Why? Is her typical search usually fruitful? Is she getting predictable in her approach? What sort of metaphorical terrain is she suggesting to students and why? Might this terrain be limiting to her (having gone over it herself already), or through teaching it, might she find something new there to notice? What about the paradox of using metaphor to convey the inexplicable or the forbidden? Metaphor is image—it forces one to delineate what might otherwise be obscure or shadowed. But it is not reducible to its parts alone. This is the great central joy and paradox Becca finds in art-making and wants to ensure that students experience also. And she stresses such an exploration at the expense of other aspects of poetry writing that another poet might pursue (exploring a particular thematic concern, experimenting with simile or rhyme or lineation or sound, to name only a few). She knows from her own experience that her overriding poetical obsessions and the extreme pleasure that she derives from writing poetry that functions effectively in metaphor are deepened and further developed when she teaches. New aspects of poetry open to her as she is writing new curriculum or examining the work that students create. Inevitably students hand her strange new ideas and ways of looking at and experiencing the world of poetry.

Similarly, in a discipline like dance, when one is forced to articulate what is most important to teach students one is going to see for perhaps only eight sessions, how does one come up with the right steps and movements and concepts to teach? What if you started with something you love and know well?

What if you have to break down what you love (Salsa dance, say) for someone who is new to dance altogether? Would you start with teaching the basic step cycle of six weight changes in eight beats? Would you teach these elements with or without music or a beat the first time around? When or why would you introduce the development of Salsa dance out of the Cuban Son and Afro-Cuban dance traditions? How would you define the basic principles of Salsa and its political and social value in Latin culture? What about your own experience in dancing Salsa? What does it say about your own values as a dancer or choreographer? After spending eight hours with you, what knowledge and understanding about Salsa dance do you want your students to take away in their bodies and minds?

Thinking in such concrete terms about one's teaching can also help an artist develop a certain kind of critical distance from one's own artistic output. When we regard students as fellow artists it can shift or deepen our appreciation for fundamental aspects of our practice as an artist. Some teaching artists fear that a focused and intentional approach to teaching will lead to a prescriptive and mechanical dynamic with students. We would argue the opposite: clarity about which specific techniques and concepts you want to transmit to students actually allows you greater flexibility and scope with which to create time and space for real invention and experimentation and expression by students in your art form. If you teach specific artistic tools, students can then apply those tools in original ways to make their own work. Finally, one cannot overestimate the power of truly enjoying what one is teaching and how that enjoyment affects learners. Planning and clarity of intent can allow a teaching artist to create a context in which she can really relax and relate to students as artists in ways that will allow her personality and enthusiasm for the medium to inspire and excite students.

Speak your own language about what matters to you as an artist

Why is it so hard for some teaching artists to name what they know and do in their art form? Why do so many of us struggle to find the words to describe what it is that we wish to teach? How does one begin to tackle what can seem like a vague, onerous task that has little to do with art-making?

Knowing what you can and want to teach is fundamental to being able to offer in-depth, quality arts learning to students. It allows you to operate fully as an artist in your work as a teaching artist. For many teaching artists in many of the contexts in which we work this is not as self-evident as it would seem. In the current educational and social contexts in which teaching artists work, there are many pressures on them:

- To integrate their arts content with other academic subjects right away

(in itself not a bad thing, but for some teaching artists a difficult place to start thinking about their own art form).

- To frame their arts teaching by referencing current trends and concepts that inform a great deal of educational and arts educational programming. We mean such things as "twenty-first century job skills," "creativity," "critical thinking," "collaboration," or "team-building" (See Chapter 2 for a critical glossary of some of these terms). These are abstractions, and often reifications, not modalities of learning in an arts medium; therefore, again, they do not answer the question of what to teach.

- To teach in a way that manages student behavior and that leads to artmaking with highly predetermined outcomes as defined tacitly or explicitly by schools, program administrators, teachers or cooperating artists.

None of these pressures are necessarily objectionable in and of themselves. But they become problematic when they work to obfuscate the art form or the power and joy of simply making art. They also often confuse teaching artists about whether and how their art form matters in a teaching context and can leave the artist always feeling at a loss as to how to proceed with her teaching.

It is hard for teaching artists to stay focused on what they know and want to teach also because they are often asked to set aside their artist identity when entering into a teaching situation. Even if it is not a K–12 setting, many teaching artists worry that they lack the skills of a classroom teacher in "behavior management," collaboration or building a sense of community. These skills certainly matter, and having a lot of teaching experience can lead to more confidence about teaching in a range of contexts. But not having a lot of teaching experience does not mean that you are not expert in your content area.

Despite what arts organization and schools and museums and others say about the value of teaching in the arts, the traits and characteristics they sometimes emphasize and articulate to funders about why the arts matter have little or nothing to do with the content of a given artistic discipline. Often when arts education administrators talk about using the arts to foster "critical thinking" or "collaboration" or "creativity" they could just as well substitute soccer or biology or history. Playing soccer well also develops collaboration and problem-solving skills, particularly if you are in the last two minutes of the game and you've just pulled your goalie. Similarly, studying the Qing dynasty in China and the geopolitical forces at play during the last days of the reign of the Empress Dowager and coming up with a well-articulated essay about their impact on political and military developments in modern Chinese history develops critical thinking skills—perhaps even more effectively and deeply than analyzing a painting or deciding how to approach a poetry assignment. The fact that work in the arts is broadly educative, like work in any discipline or domain of human thought and practice, is really beside the point. Teaching artists and those who hire them and support their work must value learning in

an art form as valuable and educationally essential in and of itself. In order for interesting and authentic art-making (and learning) to occur, they must assign value to the art that students and artists make.

One way for teaching artists to reframe this discussion and gain respect for their art form is by focusing on its particular characteristics and their own practice in the art form from the beginning of the curriculum design process. We are artists, and our emphasis needs to be on teaching others how to make art and make it well. As teaching artists we must advocate and articulate this clearly if we wish to change the terms of the debate over the value of our work. We should be advocates not just for the ancillary value of art; we should be advocates for art.

Not everything is art-making

Art-making is about using a medium or materials to communicate a particular point of view or solve a creative problem, even if in a preliminary or fragmentary fashion. Most people engage in some kind of art-making with or without us: kids draw on their own, choreograph dance steps on the playground and sing in school hallways. Some adults play instruments or paint; others restore furniture or cars. No one *needs* a teaching artist around to make art. But a teaching artist can *help* people make their own art and make it better, deeper, more interesting and more original.

Is leading students in theater games art-making? It can be if the games are a part of preparing students to use the skills and concepts of performance to create a meaningful product of some kind—a script, a set, a production, a staging of a text, a reading, an improvised or spontaneous scene or happening—*something* that is experienced by a viewer, listener or audience as a communication, even if that audience consists of the student-artists themselves.

Is bringing in outside artists to perform for a school assembly art-making? It is for the performing artist, of course, but it can also lead to interesting opportunities to augment art-making and performance for the students who experience the performance. This is true especially if someone is there to help make that connection between experiencing art and responding to it and creating within that art form. The skilled arts administrator can make a huge difference and support students' artistic experience and art-making when he or she is able to 1) bring a high quality arts experience to students, and 2) help them and their teachers make sense of it by offering them time to respond to it thoughtfully, intentionally and in collaboration with either the presenting artist or the classroom teacher or arts specialist.

We can also teach things using the skills required in an artistic medium but without a central emphasis on the art-making. For instance, we can teach literacy skills using techniques and concepts drawn from theater. We can use dance movements to teach math concepts, or make clay pots to study the his-

Steak and Rice

I was teaching full-time at an elementary school on Chicago's South Side. I ran a recording studio with the students in which they would do original music production of various kinds, and we'd also investigate some of the scientific and technical dimensions of sound. I would eat my lunch in the studio, usually something I'd cooked the night before. There were always students hanging around or working on recordings, and when they weren't doing that they were coveting my steak and rice. "Where's my steak and rice?!?" was a common refrain. It became a joke between me and a clique of seventh grade girls. This bunch was often a huge pain in the ass and one of the most talented groups of musicians/writers I've ever worked with.

One day I brought a few extra steaks and a lot more rice. Lunchtime came and soon the seventh grade clique drifted into the studio along with a fifth grader or two. "Did you eat your lunch?" I asked. "Hell naw!" one girl answered, "I don't even know what that was." (The food at this school was all precooked off the premises and wasn't particularly edible). "Cool," I said, "I've got your steak and rice." I served the food out onto some paper plates and handed it out to the girls and the two fifth grade boys. Everyone looked a bit freaked out, but they began to eat, uncharacteristically silent. Finally, the ringleader of the seventh grade clique said, in a slightly abrasive, almost angry tone, "Mr. Jaffe, what is this FOR?" I must have looked confused, because she repeated the question and then added, "What did we DO? Like, what is this FOR?"

"Why does it have to be FOR anything?" I said, genuinely annoyed. The girl smiled and laughed. She was clearly satisfied with the answer and my affect. "I guess it's for eating," deadpanned one of the younger boys. And then the students proceeded to eat, talk, and make way too much noise until it was time to be late for class.

Yes, art is "good for you" and "good for society." It makes you think, it helps you learn things, and it can be a powerful tool for revealing all sorts of truths and communicating them. But people should also have a right and means to make and experience art simply because they want to. Since at least Paleolithic times humans have made and enjoyed art because it is satisfying, social, and fun—like steak and rice. That's reason enough.

—Nick

tory of indigenous Mexican ceramics. All of these things can involve significant art-making, provided we make sure that there is scope for invention and original work, and provided we are not presenting them merely as exercises in support of the non-arts learning.

It's also possible that such integration can take place in a way that relegates the artistic discipline to a subordinate role—certain skills or exercises

in the discipline are used as a means to a non-arts end. For instance, students might use theatrical tableaus to portray scenes and characters from a book as a way of demonstrating and reinforcing their reading comprehension. Little or no emphasis might be placed on whether the tableaus are interesting to watch, expressive or engaging to an audience or to the performers. The central emphasis might be on whether they accurately reflect a close reading of the text. There is nothing wrong with such activities; they might in fact be fun and effective ways of teaching some elements of literacy. But they should not be confused with art-making, or teaching artist work in the fullest sense.

In the preceding example a teaching artist is working as a tableau specialist in support of a literacy curriculum. She should have different expectations of what such an assignment requires—adapting the tools of the medium to very specific educational goals without particular regard for artistic development of the students. Teachers, teaching artists and administrators should also understand that this way of using a medium is not a substitute for student work in the arts. It does not allow for the invention, experimentation and depth of experience in a discipline that occur when students focus on making original work. It also does not necessarily lead to any of the less tangible types of learning and development that accompany student art-making.

What matters to you or interests you outside of your discipline?

Many artists have broad interests beyond their arts discipline, and some are quite expert at integrating information and ideas from different fields. Consider an art teacher who is an avid collector of agates and who knows well the geologic processes that create these particular stones, or a poet who has studied the life and work of Gregor Mendel, or a visual artist who flies airplanes. Just as such interests and obsessions often enter or form the core of an artist's practice, they can and should enter our work as teaching artists. As an artist you probably already have processes by which you integrate ideas and practices from fields outside your discipline. These processes are an excellent starting point for considering how you might integrate extra-disciplinary content in your teaching.

A firm grasp of your own discipline and a sense of which aspects you can teach alongside other artists and teachers is perhaps even more necessary to constructing integrated curriculum than teaching a medium by itself. You also need to know something about the other subject matter—if you are a dancer and are asked to collaborate with the math teacher, then you had better have a solid understanding of the mathematics you are seeking to integrate. If you are a visual artist working in a science classroom teaching observational drawing, then you need to be serious enough and curious enough to do some study of the subjects of the drawings—whether they are insects or sea shells or leaves

or flowers. You do not need to be the lead instructor, become an expert in the field, or write the curriculum for this aspect of the unit of study—that may be the responsibility of your collaborating teacher or artist. But to find deep and interesting connections between your art form and another subject, connections that result in curriculum that is more than the sum of the parts, you need to engage fully with the other subject. If you and your collaborators engage fully with each other's disciplines, then it's probable that students will also.

We don't help students by making shallow connections between subjects and domains of knowledge. Shallow or forced integration can often distract students from learning what we are trying to teach. For instance, if we use movement in a superficial or formulaic way to teach geometry—"make a triangle with your arms and legs"—how deep is that going in dance as a discipline? And what does it really teach a student about shapes? It might be a fun and useful way for students to think about how a geometric shape looks and can be transposed or rotated in space. But unless you also ask students to think like a dancer and create something out of those shapes that communicates another meaning, and you are willing to teach them some techniques to do so creatively and artistically, then the exercise might just as easily be an inefficient and distracting way to explore geometric concepts better examined on a sheet of paper or through model building. There is nothing that says it is necessarily more educative when one uses the tools of the arts to teach or learn something.

It is important to consider as early as possible in the curriculum design process whether or not the content area that someone might be asking you to integrate into your teaching has any meaningful connection to your discipline. Does it make sense to teach this particular subject this way? Are the book arts or the writing of personal poems good ways to study the Holocaust? Might it be more engaging and educationally sound for students to delve into the subject through literature and history? It really depends on the artist and teachers involved. Do they have a compelling reason to explore this subject in this way? Have they thought through why a book structure might be the best arena for student art-making in response to this subject? Have they thought through just how difficult it is for any artist to make art about such an overwhelming and profound historical event? Are they creating time and space for students to develop genuinely original interpretations of and insights into the history with the medium, or are they directing students to use the medium to create a predetermined outcome or product? If the answer is the latter, is such directive work really encouraging critical thought about the subject, or perhaps perpetuating superficial readings and even negative stereotypes? Will the art-making open up new questions and discussions about the subject, or reduce them and close them down? It is a fine line that many artists walk in approaching such questions in their own work, and if we truly want to engage students in what it means to work like an artist in investigating the full range of human thought and experience, then we need to ask hard questions of our-

selves as educators. Students, too, need to be a part of that discussion as their art-making unfolds.

Race, ethnicity, gender, relevance, politics, and what you teach

As teaching artists we are well placed to fight for students' right to access the broadest possible range of art and artists so that they are able to work across the broadest range of thematic and artistic possibilities. It's a battle we have to fight on two fronts: exclusion of art and artists from oppressed and marginalized communities, and typecasting and stereotyping of such artists. We need to work against narrow notions of "high art," make visible the reasons behind the construction of such categories and the ways these categories are used, and reject the historic marginalizing and trivializing of artists and entire artistic traditions that is endemic in our country's history and present. Students of all colors and classes must have access to the work of black artists, Latino artists, American Indian artists, women artists, gay and lesbian artists—all artists in all genres and media, because art deals with the full range of human emotion and experience, and one should have the freedom to engage the full range of art.

Teaching artists come in all races, colors, creeds, genders and sexual identities, and each of us carries with us a whole host of personal and cultural experiences and traditions. Some of our experiences we might consider rich and useful to us as artists and teaching artists. Others we might feel are limiting and oppressive. Some have perhaps left scars on us. Our students are no different, and just as we, as artists, choose to reflect, redefine, transcend, ignore or defy our own identities in our art-making, so too should our students have this choice and range of expression available to them.

It also cannot be overstated how transformative it can be for student-artists to work alongside artists with whom they can identify, whether because of skin color, class, gender, sexuality, social or personal circumstance. In a society that aggressively tells young people what they "can" and "can't" become, in a thousand ways every day, for a student to make a personal connection with an artist who defies those stereotypes can be liberating in itself. To learn from and collaborate with such artists can change a student's life whether or not the student decides to become an artist. For these reasons, and also because artists of color, immigrant artists, American Indian artists, women artists, and LGBT artists are underrepresented in the ranks of teaching artists and in the leadership of our field, it must be part of our work together to bring more such artists into the field and its leadership, and to give all students more access and experience with the full diversity of artists.

Education in the United States is racially segregated—separate and profoundly unequal. Many schools that serve students of color do not have access

to the resources enjoyed by more affluent schools that typically serve white students. Teaching artist work is inevitably shaped by this reality of inequality and segregation. Some arts funding and programming is very much about attempting to address unequal access to the arts, and some programs specifically aim to bring into schools artists who more closely reflect students' backgrounds. As a field we need to fight for students to have access to all artists, and for all artists to have access to this work.

It's also important to remember that the experience of working as an artist—having real artistic agency, making work that *you* conceive and that expresses what *you* want to express—can be liberating and can sometimes even save people, especially young people, in terribly difficult circumstances. We are thinking here of young people we know, and know of, who have had the pleasure of working in really strong teaching artist-led studios or programs and who came to see themselves as artists and know themselves as such even if they did not continue to make art. In these contexts they often also form relationships with their peers, with teaching artists and even program administrators that are artist-to-artist relationships. Life is really hard in America for most young people, especially young people of color. When a young person is struggling to stay in high school or college, or perhaps even to find food and a bed, the fact that he or she has had that agency as an artist and formed those relationships can make a huge difference. It might be that they will approach a peer, teaching artist or administrator from a program for advice or help because they know that they will be received not only as person in crisis but as a fellow artist. Or it might be simply that when you are really down, remembering that you are in fact an artist can be the thing that pulls you through. We don't mean "remembering you are an artist" in some abstract or mystical sense; rather we mean remembering that you have some specific skills in a medium that allow you to make work that matters to you and to others, and that you always have this pleasure and outlet and power available to you. That recognition has certainly gotten us through some bad days.

This is not to say that teaching artist work is social work—to mistake it as such is to both miss the point and trivialize the powerful and vital work real social workers do. Rather the point is that teaching artist work allows any of us to discover ourselves as artists, to contribute as artists and to help each other as artists.

Stereotypical expectations about artists and students based on their perceived cultural roots can needlessly narrow a student's sense of what is possible to make or do across a range of disciplines. Rather than expand possibilities for artists and students, such pigeonholing replicates and amplifies the narrowing and limiting effects of oppression. Artists of color often have the experience of being hired with the expectation that they will bring culturally specific arts learning experiences to students. This can often translate to stereotyping of black, Latino and Asian artists, for example, the black lyric poet

who is expected to teach hip hop or spoken word, or who is asked to deal with only certain themes (empowerment, community, nonviolence) when these forms and themes may have nothing to do with his or her work.

As teaching artists we know from experience that good art is good art. Any art, any domain of knowledge can be relevant to anyone. Some educators place a lot of stock in the idea that content and teaching must be "relevant" to a student's individual experience in order for the student to "engage" and learn. This is often understood to mean that what is taught in a classroom should always be related to what a student already knows and likes. We happen to think that this notion is ridiculous and has particularly negative consequences for teaching artist work.

First of all, this idea is based on some questionable assumptions about students. The premise is that certain groups of students like certain things. In practice it often plays out as a kind of stereotyping: "at risk, urban students" in a Chicago public school will like hip hop. Therefore, if I teach music I should teach hip hop, or at least relate my teaching to hip hop. Of course, students of all colors and backgrounds in Chicago public schools like all kinds of music and have experienced all kinds of music: classical, jazz, gospel, metal, punk rock, country, etc. Some like one kind of music more than another; some identify more with one genre than another. Our students are individuals with all kinds of tastes and experiences. If we are to play a role in helping students develop their art, then we must begin by acknowledging that they have unique tastes and experiences to draw on.

Another problem with this narrow idea of relevance is that it implies that only *some* culture is appropriate or accessible to *some* people. In fact, young students in particular are powerfully drawn to what is *unfamiliar* and novel. Children are cultural omnivores and so are many adults. If you do happen to have students who are deeply into hip hop, then you know that of all genres hip hop is perhaps the most omnivorous and eclectic; its very premise is that it combines the odd, disparate and recycled in violation of all genre rules and expectations. It's all about juxtaposing Steely Dan, Stravinsky and Jabo Starks. To prejudge what will be of cultural interest to a student is to willfully narrow that student's access to the raw material of his or her own artistic expression. To expect that students will want to make art solely about who they are and where they are in the most literal sense can only be an obstacle to real art-making. We would not expect a professional artist who is black to deal with blackness, or a woman artist with children to make art about motherhood. We should not expect such things of less experienced or younger artists either. Some artists make work about themselves, some make work precisely to escape their own experience and environment or to redefine themselves on their own terms. Many artists don't deal directly with self at all. Student artists should have the full range of choices available to them in their art-making.

As teaching artists we are in exactly the right position to explode this par-

ticular notion of a relevance that is based on someone else's fantasy of who our students are, and to help our students construct their own notion of relevance based on what they hear, see, feel and think. If what *you* know is eighteenth century Italian Opera, don't worry about whether it's *relevant* to students. It's fascinating music that *you* know and love. If you bring that knowledge and passion to students, and create a context in which they can explore that music and make something of their own with it, then it will be more than relevant; it will be their art.

We teaching artists need to advocate for our own art form and that of other teaching artists in order to be respected, both as part of whatever group we choose to identify with—*if* we choose to so identify—and as individual artists with individual voices. If we do not stand for real artistic freedom for both students and teaching artists, we risk becoming artsy window dressing for the oppressive and unequal contexts in which we teach.

Many artists engage political and social themes in their own work or make work partly or wholly out of a desire to bring about political or cultural change. If you are a political artist outside of teaching contexts, then of course you should be free to work as one within teaching contexts. Some teaching artists teach because they feel that through teaching they can bring about social change, or have a particular impact on the political, moral or spiritual views of their students. These are perhaps as good reasons as any to bring one's artist self into a classroom or other teaching context. However, in some cases teaching artists, often with the best of intentions, allow their teaching to become didactic in ways that are more about their own views than opening up a space for students to express their own ideas in a medium. This can lead to work in which students don't learn much about a medium, or even about the particular issue or viewpoint that informs the teaching artist's work. Here are a few questions one might consider when thinking about how and whether to engage one's own politics and worldview in curriculum planning and teaching:

1. Are you more interested in instructing students in a particular moral, spiritual, cultural or political viewpoint, or are you primarily interested in helping them to develop their own artistic vision in a medium? If the former is the case, perhaps you should present yourself as a moral/spiritual/cultural/political teacher who uses art-making, rather than primarily as a teaching artist.

2. Are you interested in presenting your ideas or politics as a way of stimulating students to think independently and critically and make original work in your medium? Or are you more interested in getting them to think like you?

3. Are you assuming that your students all have a particular view on an issue or historical question, or are you approaching them as individual political thinkers with their own individual views?

4. Are you assuming that all your students share a particular sense of their own social, cultural or political identity, or are you approaching them as individual artists, each with a unique way of seeing things, however informed by their social or cultural context?

5. Is it okay with you if students make work that presents a viewpoint that is alternative or even opposite to yours? Are you encouraging this as a possibility?

6. Do you want your students to view you as a critical and questioning artist who has developed a particular worldview, or do you want them to view you as someone with the "right" worldview?

7. Do you want to empower your students by teaching them to see the world as you do, or do you want to empower them by equipping them with some artistic tools with which they can investigate and shape the world in the ways that *they think are necessary and important?*

We want to be clear that we're not arguing against engaging political, even controversial themes in teaching artist work. We would not be engaging students as artists if we did not challenge them to look at the world around them critically and to see social and political reality as potential raw material for artistic commentary and expression. We would not be teaching artists if we did not feel free to bring our own struggles and opinions into our discussions and exchanges with students. If we do these things in ways that leave time and space for students to develop their own intellectual, political and artistic viewpoints, much can be learned and great art-making can happen. But if we have a predetermined outcome in mind, one that precludes real investigation and original art-making, then the experience can be alienating to students and a waste of their time.

We should see part of our job as teaching artists to reject both the stereotyping of our students and of all artists. We should seek the broadest possible artistic and personal experience for our students and kick open the doors to educational and other institutions where we work to allow access to *all* artists on their own terms.

The only way to do teaching artist work with integrity in the face of powerful pressures to dumb it down, simplify it, integrate it into superficial classroom practice, or make it a mere means to a laundry list of educational, social, emotional, or political ends is to put artistic rigor and authentic art-making at the center. Our students are artists. We can apply a Golden Rule of teaching artist work: Don't ask your students to do things that you yourself would find artistically superficial, boring, limiting, manipulative, pedantic or dumb. *Do* introduce them to the full range of possibilities in your medium through the dimensions of thought and practice that you find most interesting and generative as an artist.

All Culture for All People

We don't live in a post-racial society; we live in a racist, segregated one. You don't have to be black, Latino, Arab or Asian to know this; you just have to walk into an urban public school, community center, or prison and you will see that separate-and-unequal is still the norm across America. All people of color in this country face a thousand kinds of racism every day; the darker one's skin, the more extreme the barriers, the greater the dangers. No amount of personal sensitivity or "celebration of diversity" can fix the damage done to people and society by the simple fact of an overcrowded all-black elementary school in a decaying building that sits just a mile or two from an all-white one that resembles a private university campus. The only way to fix that is to change it.

As a teaching artist who often works in race- and class-segregated schools, I sometimes encounter very specific expectations from administrators (both school and arts ed) or teachers—rarely from funders or parents. I've almost never encountered these expectations in wealthier, integrated or white schools. They fall into two categories: 1) the expectation that student art and music will not deal with difficult or dark themes, and 2) the expectation that students will embrace a specific interpretation of their own cultural or racial identity as a major theme in their work. To put it more bluntly, black, brown and poor children are often forbidden to address violence and hostility in their work (as if representation leads to action), and the same children are frequently, almost mechanically, encouraged to "celebrate" one-dimensional representations of what someone else has imagined to be their cultural heritage, representations that often don't even scratch the surface of young peoples' experiences, or the real history from which they and all of us are emerging. The implication, sometimes made very explicit, is that these children and youth are incapable of subtlety of expression and interpretation, and have no cultural landscape of their own, or at least not one worth making art out of.

The reality is, of course, very different. In the most messed up schools, in the most oppressed, impoverished neighborhoods, the kids are as smart, inventive, expressive, curious and broad-minded as any other children. Often they have a richer, more varied cultural experience than their more well-to-do counterparts. Some very well intentioned educators miss this completely. I remember once when I was taking courses for my teacher certification a "specialist in cultural sensitivity" explained to us how one Latino immigrant child's entire world was supposedly limited to the few blocks surrounding the dilapidated motel in which the child and his family lived. It seemed not to have occurred to this specialist that the fact that the family had recently walked and hitchhiked all the way from San Salvador to Los Angeles suggested a rather broader experience. And that's leaving aside the more insidious assumption that the child lived a narrow, culturally deprived life in El Salvador.

We should not expect or demand, directly or ever so subtly, that our students make art about race that is palatable to us, or make art about race and identity as conceived by someone else. The fact that a student grew up black on the South Side of Chicago does not mean that he or she will be more compelled by Langston Hughes than by William Blake. Art-making is also about refashioning, even exploding identity, and imagining and interpreting the experience of others. This is not to suggest color blindness; color is as profound a cultural reality as the oppression that defines it. Writers, artists, scientists and historians of color should be celebrated, all the more so because they are so often "disappeared." But they should also be studied because they are writers, artists, scientists and historians.

I also do not mean to trivialize conditions; oppression does oppress. If you can't read in sixth grade it will mess with your head. If you have to dodge crossfire or go hungry or attend a completely segregated school it will mess with your soul, often deeply. If you don't have the funds, or it's too dangerous, to travel outside your neighborhood, it will narrow your view of the world. If you have to fear being regularly hassled or worse by the cops, or ICE (Immigration Customs Enforcement) because of the color of your skin, it can wear you down and tear you up in a thousand ways. But although conditions, color and ethnicity make us, they do not define us. Each of our students is unique, and we find this out quickly if, as teaching artists, we relate to them as fellow artists.

As teaching artists if we don't stand up for the right of all our students to make their own art, and to interpret material and themes with the full palette of cultural and human experience, I think we risk becoming a kind of window dressing for the ugly reality of racist inequality. If, however, we can bring some small part of a future equality into schools and other places through art-making, it is by embodying the truth that all culture belongs to all people.

I'll end with a poem that is part of a student-produced CD on which fifth grade students set their writing about the Civil Rights Movement to music. You can hear the audio recording of this poem (as read by the author with her original music—I think it is much more effective as a poem with the audio) at http://casounds.bandcamp.com/track/back-in-the-civil-rights-days. The CD project was conceived by students who were studying this history with an inspired teacher who radiated her interest in the material and in what the students thought about it. I was privileged to be part of the project as a teaching artist because, together with the students, we ran a recording studio in the school in which we not only encouraged each other to make music without narrowing, censoring or stereotyping ourselves, we demanded it of each other.

—Nick

Back in the Civil Rights Days

Back in the Civil Rights days
blacks couldn't even feel
safe in their own homes.
I mean, what is that?
The more I think about it,
is segregation really over?
When you walk down the street
Do you hear "Hey nigger!" or,
"You dog, get out this neighborhood!"

Do you?

—Zakeira Ward, Fifth Grade

What is essential in your art-making process?

What, then, *is* essential to consider when naming what you will teach in your art form? We would argue that technique, and the processes through which it is applied, are the essential, teachable part of what makes artistic expression possible. The concepts, theory and experience of art-making are important and teachable in some degree, but we believe that effective teaching artist work is rooted in processes and techniques of work in a medium. Some technique can be learned organically through experience, imitation, or intuitive experimentation: many children and some adults learn to dance, draw or sing very well without any formal instruction. Students do not need us in order to make art—they do it with or without us; nor do they need us to learn the techniques of a discipline or medium. Such knowledge is passed on informally from friends, family, television, the Web, books and movies. The question for a teaching artist, then, is: What specifically is it that I have to offer that is useful to my students?

One way to begin to pose answers to this question is to look at the processes and techniques we use in our own discipline. How does a singer begin to sing? With imitation? With interpretation? With improvisation and composition? What kind of base knowledge does a singer need to start? In what order and in what relationship does one grasp and develop the tools of singing? These are complex questions with many answers, but one need not have all the answers to begin to develop curriculum. One answer to one question

may be a sufficient starting place: if you see improvisation as an essential component of musical expression and you have a sense of how it works for you as an artist, then you can begin to think about how to teach it to students in a given context. The point is that we must begin with the concrete question of *what* to teach by articulating as specifically as possible the skill, technique or dynamic concept that we want to engage with students.

Many times teaching artists are asked to address how the creative process unfolds in their work with students, as if process were a *thing* in itself, disconnected from actual art-making. We understand the impulse of educators who wish for students to take away some kind of learning that transcends or endures long after the opportunity to work in a specific art form is gone. We also understand the instinct to make connections across disciplines and content areas by teaching a single "process" with which to enter into each, for instance, superimposing the writing process of rough drafts, feedback, revision, editing, and publishing on the creative cycle one uses to prepare for a musical performance—reading or learning the music on an instrument, practicing, getting feedback, refining the performance, presenting the work to an audience. But these creative cycles in writing and in music are not in lock step; they vary wildly in their sequence according to the context and according to the individual artist, and may in fact not shed any useful light on each other at all. We do a disservice to students and to our art forms when we attempt to simplify and reduce to formulae the highly complex and often spontaneous processes we go through to make art. Often in the search for "transferable" processes and skills we obscure precisely what is interesting and exciting about work in a discipline—that which is specific to the medium.

An overly glib semantic approach to describing the multifaceted and nonlinear process of creating in an art form flattens out and needlessly schematizes the fluid and highly individualized creative process that humans use to make art and to make meaning of art. It also assumes that all artists in a medium work the same way—that all artists use the same step-by-step approach to creating work; all oil painters start in the same way with small studies, then paint, then get feedback from fellow peers, then paint some more, draft an artist statement, etc. Such schematization and overemphasis on process can interfere with a student's ability to develop his or her own processes, either based on or in reaction to established methods. In order to develop original work in a medium, you do have to have a sense of the processes of the past, but you also need room to modify or even replace them.

Still, artistic process is not an impenetrable mystery. It can be broken down and, to some degree, taught. The challenge of teaching process is compounded by the fact that process can be specific to an individual artist (and student artist), and many of us teach in circumstances where we have limited time to work one-on-one with a student. We need to come up with some way to communicate general ideas about process that are useful to a range of students.

Often, in order to sell our services or to make our presence viable and valuable in a particular educational environment, we need to be able to communicate our process to educators and administrators. Explaining your artistic process (or processes) can also help you make a meaningful (not just rhetorical) connection for educators and administrators between your teaching and common educational priorities they might have for their students, like the development of "higher order thinking skills" such as application, analysis, synthesis, and evaluation. It is also useful to explain to administrators and teachers which aspects of your creative process (we would advise you to keep it discipline-specific) you plan to emphasize when you come to teach. This will make it easier for them to support your curriculum with their own and make connections to other processes in which they engage students.

As a poet Becca has found that one solution is to think about different entry points that allow her to apply her content knowledge and the skills and techniques in the art form to make something specific. By entry points we mean ways by which one might enter into the making of something. She often gives students prompts for poems—a line, another poem, an image, or all three. Often students and Becca brainstorm together to come up with some of these prompts or raw material. This is a valid entry point into the initial phase of the creative cycle: coming up with ideas that can be starting points. Does she teach students explicitly what this "phase" is called and ask them to write it down (for instance, Step One: Brainstorming)? No. Does she care if they know what phase they are in? No. Rather, she wants them to *do* the brainstorming and come up with interesting and compelling ideas to write about. She might say to them by way of introduction that poets get ideas from all kinds of things and reading other poems is one way to begin to develop such ideas. As teaching artists we need to know about several entry points (even if we ourselves use just one or two, and in ways that would utterly baffle students) and share them with students so that they find their own ways of creating work.

While we don't think that one needs to teach a creative process explicitly or that students need to articulate their own process explicitly, we do think it is essential for the *teaching artist* to be aware of where a student is in his or her own creative process or cycle. Such awareness is an important part of developing a teaching/making sequence with students. One needs to know which tools and techniques to make available to students when they first begin a project or exercise, and which tools and techniques can be useful to students when they think they are finished with a first draft or iteration. Is that where you want them to stop for now? Or do you need to push them further into revising and refining their initial ideas? What do they need to know in order to be able to do that successfully? Have you mapped out your lesson or lessons in such a way that you are offering the right amount of knowledge and support at the right times?

As artists we live in our own creative process; we may rarely stay in any one

phase for very long, or we may slip easily and unconsciously among phases. We begin a work and revise it as we go—maybe we ask for external input, maybe not. Perhaps we already have an internalized sense of what quality looks like, so we shoot for that. Or perhaps we are trying to expand or even explode our previous notions of quality or preexisting aesthetics, and this drives a different process. Editing might factor into our initial creation phase, so that we don't actually sketch or write down every single stupid idea that pops into our heads. We may learn to edit ourselves as we develop experience and maturity. Or we might work in a completely intuitive and improvisational way—never editing and never reflecting—just creating raw work. This can be a way of working that is uncritical (although it can generate good work in some cases), or it may be a way of working critically and selectively in the moment—choosing what notes to play, or words to write or say, based on past experience and the dynamic demands of the moment.

Our point is that because teaching artists are often asked to explicitly teach a specific or statically defined creative process, we end up forgetting what it actually feels like to experience our own process and how messy and inchoate it can be. We need to ask why it matters if students know where they are in a specific process. What is the goal of such an approach? Why are we being asked to teach it? Might it, in fact, *not* teach students how to be more "creative," but instead instill in them a false notion that creativity comes from following a particular process or series of steps? That sounds like the opposite of creativity. Asking students to stop and reflect on where they are in the creative process and how they are managing it is asking them to remove themselves from actually creating something.

Because educators often lack time, skills, money, and resources to assess student art and art-making, they increasingly resort to assessing the thinking about making the art. This trend is also driven by the growing emphasis on the use of arts teaching to train students in particular behaviors and habits of mind, and by other highly utilitarian and behaviorist trends in education. So it's common for arts education organizations and schools to ask teaching artists to document student reflection on process at great length. Often the documentation we are asked to provide is framed in leading ways with an implicit or explicit agenda of proving that a particular kind of learning or behavior modification is taking place. We might be asked to get students to reflect on how they navigated an initial creative phase and then used feedback to refine their work; or how they tried experimenting after looking at the work of another student. While these may be interesting and useful things to explore with students, more often than not the questions are posed in superficial ways with the goal of providing a sort of proof that students learned something real about "creativity" or some other intangible skill.

We are not saying that such learning does not take place, but rather that this emphasis turns an art-making experience, where the work is the point

and the students are artists, into an evaluative experience in which the student's behavioral or cognitive development is the point. That may be the larger frame from an educator or administrator's point of view, but if it becomes the frame in the classroom or studio, it is a huge obstacle to student art-making. The kind of questions students and teaching artists should be considering are: Is the work interesting? Does it make original and effective use of the techniques and skills under study? Does the work reflect experimentation and innovation with the techniques being taught? If all the work looks similar and it does not evidence student invention, then no amount of reflection on process will teach "creativity." From the beginning stages of inventing curriculum we need to keep the tools, time and space for student invention and innovation in the medium at the center of our planning.

This is not to suggest that students should not learn the vocabulary of a medium; they should and must do this in order maximize their ability to critique and develop their own work and that of other artists. But the ability to *talk* about work is not primary. Some students work hard and create extremely high quality art but have great difficulty talking about how they made it or why. Have these students failed? Have we? Certainly not. Such students are simply not verbally adept or fluent enough to talk about their work in those terms, or the sources of their work may be partly or wholly unconscious. Nor does such difficulty in verbalizing about the work mean that students have not internalized notions of what it means to work successfully in a particular medium or art form. Look at their work. Check back with them in seven years, or twelve years, or twenty years, and see what they took away from the experience and joy of working diligently and authentically in an art form. If they worked in a setting in which they could create freely and make their own meaning of the experience, then they likely took away a great many useful and pleasurable insights and, perhaps most important, they took away a sense of themselves as artists. Teaching and learning about how to talk and write about art can certainly be part of our work with students, but it should be secondary to teaching and learning about making art.

WHAT TO TEACH: CONCRETE STEPS

1. Identify what you consider essential to your work as an artist

We've contextualized the question; now what? How do we begin to create curriculum? First, simply name what you do as an artist. The ways in which you describe your artistic work—the terms and language you use—what you care about and are interested in sharing with students. Some of our teaching artist colleagues who have been teaching a long time occasionally find it dif-

ficult to separate what they have been teaching from what matters to them as artists. These experienced teaching artists often have developed tried and true lessons, the origins of which can elude them. Recapturing the personal relevance and meaning behind what one is teaching is crucial to revitalizing one's artistic and teaching practice. This is just as much the case, or perhaps more so, when one is teaching in educational settings that have rigid curriculum guidelines (such as K–12 arts classrooms, or for an arts organization with a prescribed curriculum). Even in highly prescriptive and structured contexts and programs one can still find numerous opportunities for creative and highly personalized teaching and learning by beginning with one's own artistic practice and expertise.

Following is a list of questions with which one might begin.

Twenty Questions About What You Do As an Artist

1. How do you describe what you do? What do you tell people who ask what you do?
2. What sort of artist are you?
 a. A performer? Of your own work, or the work of others?
 b. A professional in your medium? How do you define "professional"? Does that word make your skin crawl? Does it hold any relevance for you?
 c. Do you exhibit or publish your work?
 d. How else do you share your work?
 e. Do you operate within a specific artistic community? Or do you work independently, or not share your work at present or ever?
 f. Do you make art for a specific audience? For any audience? For yourself?
3. What is the discipline (or what are the disciplines) in which you typically work?
4. Do you have a particular genre or style you work in within your discipline? If you are a visual artist, what is your favored medium(s)?
5. What have you researched the most or what do you like the most in terms of artistic disciplines, genres, styles, techniques?
6. Do you work in a particular craft tradition? Or do you perform in a particular artistic or folk or cultural tradition?
7. Do you find the word "art" or "artist" off-putting or not applicable to you? What other term would you use to describe how you work and what you do?
8. Are you currently making art? Why or why not?
9. What language do you use to make your art?

10. What questions or topics or subjects compel you as an artist?
11. What are your current concerns as an artist? What are you working on right now?
12. Why do you make art?
13. Where do you make art?
14. Why do you care if others make art in your art form?
15. Why does it matter to you that others learn your art form or experience it?
16. How did you learn to work in your particular art form?
17. When did you learn it? At what age and in what sort of setting?
18. Was there a particular teacher or mentor who stands out to you? Why?
19. When did you start thinking of yourself as an artist?
20. When did you start teaching? Why?

All these questions are designed to help us name and claim what we do as artists. We need to be able to do this for ourselves first and foremost. But this naming can also help us to be more clear about why we should get hired and work in a particular way with learners. Even just answering the questions above could lead to an engaging bio or teaching statement and help you provide some useful background on a resume or application.

These questions and one's responses may seem larger and more philosophical than is necessary to simply write up some lesson plans. You don't have to share all the answers—if you started taking art classes because it seemed like an easy way to get through college, or if you are still self-conscious about calling yourself an artist, well, no one needs to know except you. But taking the time to articulate your responses as honestly as possible can make it easier for you to dive into exploring and narrowing down what is essential to teach in your medium. It also helps you become more effective as a teaching artist over time. If you have already articulated your approach and reasons for teaching, then meeting and getting to know new teachers and students will go much more smoothly—you will be able to communicate the main aspects of who you are and what you care about right away.

2. Identify what you consider essential to teach in your medium

Name what you teach

This chapter offers a number of processes by which a teaching artist can name, specifically and concretely, what he or she wants to teach. You can use these processes in sequence as one big process, pick and choose the chapters that

seem more useful to you, or simply read this as one model that might inform your own ways of thinking about this question.

Once you have named what you teach (poetry, theater, painting and drawing, dance, art criticism, etc.) you are ready to start naming what you *want* to teach. This is where you must be particularly specific and concrete. The more specific you are, the better your curriculum will be and the more accessible it will be to students, teachers, administrators and fellow teaching artists. The more you have thought through ahead of time what you know and do, the more efficient and fun your planning will be. When you are clear and concrete about what you want to teach, it will also be much easier to discover connections to other disciplines, both in the arts and in other areas, and to collaborate with other artists and teachers in ways that support your teaching goals in your medium rather than dilute them.

You don't have to teach everything; just teach one thing well.

Any arts discipline includes a vast body of technique, skills, theory, and historical, cultural and traditional context and content. If one were to try to create a "complete" curriculum in a medium, it might make sense to try to think about engaging many, many dimensions of that medium in order to provide a balanced, deep and broad training for a student. But as teaching artists we are generally teaching in a more local, specific and personal way. We are rarely in a position to think about developing comprehensive, all-inclusive curricula in our discipline. That is okay! If we teach that which we know well, even if it is just one technique or approach, and we give students time and space to really experiment with what we teach, we will have provided students with a point of access to deep work in *a medium*. We can understand individual techniques or concepts as doors that lead to work in the medium, and often one door is as good as another. Ultimately, it is in the actual dynamic interaction with the medium that the most important learning and invention and innovation happen in the arts—in the actual work of art-making. So we should teach what we know, teach it with as much flexibility and from as many angles as we can manage, and teach with an eye toward allowing students plenty of time to apply what we teach in their own art-making.

Generally, in order to teach something well we have to know it quite well. We need to understand a technique or skill in some depth (even if we are not always experts in its application) so that we can approach teaching contexts and individual learners flexibly and find the right "angle" on the thing we are teaching in a given situation or with a given student. So it's probably a good idea in curriculum planning to start with what you know or can learn a good bit about before you teach it. Of course the question "What do I know?" can be huge and complicated, but again, you don't have to address it in the general

sense to create great curriculum or exciting teaching practice. You just have to answer it in a small way by focusing on *one* thing, or a few things you know that you want to teach.

We are going to provide two possible starting points here, two processes that we (Becca and Nick) have used as teaching artists. The first involves identifying a group of 10 techniques or concepts as a sort of core of practice in your discipline. The second process involves looking at a single technique or concept in your medium and thinking about it from many angles. Either or both of these approaches can help to narrow down what you want to put at the center of your teaching in a given lesson/project/program. We hope that these processes will provide an invitation or provocation to develop and/or share your own process for deciding what to teach.

Process 1: Identifying a core group of concepts and techniques in your discipline (Becca)

This process is about identifying a group of techniques and concepts that you feel are essential to teach in your discipline. It is important to remember that your idea of what is important to know and understand might differ from that of another teaching artist in the same discipline in terms of content or the scale or depth you think a learner should attain. Try to zero in on the things you care about. You would probably not teach all of these in a given residency or project or unit—but you can have this list as something to go back to as needed. Don't restrict yourself to ten items, but don't make a list of every single thing you know either. What matters to you? What can you realistically teach others? That should be your guide.

Sample list of ten concepts/principles/elements in dance
(This list is hypothetical. The list of an actual dancer would, of course, reflect the particular training, interests, and practice of that person).

1. Dance as a social and cultural expression
2. Elements of dance: body, action, space, time, energy
3. Body levels, such as low, middle, and high
4. Types of movement, such as locomotor and non-locomotor
5. How isolation of a body part leads to clarity of movement
6. Learning and applying what a choreographer does
7. Telling stories without words
8. Pedestrian/everyday movements translated into dance
9. History and basic positions of ballet
10. Evolution of modern dance

List at least ten techniques in your discipline

Now you are ready to list the techniques and skills in your discipline that you consider important for you to teach. Think about the level of mastery that you would want a learner to reach—we will discuss a bit later how the students' age and the context of the learning might affect how far they can realistically go with a particular technique or skill.

Describe the function and application of these techniques. Here are some examples across a range of disciplines:

- Pinch pot technique in ceramics. This technique allows one to create a vessel out of clay without a wheel, simply using one's hands.
- Creating a tableau in theater work. Tableaus are frozen pictures that a small group of people make with their bodies to depict a scene or a particular moment of a story or a play. Theater artists use them to tell a story without words or to highlight with their bodies key moments in a scene.
- Using dialogue in a story. This technique allows different voices to emerge in a single text. This can be very empowering and fun for third graders, for example, or for senior citizens in a writing workshop.
- Observational drawing. This technique allows someone to observe an object up close and render it based on actual observation of its shape and details.
- Adding music or sound effects to a video. The technique of adding sound that is not in the original footage is something film editors use often to build a finished work that expresses a particular meaning.
- Creating a petal-fold book in bookmaking or visual arts. This technique of folding paper to create a sculptural book form is inspired by Japanese origami folding techniques.

Becca's list of ten techniques in poetry with their function and application

1. Create a metaphor that has depth and complexity by working first within the constraints of a given word bank, that is, another poem or text or "word field." One must choose a noun from this word bank to use as one's governing metaphor and then use it to show equivalency between something one knows rather well or wishes to explore further ("This day is . . . ," "My brother is . . . " "My heart is. . . ," "Lonesomeness is").
2. Practice "showing not telling" by finding a compelling image to depict a particular abstraction (emotional or intellectual, such as "justice" or "grief" or "envy") and writing about that abstraction without using the customary word or similar abstract words.

3. Work with personification as a technique in a poem to bring an abstract concept ("anger" or "hunger") to life or simply make an inanimate object come alive ("The pencil dreams each night of clean sheets of paper. It wishes its eraser had not been bitten off. . . .

4. Work against cliché or expected language by intentionally using negative grammatical constructions or antonyms of your original word choice. This is a revision technique to use on the second draft of a poem and should not be used formulaically. When it is used randomly at first, and then with increasing intention, one begins to see interesting contradictions and possibilities opening up inside one's poem.

5. Lineation strategies: there are a multitude of ways to lineate a poem, and experimenting with different strategies for the same content allows students to see how lineation affects the meaning of a poem. Such a series of lessons would entail a great deal of reading of other people's poetry for ideas and examples.

6. Practice expanding your use of comparative language by creating lists of similes for a given color. Such an exercise for first graders might mean tossing a ball around a circle; whoever catches it next must complete the sentence "as red as . . ." or "red like a. . . ." The point of the game is to stay with one color as long as possible without repeating any similes. For 11th graders or college students this might mean dividing into pairs and creating as many similes as possible in a given amount of time. Each pair responds to the same prompt and at the end it's determined which pair has the most similes with no repeats.

7. Learn to use sound more intentionally in your language choices by doing some very specific poetry exercises: using alliteration in every other line for up to ten lines, for example, or using consonance in a similar way. The point is to make the learner acutely self-conscious of sound, sometimes to the point where meaning becomes secondary.

8. Learn to hear and apply rhythm in your word choices. Students can learn this, of course, by writing in more formal meter (iambic, trochaic, spondaic, etc.), but they can also learn this technique by doing some exercises with syllabic poems, that is, poems that have a certain number of syllables per line. One can also pay attention to the beats or accents in a line and work on poetry that uses, say, three beats to a line.

9. Use of questions as a way to enter and exit a poem. Playing with rhetoric and syntax in general and paying attention to elements of speech such as questions is an excellent and painless way to highlight a central feature of poetry—the manipulation of language to affect a reader in certain ways. Students start to learn how the language of poetry can be pushed farther than ordinary language, and they learn how ordinary

language can serve artistic ends.

10. Study and write in formal verse, such as sonnets, villanelles, and sestinas, following the strict meter and rhyme these forms call for. Such exercises can be very liberating, especially for reluctant writers (they just have to follow the rules) and for writers who have difficulty exercising emotional or thematic restraint in their poetry and thus tend to end up with extended "diary entries" for poems.

If you are having a hard time coming up with a list of techniques, ask yourself what else you need to know about your discipline. Do you need to go read something? Do you need to look at or listen to good work in your medium? Talk to a fellow artist? We do not believe that age or experience in teaching automatically makes one an effective teaching artist. What enables someone to do good teaching artist work is depth of knowledge in one's discipline and some curiosity and ideas about how to share that knowledge with others. Often with artists, young ones especially, it is not a question of not knowing enough, but of simply dragging out what one *does* know and assigning it a name. Discussing your medium and practice with someone who can recognize a concept or technique when you talk about it can be very helpful.

Similarly, going through this process of naming core skills and concepts will help you separate actual content knowledge from fads and styles in teaching. For instance, there has been a plethora of information lately about how to teach using "Web 2.0"or digital online formats—all well and good if you are adept and creative enough to call yourself an artist in these forms. Educators often fear that the only way that they can hold a student's attention is through the use of "emerging technologies" (technologies that most students already take for granted). They forget that one has to actually teach real content. They mistake the tools for content, and students end up with bogus or superficial curriculum. Teaching artists who actually know something real in their discipline feel that they are behind the times because they have not created a Wiki page for their project. We are not disparaging such approaches—they often are useful tools that can offer new and effective ways for students to communicate with each other and to create their own content. But ultimately it all must be grounded in some kind of meaningful artistic creation.

Process 2: Focusing on one concept or skill and examining it from many angles (Nick)

A first step to this narrowing is to think in terms of the *types* of things one might teach in a discipline. Such a categorization can help us think concretely about the things we know well enough to teach, and also help us think about these things in their connections to other knowledge in a discipline. It should be evident that different types of knowledge often overlap in practice. It can be

a useful and revealing exercise in curriculum planning to pick a skill or idea that you want to teach, and break it down in terms of each of these categories. For instance, you can think of one skill or concept that you use a lot in your own art-making and know in some depth, and see which category it might belong to. You might then think about what you know about the knowledge in the other categories related to this skill or concept (we've provided an example following the list below). Here is a somewhat arbitrary list of examples of different types of knowledge in some arts disciplines.

Some types of knowledge in arts disciplines

1. Practical technical skills
 a. Executing a scale pattern on an instrument
 b. Mixing chemical components to make a pottery glaze
 c. Setting up a photographic enlarger to make a print in a darkroom
 d. Knowing the elements of a sestina form in poetry
2. Dynamic application of technical skills in a discipline
 a. Improvisation of a melody from a particular scale in response to a musical context
 b. Mixing of a pottery glaze to obtain a specific coloration or effect
 c. Making of prints in a darkroom
 d. Writing of a sestina
3. Theoretical-technical knowledge in a discipline
 a. Chord-scale relationships, or the mathematics of pitch and intervals
 b. The chemical principles of glazes
 c. The optics of a photographic enlarger or the physics/chemistry of photo-emulsions
 d. The prosody of the sestina form
4. Aesthetic or contextual theoretical knowledge in a discipline
 a. The expressive, dynamic or historical functions of certain melodic and harmonic choices
 b. The functional and aesthetic effects of different types of glazes
 c. The aesthetic and cultural impact of the development of photographic film on photography
 d. The historical and contemporary applications of the sestina form
5. Intuitive or difficult to articulate knowledge in a discipline
 a. Speech-like phrasing in improvisation
 b. Color mixing for glazes to produce particular emotional associations
 c. The use of dodging or contrast filters in the darkroom to produce mood in photographic prints
 d. Evoking subliminal associations in a reader through the lexical rep-

etition that occurs in a sestina

6. Conceptual frames that may inform or drive an artist's work in a discipline

 a. Analyzing and exploring melodic conventions of contemporary R&B hits

 b. Exploring the collision of digital technology and ceramics—using digital imaging to create surfaces for ceramic objects

 c. Exploring the relationship between cropping and metaphorical point of view in photographic prints

 d. Writing sestinas about sestinas

EXAMPLE: ONE WAY OF NARROWING DOWN WHAT TO TEACH

Here's an example of how I (Nick) thought through what I wanted to teach in a particular lesson—part of an eight-session course in beginning sound/audio making for high school students. This example is about figuring out what to teach, not how to teach (that's what the next chapter of the book is about), but of course one can't entirely separate the two things. I've tried to reflect my thought process and describe how I used some of the categories in the list above to figure out what specifically to teach about a single concept/skill in music/sound. Of course, in real life my thoughts were much more confused! But I hope this will give you an idea:

- My students are just starting out working with Garage Band and recorded sounds (this is the second session). Most have not made or recorded music before, although they all have many ideas about music. They have started work on sound/music pieces by recording a single sound and using editing and arranging in the software to layer and manipulate the sound.

- We have two and half-hours in this session.

- I want them to gain some new skills with the software and also gain a bit more control over the recording of acoustic sounds.

- Mostly I want them to be actually recording, editing and arranging sounds to make a sound or music piece. So I don't want to spend too much time teaching/learning a theoretical point.

- I will show them a few more editing techniques in Garage Band but won't get theoretical about that—just show them how. Those things won't be the main thing I teach.

- Okay, but what do I want to teach them about sound? Maybe something about how sound interacts in space.

 • How you hear the same sound differently in different sized spaces.

Clap your hands in a small space with soft furniture and carpeted floors and it sounds "dead." There isn't much reflection of sound so most of what you hear is the direct sound from the clap.

- Clap your hands in a large space with hard surfaces, like a hallway with firebrick walls, and you hear a reverberation after the clap. Sound is reflected back to you after you hear the initial sound.
- If someone else claps his or her hands near you, it also sounds more like the small, "dead" sounding room. You mostly hear the direct sound.
- If someone claps his or her hands far away from you hear more reverberation.

- I still need to narrow things: I've identified at least three possible fundamental concepts that link to many different skills:
 - Different surfaces and materials reflect sound to different degrees.
 - Different spaces sound different to us also because of the volume level and duration of reflected sound we hear.
 - What we hear is also affected by our distance from a sound source, partly because if we are farther away we hear a greater proportion of reflected sound relative to the direct sound.

- These are too many concepts for one session.
 - I can either simplify—just teach that how we hear things can be affected by the size and surfaces in a space and our distance from the source. . . .
 - . . . Or I can pick one of these concepts and explain it in more depth. For instance, I could explain or even demonstrate how sound pressure/intensity follows the inverse square law—as you move away from a source, loudness drops off very quickly at first and then more slowly. (Have to review the particulars and the math if I am going to teach this!!)

- I've decided to go with the "simplify the explanation" option and teach the more general principle. This will give students more options to play with (using both the size and type of space, and the distance from the microphone to get different sounds recorded). I think students will be able to figure out some of the more specific implications through their actual recording of sounds.

- Okay! I've identified the concept I will teach: The type of surface, size of a space, and location in a space affect how we hear a sound in that space. That knowledge is technical-theoretical—it's related to theory in acoustics but has more technical implications than directly aesthetic ones. Now I'll think about some related knowledge in the other categories on the list above:
 - Practical technical skills
 - Choosing a space for a specific sonic effect

- Positioning the sound source or microphone in the space to capture that effect
 - (These seem easy and good to teach in this session!)
 - Dynamic application of technical skills in a discipline
 - Using the above skills to get some interesting sounds for their pieces (Yup, makes sense in this session!)
- Aesthetic or contextual theoretical knowledge in a discipline
 - Lots of points to make about how to manipulate a sense of space for many different musical effects. Mood, dynamics, genre—all can be cued or suggested by manipulating sonic space.
 - Also historical points about how reverb effects in particular are a major historical and genre cue in recordings. For example, a certain type of reverb can stamp a song as from the Sixties or the Eighties. (Hmm, this seems to involve too much talking to teach directly in this session. Maybe I can mention it when we listen to student work at the end of the session. Maybe it will come up in discussion.)
- Intuitive or difficult to articulate knowledge in a discipline
 - Sense of space in a recording can elicit all kinds of associations in a listener (claustrophobia, eeriness, openness). (This too involves too much talking to go into directly. Maybe this is another thing that will come up when we listen to the work. I think students will intuitively discover these dimensions of space as they experiment with their recordings).
- Conceptual frames that may inform or drive an artist's work in a discipline
 - Many possibilities here. The work of many sound and music artists has been about the use of acoustic spaces and also their metaphorical or symbolic counterparts.
 - Students might want to take exploration of sonic spaces in general, or of particular sonic spaces, as a key feature of their work or as its conceptual frame. (I think at this early stage too much "big concept" might distract from experimenting with the specific characteristics of the medium. These ideas are worth keeping in mind, though, as students think about their longer-term projects).

So, what did I do here? I thought about something from my own arts practice that is interesting and useful to me: using different spaces for sonic effect. I then articulated as clearly as I could the principle(s) and skill(s) associated with this aspect of my practice. I realized that there were several principles in play. I chose one and considered it in connection with various ways of thinking about and making sound and music. I chose a few of these as things that

would be easy to incorporate in my teaching in a way that would support and leave plenty of time for student art-making. I rejected others as a distraction, or decided they could be dealt with peripherally.

This may seem like an awful lot of detailed thinking for one session! In real life I am not often this methodical. But I've found it really useful to do this sort of thinking when I can. When I do, I find that my planning and teaching are much clearer and leave more space for students to apply principles and skills in their own original ways. I also find that doing this sort of detailed thinking about what to teach also makes my less formal and more intuitive planning richer and clearer as well.

Note that I have not yet thought about how to teach the skills and concepts I want to teach. But because I am now quite clear on the "what," I can immediately see a number of ways of teaching this "what" in the context of this class. I still have to work out the details, but because I've really narrowed things down I will be able to teach the concept with a maximum of efficiency—which in this case means very little explanation and lots of student experimentation. As it actually played out, I waited about an hour into the session and then asked if anyone was bored or stuck on their piece. Those who were came with me out into the hallway, where I explained and demonstrated, in about sixty seconds, the principles of reflection in a space and of distance from a microphone. The students went to work finding new sounds to record using these principles. The rest of the class was introduced to the concept when we later listened to student work and talked about the sounds a few students had recorded in different spaces. We did not end up addressing some of the other related concepts I thought we might talk about when listening to the work, but we will probably discuss these in other sessions.

3. Decide what you consider essential to teach within a specific space, time, or context

In a sense, all teaching is an act of triage. Teaching and learning are not mechanical or linear and are highly dynamic. The time and space available for teaching are limited, students are unique, and knowledge is neither static nor "complete." One of the central activities of teaching is deciding what is and what isn't essential in a given context.

Teaching artists work across a huge range of contexts. They often have little to no control over the space in which they will be working, the size of the group, or the kinds of learners they will be teaching—these learners might be novices, they might be 10-year-olds, they might be serious practitioners, they might be emotionally disturbed teenagers. Some teaching artists know right away what they are capable of and with whom they will be most successful, and they select those teaching situations accordingly. Others are trying to fig-

ure out this element as they go, by trial and error. Still others don't care—they are able to walk into any room and begin teaching.

What if you have only forty-five minutes with students? Thirty minutes? Or even less time? What is it that you want to leave with them besides a good impression? What sorts of things might you be able to communicate or have learners do that would still get at what you consider essential in your discipline? If you are too gimmicky, they will regard you as simply another form of entertainment. If you are too general or didactic in your approach, they will be bored, regardless of your medium. Consider these questions:

- If you had five minutes with a group of students, what would you want them to know about your art form?
- If you had one hour with students, what would you want them to know about your art form?
- If you had five hours (consecutive or over the course of a week or five weeks), what would you want students to know about your art form?
- If you had twenty-five hours total, what would you want students to know about your art form?

We might also think about space and materials. None of the following situations may ever actually occur, but consider them and how you would respond. What effect do these kinds of constraints have on your ability to distill what is crucial about your discipline? How might such constraints affect your teaching in creative ways? Think of the following situations from the perspective of your own discipline. If you are a ceramicist, and there is no clay available, what can you still teach? If you are a musician and there are no instruments, then what? What if you are a poet with nothing to write on? These are not empty questions. They are about getting you to think about the "what" behind anything you teach—asking you to look beyond technique and materials and student disposition and experience to see the essentials of your discipline. Keeping an eye on such core elements allows you to improvise and teach effectively in any situation that may arise.

Address how you would handle the following circumstances from the viewpoint of teaching in your particular art form:

- You have a classroom of twenty-eight third graders and the only supplies are a notebook and pencil or pen for each student.
- You have forty-five minutes with a group of eight slightly hard of hearing senior citizens and a full range of whatever resources or tools or materials you need in your medium.
- You are stuck in an elevator for one hour with three sixth graders who don't speak your native language.

- You are put in charge of an ever-changing group of teens who drop in to the after-school program for three days a week for ten weeks.
- You are able to take students on a guided tour of a local museum and spend an hour afterwards working in your art form. Which museum would you choose and why? What would you create with students?

4. Integrating other subject areas: think about how to connect what matters to you in your art form to subjects outside of your discipline

As artists we are curious about many subjects, some related directly to our discipline and some not. Often when we work in school settings we are asked to integrate art-making with other subject areas. Sometimes the premise behind this is that such integration will make our work with students more "relevant" to the existing curriculum or justify the fact that students might be missing part of their reading block. Sometimes it is because there is a happy congruence between working in our art form and exploring another subject area, and studying the two disciplines together informs and enlarges one's understanding of both. In either case, you still have to have a firm grasp of your art form in order to see where it can best be integrated with other curriculum, and what aspects of it are best suited to this kind of integrative approach. As we mentioned earlier, you do not have to be an expert in another subject to integrate it into your work. You do have to be curious about it and understand it well enough to ascertain whether the integration that is being proposed makes sense.

The question of how and whether to integrate arts teaching with other curriculum is complex. We address it further in the next chapter of the book. Here we want to emphasize that it is essential to think through the "what" of such integration just as one would think through the "what" of teaching in an arts discipline. If anything, clarity about what is being taught in both the arts medium and non-arts discipline is even more essential than when teaching in the arts alone. The more clarity there is in both areas, the more real the connections that can be surfaced and developed into teaching, learning and work that is compelling and creative in both the arts medium and the non-arts discipline.

Four ways of integrating art-making with other subjects

When practiced with thought, study, careful collaboration and planning, arts integration can yield powerful insights and learning in the arts and other subjects. When approached superficially, it can lead to formulaic work in a medium and can actually obscure or confuse learning in an academic subject. What follows is a very general framework that one might use to think about

the different ways of approaching the integration of work in a medium with a non-arts subject.

- **Organic integration:** Making science/history/mathematics *with* art.

 In this type of integration the tools and methods of art and other subjects overlap in ways that reflect authentic work in both disciplines. Such integration can lead to a particularly deep kind of learning in both the arts medium and integrated subject as well as cross-disciplinary insights. This kind of integration is often overlooked in schools. It can be discovered by asking simple questions like, How do biologists use drawing in their work? How do physicists use sculpture or modeling in their work?
 - Botanical drawing—using the tools and methods of the visual arts to document and investigate the biology of plant structure and form.
 - 3D modeling of physical systems—using the tools of the sculptor, visual artist and animator to study various phenomena.
- **Organic integration:** Making art *with* science/history/mathematics/ engineering.

 In this second type of organic integration student-artists use the techniques of science, history, mathematics and other subjects as tools for their art-making. The aim is to make art, but the authentic use of tools from other disciplines leads to learning in these disciplines as well. The non-arts learning is driven by the aesthetic and technical needs of the student-artist's work in a medium. This kind of integration can be discovered by asking questions like, How can we develop a pigment that creates a certain effect? How can we get this 15-foot-high sculpture to stand up? How were the glazes and color effects of Navajo (Diné) pottery created?
 - Learning welding to make sculpture.
 - Learning the chemistry of pigments to make paints.
 - Learning geometry to invent, plan or implement artistic or architectural ideas.
 - Studying historical or archeological sources for aesthetic and technical precedents for art-making.
- **Integration by analogy:** Making art that attempts to explicate specific objective and subjective features or dynamics of a subject.
 - This is perhaps the most common type of arts integration in schools. It involves making art as a means of reflecting on or interpreting historical, scientific, mathematical and other subjects. It relies in large part on student exploration of objective and subjective analogies.
 - This type of integration can be generative and educative where the analogies engaged are accurate. But if the integration is superficial and the analogies are misleading, it can lead to superficial work in the

arts medium and possibly to greater confusion in the non-arts subject.

- For this kind of integration to be successful it is essential that the teaching artist know enough about the non-arts subject to explore useful and accurate analogies in the arts medium. If the teaching artist is collaborating with a teacher, close and extensive collaboration in planning is also important.
- It is very hard to present examples of "good" and "bad" integration by analogy, because the artistic and educational success of such work resides in the aesthetic and intellectual details. "Dancing a hurricane" might reflect trite and sterile choreography and might also not in any meaningful way reflect meteorology or climate science. But it's also possible that such a dance could be artistically powerful and also reflect real principles of climate and weather. The difference usually has to do with the depth of the collaboration between a teaching artist and academic teacher.

- **Interpretive integration:** Making art as a way of interpreting or commenting on a subject.
 - This, too, is an area that appears to be insufficiently explored in arts integration in schools. Essentially, it involves parallel teaching in an arts medium and an academic subject. Students study a subject, and also an arts medium, and make art with few constraints other than the general frame of commenting on the non-arts subject. The non-arts subject provides the thematic material for the art-making.
 - While this type of integration is explicitly not about direct or literal analogies to academic material, it can still yield interesting and educative insights into that material. These insights can ultimately prove more generative and educationally useful than the more literal or direct connections that emerge in integration by analogy. Such insights and connections between the art-making and the non-arts subject can often be accessed after the art-making is complete, or while it is in progress, through discussions about the work itself—just as is the case with art outside of schools. What does this painting tell us about the Civil Rights Movement that we didn't know before? What does this piece of music tell us about the water cycle that we didn't know before?

Finding connections with collaborating teachers

One way to think about how to integrate your subject into other subject areas is to take the time to list the top five concepts and the top five techniques that you consider essential in your medium. Then ask your collaborating teacher to do the same for his or her subject area. Compare your lists and see where

there are connections. There might be very straightforward connections or ones that are less apparent. Are these meaningful opportunities for creative experimentation, or simply dead-ends? Are there analogies to be made that are accurate, interesting and generative, or are the analogies that emerge superficial, facile or misleading?

EXAMPLES USING THEATER AND HISTORY

A theater artist's top five concepts:

1. Exploring body, voice, and imagination as tools of the actor
2. Occupying a character
3. Rehearsal is essential
4. Ensemble
5. Theater is story

A theater artist's top five techniques or skills:

1. Using voice with confidence and good projection
2. Using body to communicate facts about and feelings of a character
3. Using tableau to better internalize a story's main parts
4. Understanding cues
5. Connecting personal experience to that of a character in order to make him or her or it come alive for the audience

A history teacher's top five concepts:

1. History is someone's story
2. Perspectives vary according to who is telling the story
3. Our past affects our present
4. Studying history can help us better understand our present .
5. We each carry history within us

A history teacher's top five techniques or skills:

1. Understanding how sources inform a narrative
2. Looking for more than one account of the same event
3. Analyzing a particular historical event using cause and effect
4. Writing a critical essay about a particular event
5. Learning how to search for the voices that are not represented in the published narrative

Potential points of intersection or connection:

- Researching a particular event and writing a five-minute scene that captures an essential, illustrative moment through the use of particular narrative techniques in theater
- Exploring voice as a concept across both theater and history: assigning roles for a narrator and characters and staging a performance of a particular event
- Using tableau to create a timeline of a particular historical event to explore cause and effect

5. Consider how your artistic process will inform what you teach

Process is inseparable from making and knowing things in an art form. But it is useful to think about it and articulate the different ways that you can teach it. What about your process *is* worth teaching? Are there certain steps that a novice should take in order to be successful and get a sense of what is possible in an art form? Is there a part of your process that is helpful to return to when one is stuck or cannot recall how to proceed? Or is there a part of the process that you teach better than another? Perhaps you are excellent at helping students come up with ideas to develop musically. You might focus your curriculum on that stage of the work and actively collaborate with another teaching artist or a music teacher to help students work through developing and refining their compositions and ultimately performing or recording them. The clearer you are about this part for yourself and your own thinking, the better.

Below are some examples of the creative process in different disciplines. They are purposely presented here in a very straightforward and somewhat reductive and partial manner. Most artistic processes are not this neat, although some artists have very clear and sequential processes that they follow in order to produce work. Some of these processes assume a performance cycle—not every dance teaching artist is interested in having students do a final formal performance. In cases where a performance is not the aim, the cycle may be tighter or include smaller, informal sharing along the way. See if any of the processes make sense to you, and then create your own schematic or list or graphic conveying how you think someone creates or performs or responds in your discipline.

EXAMPLES OF PROCESS IN DIFFERENT ART FORMS

Theater

1. Warm up body, voice, imagination

2. Read and learn script
3. Rehearse
4. Get feedback
5. Rehearse
6. Perform

Music composition

1. Explore sound and ideas
2. Compose/record
3. Get feedback
4. Refine composition
5. Publish/perform

Dance

1. Learn or create basic steps of a dance
2. Practice them alone and/or together with others
3. Get feedback
4. Adjust and refine steps and movements
5. Rehearse
6. Perform

Writing

1. Research/brainstorm ideas
2. Create rough draft
3. Get feedback
4. Revise draft
5. Edit
6. Publish/share work

Art criticism

1. Look at/experience art
2. Write down observations and questions
3. Research
4. Respond/explain/evaluate (verbally or by way of an art form)

Visual art

1. Observe and/or sketch
2. Draw or paint or sculpt
3. Get feedback
4. Refine work or design
5. Exhibit/share work

What is your process?

Think about how you work in your art form. Answer the questions below to help you come up with some language to describe how you work.

1. What part of creating something in your art form is most pleasurable and interesting to you?
 a. Coming up with initial ideas
 b. Sketching and drafting
 c. Working for longer periods of time on making something
 d. Revising the work
 e. Getting it ready to share with others (things like adding finishing touches, dress rehearsal, mounting it for exhibition, etc.)
2. Where do you find yourself most often stuck creatively? Do you struggle to find good ideas? Are you impatient with taking more time to go back and revise something?
3. Where in the creative cycle do you tend to take the most time? Is it because you love this stage or because you have no choice (constraints of medium, your own limitations, etc.)?
4. How long does it take you to make a work?
 a. A few minutes
 b. A few hours
 c. A few days
 d. A few weeks
 e. A few years
 f. I don't "make" anything—I perform it, live it, experience it.
 g. I don't understand the question.
5. Do you find it useful and generative to work with others on a project? Are you more of a solo artist? Why? If you like to collaborate, how come? What kinds of collaborators inspire you or push your work further?

6. Do you find outside feedback:
 a. Useful?
 b. Crucial?
 c. Occasionally quite helpful?
 d. Often annoying?
 e. Baffling?
 f. Unimportant?
7. Who do you ask for feedback on your work? Fellow artists? Someone outside of your medium? One person or many?
8. What are you most afraid of when you begin making or performing something?
9. How do you know when you are done? What kinds of things do you look for?

What can you teach about the artistic process?

Now that you have thought about your own process, think about which aspects might be teachable to students. Consider teaching them some part of the process that you think is particularly enjoyable or important to understanding the art form in more depth. Or consider working with students in a way that allows you to explore what might be some of the thornier aspects of the creative process, for instance, how to incorporate multiple sources of feedback? Or how to take into consideration audience and context when deciding what and how to share one's work?

It is important to remember that there are things that one sets out to teach intentionally, but always, in any teaching situation, there arise unforeseen opportunities and questions that present themselves as teachable moments or just detours from the lesson plan. This is fine. This is good.

Naming what to teach about process: some prompts and ideas

1. Where do artists get ideas? If you are good at coming up with original ideas in your art form, what strategies might you share with students that would lead *them* to original ideas? The more things you can think of, the more likely you will be successful in teaching this step. Things like:
 a. Looking at quality examples in your art form for ideas and inspiration or a model for how to structure one's own work
 b. Researching a particular topic
 c. Asking questions
 d. Working with personal artifacts
 e. Add your own idea(s) to this list.

2. In what ways do artists create work in an ongoing manner in your discipline? If you value most the time and space that art affords one to think and create multiple drafts or one extended piece of work, how might you argue for teaching in a way that creates that time and space for students? What kind of resources or residency structure would you need to have in place for that to happen? Examples might include:
 a. Dedicated studio space where students can keep work in progress
 b. A notebook containing all writing drafts and revisions
 c. Access to a camera and/or digital editing software
 d. Stage space for students to rehearse or create scenes or performance
 e. Open space to move
 f. Access to a library of images or books for ongoing reference and consultation
 g. Add your own idea(s) to this list.
3. How can artists work together? If you are someone who works well collaboratively, and you find collaboration to be a useful way to come up with and refine ideas, then how might that play out in what you decide to teach in your discipline? Things like:
 a. Focusing on teaching what it looks like to work as an ensemble in your art form
 b. Teaching collaboration by doing collaboration—in all of its messiness. This might mean working side by side with students to create a single piece of work or performance.
 c. Teaching the value of having multiple perspectives on the same piece or example (facilitating a group discussion)
 d. Spending a significant amount of time on teaching a process of peer critique so that students learn how to access each other's perspectives in order to refine or simply better understand their own work
4. How do artists troubleshoot challenges and problems that arise? If you are drawn to solving problems in your own work, or if you like to work in ways that challenge you to rethink how to approach something in your discipline, what aspects of working in your art form might you teach to students that would engage them in similar ways? Sometimes, due to a lack of resources, the challenges are built right into the work.
 a. Re-envisioning the scope of individual work because there are not enough computers for everyone to work singly on a project
 b. Taking a hike with students indoors instead of outside to look for bugs to draw because of inclement weather
 c. Figuring out how to take a mistake or accident—a splotch, a broken-off piece of sculpture, an off-key voice—and make it a part of the work

5. How do you know when you are done? This is a simple question, the answer to which could theoretically occupy one for an entire lifetime. It encompasses the notion of quality and how to develop aesthetic judgment in one's discipline. For first graders it might be that they need to come up with at least one new way of describing their mom that they have never heard anyone else use before.

 a. Teaching students how to select work for a final exhibition or publication

 b. For a performance-based discipline, filming or photographing students at work and having them critique what they see and hear

 c. Designing with students a checklist that they can use to evaluate their own work or that of others. This will force you to come up with language and evidence for what quality work looks like, what so-so work looks like, and what still needs work.

6. Consider the age and experience of your students and how it might or might not affect what you teach

Part of the "Curriculum Sketching Exercise" in Chapter 2 is about creating curriculum for outlandish and absurd contexts. Nick has led workshops where teaching artists created curricula to be taught to a stranger in two minutes on a train, to be taught to survivors on a lifeboat, even to be taught to monkeys (really!). One thing that has consistently been shocking about this exercise is the ease with which we seem to be able to adapt the concepts and techniques at the core of these curricula for more conventional students and contexts. A curriculum for monkeys that uses signing and images to explore visual-emotional associations is easy to reconfigure for high school students (ha!). A series of lessons about narrative and framing in filmmaking, conducted by students on a lifeboat that exists entirely in their imaginations, can quite simply be scaled up for fourth graders with access to a few video or still cameras. Why should this be the case? Does this mean that teaching artists don't have to consider their students' ages and backgrounds? Do developmental, educational and contextual frames somehow not apply in teaching artist work?

The answer is both Yes and No. Yes, we should consider the age and experience of our students to some degree when we plan teaching artist work. A 5-year-old may not be capable of sufficiently fine motor control to safely operate a band saw. And if a 5-year-old (or an adult) cannot write, then he or she cannot complete a lesson that involves writing a sonnet. These are technical and educational considerations, and this sort of difference is in play with any students of any age and experience. We should try to make as few assumptions as possible about what our students can and can't do, and we should be par-

ticularly careful to avoid stereotypes and easy categorizations. Nick notes, for instance, that most 5-year-olds he has met are more capable of truly spontaneous musical improvisation than some highly trained musicians who have told him that their particular training and experience have severely impaired their ability to improvise. It's good to think through whether you are asking students to do things that are within their current ability, but it's also important to err on the side of assuming that, given a little time, students are capable of damn near anything you are capable of. We'd like to think that's how we teaching artists are: We assume, "Hey, if I can do it, you can, too, which is precisely why I'm here working with you."

And yes, it's also worth thinking about how people grasp concepts at different ages, and also in relation to their educational and life experience. If you have no idea what electricity is, it makes little sense to explain how a microphone works. A teacher needs to begin by giving you at least a simple, but sufficiently accurate model of electricity as a movement of electrons in a conductor before she can usefully introduce the principle behind a microphone. It's also well established that as one grows older, one becomes more capable of grasping concepts in detail and in depth and seeing individual concepts in broader context. So while a 5-year-old can easily learn how our pupils dilate and contract in response to ambient light, he or she may have a harder time grasping the electrochemical interactions in our brain that are responsible for this phenomenon. The former can be easily demonstrated; the latter requires several more steps of abstraction to be able to "see."

We teaching artists shouldn't get too hung up on our students' age and experience, and there are two reasons why not. The first is not specific to working in the arts; it relates to the fact that our way of teaching allows for flexibility, time and depth, whatever the subject under study. This is one reason why teaching artist collaborations with classroom teachers can be so powerful—it's not just the art, it's the flexibility and time made available to approach concepts in depth. With time and space, many very complex concepts can be broken down (without dumbing them down) in ways that take into account a student's age or experience. The key is to understand the concept or technique well enough yourself that you can simplify it while preserving its essence in your teaching. If the simplified content or technique is still accurate and preserves what is essential, students will be able to build on it as their capacity grows with age and/or experience. If you know your medium or content in depth, you will be able to scale your teaching for students of greatly varied age and experience. You may even be able to run teaching artist work in which 5-year-olds work side by side with high school students using the same tools and techniques.

The second reason why age and experience are not decisive in teaching artist work is that our students are *making art*. The ability to express oneself artistically, associatively and metaphorically develops very early, and because

Identity, Super Mario, and the Wonders of Going Off Task

Back in the 1970s, when I was a kid, the theme was always "pollution." You had to write essays about the evils of pollution. You had to draw pictures, make filmstrips and even script little skits about how pollution was the worst thing ever. And you always knew what your writing and "art" was supposed to look like; you knew what was expected. If you ever drifted off task you had only to remember the ubiquitous public service TV ad with the stereotyped weeping Indian (actor Iron Eyes Cody) standing amid litter and industrial waste.[1] Making this work didn't feel anything at all like art-making. It felt more like a quiz you knew exactly how to ace. It also felt a little humiliating in an "I'm being asked to perform" sort of way. Not surprisingly, the art we made about pollution was usually pretty lame and generally went right into the trash and from there probably into a landfill or the ocean. The theme was safe, predictable, superficial and entirely disposable.

Today we like to ask kids to make art about things like "identity" and "community." I'm a musician. If you asked me to make some music about "Who I am" or "What community means to me," I'd be really bored and resistant. It's just that those themes seem at once vague and played out and not the least bit generative. I suppose if I had to do something with them, I'd find a way to make them interesting to me, but that would likely involve a pretty radical, and possibly "inappropriate" reinterpretation of the themes. But before resigning myself to these themes I'd ask you if it would be okay for me to make art about something else—something I have ideas about, maybe some knowledge of, or experience with. Maybe airplane engines, or cows or the Soviet space program. I hope that if you're a teaching artist, you'd say yes to that, or at least you'd say, "Can you find a way to discuss who you are in terms of cows, or the Soviet space program?"

Asking a third grader to write poetry about identity or community is a little like asking an adult poet to write about Polly Pocket or Super Mario. Actually, it's worse: it's more like asking an adult to make art about how Polly Pocket is really pretty, or how Super Mario is really good at jumping—the expectation is obvious, superficial, limited and uninteresting.

Sure, a third grader can understand the words "identity" and "community," and perhaps the concepts, and certainly third graders experience and enact identity and community in many different ways every day. But as far as I can tell, identity and community are not of particular interest to most third graders and do not loom large in their aesthetic and intellectual experience. The problem is not the theme itself, but how it's presented. Given a bit more specificity, one could examine all sorts of interesting things in the worlds of Polly or Mario—ask a third grader and you'll see what I mean. And if you

really want kids to examine community in an interesting and inventive way (community is also about exclusion), Polly's shopping-centric world is not a bad place to start.

Original and interesting art derives from artists' attempts to examine and communicate ideas, feelings and associations about things that interest them and matter to them, often even to the point of obsession. So it should not surprise us that when it's time to make some art, many kids will want to begin by referencing stories, characters and worlds that are familiar and compelling to them. Some of these will derive from personal experience, but many will derive from lived interaction with the cultural landscape, including cartoons, video games, movies, books, TV shows and music. This is as it should be: the raw material for art is the artist's experience with his or her own world and imaginings about other worlds.

Should we fear that beginning a poem or a painting with Super Mario represents some base act of imitation? No more than we should consider Joyce's Ulysses a hackish rip-off of Homer, or Michelangelo's Pietà an imitative recycling of that ubiquitous Jesus character (well, it might be, but that's not my point). Just as with common adult tropes and narratives, whether the art that incorporates them is any good depends not on the trope but on the original interpretation and transformation effected by the artist.

So when students want to incorporate a character or world about which they know and care a great deal, take it as a sign of their investment in the art-making and consider saying, "Hell yes, please do." The students' enthusiasm and detailed knowledge, and your expert support, will take them far beyond mere imitation.

By the way, Iron Eyes Cody, who lived his life, both on and off screen, identifying as a Native American Indian of Cherokee and Cree ancestry, adopted several Indian children, including two brothers who were Dakota-Maricopa, married an Indian woman named Bertha Parker, and was a lifelong supporter of American Indian causes. He was born Espera Oscar de Corti in Louisiana in 1927, his parents both Italian immigrants. Now there's an interesting story of identity about which children and maybe even adults could make some interesting art.

—Nick

art-making is about the mediation of objective and subjective experience, it allows for a huge range of original expression with very limited conceptual and technical tools. One could conceivably draw for a lifetime, and even make consistently interesting work, with one type of pencil mark and one simple theme or idea. Certainly the experience and worldview of a 5-year-old are different from those of a 50-year-old, but that in no way suggests that a 5-year-old has less capacity for invention, association, expression and translation into an arts medium, provided the 5-year-old is allowed to draw on his or her own cul-

tural and associative landscape. This is where we occasionally see a self-fulfilling prophecy: children—and sometimes adults—presented with stereotyped or superficial thematic constraints will likely produce limited and unoriginal work. So the question is not "Can a 5-year-old write a song?" The question is whether we are creating a context in which the 5-year-old is free to write the sort of song that is of interest to this particular 5-year-old. We should never assume we know what that song is going to be like, either, before we've heard it.

7. Consider how performance and exhibition of art will inform what you teach

Not all artists teach in the way that we often think of as teaching. There are many ways to engage students in high quality arts learning besides direct instruction or hands-on art-making. Students can learn a great deal through the experience of a performance by a skilled musician or dancer, or meeting a visual artist and getting to see his or her work up close. Putting the work of interesting, original, innovative, skilled and/or experienced and influential artists in front of students is extremely important. It takes an equally smart and talented facilitator to maximize that experience, however brief, and transform it into a meaningful learning experience for the students present. Figuring out how to engage students in a performance or exhibit, giving them enough time to reflect and ask questions, and then building on that experience in other ways—perhaps through work with another teaching artist, an arts specialist, a classroom teacher—is a very artful and synthetic kind of arts education because it involves working with students to knit together many strands into a meaningful whole. The best kind of arts experience allows one to make a personal connection to something or someone larger than oneself. Sometimes it is only one moment, one performance, one song that allows us to understand something new about the world and what is possible in it.

None of this potentially inspiring stuff will happen, though, if you bring in artists who do not do interesting and generative work or who do not represent their discipline with any depth or awareness of cultural or historical context. Overly facile productions do a disservice to an art form or tradition and can alienate and bore students. So, too, can a show or exhibit that does not offer students some context and ways to engage (although some works stand just fine on their own). If we thought about the range of students with whom we work as fellow artists, people who need to know and understand interesting and generative work in a medium, then we would be more discerning in the selections of art and performance to which we introduce students. We would look for and demand quality. We are arguing not for a singular dominant aesthetic, but for work that reflects core qualities of the discipline as you understand them as an artist. Giving arts learners access to a wide range of teaching

artists and contexts in which to learn art is the best insurance against substandard, boring, monolithic art.

ENDNOTES

1. This was a corporate-funded billboard and TV campaign that was everywhere in the early 70s. The TV ad featured an ostensibly American Indian man in traditional dress canoeing through trash-strewn waters and overshadowed by an industrial landscape. As he stands alongside a litter-strewn highway, a stern voiceover intones, "People start pollution; people can stop it." The actor turns toward the camera and a close-up reveals a tear running down his face. This particular trope is all the more grotesque when one considers the fact that it was airing during a period when federal authorities and their proxies were violently suppressing the American Indian Movement and other Indian rights activists.

2

How Will I Teach?

THIS CHAPTER of the book is about opening up possibilities for teaching artists. It is *not* designed to provide a method, formulas or activities on which to base your teaching. Your teaching can be as original and personal as your art-making, and probably should be. But we hope that the points that we discuss in this chapter will be useful in helping you think about ways of articulating how you teach, and in planning and implementing work. Consider it an invitation—one teaching artist to another—to a discussion about the infinite variety of answers to the question "How will I teach?"

We have divided this chapter into three parts:

1. A discussion of some general ideas and contexts related to the question of How to Teach, like whether our role is to help students become better artists

2. A discussion of "Creative Tensions in Teaching Artist Work" that addresses issues inherent in our work, like the question of arts integration vs. "art for art's sake," and the teaching of intangibles like "creativity." Many of these tensions are specific to the context and culture of American K–12 education; many are inherent in teaching in general. We hope that the more cognizant you are of these tensions and how they may play out in your planning and teaching, the better able you will be to decide how you will teach in your art form in ways that help you and students navigate this terrain most successfully.

3. A set of models, lists, approaches and exercises to help you think through, design and teach curricula in your medium, and develop solutions to practical problems from "classroom management," to getting gigs

Throughout the chapter you'll find little essays and lists that comment on or serve as extensions of the main text. The chapter is designed to be useful whether you read it as a continuous text or page through it casually looking for ideas.

HOW TO TEACH: IDEAS AND CONTEXTS

Teaching artist work is very simple

Teaching artists help and encourage everyone to make his or her own art. What could be simpler? And yet this kind of simplicity in teaching requires particular forethought, imagination and expertise in one's medium.

If you think about it, the most important ingredients in developing an original voice and powerful creative solutions in any medium are time and space to work with the medium, useful feedback and criticism from others and exposure to a wide range of work in the medium. If Nick gives students time and space to work on their own music, facilitates critiques with their peers and with non-musicians (listeners!), and encourages students to listen to many different kinds of music, he feels that he's done good teaching artist work. And this does not rule out integrating all kinds of academic content or using the medium as a mode of inquiry—that, too, is time and space to work in the medium.

To be a teaching artist can also be as simple as being a sort of "tech support" for student-artists. You *can* walk into a classroom, show some kids how to hit "record" in Garage Band, and then step back and see what happens. Some of the most educative teaching artist work we know happens in this way. Some of the best student art we've seen is made in such contexts.

In fact, some of the most rewarding work Nick has done as a music teaching artist involved almost no "real teaching" at all. In one project he walked into a classroom of thirty-five high school students who, with a couple exceptions, did not play music, and asked them to compose original work that they would perform in an hour. The results were remarkable: very original and interesting music, and equally original and interesting musical insights gained by the students. The students drew on their pre-existing ideas about music, developed over years as casual listeners. This was enough for them to delve into serious art-making in a medium that was entirely new to them as creators of work. In this case, Nick's teaching, in collaboration with a music specialist, was mostly about creating a context—time and space for art-making.

Teaching artist work can be very complex

The complexity of teaching artist work, then, is in the preparation and analysis of our practice. We need to think in depth about how to teach specific ideas,

techniques and approaches in a medium that lead us to address questions that are often complex but also subtle and interesting. Such thinking, planning and teaching should be specific: it should fit the teaching artist, the students, the medium and the teaching and learning context. General formulas in teaching are of limited use. Teaching theater requires approaches that are different from those used in teaching stop-motion animation. Of course, parallels do exist; all art-making and teaching shares certain characteristics. But often, if we approach teaching primarily from the point of view of generalities, we end up missing precisely what is unique and interesting about a subject or medium. And if we miss that, we miss what makes us especially useful as teaching artists, that is, teaching *as* artists.

Teaching artist work is also often complicated by the institutional, political and economic contexts in which we work. Although sometimes our goals overlap with those of teachers, administrators, funders, prison administrations, hospital managements, etc., often they do not. It's common for our work to be presented as serving goals that are not directly related to art-making or even content learning. But it is important to remember that, at least as far as we can tell, no student ever wanted to hang out with a teaching artist in order to learn " twenty-first century job skills," or "mindfulness." While many good things can come of teaching artist work and art-making in general, we should bear in mind the main reason students want to work with us: because they want to make art. This is also why most of us are working with students: because we want to support the development of their original work.

It can be complicated to negotiate the tension that often exists between what we bring to students—art-making—and the other "outcomes" that institutions and employers sometimes want us to bring about. If we remember that good educational or social outcomes derive precisely from the fact that people are making their own art, and learning actual stuff (techniques and concepts in the arts, concepts and techniques in other areas under study), then this negotiation becomes a lot simpler. What we have to offer is our expertise and enthusiasm as artists, and this is the basis on which teaching artist curriculum should be constructed, taught and justified.

We should be helping students to become better artists

We sometimes hear teaching artists and arts educators say something like this: "Our goal is not really to teach the skills of a particular medium because most of these students will not become artists." Most often they are talking about students of color, American Indian students, poor, working class or immigrant students in race- and class-segregated schools. This attitude is profoundly opposed to all that is useful and unique about what teaching artists do.

In the first place, this suggests that "becoming an artist" means "becoming a professional artist." The implication is that the only valid reason to learn an

arts medium is to make it your *job*. This is a very narrow and alienating view of art and artists. Many of the greatest artists never make a dime from their work and do all sorts of other things in life, both for a living and for other reasons. To argue that rigorous and high quality teaching in a discipline is required only for future professionals is to echo the prevailing premise in America that education equals employee training, which is to say that the only reason to learn something is to make yourself, or, more likely, someone else, money. This notion not only justifies and perpetuates class and race inequality in education; it also contradicts art in its very essence. Art-making is universal: everyone is capable of it. Everyone has artistic impulses, and throughout human history art-making has been one of the main things humans do voluntarily for themselves and for each other.

The other implication of this attitude is that a teaching artist or educator has the right to decide in advance what a student will do with his or her life. When we hear someone speculate about students in this way, we want to ask—and sometimes do ask—"How the hell do *you* know what your students will or won't become?" Such speculation is really just an adaptation (perhaps unconscious, perhaps not) to the oppressive racist reality of America and its profoundly unequal educational system.

This attitude also reflects a very narrow notion of education. Often it is expressed to support the idea that the arts should be used to teach non-arts skills (behavioral, emotional, academic, etc.), but in fact it completely misses the mark in this regard. It is true that one can learn a great number of things from art-making, and that these things span many social, intellectual and emotional dimensions of thought and action that can be transferred to numerous areas of one's life and work. But such learning happens precisely when one is able to explore the skills and concepts of an arts medium in some depth, and when one makes actual art. It is real training and work in a discipline that leads to the associative and inventive thinking characteristic not only of artists, but of thoughtful physicists, auto mechanics, historians and janitors—which is to say, everyone. The real connections between art-making and other areas of human work and thought are accessed through . . . real art-making.

Perhaps worst of all, the designation of students as "non-artists" often goes hand in hand with the kind of stereotyping that is thinly veiled by euphemisms like "at-risk" or "urban youth." Such stereotyping is not only dehumanizing in the way it essentializes individual students; it also denies the fact that every one of these students has a rich, unique and varied experience and vision from which human culture might benefit if they were expressed through art-making and other modes of thinking and action.

By no means do we wish to suggest that all teaching artist work should be rigidly skills-based and that all student work should resemble the work of highly skilled artists. If we teach from our expertise and interests as artists, if we treat our students as artists, if we are interested in and engage their work

Steal Your Students' Ideas

I appear to be a teaching artist. I work at creating contexts in which students of all ages have space to work, to do their own work. In my case such spaces are usually recording/performance studios of some kind. Sometimes they are full of instruments and recording gear: microphones, computers, drums, samplers, guitars, and keyboards. Sometimes they are just full of students. The atmosphere shifts rapidly from calm to chaotic and back again. Often the studio feels more like a playground, other times like a classroom, still other times like music itself.

I appear to be interested in teaching because I am. I like to teach the skills and craft of audio engineering and the science that explains the mechanisms of sound and its storage and reproduction. I like to show fourth graders how to "flip coil" a microphone cable so it doesn't take a set. I like to help seventh graders analyze room modes and visualize the big, longitudinal movements of air that are bass notes.

I like to teach things about music: how notes are divisions of time and representations of the speed of vibrating bodies—strings, drumheads, vocal chords. I like to encourage children and adults to pick up a new instrument and begin to make the music they already hear. I like to argue about music and agree about music. I like to listen to it with people. I like to create contexts in which students can experience the incredible dynamic of playing music with others and creating new sounds and messages in real time.

I like to encourage students to work independently, both to frame the creative problem and to develop the solution. I give as few directions as possible. I resist the temptation to worry about how student work will turn out, or even if it will turn out. I try to suppress the impulse to think that their work is about me, or is a measure of my teaching. I often hang out in the hallway outside a studio or classroom when I feel my presence is superfluous and a distraction. I'm known as the teacher or teaching artist who leaves the room. I often wonder how much it matters what I do—given time and space people will make art.

I work to find ways to limit the influence of my own aesthetic, to help students develop their own aesthetic and make their own statements. I demand that their work startle, confuse and provoke me. I tell them repeatedly, "If I get more than 50% of the music you make, you are messin' up." I demand that they confound my expectations, those of their school, society, of their peers and of music itself. I demand that they redefine expectations and make something that has not been heard before.

And this is perhaps the most damning and obvious clue to my secret: I'm there to steal. I do want to help make time and space for kids and adults to work and play at their art, and I do want to contribute to a real change in the

way people learn and are taught. But more than that, I want to hear the new sounds, the new approaches and the new stories that only a fourth grader can conjure and I want to steal them for my own work. I want to do this because they are inevitably better, fresher and more interesting to me than my own ideas. I went into a public school classroom in the first place to hear new music and to steal it. I often tell students, especially Kindergarteners, "I am here to push you to have good ideas . . . so I can steal them." For some reason they find this amusing.

I am a failure as a thief. As it turns out, that which is really original (or as original as any art can be) is very hard to steal. The fire escape that leads to the second story window of real fourth grade genius is completely ice encrusted, and I've fallen off it repeatedly. I find myself not with a stolen idea, but standing in the street below, listening to the music. As it turns out, this is not a bad place to be.

There are many reasons why I like working as a teaching artist and why I think it's useful, important work. But when I'm with students, I find that for me, it's best if I'm there mainly to respond to their work as art, period. Not as a researcher, not as a reformer, not even really as a teaching artist, but as someone who is interested in the sound, the music, and the statement. That seems to be what most engages me, and most engages them, because every artist wants and needs a response. That might mean a critique, an exclamation, a discussion, a laugh, a technical suggestion, a scream of "You are a little genius," or simply getting out of the way. Sometimes it's hard to forget those other roles and focus on the music. I do it by looking to steal and failing at it.

—Nick

as art, if we look to teach in a way that helps students gain ever more control over their vision in a medium, that is a very great deal. And if we approach our students with genuine interest and enthusiasm for their particular ways of seeing, thinking and making, for their experience and cultural landscape, and with the highest expectations for their ability to make great, interesting and useful things out of all of this, we stand to gain as much as—perhaps even more than—our students.

HOW TO TEACH: CREATIVE TENSIONS IN TEACHING ARTIST WORK

Another way of thinking about teaching artist work is in terms of the tensions or "problems" of teaching in our disciplines, and teaching in general. This is

not a "negative" way of thinking about the work. Rather, it's an approach that acknowledges that teaching is, by its nature, problematic in a very interesting and creative sense. In order to teach, we have to struggle with the inherent tension of attempting to transmit existing ideas and techniques in a way that can lead to *new* ideas and techniques. We must ourselves, and with our students, deeply assimilate existing knowledge, but constantly look for ways to make this knowledge *dynamic* so that it opens up options for students rather than restricts them. How this tension plays out in teaching artist work is interesting in some ways because much of what is essential to art-making cannot be fully articulated in language. Teaching in the arts is a struggle to name technical and conceptual characteristics in a medium without reducing or over-determining them. We want students to be able to talk and think about how a medium or a work of art "works" but also to develop intuitive, associative and emotional ranges in their own work that often defy clear definition.

The (partial) solution to this tension is to be found in keeping teaching and learning close to the medium and material itself. A dynamic expression of technique or concept is to be found in the actual art-making; a dynamic *learning* of concept and technique is also to be found in the actual art-making. We'd even argue that "good," interesting, compelling, original art is as much the result of effective and efficient use of a material or medium as it is about the particular emotional, intellectual or spiritual impulse that leads an artist to make work. We cannot recover an artist's "true" intentions; we can only imagine them. But the ways in which the medium is worked can be experienced directly. Great poets make poetic words do things that only poetic words can do. Great photographers exploit the unique peculiarities in the way light interacts with a chemical emulsion or a digital sensor. Great musicians make their instruments produce sounds that are at once surprising and particular to the construction and function of those instruments. Some of the most compelling Paleolithic art uses existing features of a medium—cracks in a stone cave wall or a piece of bone—as compositional elements and also as self-reflexive commentary. Art has always emerged from a dynamic interaction between the artist and a material or medium, which often involves a kind of play and experimentation and often defies linguistic categorization. All of this suggests that a central feature of any art teaching should be lots of time and space for free work with a medium.

You want me to teach what?! A short critical commentary on edu-speak jargon

What we have to offer is expertise in and enthusiasm for an arts medium. But we often face pressures to abandon exactly those things that make us useful as teaching artists. Many of the people and organizations that hire us do not think it is enough to teach people to make their own art. In many contexts in

which teaching artists work, especially public schools, the arts are increasingly seen as a means to an end. Often the goals of teaching artist work are defined by non-teaching artists and couched in educational or psychological jargon. To a teaching artist who is new to working in public schools, or to large arts education organizations, it can often seem as if there is some special, mysterious body of theory and practice and a whole language of arts education into which he or she is uninitiated. It can be intimidating, confusing and alienating. Instead of being asked what and how you teach in your medium, you may be asked to teach things that you have never even heard of. There will be many people who disagree with what we are about to say, some very smart people who do very important work in arts education. But we want to suggest that we *can* choose to *not* swallow these often ill-defined priorities that often have little to do with teaching a medium, and sometimes conflict with such teaching. If we do make such priorities our own, we risk negating exactly what is educative, liberating and fun about art-making, and exactly what draws students to it.

We want you to teach the kids _____. Here's a short list of a few of the things that often appear in the blank, along with some critical translations:

Creativity

There's apparently a whole industry devoted to the study of "creativity." The industry encompasses everything from self-help authors to areas of cognitive and neurological research. Some of the discussions around creativity seem interesting and maybe even useful. Most seem facile and simplistic. But where teaching artist work is concerned, the idea of "creativity" as a *thing* that can be taught is highly problematic. The reason is that it's increasingly presented as a substitute for putting art-making at the center of the work. Teaching artists are told that time and space for really learning a medium are secondary to "teaching students to think creatively." But if creativity exists as something discrete, it's only in the context of *creative work*. For teaching artist work, "creativity" should mean that students are finding original solutions to creative problems in their art-making. So, where teaching artist work is concerned, for creative thinking to happen, original art-making has to happen.

Social/Emotional Growth, Impulse Control, Cooperation, Collaboration, etc.

Much of current elementary pedagogy (and, increasingly, high school pedagogy), especially in underfunded race- and class-segregated schools, focuses less and less on teaching actual stuff and more and more on teaching *behaviors*. Many arts education advocates and organizations have correctly argued that art-making can help people learn to work together well, can make people feel more interested in their lives and the world around them, and can lead

to many different kinds of emotional insights. But *where this type of advocacy becomes the main reason for teaching artist work, it begins to displace teaching and work in the medium.* Students do not like working with us because we will teach them to behave in certain ways. What could be more alienating and dehumanizing than being instructed to make art so you can become a "better person?"

Twenty-first century job skills

This positively sinister term seems to have come into vogue over the last five years or so. Generally, it's used by arts education advocates and policy makers to suggest some sort of link between artistic skills and "habits of mind" and the needs of corporate capitalism in the ostensibly new "global economy." The vaguely argued or implied premise is that there is something about the current state of global capitalism that leads employers to seek out more creative or inspired workers. In fact, nothing could be further from the truth. It is precisely because there is less need than ever for skilled and semi-skilled workers that not only the arts, but serious academic content in science, math, history and English have been ripped out of the public schools, and curricula are increasingly about following directions and processes. The "Sputnik Crisis" of the late 1950s reflected a real need for more engineers, scientists and skilled production workers; the American economy of the twenty-first century is dominated by a high degree of automation and rationalization in production and service industries. Computer-based "enterprise management systems" have brought about unheard-of increases in worker productivity and corporate profits in industries as varied as computer manufacturing and medical billing. The unhappy, alienating truth is that employers increasingly want people who are willing to follow directions reliably and consistently, along with a very, very few people to think "creatively" and decide what color the new cellphone model should be.[1]

So why then the prattle about "twenty-first century job skills?" Well, we can think of two reasons why this trope serves the needs of corporate employers. The first is perhaps well illustrated by Starbucks' claim that they like to hire artists and creative people. From what we gather from friends who work there, Starbucks hopes that artists won't be likely to organize unions because they'll figure their highly exploitative service job is just a "day gig." And in fact some of the arts education advocacy prevalent in public education all but promises that the arts help train compliant, focused, and cheerful workers . . . which wouldn't be such a bad claim if the companies seeking such workers paid a decent union wage.

The second reason companies like to be associated with "artists" and the arts is that it helps with brand appeal and marketing to certain desirable demographics—a veneer of "creativity" and artiness sells.

The real question is, Why are we in arts education echoing this sort of cynical, utilitarian nonsense? Whatever the motives behind "twenty-first century job skills" advocacy, it's based on a premise that in our view is antithetical to art-making and therefore to teaching artist work—that the goal of art-making should be, first and foremost, to train students to serve someone else's economic and political ends. Twenty-first century arts education advocacy in America has become far too focused on arguing that the arts are good for the corporate bottom line. We teaching artists are well placed to blow up that paradigm.

The problem with planning

You're holding in your hands a book that is supposed to help you do teaching artist work and also to enable you to bring a certain skepticism and critical attitude to the educational contexts in which we work. In a sense, the mere existence of this book poses an obstacle to good teaching artist work. It encourages us to think intentionally and to plan teaching artist work carefully. That is generally a good thing. But because we are artists, when we begin to plan and invent, we begin to construct at least a vague idea about how the work will end up. And *that* can be a problem, because the whole point of teaching artist work is to help students develop *their own* art, or perhaps art that belongs to no one or everyone.

When we start thinking about teaching artist work *in general*, it often leads us in the direction of crafting elegant, clever and artful lessons/projects/programs. Although these may lead to great teaching, they can sometimes be over-determined and limit the room for student invention both in the art-making and in the associated learning. The point can quickly become the "project" rather than the art-making and the things that one might investigate and learn through that art-making. This sort of careful scripting of our teaching can intersect with pressures from schools, arts organizations and other institutions to produce student work that hews to particular expectations or preconceptions. Even with the best of intentions, the intersection of "teaching artistry" and political or administrative needs can lead to some beautifully conceived, elegantly described teaching that is completely sterile. This sterility is most often visible in formulaic student work, or work that is simply a replication of the teaching artist's aesthetic. Students can learn a good deal about technique by essentially apprenticing on a teaching artist's project, but how much more might they learn if even a little bit of space is opened up for their own creative agency?

One way of dealing with this tendency in our work is to consciously resist the temptation to predetermine the art-making. We should work constantly to create a situation in which we cannot foresee what students will make with the tools we help them to develop. We should encourage, and even demand,

that students forge their own aesthetics and find their own creative solutions. We should constantly seek, even where there are tight creative or political constraints in play, to open up areas to student agency. If the mural's subject is predetermined, then insist that students interpret the subject in original ways. If the actual tropes and figures are already determined, then insist that students play with new ways of translating these tropes with the techniques of the medium, or better yet, invent new techniques. And so on. We can also advocate enthusiastically and honestly for this creative agency on the part of students. If there are "non-arts outcomes" to be realized in art-making, it is precisely through real creative work—work that reflects the vision and invention of the student artist—that such outcomes are possible.

"Big Idea" or generative idea?

We often frame our teaching with broader conceptual or academic questions or investigations—including terms that are by now ubiquitous in American education, such as "big ideas." But in order for these to be helpful to the art-making, and in order for the art-making to yield real insights into such concepts or subjects, it's important that we think very specifically and carefully about *how* a particular medium or technique relates to the larger concept. If the connection is too vague or too general, it can inhibit the teaching, learning and art-making. Conversely, if we are specific, we can often find very surprising connections between concept and medium that can lead to highly original and interesting student work.

For example, let's say Nick sets out to teach students how to use Garage-Band to record and arrange sounds. As a conceptual frame he proposes the idea that sounds can reflect emotional states. He tells students that he wants them to make a piece that reflects their current emotional state. The result might well be interesting work, but it's hard to say if the students will have learned any more about working with sound, or about emotional states, than if he'd simply said, "Now that I've shown you these techniques, go make some music." This is because *all* art in some degree relates to "emotional states," and such a general creative constraint, or organizing concept, if anything, encourages students to engage familiar, even obvious tropes like "happy music" or "sad music." Again, the music might be interesting, but the idea of "happy music" by itself is not particularly interesting. The musical results might be similar to those that Becca often experiences when working with students who are just beginning to experiment with writing—she has to push students to move beyond general description ("I am happy") to more specific, original and interesting description ("I am a fried egg, still sizzling in the pan"). The problem is not that students writing first poems do not have interesting ideas or associations, but that they have not yet begun to investigate *the medium as a means of transmitting these ideas.*

Another option for Nick would be to begin by narrowing both the conceptual and technical focus. He might engage the students up front in a discussion that aims to make the concept of "emotional states" more precise. Such precision might be more generative precisely because it is more specific and therefore requires more detailed and potentially original artistic thinking and action. Maybe students could consider just how many types of "sad" there are. Or maybe they could imagine "emotional states" as analogous to states of matter: Is "happy" a solid, liquid or gas? Or maybe they could play with the language a bit: What state is "vengeful anger?" (Rhode Island, obviously). Such a discussion might take only a few minutes, but now they would be on associative and metaphorical terrain that could lead to a specific investigation in the medium.

Nick might also try to become more precise with the dimensions of sound or music that could relate to "emotional states." The group might have a quick discussion about *what* it is in a song that telegraphs mood. Often the mood of a recorded work of music is communicated in the instants after we apprehend that it's music. Any first grader knows right away whether a song on the radio is happy/sad/scary/angry. This mood is conveyed by a number of things: a variety of musical choices and conventions (melody, harmony, instrument choices), timbres of instruments and sounds, lyrics, and less obvious choices like ambience (reverb, echo etc.). Students can hear these things even if they don't have the words to name them yet. They might pick just one of these characteristics, maybe timbre, or the texture of a sound.

Now, after two brief discussions, students are in a position to investigate a *specific* relationship between the medium and a *specific* emotional state. They might:

- Learn how to record sounds with a microphone with an eye toward capturing different timbres (bright, dark, rough, smooth).
- Learn how to layer and sequence recorded sounds in the software to further affect timbre, and changes in timbre over time.
- Work with the techniques they've learned to make sound pieces or songs that aim to convey one or more very specific emotional states: "What timbres would create a mood of 'confused happiness,' like what you feel when you walk into a surprise party for your birthday?" This might take us into a whole other question of portraying *mixed* emotional states, which is something that art does very well!

Our experience has been that this type of detailed conceptual and technical focus allows students more opportunity to really work at the subtleties of a medium and also investigate the subtleties of a concept or subject in more artful and educative ways. This results in more interesting insights for them and for us as teaching artists, and in more interesting art, which is really the point.

It's also possible to engage conceptual frames on the "back end." In other words, one can have students work freely in a medium without explicitly addressing concepts, but then, in discussing, critiquing or "reading" the work they can think about how the work relates to a concept. For instance, in Nick's hypothetical case above, they might have made music freely and then discussed and analyzed the role of detailed "emotional states" in the finished work. Sometimes this retrospective approach can result in a more natural and instructive connecting of the art and art-making to the concept that is being investigated.

This is not to say we even *need* a concept in order to teach or make art. It's important sometimes just to teach students to record with GarageBand and then give them time and space to make some work without constraints. Along the continuum between those extremes are contexts in which we might ask students to consider a concept, or range of concepts or questions, and give them a choice as to how and whether to engage them in their art-making.

When we try to relate concepts to art-making, the more detailed our focus, the more deeply we and our students can engage the medium.

Process and product are inseparable

Another tension that we encounter in teaching artist work is a supposed dichotomy between "process" and "product." The discussion can be confusing. Sometimes those who argue for the importance of "product" are defending time and space for students to actually make original art, not just talk about it. Other times "product" is code for predefined, highly scripted art-making that is more about meeting administrative or political expectations than encouraging student originality.

"Process" can be an equally slippery term. Some very good teaching artists encourage an emphasis on artistic process as an effective frame with which to teach and organize the concepts and skills of a medium. They rightly defend time and space for experimentation and failed attempts against an over-emphasis on having students produce finished, or superficially "slick" work. But in other cases arguments for the primacy of "process" are used to justify teaching artist work in which students are taught very little about a medium and are not given time and space to make any work at all. The results can be artistically and educationally sterile and alienating.

If we look at art-making, we find that, rather than a dichotomy, process and product represent shifting points along a continuum or range. Some artists work very consciously through a specific process; others do not. For some artists their process *is* their work; for others even the idea of articulating a process conflicts with their aim of conveying through their art that which cannot be articulated. But in all cases what defines an artist is the fact that he or she *makes art*.

To separate process and product in making or teaching art seems unnecessary and undesirable. Again, we are dealing with a range or continuum and the search for a balance that fits the situation. It can be useful for a teaching artist to teach a particular process for art-making, but it is also important for students to be exposed to many different ways of working and to develop their own processes. It can be interesting and educative to examine art *as* process, but if the investigation doesn't lead to any art-making, it is more an exercise in art criticism or history than teaching artist work. It is also possible and often desirable to teach the techniques of a medium and let students develop their own processes. Much of art-making at its best is associative and only partly conscious and intentional. In our desire to be prepared and organized we sometimes script our work too much and even predetermine what student work will look or sound like. This is never a good thing. We should not be working with students to replicate our own vision; we should be there to be surprised and even sometimes baffled or disturbed by theirs.

We should also be careful not to mystify process, or reify it as a single thing. While in some ways process is idiosyncratic to each artist, in other ways it is not. Most artists engage in certain basic steps or sequences of developing an idea (whether consciously or intuitively), trying out various ways of expressing the idea in medium, revising and modifying their work, perhaps as the result of formal or informal critique, and eventually bringing it before some sort of real or implied audience. Each of these steps can be examined in terms of different models and approaches. Some can be taught and practiced—critique methods, for instance—others, like intuitive and associative thinking, are hard to teach directly and are best practiced through active application, perhaps supported by exercises or prompts. But all of these sequences and approaches are most meaningful and interesting insofar as they are part of *art-making*.

Finally it is essential to remember that what draws students to teaching artists is that we are there to make time and space for *art-making—their art-making*. If nothing is getting made, it is likely that we are failing to provide what is unique and useful about the way teaching artists teach. We are different only because we relate to students not as students, inmates, old people, young people, or sick people; we relate to students as *artists* and approach their work as art. It doesn't always have to be finished art, and it certainly doesn't need to fit anyone's expectations, but it is art.

Technical proficiency is not the same thing as the ability to make interesting and original art. Technique allows for options—the greater an artist's depth and breadth of technique, the greater his or her expressive palette. But efficiency is also a key component of expressive and engaging art; in art-making efficiency and power of expression are often in tension with technical options. The more options one has as an artist, the more one has to struggle against the sterile application of technique for its own sake. The more available choices, the more one must seek to choose only the notes, brush strokes, words, or sounds that

are essential to the work, its idea and feeling. It is absolutely possible for a complete novice with minimal technique to make powerful work, especially if he or she has been exposed to a range of work in the medium (has listened to a lot of music, for example, or read a lot of poetry). We can expect our students to make "real" work from the first day, even if the nature of the medium and their inexperience limits them to particularly efficient or even fragmentary work.

People generally like making art for an audience. The expectation of an audience of one person, or even an imagined audience, often deepens an artist's focus and expressiveness. The Web and other technologies now offer any artist with access to the Internet a potential audience of hundreds of millions. Such an audience is an entirely different question, but it does mean something to an artist, perhaps even more to a young artist, to be able to make work public in a real and immediate sense. While it is important to allow students time and space to experiment freely without an audience (real or implied), and to conduct exercises and games in a medium, it is also essential to help students make work that will have an audience, even if that audience is just a few of their peers. We should always look for ways in which students can share their finished work with the audiences that matter to them. This is the realization of the artistic impulse that seems central to human existence and activity: to communicate one's own subjective experience to others.

That said, it's also useful to remember that powerful and compelling art often exists completely outside conventionally defined notions of audience, performance and even "work." Some of the most gratifying musical experiences Nick has had, for example, have been informal improvisations where the audience was limited to the players themselves. What defines student work as "real art-making" is not how finished it is, or whether it is distributed or performed before an audience. Student work is real art-making when it is a genuine and original expression of ideas, associations and emotions of the artist.

A "disciplined mind" is not always the right tool

Some arts educators like to stress the ways in which work in the arts purportedly trains students to think in a disciplined and reflective manner. There is ongoing discourse around the sorts of habits of mind or ways of thinking that the arts engender in students. This may be the case some of the time, but it should not be the point.

Very deliberate, conscious and procedural thinking is often highly useful in solving certain types of problems in any type of work. To efficiently troubleshoot the electrical system in a car or analyze certain kinds of experimental data in the sciences it is important to follow very specific sequences and set aside certain kinds of intuition and speculative thinking. The same is true when solving some artistic problems, like how to coordinate the staging of a complex multimedia performance, or how to engineer a steel sculpture so that

it will withstand high winds. Important creative insights and intuitive leaps sometimes derive from very disciplined thinking and action. Therefore, part of teaching artist work should involve the creative practice and application of disciplined thinking and action where they relate to work in a medium.

But creative leaps in the arts, sciences, humanities and all sorts of other fields also derive from associative, intuitive and unconscious sources, and these sources are often underused by students in school. The trend in public education is strongly toward algorithmic curricula that are tightly aligned with certain desired outcomes—some useful, some inane or indefinable. One thing we as teaching artists offer students and teachers is time and space to work and learn in a more balanced way.

Although students, especially younger ones, often make use of very spontaneous and imaginative association and intuition outside of school, they often suppress such thinking in the classroom. Once when Nick was running an after-school recording studio at an elementary school, he noted that the writing that students did in the studio—lyrics, poems, even stories—was markedly more original and experimental than the writing they did in Language Arts. He was not teaching writing; in fact, much of the students' writing in the studio was a spontaneous development that occurred precisely because the atmosphere was all about art-making, and some kids like to write (kids would also draw in their recording studio, just because). The Language Arts teacher at this school was very good; he supported his students' efforts toward developing original and artful writing and in no way censored them. But just the same, the work that emerged from the studio was more interesting and free of many of the formulaic and clichéd aspects of the creative writing that they would do for Language Arts class.

Nick asked students and teachers about this contrast, and their answers were a revelation. He had expected the difference to be related to how students perceive teacher and school expectations—that in class they were writing for a grade or for academic success rather than to explore their particular vision. But as it turned out, this was not the case. In class they were writing to "appear smart" to their peers—smart in the sense of "doing the things a good student does." As they explained, this meant producing a particular kind of formulaic writing about typical themes—positivity, hope, identity, etc. In other words, the students consciously narrowed their expressive and thematic range to fit a shared stereotypical norm.

Students further explained that in the studio they perceived entirely different norms. The emphasis was on originality and willingness to experiment with a medium and with the full range of ideas, sounds, images and themes. They felt it appropriate to try ideas in the studio that in class might be ridiculed as "weird" or "dumb." Oddly, the fact that this was primarily a studio for music production made students feel even more capable of taking chances with their writing.

The conclusion that Nick drew from this experience was that we have a particular opportunity, and perhaps even duty, as teaching artists to provide contexts that support *undisciplined* creative thinking. Such thinking is often the source of what is particular and compelling in good art; there is little space and time for such thinking in most formal schooling and perhaps not enough in arts teaching and learning. Simply encouraging students to "think outside the box" or subvert convention and expectation is not enough; sometimes such rhetoric can even create a new set of formulaic expectations. What students need is *time*—time to work in a medium sometimes systematically but also spontaneously and freely, in an atmosphere where original art-making is really and truly the main point.

Art-making is always integrative

We often hear of a supposed dichotomy between "arts integration" and teaching "art for art's sake." We've noticed that this "debate," like many in education, is shaped by the reality of horribly unequal race- and class-segregated public education in the U.S. In expensive private schools, public magnets, and public schools in wealthier, predominantly white neighborhoods or suburbs there is often lots of art and music making and usually a balance of classes taught by full-time arts specialists and more integrative or cross-disciplinary arts projects led by teaching artists. In these schools no one ever seems to feel it necessary to debate whether one should teach "art for art's sake" or explore "arts integration." They just do both, and often it's hard to tell the difference. But where resources are scarce art-making is seen not as an essential part of any balanced education but as an activity in the service of goals established by someone other than students and teachers. As teaching artists we should carry the banner not only for equal access to arts learning but also for the right to arts learning as part of the right to a decent education for all.

Nick once asked a group of seventh graders, "What is the connection between science and art?" anticipating a lengthy and very profound discussion. After an awkward silence a kid in a Led Zeppelin T-shirt in the back of the room lazily raised his hand and with an ironic air pronounced, "Paint." It was about the most complete answer Nick could imagine at that moment, so they ended the discussion right there and the students went back to work on their sound and video projects. What the student had reminded them was that the connections between the arts and other disciplines are often simple and concrete. When we look for such real connections in the methods and techniques of artists, scientists, historians, mathematicians, engineers and mechanics, we will always find fascinating ways of learning through making. We will find ways to make real art *and* science, math, etc. Making things is always educative and usually fun. As soon as that kid said "paint," Nick could imagine any number of projects for exploring the chemistry, physics, psychol-

ogy, history and mathematics of paint, pigment, and color in support of original art-making.

In fact, all art-making is "integrative," because it involves the investigation of many different areas of knowledge, experience and material reality. The earliest preserved cave art is replete with highly anatomically and behaviorally accurate depictions of large mammals in action. It appears to be the work of people who were very interested in their own lives and the world around them and clearly had studied both in great detail. They were painting in caves from memory, and yet were able to depict with both expression and accuracy many essential and moving truths about their subjects. The fact that much Paleolithic cave painting appears to be the work of adolescents and children makes this evidence of careful observation all the more striking.[2] It would seem that as long as we've been artists we've also been arts integrationists.

Any area of human work and thought, from plumbing to theoretical physics, engages the tools of art-making, whether visualization, improvisation, or expressive experimentation. So why not consciously combine art-making and other types of study and work?

Can sixth graders write poetry about physics? Sure. Can it be good poetry? Absolutely. Will it lead to novel insights, and a deeper understanding of the science? It might well. The models and questions of physics, both classical and modern, are full of astounding and moving metaphor, symbol and narrative, some of which might be well expressed only in poetic language. Poetic expression of certain concepts and questions of physics may also provide a reinterpretation and reframing of scientific truth, offering clarity and even new insights that not only are literary but also may spur scientific thought.

Their poetry might also be terrible. A superficial, formulaic or forced attempt to use an arts medium to explore academic content often leads to confusing false analogies, oversimplifications, and sterile, unoriginal art-making that is alienating to students, teachers and teaching artists.

The poetry *won't* be terrible if:

- The teacher knows the physics.
- The teaching artist knows poetry.
- Both the teaching artist and teacher are personally interested in exploring the connections between their disciplines, and both have time and space to find real and interesting points of intersection.

In the absence of any of these conditions it's probably more fun and a better use of everyone's time (especially the students') simply to teach the physics, teach the poetry writing and forget about a mechanical "integration." If the teaching is any good, it's likely that at least a few students will write some cool

poems about physics. They'll certainly be equipped to think about metaphor physically, and physics metaphorically, and isn't that really the point anyway?

So again, we have the luxury of implementing a range of approaches and deciding whether and how to integrate based on the context, the material under study and our own ways of working. Sometimes the gig requires integration of academic content even where it may not be a natural fit. This is where we teaching artists have a chance to earn our pay, not by simply settling for superficial and forced integration but by working with teachers to find time and space for the investigation of real connections that lead to interesting and original art-making.

Free expression and censorship

Teaching artists often have to navigate the tension between free creative expression and ensuring that what students make is school-appropriate. Appropriate? What does that even mean? Art is supposed to push boundaries and buttons and that is part of why kids are often particularly good at making art. On the other hand . . . you don't want to get fired.

There is nothing wrong with deciding, as a teaching artist, that a school's or institution's "culture" or its norms are important to you, or that your own standards of content should play a role in your work, as long as you present this to your students openly and honestly. It is fine to say to students, "Violent imagery is uncomfortable for me (or for this school), so I will not be able to work with you on writing that incorporates such imagery." This is an acknowledgment that the limitation is yours or the school's, and it is not the same as denigrating student work because it deals with difficult themes.

That said, as teaching artists, we should defend freedom of expression for student artists. This is a particularly important issue in race- and class-segregated schools, where students are often subject to standards of "appropriateness" that are entirely different from those in wealthier, whiter schools. There is an insidious and racist premise underlying this double standard, once expressed to Nick by a teacher in an all black school as follows: "You don't understand—these kids will go out and do the violent things they rap about." How profoundly alienating and dehumanizing to say to an artist: You are forbidden to make art about X because it will lead you to do X. How much more alienating and dehumanizing to say: It might be okay for some artists to make art about X, but it sure isn't okay for you. As teaching artists we can't win this battle every time on every gig, but we should try.

Nick in particular can cite specific instances where this tension has erupted in his work with students. Below he describes some of his experiences with free expression and censorship and how those have played out in the classroom with students.

I've operated student recording studios in a wide variety of contexts, most of them in schools with fairly narrow interpretations of what constitutes "appropriate" subject matter. I always maintain a very strict rule: zero tolerance for censorship (especially self-censorship) in the studio. My feeling was and is that you cannot ask people to make art and develop an individual voice and then tell them what they can and cannot deal with as subject matter. Any artist, no matter how young or old, should have the freedom to approach the full range of human experience and feeling as they know it and see it.

I combine this zero-tolerance policy with a request: If possible, please do not get Mr. Jaffe fired. So far students have had my back. As it turns out, most kids are well acquainted with the politics of artistic expression and the difference between production of art and distribution of art. In the studios I ran with students it was common for students to produce work that was for their ears only. Sometimes this was because the work conflicted with school or parental norms, other times simply because it dealt with themes they felt were better understood by their peers. It was also common for students to spontaneously record "radio edits" of songs; they had learned the art of dropping certain words while singing or rapping, even vocalizing the common commercial practice of reversing a word or rapidly pulling down a fader to make a word unintelligible. That this technical and commercial technique became a vocal technique common among fifth grade rappers is very interesting to me as a cultural and musical phenomenon. In my experience, teachers and parents are often more in favor of real freedom of expression in the arts than they are given credit for.

Occasionally we have to deal with an objection or concern on the part of a school or program administrator. In those situations I try my best to leave decision-making power in the hands of the student-artist. I might express an opinion or offer advice, but ultimately it is up to the artist to make the call whether to partially or completely suppress his or her work. And given this choice most artists, young or old, generally make a thoughtful choice based on their artistic intent. I have never censored a student, and I have yet to be fired.

Does this mean that I am never uncomfortable with the themes and images my younger students incorporate in their art? Are you kidding? Even apart from imitation of the ubiquitous and sometimes gratuitous and backward tropes of commercial culture, the sorts of things kids think about much of the time are just plain disturbing. They often have less of a filter than adults on the images and associations they conjure. Again, that's part of why kids make good art. But I also object politically to certain types of images and characterizations in student work. I argue with students, even young students, about the politics of

gender, race and class, and I critique candidly work that I think is fac-
ile or gratuitous. But ultimately the student is the artist and makes the
call. I suppose I can imagine a scenario in which a student's work was
so politically or personally objectionable to me that I would refuse to
help that student with the work, but happily it has never come to that.

I am by no means suggesting that other teaching artists should
take this stance. It is absolutely okay—in fact, often necessary—to set
limits on a variety of things in any teaching context, including the con-
tent of art-making. I present this view merely as a possible model, one
that underscores the possibility that students of all ages can and do
think of their work in social and political context. And they often do so
with a great thoughtfulness and a nuanced appreciation of the conse-
quences of art. I have not yet had to go on strike.

Here are a couple of stories about "appropriateness." Some years
ago I was teaching full-time at an elementary school on Chicago's
South Side. I ran a studio with students in the basement and taught
a full part of the curriculum—an interdisciplinary class called Record-
ing Arts and Sciences. All the students in the school spent an hour a
week in the studio class. We learned about the science of audio record-
ing and many things about music, but mostly the students worked on
music of their own. During lunchtime and study halls and after school
the studio was always packed with students working feverishly on their
recordings. The music was amazing, and the environment was full of
artistic invention—so much so that arts educators and funders began
to visit the studio to get a better sense of what was going on.

In the autumn of my second year at the school a group of visi-
tors from some high profile philanthropic funding organizations was
scheduled to visit the studio. I told my principal about the upcom-
ing visit, and she looked at me anxiously. "What class will you have in
there when they visit?" "7B2," I replied, referring to a very lively and
slightly rowdy group of seventh graders. "Well, you need to make
sure that they are not working on anything inappropriate." I said that
I would inquire, and explain the situation to the students, but that it
was entirely up to them what they worked on during this visit.

As it turned out 7B2 were working on a post-feminist hip hop joint
titled "I'm the Devil's PIMP." In this very funny and hard-hitting track a
group of girls listed their many boyfriends, accompanying each name
with a flattering and then not so flattering description. The hook was
simply the line "I'm the Devil's PIMP" repeated over and over. The beat
was typically awesome, the vibe of the song original and compelling,
and the whole thing positively charming and even liberating in a sev-
enth grade girl sort of way. The whole class loved the track and most
students were contributing to the project in some way.

I told the main movers on this project that the principal had some concerns about lyrics and content during the upcoming studio visit. I made it clear that I was not at all suggesting that the students censor themselves but mentioned that if they wished to appease the principal and perhaps save me a little trouble they might consider recording something other than the hook vocals that day. The students were adamant: "Don't worry Mr. Jaffe, we understand! No problem! We got you!"

On the day of the visit our dignitaries entered the studio accompanied by a nervous principal. Everyone watched with admiration as students set up mics, donned headphones, and rolled the beat on the recording workstation. The room was silent but for the faint sound of the beat leaking from headphones. Sixteen bars into the song the four girls gathered around two mics began to rap the hook lyrics: "I'm a lady P.I.M.P.! I'm a lady P.I.M.P.!" The principal blanched and looked at me reproachfully. The visiting funders, in contrast, seemed unfazed and entirely engrossed in the magic of a really interesting seventh grade recording session. Later the students cheerfully and earnestly told me, "You see, Mr. Jaffe, we got your BACK! We not only changed "Devil" to "lady," we spelled out "pimp" instead of saying it!"

I learned two things from this experience: 1) ideas about "appropriateness" are often so arbitrary that even super-smart seventh graders can't make sense of them, and 2) funders often do value real art-making, warts and all.

The second story played out during a one-week residency I did at a YMCA in Chicago. The idea was to have students from a school where I taught run a recording studio that would be open to young people from the neighborhood. Kids would come in off the street and my students would help them record their music. The residency was part of a larger week-long event that was well publicized, so there were quite a few teachers, arts educators, parents and administrators watching all the action in the studio. At one point during the first afternoon a kid about fourteen walked into the studio with a bit of a swagger, heard a beat playing and asked if he could record some vocals. He said he'd never recorded before but considered himself a rapper.

A student got him set up in front of a mic and dropped the beat. The kid started in energetically and competently with some fairly violent and obscenity-laced 50-Cent lyrics that were popular at the time. He rapped about eight bars, stopped and looked around with a provocative smile while the beat continued playing. Parents, students, and administrators looked at me. I looked off into the distance as if I wasn't paying much attention. There was an awkward pause while the kid on the mic waited to see what would happen. Then, when nothing hap-

pened, he said in an almost comically professional voice, "Let's roll that back and try it again!" My student restarted the beat and the kid on the mic began to rap his own lyrics, which were not only not "inappropriate," they were more interesting and original to my ear than "Fiddy's" were. He walked out of the studio an hour later with an interesting little original track, his first recording.

Kids make art on their own all the time. It is increasingly rare, however, that they are asked in school, or in after-school programs, to make art about what is really on their minds. It stood to reason, therefore, that this particular kid thought it necessary to test this context to determine whether it was about "school" or about art. Once he'd established that the studio was there for people to make their own work, he . . . made his own work. Gratuitousness and superficial imitation are often about testing the limits of free expression; when we are clear that we really mean "Make your art," there are no limits to the originality and profundity of student work.

Collaborate with classroom teachers, don't *be* a classroom teacher

Teaching artists who work in schools or in other contexts with young people are sometimes encouraged to study the things classroom teachers study: early childhood development, "classroom management," incentive systems with which to engage students, etc. A good deal of existing professional development and training for teaching artists is almost identical to the pedagogy courses elementary school teachers take in undergraduate and graduate programs.

This is not a good thing, for several reasons. In the first place, current trends in elementary pedagogy are a deformed reflection of the savage reality of overcrowded, underfunded race- and class-segregated public schools—which is to say that contemporary Ed school curricula and teacher professional development in the U.S. focus increasingly on crude behaviorist techniques designed to keep students "on-task," and simplistic, often scientifically refuted generalizations about cognition and intelligence. Generative theory of pedagogy is often dealt with only superficially, and less and less attention in elementary teacher prep is given to actual subject area knowledge and teaching. There are of course many exceptions to this trend, but it remains the trend. To make matters worse, what filters down into the teaching artist field are often the most simplistic and uninteresting parts of the latest pedagogical fads, techniques and concepts that are of little use to classroom teachers who want to actually teach (rather than simply "manage"), much less teaching artists.

Another reason why it's not a good thing to train teaching artists the way

No Irony, No Revolution

The fourth grader is cute as hell, and annoying as hell. He's an expert button-pusher. He writes a song lyric:

I'm rich.
I'm richer than you.
I'm really rich.
I'm SOO rich.

He looks quite pleased and seems to expect me to chastise him. Perhaps he thinks I'll say something like "That's negative," or "That's not you; write about you."

I say to the fourth grader: "That's a start. You want to make people think you, or this character here, is rich, right?" He nods enthusiastically, and just a bit sarcastically. "Okay, cool. This sounds pretty good rhythmically the way you say it, but as a listener, I could use a bit more of a picture. Show me how, or why, or where you're rich." The fourth-grader walks away chewing his pencil.

Five minutes later he's back.

I'm soooo rich.
I've got a mansion.
You don't.
I've got a S-Class Benz with 20-inch rims.
You don't.

I say, "That's definitely more of a picture. The thing is, I think I've seen that picture in just about every hip hop video on TV." He nods, tentatively and not so sarcastically. "It might be played out." He nods again. "How about a picture that will really flip it, really surprise someone? A picture no one has seen before." He doesn't answer and walks away chewing his paper.

This time it's only two minutes.

I'm rich.
I'm so rich my house is made of money.
My shoes are made out of money.
My money HAS money.

I can't help myself. I slap the table, laugh out loud and yell, "That's it!" He looks a little freaked out. "That's funny, right?" He nods. "Why is it funny to you?" I ask.

"Because that stuff can't be: shoes can't be made of money; money can't have money." Now he's smiling.

"So then why'd you write it?"

"Because they haven't seen that. They probably never thought of that."

He walks away chewing his irony and his art.

—Nick

classroom teachers are trained is that *teaching artists are not classroom teachers.* This is not to say that full-time, in-school art teachers are not teaching artists, or that teaching artists don't sometimes also work as classroom teachers. We mean that when we teach as teaching artists, we should be doing something different and distinct from what a classroom teacher does. There will be overlap with some classroom pedagogy, but in our role as teaching artists we seek to shift the teacher-student dynamic toward an artist-artist dynamic. The reason students, teachers and administrators ask us to come into their classrooms and after-school programs is that we bring something that is not already there. We bring the work, play, atmosphere and ethos of art-making and all the intellectual, social and emotional dimensions that come with it. We are not there to replicate what exists in schools; we are there to complement it, or in some cases to subvert it.

This is not to suggest that we shouldn't learn some things from teachers and colleagues about how to operate in a room of thirty-five wired 7-year-olds. Good teachers do have special, near-magical skills that enable them to create a safe, fun, pleasant environment for teaching and learning even in the most hellish conditions. Teaching artists should learn those skills where they can, and often the best way is to observe good classroom teachers.

Good classroom teachers know that a good classroom environment ultimately derives from, and exists to support, good teaching and learning of content. If the curriculum and teaching are solid, one at least has a shot at making even an overcrowded classroom a fun and productive place. If curriculum is an afterthought, or secondary to "classroom management" goals, then no amount of "management" will make the classroom anything other than a boring, distracting and unpleasant place. As teaching artists we need to learn that lesson too. Even in circumstances where no amount of good teaching can create a positive environment, keeping a focus on the content and the medium is the best option for us as teaching artists and educators. If even a few students are able to engage with the work, we have accomplished something. Our primary role is always to engage students as fellow artists, not as students to be "managed."

Where we should seek to work closely with and learn from teachers is on the *content* of our work. If we are going to do an art project with a teacher that relates to the science of the water cycle, we should study the water cycle. We need to understand academic content in order to determine whether and how it might serve as generative raw material for art-making. Our work with teachers should focus on finding real and interesting connections between what we know and teach, and what teachers know and teach. Our work together should be exciting and thought provoking for teacher and teaching artist alike; if it is, it will also be exciting and thought provoking for students.

Teachers often know their students well and can help us get to know them

too. But we should be aware that teachers, of necessity, know their students as . . . students. Even if they have rich and warm relationships with students, teachers must view them in terms of their academic and social development, needs and performance. Teaching artists, however, have the luxury and duty to approach students as *artists*. What makes real art-making so appealing to students is precisely that it offers relief from the constant focus on them as students; teaching artists put the focus on the work as art, not as a document or artifact of a student's progress, personality, mental health, academic understanding, etc. This is not to say that student work should never be considered through such lenses, but when we are working with students we must treat their work as art, plain and simple. If we do not do this, we fail to bring to bear exactly what makes teaching artists uniquely useful to people, schools and our culture.

"Best practices" are for phlebotomists

The term "best practices" is currently widely used in the fields of education and arts education. It has become a kind of shorthand for "what works" in classrooms and is advocated by educators in and outside of arts education. Everyone assumes that we all want to apply "best practices" to our teaching. No two people are likely to define "best practices" in the same way, however, so it can be anxiety-inducing for teaching artists to try to hit this target when they are planning how to teach.

It's also a term and concept that has become popular with health insurance companies in their ceaseless efforts to narrow the scope of patient care and cut costs. The idea in medicine is that one can determine the best response to a specific illness or complex of symptoms by looking at statistical data. Once the "best practice" has been determined, in the insurance company's view all doctors should adhere to it. It has been shown repeatedly that the means used to derive these "best practices" are not only highly politicized in the interests of cost cutting, they are also medically and scientifically flawed. Time and again, mandated "best practices" in everything from oncology to critical care have had to be revised or reversed within months or a few years because they had been found to be medically unsound, and in some cases deadly.

The reasons the search for best practices in medicine has failed are complex, but essentially they boil down to the fact that disease and treatment involve many variables and highly dynamic processes that are often idiosyncratic to individual patients. Our knowledge of how diseases and the human body function are still too incomplete to allow for such rigid standardization of medical practice.[3]

It does make sense to study data on something like the steps taken to prevent infection when drawing blood and to develop procedures based on the

latest data. This makes sense because pretty much everyone's veins are the same, and the process of drawing blood does not vary much.[4] It is a technique that can be standardized with useful results. But that is very different from attempting to standardize the treatment of a patient's blood sugar in intensive care, something that is orders of magnitude more complex in terms of both causes and effects.

Why the hell are we going on about medicine in a book for teaching artists? Because if it is dangerous, if not impossible, to attempt to rationalize and systematize "best practices" in a discipline that is scientifically based, imagine how misguided it is to do so in arts education. Yes, we can and should learn how to teach better; we should also try to understand how students learn, and what works and doesn't work for us in our practice and in our disciplines (see Chapter 3 on Assessment and Evaluation). But when we begin to throw around the notion of best practices, we are suggesting a kind of standardization that trivializes the all-important specificity of context: the individual teaching artist, the individual students, the medium. While some may use the term simply to suggest some basic tried and true techniques ("If you speak quietly to a group of students, they will usually lower their voices as well"), the term confers upon such teaching lore—which is seldom useful to apply uncritically—the status of expertise.

The great physicist and teacher Richard Feynman often remarked that he did not know how to teach—that he did not have a systematic way of determining what worked. He had ideas and intuitive insights but no "science of teaching." He also once characterized science itself as the "belief in the ignorance of experts."[5] We should absolutely learn from each other and learn the many rich lessons of past teaching artist practice. Although this handbook is not scientific, we hope it shares with science an impulse toward joy in discovery and the development of new ideas, along with a distrust of claims to a kind of expertise that is too fixed or static and too quick to generalize about practice.

Making a space that is about the work

Creating space in which to make art is one of the most important things we do. We often need to negotiate creating this space within a school or institution and find ways to create a space for students to think and work as artists where no such space existed before. We have to create physical spaces and also intellectual and affective ones. We can even organize and plan how to teach around the simple question: What space will I make for students to work? Instead of thinking in terms of planning a curriculum, it can sometimes be just as useful to think in terms of planning a studio.

The workspace or studio we create can and should be distinct within the

classroom, prison rec room, or wherever else our students normally spend their time. It should belong to our students as well as to us—we are artists together. Creating such a space for shared work may not involve any physical changes at all. Sometimes we come into a classroom for a 50-minute session and there is no time even to rearrange chairs or desks. We can establish a workspace by directly or indirectly declaring a workspace. For the next fifty minutes this is a writers' studio, a book artists' atelier, a recording studio. This is no longer a classroom, or a senior center cafeteria. Different rules apply—we are here as artists to make art. Sometimes it's enough to address students, artist to artist, to set that tone and establish such a space. Sometimes it's enough to remind students that art-making is *voluntary*. No one can force you to make art. If you are in a space, real or implied, by choice, then you think, learn and work differently—perhaps more like an artist.

Creating a workspace often involves negotiation. If you are collaborating with a teacher, or just working in a teacher's classroom, it is important to have a clear dialog about why it may be useful to have a "studio" in the classroom and why different rules and standards may apply in this space. Some excellent teachers run their classrooms in ways that are quite similar to the way a studio might run, so it may not be a big shift for teacher or students to create a studio workspace. Other excellent teachers run more highly structured and directive classrooms. Although some teachers may question the importance of having a different set of rules for a "studio," it's been our experience that teachers who are confident in their ability to direct students and control a classroom are often comfortable letting go of such control because they know they can reestablish it any time they want to.

None of this is to suggest that a studio or workspace needs to reflect a completely free or "anything goes" attitude. Some studios have rigid rules; some teaching artists work best with very directive teaching and very clear guidelines for students. The point is not to abandon "rules," the point is that any structure or rules should reflect the needs and the imperatives of the medium and the art-making. Although many of the studios Nick runs with students are quite loose and chaotic, he is very rigid about certain things— like the "correct" way to coil a microphone cable. Similarly, when Becca comes into a classroom to create poems with students, she insists that everyone be quiet when a poem is being read aloud so that all can hear exactly how the language is working—even if the rest of class time is filled with a constant buzz of voices. But we've found that students rather enjoy such rules, and even enjoy castigating each other for violations, because the rules are very clearly about the work, not the student. Nick would never presume to lecture a student about her or his own shortcomings as evidenced by a failure to coil a microphone cable the right way. He would never do that because *he* some-

times fails to coil the microphone cable the right way, and also because they are there to make music, not to "build character" or train "better citizens." If any of them ever builds character in a recording studio, it is only through the process of making actual music. Understanding the limits and uses of "rules" in one's teaching can be very useful when one has to take into consideration the focus on classroom management in schools today.

HOW TO TEACH: CONCRETE STEPS

Fourteen ideas about "classroom management"

1. Consider never using the term "classroom management." It implies that creating a good learning and working environment is a discrete skill, and to us the term equates what educators do with what corporate managers do. Consider thinking in terms of collaborating effectively with students on learning and art-making, or, where necessary, effectively asserting control over a group of students in the interest of organization. That seems both a more accurate and more honest way of talking about this part of teaching.

2. Ninety percent of a good learning and teaching environment has to do with curriculum. If your curriculum is based on engaging study of engaging material, students will be engaged.
 - By "curriculum" we do not mean just a syllabus or lesson plan. While these things are important, they are only a small part of successful curriculum. What we mean is that if you have something real to teach, some clarity about what it is and how to teach it, and some genuine enthusiasm about it, students will almost always respond and engage with the work. If any of these things are lacking, engaging students will inevitably be difficult.

3. You do not need to expect the same norms of behavior as are appropriate in other contexts.
 - You need to establish an environment that serves art-making in your medium with your students. If you are in a classroom it is okay, and in many cases even necessary, to allow students much greater freedom and spontaneity than may be possible during academic classes.
 - One of the most important things we bring to schools and other institutions is a *different environment for art-making and learning*.
 - If it's okay for adult artists to talk a lot, mess around some of the time, and even create some controlled chaos in their workspaces, then it must be okay for young artists to do so as well.

4. You should be extra collaborative with teachers and staff around this question.

- If you are working in a school or other institution with specified norms and rules of behavior, you *should* seek to modify or suspend them as necessary in order to create a space for art-making. But you also should seek to work as collaboratively as possible with teachers and staff to explain your needs and the needs of the work and determine what may or may not be possible and acceptable in a given situation.
- If you frame the question as one of creating an art-making space and not one of "superior teaching methods," you may often find that teachers are not only willing to work with you but even enthusiastic about creating a "de-schooled" space.
- Confident and capable teachers understand that students are perfectly able to work in different ways in different circumstances. Just because a teacher allows noise, movement and even some chaos during art-making does not mean that he or she has to accept these things at other times. Kids in particular are very aware of the fact rules and norms are contextual. Consider how differently kids behave on a playground—where they often have their own quite elaborate and developed systems of social and physical norms—and in even a loosely run classroom. It makes sense that a studio, physical or metaphorical, should have its own rules and norms, tailored to the work being done in it.

5. Make your own rules, but make as few as possible.
 - You have to find the rules that fit you, your medium and your students.
 - With teenage or adult students we almost never impose "rules." We simply explain safety norms and technical practices that relate to properly handling equipment.
 - In many teaching contexts with kids Nick has only one rule: Don't be a jackass. This is generally understood by kids of all ages to mean "don't be rude, disrespectful, destructive, obstructive or dangerous."
 - Sometimes we are more explicit: Either make work or stay out of the way.
 - When there are students who, for whatever reason, find it hard not to obstruct the work of others, we sometimes designate a corner as "the play area." If you don't want to work, you can either watch others work or you can go to the "play area" and do whatever you want, as long as it's not dangerous. You might be surprised at how few kids will take you up on this offer. No one really wants to be seen as trivial and excluded on that basis.

6. Make your rules serve the art-making and the discipline, or be clear that they are about something else.

- The more distinctly your rules relate to the art-making, and the less they seem like an arbitrary extension of the school's or institution's rules, the more they will support your teaching.
- You should be able to explain your rules. For instance, if you want to forbid kids in a digital studio to have Facebook open while they are working in Photoshop, be clear about why. Maybe it's because you want them to focus intensely on their images without distraction. Maybe you feel that this is essential. But if it's really because *you* find it distracting or disrespectful for them to be multitasking, then you should say so. Either rationale is valid, but it's much easier for any artist to accept rules when he or she is clear about where they are coming from.

7. Don't drive yourself crazy.
 - It's your workspace too. It's okay to have rules and even arbitrary demands to protect your sanity. Just as you relate to students as fellow artists, they should relate to you as an artist also. Sometimes you just have to say, "No freakin' drums today! I can't take it!" Usually students get this. But if they don't, they should.

8. Be flexible.
 - If the rules are there to serve the art-making, then they should be adaptable and flexible as the situation demands. Students get this too—they are used to negotiating all kinds of expectations and contexts, and since teaching artist work is about art-making, not behavioral training, consistency is not the main thing.

9. Involve students.
 - Even very young students are completely capable of highly nuanced and effective self-organization. A few minutes of watching kids on a playground will confirm this: When they want to, kids regularly establish collaborations, enforce expectations and just generally get things done. If kids are involved in something that matters to them— a game, a sport, art-making—they will often take care of the interpersonal details themselves, leaving you free to help them develop their work as artists. If you don't get too hung up on behavior, they probably won't either.
 - Sometimes you can usefully co-opt existing social mechanisms in a group of kids. Some kids are good at organizing other kids and are accorded a certain leadership by their peers. There's nothing wrong with delegating organizational tasks to kids who are good at them, as long as you don't make too big a deal of it—recognize and use the respect a kid has earned from peers, but don't exaggerate it. The kid who has a lot of younger siblings may be particularly good at quieting a group down and getting them focused.

- It's okay to delegate authority for other reasons. Sometimes Nick will ask a class to identify the kid who is compulsively organized and tidy. He'll ask that kid if he or she wants to be the "studio manager" in charge of making sure everyone keeps the place in good working order. Often this works out well, but only if he is careful to be informal about the whole thing and not get dragged into an exaggerated and overblown assigning of hierarchical posts. The point is for the kids to keep the studio up, not for some kid to have a formal position of authority. If the kid is perceived to be the "studio manager" based on Nick's arbitrary choice, then he or she is likely to have a hard row to hoe. But if the kid is understood to be the "studio manager" because he or she is good at such things, or just interested in the role, and it's understood to be a useful and helpful role, then usually things will go well.
- Sometimes you can usefully support leadership and organizational ability in a kid who *is not* viewed as a leader or organizer by his or her peers. Once in his classroom, a seventh grader who was generally perceived as a slightly annoying know-it-all spontaneously brought Nick a beautiful floor plan with which he wanted to completely rearrange their recording studio in the interest of better work flow. The plan was brilliant. Nick told the student he could implement it provided he could get the other kids to help him. It was a struggle, but the student made it happen. He learned some things about persuasion and collaboration, and their studio was the better for it.

10. Avoid appealing to external authority.
 - Few things can blow the atmosphere in a student studio more quickly than threatening to send a kid to the principal. Of course, in instances of serious misbehavior or destruction one may have no choice but to default to standard school or institutional procedures and to defer to teachers and administrators. In all but the most serious instances this is probably avoidable. If it is at all possible, you want to maintain a "de-schooled" space for art-making, not because school is inherently bad but because real artistic invention and exploration require that students and teaching artists work in an environment that is free from the normal expectations and limitations of many of the institutions in which we work. Perhaps we need to put aside the fact that we are in school, or prison, or a hospital, and feel that we are in a studio or other place where art-making is the whole point. We have to maintain a good working environment on the premise that we are all there to make art, and we should remove any obstacles to fun and unfettered art-making. When the work itself is at the center, it is remarkable how thoughtful and collaborative groups of kids can be, even

kids who are considered "rowdy" or defiant in other situations.

11. Don't escalate conflicts unnecessarily.

 - Of course, one has to put the safety of students above everything else at all times. And when collaborating with a teacher one should defer to the teacher's greater familiarity with her or his students in situations where students come into conflict. Some conflicts between students are very serious, longstanding and potentially dangerous.

 - We should also remember that kids are often self-regulating in minor conflicts. Conflicts frequently come about for trivial reasons—a kid is having a bad day, a kid was gratuitously mean. For good art-making to happen, we have to promote an atmosphere in which criticism and even negative opinions can be openly expressed, but also kept in perspective—as opinions. Of course, when the expression of opinions becomes hurtful and destructive to students, it becomes an obstacle to art-making and learning. But small conflicts between students are often momentary and can be escalated by excessive or premature adult intervention.

 - We do not have to maintain perfect peace in a kid studio any more than we do in an adult studio or workplace. Students do not have to like each other all the time, or ever, for good art-making and even close collaboration to take place. If students are to feel that the work they are doing is genuinely their own and if they are to develop their own artistic vision, they need to have a sense that they are not being constantly controlled. Just as many important and complementary types of learning and experience happen in unsupervised play on a playground, the particular learning that takes place when we make art that is our own can take place only when we feel a certain freedom of expression in the moment. If the emphasis stays on the work, not on the students' behavior, more often than not conflicts will quickly recede. If you must intervene, do so with an eye toward getting kids past conflicts quickly and back to working alongside one another as artists. Shake hands and move on.

12. Do not allow yourself or others to use art-making as a reward or to deny it as a punishment.

 - Because students often look forward to working with teaching artists and making their art, teachers, administrators and even teaching artists can be tempted to use art-making as a reward, or the denial of the opportunity to make art as a punishment. This can take the form of allowing or denying participation in art-making based on a student's behavior in other contexts. Student behavior, performance or achievement can be used as a criterion for selection for arts programming.

- While this impulse is understandable, especially in classrooms and institutions where it is very difficult to establish a positive environment for learning and art-making, we believe that to use art-making as a behavior management tool is alienating to all involved, counterproductive educationally, and ultimately incompatible with creating a context for free art-making.

- Selecting only "well behaved" or "high achieving" students for arts programming inevitably interferes with students' sense of themselves as artists and encourages them to produce work that will maintain or enhance their favored status. This is not to suggest that one can't have application or selection criteria to determine which students might benefit most from, or are most committed to, a given art class, project or program. But these criteria should be about art-making, and the specific project or class, not about a student's performance or behavior in other contexts.

- As teaching artists we often experience the ways in which art-making can be especially liberating, exciting and fulfilling for students who struggle in academic and social contexts. It frequently turns out that such students have some of the most interesting artistic ideas, and sometimes are particularly inventive and powerful artists, perhaps for some of the same reasons that they have difficulty in other areas. To link such students' participation in arts activities to performance or behavior in other contexts can be particularly destructive and interfere with what is most beneficial about art-making for these students. It can also deprive the group as a whole of the contributions of such students, and ultimately deprive all of us of some very good and important art.

- In order to teach art we need to approach all our students on their own terms and as fellow artists. We cannot and should not judge them by external criteria, by who they may be in another context, or by what a teacher or administrator has told us about them.

13. You are a role model. You are not a role model.

 - You do play a big role in setting the tone in the room. That's just something that happens when you are in a teaching capacity, even if you are pretty low-key about your role.

 - If you approach students as artists, they will probably approach each other as artists.

 - If you concern yourself with the work and not with ego or interpersonal stuff, it is likely that your students will do the same.

 - The only role you should model is you. You are not obligated to model some abstract standard of behavior or set of values different from the one that you live spontaneously. If you try, it is unlikely anyone will

be positively influenced. If you are not spontaneous and not yourself, it will be hard for anyone to engage with you in an interesting and artful way. No one likes a phony, no matter how well intentioned the dissembling.

- Who you are and how you work can in itself be a powerful and liberating influence for students. That influence can take many forms: It can develop because in some sense students see themselves in you, or because they see you as very different but can connect with you through art-making.

14. Be yourself.

- Whether you are projecting a teacher's authority (as teaching artists sometimes must) or are simply relating to students as fellow artists, as long as you are yourself students will engage with you. They might not agree with you, and they might sometimes drive you crazy, but you will have a relationship with them, and interesting art and other things will undoubtedly come of it.

- If you find yourself trying to project a persona that does not feel comfortable to you, or trying to get students to behave in ways that do not make sense to you—ways that you yourself would never want to be asked to behave—there will always be a disconnect that will get in the way of the work.

- If you make assumptions and generalizations about students based on cultural, generational or other stereotypes, this will inevitably interfere with your ability to engage them as artists. Even if you are making such assumptions based on good intentions (a desire to be relevant to your students or to seem more familiar to them), students—or anyone—will pick up on the fact that you are responding to them based not on who they *are*, but on who you may think they are. This will be no fun for you or them and will interfere with real art-making. Better to acknowledge that you may not know much about your students' interests and lives (you can find out from them!) than to make what may be incorrect assumptions.

- This work is as much about your own artistic development and fulfillment as that of your students. Your students need to be able to be themselves in order to make their own work and enjoy it. The same goes for you.

Engagement

Where there is an invitation to make genuinely original work you will find endless student "engagement." Positive student behavior and cooperation in the learning at hand become much more the norm. Compelling art often has

Chaos Is Often Not
What It Seems

One of the most surprising things to me about kids is their ability to work effectively and even thrive amid sensory and social overload. At various points in my teaching career, both as a teaching artist and classroom teacher, I had many class sessions in which I despaired at the level of noise, cross-talk, and fooling around. I was certain that no work was getting done and nothing was being learned. Students were getting up from their work to talk to other students, making jokes and trading jabs across the room, exclaiming loudly, and generally acting like kids (or, truth be told, many adult artists). At the end of many (not all!) such sessions I'd look at student work, or their notes, or talk with students informally and find that in fact some very good work and very clear learning had taken place.

During the art-making parts of my teaching I came to accept a very loose and even noisy atmosphere. However, I was often shocked to find that when the work demanded order, organization or silence (this was a student recording studio after all), students seemed to have little trouble shutting off the chaos, noise and movement.

In one elementary school where I ran a full-time studio as part of the curriculum I spent a lot of time talking with students about this question because I was curious. I even did an informal study about how this question of environment and social openness plays in classroom art-making. Students were almost unanimous in insisting that the slightly chaotic and social atmosphere was a huge part of why the studio was one their favorite places in the school. I pushed them on this: So you like it because you can hang out with your friends and not get in trouble for screwing around? Their response was emphatic: No, we like it because we can do our work and still be ourselves.

Years later I asked many of the same students what they remembered about this particular recording studio. One of the most common responses was that they remembered a certain atmosphere of "fun and doing cool work." In their minds, social openness and the work were linked.

When I really thought carefully about my own work experiences—both good and bad—as an artist and in other fields, I realized that this should be no surprise. When you feel you can be yourself, open and expressive in the ways that are particular to you, and accepted as you make creative, fulfilling work alongside others, it just feels good, in a way that fosters the fearless experimentation and intense enthusiasm that can lead to good art-making.

Does this mean that a chaotic, noisy, social atmosphere is always conducive to art-making? Absolutely not. In many circumstances, I find it impossible to work well at music or anything else with distractions of any kind. I do believe that an atmosphere in which artists of any age feel free to be themselves and to act as they do outside of institutional constraints and expectations is good for art-making and also for teaching and learning.

—Nick

an obsessive quality to it, and artists are often obsessive and sharply focused in their work. Coincidentally, so are children. If a student is encouraged to make something that is a real expression of his or her way of seeing, hearing, feeling, or imagining, then you will have to drag that student away from the work. This is not to say that all young artists find an easy path to original expression. Artists young and old can feel timid, unsure or even hostile about the idea of making work. That's where we teaching artists earn our pay: We are experts at helping other artists discover what is important and interesting to them as they work in a medium. It can be very hard to do sometimes, but it's always worth it for the student and for the teaching artist.

This means we also have to give student artists a choice. You cannot force someone to make art, or at least not good art. Who would want to force someone to make art anyway? Often when we give a student artist a choice, the student will eventually begin to work with the medium because it would seem that making art is something that, under the right conditions, everyone likes to do. Nick had students who had spent weeks in an after-school recording studio sulking in a corner and criticizing other students' work. Later, as they spontaneously decided to begin on their own work, it became clear that these students *were* working: preparing themselves and clarifying their own vision. Becca has her own version of this student: the one who refuses to write. When she walks over to check on the progress of this student's poem, she is met with a blank page—or more likely, a page filled with sketches and disturbing images of strange monsters or drops of blood dripping from an ax. Obviously this student is able to visualize. So Becca's job becomes one of showing this student (often a very reluctant writer) that he can attack the page with the same vividness and level of disturbing imagery in his poetry. As artists we've all experienced such conflicts and roundabout approaches, and we should recognize and allow for them in our students.

"Engagement" is a very popular word in general and arts education these days. It conjures up visions of students working away happily as "self-directed learners." But anyone who has ever spent any time with kids (or adults) knows that one can be intensely and happily engaged in mindless tasks. Nick won't even tell you how many hours he's wasted deeply engaged in playing a particularly dumb, but entertaining online game. "Engagement" is no proof of learning, "creativity," or anything else. We would never judge an artist's work by how "engaged" she or he is in the studio. If we are to treat our students as artists, then "engagement" is beside the point.

That said, if your students are bored and sullen, it may not be your fault. There are lots of reasons a student may not feel like making art, or making art in the ways you are suggesting. Sometimes we can get past individual blocks and barriers and sometimes we can't. But if most of your students are not into the work, there may be something that needs changing. More often than not, the obstacle is that we have not left enough space for individual or col-

A Story About a "Problem Student" Who Is Also an Excellent Artist

I've been lucky enough to spend much of the past five years setting up student-run recording studios in elementary, middle and high schools. A lot of amazing music has come out of those studios—much that I like, some that drives me crazy, all of it music that I could never have imagined before I heard it. As teaching artists we help students to make their art, but we also create contexts in which people often relate to each other quite differently from the way they do elsewhere, sometimes seeing far beyond immediate and narrow concerns.

Will* was eighth-grade valedictorian, a soloist in a concert choir that performs with the Chicago Lyric Opera, a tremendously capable, thoughtful and imaginative kid who contributed to more than his share of amazing tracks over the two years we worked together. Two years later, when I was looking for a high school student to help me run a new after-school studio, Will was a natural choice.

When I arrived on what was to be Will's first day of assistant teaching, I was a little surprised to see Travis standing in front of the door. Travis was a classmate of Will's, but not the Valedictorian. In fact, Travis had been threatened with expulsion from seventh and eighth grade more times than he or I could remember. He'd failed practically every class and provoked every teacher, and was so disliked by his classmates, including Will, that they beat him up more than a few times. Travis was not always an easy person to be around, but he was already a very, very good artist.

Travis and I had gotten to know each other quite well because Travis was a constant presence in the studio. It was the place where he worked. Travis worked quietly and intensely on allusive hip hop tracks full of new ideas and strange sounds. When he couldn't work on the music, he worked on complex, expressive drawings, epic comic strips, and stirring expressionist films made with the simple Moviemaker software he'd discovered on our studio PCs.

In the studio Travis also somehow became a collaborator—slowly and fitfully, but deliberately. His classmates grudgingly conceded Travis's skills as a visual artist and even called on his idiosyncratic writing and rapping when they needed a fresh approach to a track. By the end of eighth grade Travis could be found in the gym, quietly directing a dozen of his classmates in a music video that he'd scripted and organized entirely by himself. They still didn't like Travis, but somehow he'd involved them in his work, probably because it was good work.

So, that October afternoon I was happily surprised to see Travis, now a sophomore in high school, standing in front of the door to the new school where I was teaching. "I heard that you had a studio here, Mr. Jaffe," Travis said. Then he walked into this unfamiliar studio, sat down as if no time had

passed, and immediately began working on his music. When Will showed up, they nodded to each other but that was about it. Will began to help the first graders record a drum track; Travis gave up his place at the computer to the younger kids and went off into a corner to draw. And so it went in the subsequent weeks, Will teaching directly, Travis teaching by example.

A few months later I was driving Will home and I mentioned how strange and cool I thought it was that Travis had appeared by chance on Will's first day and had gone right back to work. Will looked at me with that pitying smile adolescents reserve for a particular kind of adult obtuseness.

"I called him. I told him he should come down to the studio."

"That's excellent," I said. "I had no idea. I figured you couldn't stand him."

"I can't, really," said Will "But I thought he'd be looking for a place to work."

Postscript: As we go to press it's been almost a year since I last saw Travis. He recently called me on the phone to catch up. Now in his junior year of high school, Travis performs and tours with one of the best concert choirs in the nation, assistant teaches in a well-known youth art program, and is having one of his comic books published.
*Names changed.

—Nick

lective invention on the part of the students. We may have framed things too narrowly, or pre-determined the outcome too much. Such situations can be a very exciting opportunity to open up room for student invention. If we have too many creative constraints or conceptual prompts, we can remove some. We can even scrap the whole "plan" and ask the students what they would like to do with the medium. It can be amazing to see how quickly a room full of bored, apathetic students can come to life when they are asked not just to solve a creative problem but to frame one.

"Do I have to do this?"

When we first stand up in front of a class and explain what we are about to do, there is one question we always hope someone will ask: "Do I have to do this?" We love that question, and we love the kid who asks it. Nick's answer is always the same: "Of course not. You don't really have to do much of anything." Sometimes there's a follow up question: "I have to be here in school, right?"—to which he likes to reply, "How fast can you run?" Becca's response to such questions is similar, although depending on the student, sometimes

less direct—perhaps more of a shrug. Then she gets down to work as if it is a foregone conclusion that they are all there to make poems. Or else she says, "No one is obligated to like writing poems, but please go along for the next fifty minutes or so." Or she will make it socially awkward for them, only half-kidding. In her view, she is there to write poems with students, and any static around that is an impediment that she will get rid of however she needs to.

We like to have this exchange with students because it recasts things in terms of art-making. We bring a different purpose and experience into schools and other institutions, one that is not about personal performance and fulfilling expectations as a student but about making work that is interesting and compelling to the artist and to an audience. It has been our experience that precisely when the context becomes about "the work" and not "the student," a different type of learning begins to take place—learning that is not only intrinsically motivated, but dynamic and purposeful—like art-making.

There's also the student who doesn't want to make art. There can be various reasons why he or she doesn't want to engage with your lesson or medium, just as there can be many reasons why you sometimes don't feel like making work. We've found that often this student has some of the most interesting ideas and eventually does some excellent work, and we especially enjoy the experience of trying to find a point of access to the work that works for this student. In our experience, it particularly pays to approach the student who won't work *as an artist*.

Seven Things to Consider When a Student Doesn't Want to Make Art

1. No one forces you to make your work; you shouldn't feel you have to force anyone else to make work.
2. All people are "creative" and "talented," which is to say all students are capable of the full range of expression and invention in any medium when given the tools.
3. Everyone has interests, ideas and associations. Everyone has aesthetic experiences and an aesthetic. Find out what music, art, film, television, comics, video games, or books your student likes and dislikes. There will be ideas and stories in that conversation that may be an interesting place for a student to begin.
4. If a student is timid about expressing ideas in a medium or experimenting, work to create the sense that "it's all about the work," not the student. Art-making is different from schooling; the work is not identical with the student and is not a means of evaluating the student.
5. Some people like to make art that is obviously about *them*; many people don't. Some students expect that art-making is supposed to reflect their identity or directly represent their "feelings." Encourage students to fictionalize and create new and different identities and characters. Remind students that much great art is made by artists who deeply disguise their

identity or "feelings" in the work and sometimes even hide their agency.

6. If a student is skeptical of his or her ability in a medium, remind them that art and technique are not at all the same thing. Simplify technique: break it down into small elements without dumbing it down.

7. Sometimes a student is just not interested or excited by the particular prompt or creative constraints you have imposed. Just as you, in your own work, feel free to discard beginnings or ideas that don't hold your interest, you should feel free to allow your students to do the same. Ultimately, it's not about this one lesson or session, it's about a student's developing a voice in a medium.

Eight scenarios for improvising when/while you teach

If you teach in schools, prisons, senior centers, pretty much anywhere, it's going to happen. A lot. You will have been promised a room with fifteen iMacs or thirty watercolor kits and you'll show up to find one early-Nineties vintage IBM XT or, instead of watercolor kits . . . some water. Now, you should feel empowered as a teaching artist to have certain basic needs met, if not for yourself then for your students. It *is* okay in situations like these to say, Hey, I can't teach without supplies. But, if you are the sort of person who likes to improvise, and many teaching artists are, it's also okay to go for it anyway. If we are the Special Forces of art, it's partly because we do know how to get the job done with a single match and a bit of string. Sometimes the educational and artistic results are even more interesting and fun than what you had planned. Since scarcity is more the rule than the exception in many teaching artist situations, we offer this list in the spirit of improvisation. As with all the lists in this book, we'd love to know if you have a similar one.

- You are supposed to teach watercolor painting. There's no paint or brushes.
 - Can you teach some of the same techniques using water alone, perhaps spread with fingers or other things? Might paintings using just water on paper be interesting?
 - Can you teach drawing instead?
- You are supposed to teach drawing and there are no pencils, crayons, pens, . . . nothing!
 - Can you have students visualize, alone or in groups, in great detail, what they would draw if they had a pencil? Maybe they will draw entirely differently after this exercise, once the pencils arrive.
- You are supposed to teach photography but there's no camera.
 - Can you find enough paper to cover the windows and make a camera obscura (a giant pinhole camera)? Even if you don't have any photo

A Story About a Student Who Didn't Want to Make Art

Jason* would come into our recording studio every day, bend his very tall seventh grade frame into a folding chair and spend the entire session obnoxiously critiquing everyone's work. "That beat is really totally and completely whack," he would mumble, and when I prodded him to make some music of his own, he would look acutely uncomfortable and say nothing. No one seemed the least bit inhibited by Jason's remarks, and he wasn't really in the way, so I let him alone. I figured every studio can use a critic, and I told him so.

About a month into the school year Jason began to modify his modus operandi: He continued to mercilessly critique the music around him, but his comments were more thoughtful, detailed and musical. Often he'd accompany them with what he called "debate questions": "Who was the greatest lyricist of all time in any genre?" "What is the most truly classic hip hop beat ever?" Jason began to style himself as some sort of musicological archivist and would drag me over to his laptop to show me his huge, genre-busting mp3 collection. "I've been studying '60s folk," he'd say with a mixture of embarrassment and pride. "It should be sampled more for hip hop."

It was only toward the end of the school year that I got Jason to show me a little of his own work. He'd been writing lyrics and poems all along—notebooks full of them. It was powerful and very atypical stuff that combined his interest in history and politics with his peculiarly thoughtful and very critical take on the evolution of American music. One moment we'd be watching Reagan threaten Russia on TV, the next we'd be treated to an almost scholarly lecture on the roots of hip hop—but somehow it all worked together as a viscerally visual, musical and poetic whole.

Jason's writing was really new and fresh and very different from that of his peers. It seemed to me then that Jason's "critic" role was partly a way of expressing his anxiety about his own work, but also a way of working out his own aesthetic. So much of art seems to be created first in opposition and tension. We have to respond to what is in order to make something new. And what is really new is at once thrilling and scary as hell, especially if it's got your name on it.

All of this takes time, and the progress may not be measurable or even visible. But once a young artist is ready to make a leap in technique, expression, and innovation, things often move very quickly. Teaching artists are uniquely placed to tinker with the mechanism of the School Clock, correlating it with the elastic chronology of creative thought whenever possible and surreptitiously winding back the hands when necessary.

*Name changed.

—Nick

paper, students can experiment with the camera obscura to learn things about the medium and about optics.

- Can you use a cell phone camera and work on finding the things such a camera does particularly well?

■ You are supposed to teach kids to do digital audio recording, but there's only one computer and there are thirty-five kids.

- Can you have kids compose, improvise, or write in groups using vocalization, singing, rapping and/or percussive playing on objects, etc. and record in turn? Can you have kids work in groups to create parts of a larger piece and then have them record that as one big group?
- Can you work on composing, arranging and performing instead of recording? In many cases those elements are really about 95% of successful recording anyway.

■ You are supposed to teach sculpture, but there are no materials.

- Of course there are materials!
- Furniture
- Bodies
- Dirt
- Paper
- Paperclips
- Knapsacks
- ?

■ You are supposed to teach dance but you have been provided a 10 x 10-foot space for twenty kids.

- You will be teaching non-locomotor or highly restricted or very close movement!
- Propose to the students that they develop a piece, a dance, a vocabulary of movements or a whole genre or school of dance specifically adapted to exactly this situation.

■ You are supposed to have your students perform. You were promised a quiet auditorium with a rapt audience. You end up in a noisy gym with people coming and going.

- Can you reframe the piece for the students as a sort of public art performance where a quiet, attentive audience is not essential?
- Can you move the performance to an unconventional space like a hallway or playground, bring the audience with you, and by shifting the location emphasize that *now* everyone is in the venue and needs to shut up?

■ You are supposed to teach kids to write poems. There is no paper, and there are no pencils or computers.

- Can you work on recitation?

- Can you work on visualizing metaphors?
- Can you compose a poem collectively, on the board or just orally?

The art of exemplars

One thing seems certain: To become good at making work in a medium it generally helps to consume a lot of it. It's important and useful for teaching artists to introduce students to artists and work in their medium and to encourage students to become critical, active and omnivorous consumers of art. To become a good poet it helps to read a lot of good poetry. To become an inventive and interesting musician you have to be an open and interested listener; listening to a lot of music is a big part of becoming such a listener. This is not to say that formal consumption or exposure to art is the only means of developing a vision and "vocabulary" in a medium, but it is one key way of doing so.

Interesting and original work by artists in different media is prime ground for developing ideas and opinions about one's own work. As long as the premise behind study and discussion of such works is that they will be used critically as a basis for new ideas and approaches, this study can only help students develop as artists.

What we need to avoid is simplistic or formulaic approaches to the study of art, especially in the context of art-making. Many of us are familiar with the sight of thirty very similar versions of Frieda Kahlo's famous self-portrait hanging in a school hallway. Although imitation is sometimes a useful way of learning how a technique or approach works, if it is to generate interesting student work it has to lead to reinterpretation or reinvention. Furthermore, for imitation to be educative it has to go pretty deep and be pretty specific. Adopting "sexy" or clever conceptual frameworks of famous artists is an easy but sterile exercise. Having students play with the grid portraiture technique associated with Chuck Close might lead to interesting experimentation and invention, especially if it is studied in the context of other uses of similar technique. But, "Let's have all the kids make a Chuck Close-style portrait" is more likely to lead to a paint-by-numbers exercise that is unproductive and boring both for the students and for you. One way to tell the difference is to look at the student work: If it all looks the same (and if that is not explicitly the goal), then there is probably very little artistic development happening.

The point of learning by imitation is for students to experience, to the greatest extent they can, the technical possibilities and limitations of a medium that a given artist faced in creating a work. It's not particularly interesting or instructive to write and record a generic pop song that sounds vaguely like a bunch of existing pop songs. But to try to cop the exact sound, aesthetic and ethos of a particular artist or song can teach one a great deal about an artist and a medium.

Here's a list of a few ways one might use existing works by artists in teaching artist work. There is no particular reason to use canonical or "great works of art" other than the fact that such works are often rich in themselves, or have important cultural, historical or political associations. Often, one can use student work, even less developed work, and "bad art" as an instructive basis for discussion and study.

Eight Things Teaching Artists and Students Can Do with Examples of Good Art

1. Look at, listen to, or watch it just for fun.

2. Critique it just as you critique each other's work.

3. Analyze it in terms of technique and craft.

4. Imitate or appropriate specific aspects of an artist's technique or craft as a way of generating new work.

5. Study a particular work in historical, social, political or psychological context as a means of thinking in different ways about one's own work or about art in general.

6. Caricature or stylize an artist's work as a way of understanding what is particular or essential to that work. One can do this with student work too. It is interesting to have students (or any artists) attempt to caricature their own or each other's work. One can become aware of what is specific to one's work and also what is perhaps reflexive or formulaic. If the atmosphere is one of genuine interest and collegiality, students really enjoy this sort of investigation.

7. Try to imagine the aesthetic or thematic "opposite" of a particular work as a way of understanding what is essential to that work. Try to make such contrasting work. As in Item 6 above, this can be done with student work also.

8. Bring in work you love or can't stand. Talk about it. Have students do the same.

What if my students' work is terrible? Or, how to remember it's not about you

In many contexts in which we work as teaching artists we face pressures and expectations about student work. We discuss some of these in other parts of this chapter, but here we want to address a particular anxiety with which all teaching artists are familiar. We want student work to reflect well on *us*. We want it to be interesting; sometimes we want it to be pretty, or at least polished. Often we want it to please parents, schools, administrators and other

teaching artists. There is a huge temptation to guide students and even to design entire programs in such a way that the work that students make will satisfy expectations other than those of the students themselves. One of the hardest jobs we do is to find space, even in the face of these sometimes intense pressures (both external and internal), to allow students to make *their work.*

The external pressures are much easier to confront than the internal ones. We can argue with administrators and explain the importance of student agency. We can also accept certain expectations as creative constraints and present these openly to students as the kind of challenge that artists have always had to face. But it can be much harder to recognize and acknowledge our own fear: "What if the students make work that I don't like or don't understand, or worse yet, that makes me look bad?" Dealing with this question psychologically and pedagogically is another one of the ways we teaching artists really earn our pay. When we do it well, it can make a qualitative difference in student learning and art-making. When we don't do it well, it can result in projects that waste students' time and are alienating to you as the teaching artist.

Of course, we can't tell you how to answer this question. Ultimately, it goes to the heart of the problem of teaching in the arts—transmitting existing knowledge and precedents in a medium while simultaneously helping students to *invent and originate* their own work and aesthetic. We do want our students to become proficient in the skills of the medium, but proficiency is useful to them only if they also apply the skills in their own original ways. There is no easy solution to this tension, but here is a list of ideas that we've found useful in approaching it:

1. At the beginning of a project imagine your most feared outcome— perhaps student work that is just bad (in your view), or work that is interesting but alienating and incomprehensible to teachers or administrators or is very obviously not at all what they expected or hoped for.
2. Remind yourself that you are here, as a teaching artist, precisely to create a teaching and learning context in which such outcomes are possible. This is not to say that you should strive toward failure, but if failure on someone's terms is not a possibility, then no real teaching or art-making is happening.
3. Remind yourself that *this is not about you.* Student work is, and should be, *their work.* Nick sometimes tell students, "If I understand more than 50% of your aesthetic choices, you are screwing up!" He's only half joking. Nick's point is that students should invent and should surprise him and everyone else. And if he really means that, then some of the work will be uncomfortable to someone.
4. Remind yourself that, in a sense, this discussion is not about the students either; it's about the work. What makes us useful as teaching art-

ists is that we do not look at student work with the student "standing behind it," which is to say, as an artifact of who that student is or how he or she is performing. We stand side by side with students and look at their work as art. We help them gain the critical distance all of us artists need to develop our work. So none of this is about success or failure in the personal or institutional sense. Our main focus should be on the art itself—what is working in a piece and what needs more work.

5. The more real control over the work your students have, the more they will learn, the more you will learn and the more their audiences will learn.

Ideas for how to critique work with students

One of the most useful things a teaching artist brings to students is the time, space and structures that allow students to respond to each other's work. Critiques, formal and informal, are a key means by which students gain control of their own aesthetic, learn the concepts and vocabulary of a medium, and experience the complexity of how an audience responds to their work.

Critiques, especially informal or one-on-one discussions with students, are a chance to identify features of a student's work that are interesting, inventive or particularly effective. Often such features are, at first, spontaneous gestures or semi-conscious choices. In discussion with a teaching artist or fellow student-artist such features can be surfaced for further exploration and conscious application.

We try to emphasize for students that any response to a work, no matter how critical, can be useful to an artist, so long as the artist is able to achieve critical distance from his or her work (see it through the eyes of another) and feel confident in his or her ultimate control over aesthetic and technical decisions in making the work.

We encourage students to thoughtfully consider all responses and criticisms *as artists*. By this we mean that a criticism or response can be raw material for one's own art-making, just like clay or sound. When someone responds to a work, whether positively or negatively, the artist can always ask herself or himself, "How might I *use* this response?" The question is not so much whether one agrees with a criticism or suggestion; it's whether the criticism or suggestion leads one to a new insight or idea about the work or about other work. Even criticisms with which one disagrees, sometimes even really ill-considered responses, can lead an artist to a clearer understanding of what he or she is trying to achieve.

One way to introduce students to critique is by practicing with the work of another artist. For this purpose Nick sometimes brings in his own work-in-progress, and he tries to choose work that is problematic or even weak. With a

Unknown Cookie (How I Learned to Get Out of the Way)

I was working full-time in an elementary school on the south side of Chicago. The school had a music focus, and I was able to establish a recording studio as a full part of the curriculum titled Recording Arts and Sciences. I did some direct teaching of music and audio engineering concepts and techniques, but most of the time students worked on original recordings. It was like an adult studio, only the students were usually more efficient than most adult rock bands I'd worked with.

It was an article of faith for me that the students would conceive and direct all their recording projects from the beginning. I would not tell a class what to do during "production time." Some classes would decide to do a group project; others would split into many small groups, or individual students would work on their own.

In my second year one particularly dramatic and lively group of fifth graders spent the first session of the semester arguing. I tried to keep my cool and keep the discussion focused on the music, but to little avail. This group just wanted to fight. The following week the second session began the same way. After fifteen minutes of pointless name-calling only thinly disguised as an argument about a title for their song, I had a strange and sudden impulse to just leave. I was fed up, and also worried I'd soon start to raise my voice. I said, "You guys figure it out or whatever. I'm leaving," and I walked out of the studio and closed the door.

From what I could tell on the way out, the students were a bit taken aback but tried to play it off and continued to bicker. It felt strange to me to be in the hall, and I was worried both that the kids might come to blows and that my principal might see me. I listened at the door for sounds of a fight but I couldn't hear anything. After about five minutes I couldn't resist opening the door and taking a look. T., one of the ringleaders of this group and a favorite student of mine, was at the white board writing a list, and kids were calling out titles. As soon as I peeked in, students began waving me off. "Go away, Mr. Jaffe, we got this!" I went back into the hall. After a while one of the quieter students came out and sat down on the floor. "How's it going in there?" I asked. "Fine," she responded. "Why'd you come out?" I asked. "Just thought I'd take a break and see what you were doing," she answered.

A few minutes before the end of the period I went back into the room to find that the students were well into writing lyrics for a song titled "Unknown Cookie." How'd you come up with that?" I asked. "Well, some people wanted a song about the unknown and others wanted a song about cookies, so we put it together." I was skeptical—I hate obvious and formulaic compromises, and "cookies," unknown or otherwise, seemed a boring subject for a song. I was so happy they'd finally gotten to work that I bit my tongue.

Over the next two sessions this group of young musicians and engineers produced one of my favorite pieces of music ever. It was an all-acoustic piece that layered vocal harmonies, reverb-soaked drumline-type beats played on a snare and a floor tom, a crazy bass line, and rapped and sung lyrics about cookies with strange ingredients and ambiguous purposes. The hook, repeated throughout, was "I bust your face I take your cookie/ Gimme some of that cookie now!" The first line was rapped quite aggressively; the second part was sung in a sweet three-part harmony. The entire effect over three minutes was that of a highly original, slightly disturbing and funky-as-hell meditation on food, hostility and a few other things I didn't care to examine too closely. Eight years later I like it even more than I did then. For weeks after "Unknown Cookie" was completed I begged T. to tell me what she and her peers thought it was about. She'd smile at me pityingly. Finally, one day, in exasperation, T. told me, "Mr. Jaffe, it's about us, obviously."

I learned two things the day I first walked out of the studio. The first was that often when kids (or adults) are fighting in an art-making context, it's a kind of performance. As it turned out, I was the audience, and when I left the performance ended and the work began.

More important, I learned that sometimes it's useful literally to "get out of the way." I began to make this a central feature of my teaching. I'd always tried to step back when students were working; I'd show a student how to operate the recording workstation and then move away and let the student work. But now I began occasionally to leave the studio entirely and hang out in the hall. Sometimes I'd do this when students were running a session smoothly, sometimes when they were having problems or arguing. This became a sort of game, but also an expression of real independence on their part, and of confidence in them on my part.

I began to observe that when I was not in the room, students not only organized themselves more efficiently, they also seemed to learn certain technical and musical skills more quickly and more permanently. We all know the feeling of trying out a new skill for the first time with no "safety net." It is one thing to drive a car for the first time with an adult or instructor in the passenger seat. It is another to do it alone. Something changes when you are doing it "for real," and in art-making it seems to me that this "something" is about sharpened learning and more intentional control over artistic expression.

Students liked the idea that I was nearby, but not "there." Some students would hang out and work in the hall with me. From time to time a student would come out and ask me a technical question, but if I moved to enter the studio to help they'd inevitably say, "We got it! Just tell us which button to press and we got it!" If I got lonely or felt useless, I'd go back into the studio and "get my teacher on"—direct things for a bit, or even lecture on a technical or musical topic. That was fine, too, and even provided students with a welcome break from the intensive work of self-organization.

A big part of what we, as teaching artists, offer is de-schooled and de-institutionalized time and space for students. Things are learned differently in such spaces, and such spaces are where original art is made. We treat learners as artists, not as students, inmates, patients, seniors, etc. One way of doing that is to get out of the way.

—Nick

little encouragement, students are usually able to move quickly to thoughtful, very candid criticism. Then Nick talks a bit about the ideas those responses have given him and how he might use them in this work or in other work. For many years Nick resisted making his own work visible to students in this direct way, fearing it would make things seem too much about *him*. But as it turns out, the students are just as capable of making a discussion about *the work* when it's their teacher's work as they are when discussing their own. In fact, Nick's participation and modeling seems to encourage the students to think of themselves as legitimate critics of their own work.

It is also useful to have students read some art history, criticism or other critical writing about art. There are examples of such writing even for younger children. This kind of reading can be useful in developing students' grasp of concepts and vocabulary as well as their ideas about what art "does" and how it functions in different social and cultural contexts. When one can think about and experience art in terms of broader meanings, and when one feels comfortable in constructing new ideas and arguments based on such meanings, it can enrich one's experience as both a consumer and maker of art. Critiques can be about this dimension of artistic experience as well. They can be a fun and generative experience in themselves.

That said, it's important not to overemphasize analytical and conceptual frames in teaching artist work. There is a difference between reading, talking and thinking about art and making art. Unless our main intention is to teach art history or criticism, we should work hard to keep concept and theory closely linked to the practice they support.

Eleven ways one might construct or think about critique:

1. Look at or listen to the work. Let students talk about it.
2. Use a more structured process like "Descriptive Review."[6] This process allows students to defer judgment for a while and focus on the work more objectively. It gets them used to separating the work from the stu-

dent who made it. Once students understand its steps, they can begin to use it more informally, but at first it is helpful to facilitate this process and practice it as a large group.

 a. Ask students what they notice in the work and about the work (specific details, associations, technical features).
 b. Ask students what questions the work raises for them (technical, aesthetic, thematic).
 c. Ask students what they think the artist was going for (think like an artist).
 d. Ask students what meanings or ideas they take from the work (metaphorical, narrative, political, social, aesthetic, technical).

3. Use "Critical Response."[7] This is a reflective protocol you might want to use to focus more on a student's artistic intent and the communication of that intent. The kind of information surfaced by these questions often has little to do with technical accomplishment (unless that is specifically asked for by the artist). One of its strengths is that even if the responding students are unsure how to approach a work of a peer, they have a fairly structured way to begin talking about it that builds meaning incrementally. So not only does this process help the presenting artist or artists, it also can build the confidence of the responding students as they learn to communicate the elements and concepts and strategies at work in a particular discipline.

 a. Ask students what they notice in the work and about the work (specific details, technical features).
 b. Ask students what the work reminds them of (personal experience, associations, other art, books or stories, a person, etc.)
 c. Ask students to consider the emotions that the work contains or expresses or that they feel when experiencing the work.
 d. Ask students what questions the work raises for them (technical, aesthetic, thematic).
 e. Ask students what they think the artist was going for (think like an artist).
 f. Ask students what meanings or ideas they take from the work (metaphorical, narrative, political, social, aesthetic, technical).

4. Use the "Tuning Protocol."[8] This process is best used by a group that has some experience working together; the process can more easily separate the work from the person because it asks responders to a work to evaluate it—not just describe it. When used regularly and well, the feedback from a Tuning can propel work-in-progress forward quite rapidly.

 a. Warm feedback—respondents describe what they see working or what they like in a work.

b. Cool feedback—respondents consider aspects of the work that might be improved or clarified by framing their response in the form of a question: "Why did you . . . ?" or "I wonder . . . ?"

c. Hard feedback—respondents ask deeper questions that get at larger, structural aspects of the work: "What would happen if you changed . . . ?" or "Have you thought about . . . ?"

5. Have students practice critiquing works by other artists, or your own work. Model how even negative critiques can be useful and interesting to an artist.

6. Take your normal sequence or protocol of critique and reverse it.

7. Have students pair off and critique each other's work.

8. Encourage students to critique each other's work informally as a matter of course, but also encourage students to be sensitive to when a critique is useful to an artist and when it may not be. Critiquing work in a useful way is a process that often is learned best through practice and experience.

9. Conduct a "ghost critique." Critique a work that doesn't exist yet. Challenge students to create the work implied by the critique. This can lead to interesting insights about art-making.

a. Such a "ghost critique" begins almost as an improvisational game. Nick might start it off with his students, especially if students haven't done one before, with an entirely random comment: "This song is interesting to me, but it lacks structure and I lose interest around the 2-minute mark. Might need to bring back that horn line that is in the first chorus."

b. Students then follow up with more comments that have to relate in some way to previous ones, although they don't have to echo the aesthetic judgments. For instance: "I disagree. I think right around the two-minute mark is where I'm drawn into the song. I start to realize that there is no clear structure right at that point when the rhythmic pulse disappears and that sort of atonal mandolin sound, with all the reverb on it, comes in. That's where the whole thing starts to work for me as mysterious because it does not have a clear arc—I don't know what's coming next."

10. Conduct critiques that examine only one feature or dimension in a medium. For instance, critique photographs with a narrow focus on how tonal range is employed by the artist; critique music with a narrow focus on the use of timbre and texture; critique poems with a narrow focus on the sonic characteristics of the lines.

11. Conduct silent critiques during which students have time to look at or listen to each other's work without comment. This can help a student

artist to focus on what features or ideas expressed in a peer's work are relevant to his or her own work. You might also give students the option in a silent critique of leaving brief notes next to a student's work.

Ranges in teaching

So now that we've told you that you shouldn't uncritically adopt methodologies or formulas, and that it's important to think in terms of what is discipline-specific, you might reasonably ask, okay, what can you tell me that *is* useful to do?

There are in fact general frames that can be useful when planning teaching artist work. In this book we've chosen to present these as a series of "ranges" of teaching. We want to contrast this idea of ranges with curricula based on a particular methodology or political or social theory. Our teaching should be *informed* by theoretical or methodological ideas, but in making curricula we should take advantage of the flexibility and spontaneity that is so important to teaching artist work—theory should be closely intertwined with, and flow from *practice*. We should think in terms of a range of choices about how to teach, choices we can make based on the medium, technique and content under study, the students and the teaching context, and our own expertise, interests and personality. When we think in terms of "ranges" of teaching instead of "methods" of teaching, we allow ourselves the ability to adjust and experiment in multiple dimensions—the various ranges discussed below.

Working the range 1:
Structured practice vs. free application

Learning how to do just about anything involves some combination of structured or rote practice, and free, dynamic application. In basketball you learn the mechanics of shooting a layup but until you practice it in a dynamic context—a scrimmage or game—you can't really integrate it into your own game in a meaningful way. Conversely, if you haven't learned solid mechanics and fundamentals of a layup, your ability to use it will be very restricted.

Similarly, in painting you might learn and practice the basic principles and techniques of handling watercolors, but it is when you begin to experiment with and apply the principles and techniques to original work that the technical practice and learning becomes meaningful and expressive. Just as in basketball, the quality of the initial learning affects the range of the original work.

As teaching artists we can think about the balance between directive or structured teaching of a skill, technique or concept and free application—art-making. We have a range we can work. At one extreme we might spend all our time with students practicing a single technique. I've seen students spend

Opinionated

Here's what I like: I bring in a recording, maybe some Miles, maybe some MC5, maybe some Tribe Called Quest, maybe some Bartok. I play it for a room full of recess-deprived fifth graders. They listen, more or less. Afterward I ask them, "What do think?" A hand shoots up in the back, and I call on the usual suspect. He or she exclaims with great pleasure, "IT SUCKS!!"

I like this much more than when no one says anything. I even like it more than when everyone nods and indifferently murmurs, "Yeah, it's cool, I guess." Where there's a strong reaction, there's an emotional response, there's a critique and there's something to be learned about music, art and maybe some other things.

We move on to the next question: "WHY does it suck?" Suddenly the critique becomes more nuanced and balanced. Just as suddenly the piece has defenders in the room, and we're discussing the importance of rhythmic pulse and the tension between convention and subversion of convention in music. We examine dynamics and timbre in the piece, we argue about emotional associations and cultural expectations. These students bring to bear a wide range of informal musical experience and very defined notions about "how music should be." Yet, they are also very open to expanding and revising their tastes. Perhaps most striking is the fact that the discussion, although very heated, is completely devoid of personal animosity (of which this group is quite capable)—it is a debate about the music.

When people, especially young people, are having a real dialog about art and taste, there's an electricity in the room that is not so different from that present when they are making art. Like the art-making, the critiquing is exciting, engaging, educated and educative. Like the art itself, the critique is a point of departure for investigation of all sorts of things and for the making of more, perhaps better or deeper, art.

Yet, we're often uncomfortable with criticism, especially in the context of student art-making. Recently a teacher confided that art-making in the classroom caused her great anxiety because she felt unable and unqualified to respond to student work. "How can I say I like one thing more than another? Who am I to say this drawing is better art than that one? I'm not even sure what I think of a work of art I might see in a museum." Of course, once we started talking about actual examples of work, it became clear that this teacher had very specific and thoughtful tastes that were continuously evolving. But she feared that exposing her tastes and opinions might be oppressive and inhibiting to students, or expose her as a "non-expert."

I think we sometimes miss a crucial distinction: if the teachers or teaching artists are making the creative decisions, then, yes, their opinions, no matter how informed, might inhibit student expression. But if we are really allowing

students to frame and solve the creative problems posed in their art-making, then a clearly expressed response to their work is potentially a huge spark to innovation and development, regardless of whether the student agrees with the response or rejects it. The question is not whether we as teaching artists and teachers should express opinions, tastes and responses, but whether the students are really free to decide for themselves what to do with these responses, and whether teaching artists and teachers are inviting dialog that may lead them to change their own views.

This is not to say that the question of teachers' or teaching artists' tastes and opinions isn't sometimes tricky. Some students are very easily inhibited or even hurt and have a hard time separating themselves from their work. These same students are also sometimes the most expressive artists. For critical discussions to lead toward creative risk-taking rather than away from it, it's essential to create an atmosphere in which the discussion is about impact and meaning of the work, not the value of the artist. One of the things that is most exciting to students about art-making is that it often offers the only relief during the school day from the pressures of the ubiquitous focus on assessing them.

We also need to recognize the inevitable and automatic authority that comes with the title of "teaching artist" or "teacher." If we really want students to develop their own original voices, we have to take active steps to limit the impact of our own aesthetics and predilections. There are as many ways to do this as there are teaching artists; I tend to present myself to younger students as a bit of a joke—profoundly unhip and generationally distant. I often tell them, "If less than 50% of the music you are making freaks me out, you aren't trying hard enough." Whatever the approach, it is part of the artistry of the teaching artist to know how to critique and provoke in ways that create rather than limit possibilities for students.

One thing is certain: There are few things a room full of fifth graders likes more than a really good argument—except possibly some really good art-making. Taste is a form of expression.

—Nick

hours at a time happily struggling with rudiments on a snare drum. They are willing to do this because they know it is a precursor to making their music. Sometimes what we have to offer as teaching artists is best expressed by intensive technical teaching; students can make the art later.

At other times we might choose to do no explicit technical teaching, or no obvious teaching at all. In the project mentioned earlier, Nick showed up in a high school class of thirty-five students who, with a couple exceptions, had never played a musical instrument. He simply told them that they had an hour to compose and perform an original piece of music. He gave no fur-

ther directions and did no "teaching." An hour later they'd self-organized into five groups, each of which performed interesting and musically compelling pieces, including a couple he thought were exceptionally good. Nick's teaching in this case was restricted to creating a context. Musical learning arose out of the student-directed art-making, the reverse of a more common sequence in which composition, improvisation and performance often come months or even years after a student embarks on musical study. The point here is not that direct teaching, or teaching *before* art-making, is in any way an inferior approach, but that it is one choice along a continuum of approaches.

As we approach the question of how best to balance direct teaching of technique and theory with free and dynamic application—art-making—we should feel free to engage the full range of possibilities and not limit ourselves to a rigid, general methodology. Our work is about helping people to make their own art, and this gives us a certain freedom to choose along the continuum based on the medium or subject under study, the students' and our own interests, our personal style and preferences, and the teaching context.

Working the range 2:
Creative constraints vs. open-ended art-making

Sometimes we ask students to make art within very narrow creative constraints. Other times we provide no creative direction and ask students to both frame and solve the "creative problem." Either of these choices, and any point on the continuum between them, can be equally educative and generative for students, but only if there is space for students to invent and experiment with the medium. Highly interesting original art-making can happen even within very narrow constraints, as long as students are being asked and allowed to make *their own work* within those constraints. With this range, too, we should feel free to explore all the possibilities and should not be limited by generalizations about method. More on this range, too, later in the chapter.

Often we will be constrained by the needs of a school or other institution to work with students on art that deals with particular academic or thematic content. We may be charged with having students paint a mural "about hope," or write poems about the Civil Rights Movement. Such constraints, even very formulaic and narrow ones, *can* be generative and interesting. The challenge is to find ways in which students can interpret and invent within the constraints. It is also essential that such constraints be transparent to the artists—the students. If we attempt to manipulate or coerce students into producing work that meets a school's expectations of what student work "should be," or that reflects preconceived notions of student identities or values, we are not teaching art, we are teaching obedience. But artists have always had to deal with political and commercial constraints—from patrons, employers and regimes—and have

found space to create profound and original work within these constraints. Students can do this too, but only if teaching artists are open about the nature of the constraints and create and protect space for student invention within them. It is not okay for a teaching artist to tell a student, "This poem is too dark. You should write more inspirational poems." The problem with saying such a thing is not that it is subjective judgment of the work; any critique is subjective. The problem is that it is not a useful judgment of the work. It is unlikely to lead to more interesting student work unless the student simply rebels against the critique and works toward a more effective "darkness."

It *is* okay to say to a student, "Your teacher wants you to explore inspirational themes. Let's find some original and interesting ways to interpret that idea—ways that reflect your way of seeing and writing." That is an honest and transparent acknowledgment of the political context in which the student is being asked to make art. It leaves room for invention, interpretation and perhaps even effective subversion.

The art of the prompt

Constraints in the form of prompts can be really useful in teaching artist work. In a sense, all art-making begins with a "prompt." The key to creating generative prompts is specificity. Specificity is a central characteristic of art. Human experience, narrative and emotion are to a great degree universal. What makes good art interesting and compelling is that it addresses universal experience in surprising, inventive and unique ways that are particular to the vision or thinking of a given artist or group of artists. So it makes sense that the ideas and associations that spur good art-making have a certain degree of specificity and detail. Profound and original ideas in the arts, as in other disciplines, most often result from very specific and intense observation and investigation, rarely from vague and poorly defined notions.

For instance, the idea or definition of a poetic metaphor is simple enough. Everyone employs metaphors all the time, consciously and unconsciously. But what constitutes an effective or interesting metaphor is harder to pin down, and if you've never consciously worked with metaphor in the context of poetry, it can be a daunting task to begin constructing metaphor on an entirely blank slate. A prompt can serve as an invitation and a structure as one begins to translate the general idea and experience of poetic metaphor into original and specific metaphors.

There are also techniques and concepts in various media that are easy for students to apply based solely on their experience as consumers or "experiencers" of art. Just about everyone has musical experience as a listener (or through sensation and visual cues, if you are hearing impaired), and therefore has musical ideas, opinions, and preferences that can be applied to music making even without specialized technical or musical skill. Even young children

Table 2.1 Good Prompts vs. Weak Prompts

Good Prompts (more specific)	Weak Prompts (less specific)
Generate a list of weather terms, the more specific the better. As in, "F-5 tornado" or "low-pressure system" or "gale force winds" or "sun shower" or "aurora borealis." Equate yourself or someone you know to one of these terms. Make a metaphor, not a simile. Write this, paint this, sculpt it, act it, dance it, whatever. **Poetry examples:** My mother is an F-5 tornado that we knew was coming but couldn't escape. . . . My little brother has become a low-pressure system. He moves throughout the house, high winds shaking the windows loose, all his Legos swept into miniature cyclones that circle his ankles. . . .	Describe the weather on your favorite day. What do you see, hear, smell, taste? Describe someone who reminds you of your favorite kind of day. What does he or she look like, sound like, etc.? Write this, paint this, sculpt it, act it, dance it, whatever.
Find a box of carpentry tools or plumbers' tools or electrician's tools. Look at these carefully and handle them and feel them in your hands. Try to identify their names and/or their function. Guess their function if you do not know. Use one or more of these tools to create a metaphoric equivalency between the object and an emotion or abstract noun. Write this relationship, or paint it, sculpt it, act it, dance it, sing or play it on an instrument, whatever. Examples to develop in an art form: Jealousy is a digital oscilloscope recording and storing each voltage that the heart pumps out. . . . Anger is a hammer at work on the roof, pounding one nail at a time. . . .	Think about tools that you know and choose one to describe in your art form. Think about what it reminds you of or consider what feelings come to mind when you think of it or see it. Try to incorporate that memory or emotion into your rendering.
Look around your classroom and find one potentially dangerous object. Make it come alive by describing what it does when it gets disturbed, angry, jealous, a headache, or gets its way.	Look around your classroom and find an object that stands out to you. Make it come alive by giving it a voice or human actions and emotions.
Find a piece of art that you really like (a song, a painting, a poem, a dance, a monologue, a photograph, etc.). You can choose something outside of the medium in which you are currently working.	Find a piece of art that you really like (a song, a painting, a poem, a dance, a monologue, a photograph, etc.). You can choose something outside of the medium in which you are currently working.

Table 2.1 Good Prompts vs. Weak Prompts

Good Prompts (more specific)	Weak Prompts (less specific)
Describe its qualities in specific terms. Describe what it reminds you of. Describe the emotions you feel when considering it or that you feel live inside it. Ask it one question that you know it would never deign to answer. Give it a new title based on your above responses. • Look at your responses and create something that works in the opposite direction to things that you just named. If it is a song in 4/4 time then create one in 7/4 time. If it reminds you of your first kiss then what you create could remind you of your first break up. • Make your piece answer the question.	Describe its qualities in specific terms. Describe what it reminds you of. Describe the emotions you feel when considering it or that you feel live inside it. Write down questions that it raises. Speculate what you think the artist intended by this piece or what meaning that you think it conveys. • Look at your responses and find a line or sentence or idea that interests you and pursue it further—developing a new piece in your medium that follows that thread.
Write a story in which the main character goes on a journey somewhere that you have never been and that you either really want to or that you would be too afraid to go.	Write a story about a trip you have taken with someone in your family. It could be to somewhere far that you have visited or just to the mall.
Isolate three movements from a phrase in a dance with which you are familiar. Use them however you like (but include all three) to create a 12-beat phrase that conveys a specific emotion. Vary their speed, energy, and the space in which you move in order to create that meaning.	Come up with three separate movements and use them in a 12-beat phrase. Vary their speed, energy, and the space in which you move.

have ideas about music and songs that they can immediately begin to translate into musical expression using just their voice or hands—clapping, beating on a table, etc. No prompt is required for students to begin making music. What is perhaps less intuitive and sometimes daunting is the prospect of assembling fragmentary musical ideas—a beat, a vocal phrase, a melodic fragment—into a longer, coherent work. A prompt can also provide a useful narrowing of options that helps students bridge the gap between fragmentary work and more complete work.

As important as specificity is to a good prompt, it is also essential to make sure that prompts are not too prescriptive or didactic. The point of a prompt is *not* to suggest to a student-artist what their work should look like, sound like, or mean. It is to open up possibilities for the student to determine the work.

The table above compares prompts that we feel are more generative and lead to better student work with some that are less inventive or effective. Clearly, one difference is that the more generative prompts are more specific and therefore

lead students to think in particular ways, thus helping them develop an original vision or aesthetic. You may see other differences that distinguish the two types of prompts. We'd be very interested to hear what they are.

Working the range 3: Fragmentary vs. finished work

Successful teaching artist work can be evidenced by something as small as a single original poetic metaphor spoken by a student or something as big and complex as an entire student-composed, student-staged, and student-performed multi-act opera. How far a student takes a piece of work can depend on many things. Often the main constraint is time. But some students work quickly and some works come together quickly.

It's worth considering the idea of a range of approaches in which we stress the importance of more or less complete work. This is particularly useful to think about in a situation where there is very little time for students to work. In a 50-minute class with third graders it may be more artistically and educationally useful for a student to invent a single, evocative and original metaphor than to "complete" a formulaic or unoriginal poem. A student need not spend an entire fifty minutes on a single metaphor (although that might be interesting, too), but it may be worth spending fifty minutes experimenting with metaphors with the aim of nailing one really good one. Even if a poet teaching artist never returned to a given classroom, to have helped a student develop a single strong metaphor might better serve the student's future efforts at writing and reading poetry than a more superficial exercise that led to a complete poem.

The point is not always to have students create finished, polished work, but to provide the tools and the time for students to develop their work, however preliminary or fragmentary, in interesting and original directions.

An example of how a range might play out

It can be very useful while planning and while teaching to think about what might happen if one were to shift in either direction along the continuum. The following list of scenarios illustrates how one might do this. In this example, we're going to pick Range 2, Creative Constraints vs. Open-ended Art-Making, because it can be the hardest one to conceptualize. One could easily think through the other ranges in the same way. We will use a music/audio production as the medium.

This list of scenarios represents movement from the most constrained, predefined end of the spectrum (creative problem framed *for* students) toward the most open end (creative problem framed *by* the students). Any of these

possibilities can be generative of good art-making and learning, but particular types of art-making and learning will differ along the continuum, if not always in obvious ways (sometimes the most original inventions come about in the most constrained circumstances).

Moving from a creative problem framed FOR students . . . all the way to a creative problem framed BY students:

⇒ **(Highly predetermined)**
⇒ Ask students to record an album of music or songs composed by someone else. Specify the genre/style, and all major aesthetic choices.
⇒ Ask students to record music written by someone else. Specify the genre/style, and major aesthetic choices, but encourage students to determine how that music will be collected and disseminated (Album? Website? Performance?)
⇒ Ask students to record music written by someone else but encourage students to interpret with their own stylistic, arrangement and production choices.
⇒ Ask students to compose and record music that relates to a specific theme, genre or style.
⇒ Ask students to compose and record music.
⇒ Ask students what they want to do in the studio for a group project.
⇒ Ask students what they want to do in the studio without specifying group or individual projects.
⇒ **(Very open-ended)**

Inventing, planning and revising teaching artist curriculum

This section[9] provides one possible model in which a teaching artist might come up with an idea for a lesson, project or even a program, and make it real. It's presented here not as a formula we think you should adopt, but as a framework you might find interesting and, we hope, thought provoking. Perhaps there will be parts that you will want to adapt to your own practice. Or perhaps you will find this particular model antithetical to the ways you work; in that case it may serve as a useful foil.

The premise underlying this model is that teaching artist work can be very much like art-making: improvisational, inventive and interesting. The challenge is to translate one's artful teaching ideas into a plan that is workable and intelligible (to you, to students, to teachers and administrators) *without diminishing the artful idea at the core*. The model has two parts: The

first includes two exercises designed to help teaching artists invent curriculum ideas; the second is a curriculum planning and writing model. Both the exercises and the curriculum planning model can work well for individual teaching artists or as part of formal or informal group workshops. No previous teaching experience is necessary for these exercises to be useful. In fact, in our experience facilitating such workshops, it is often the least experienced teaching artists who come up with the most interesting ideas for curricula.

EXERCISE 1: Extreme curriculum invention

In this exercise an individual teaching artist or a group of teaching artists develop curriculum ideas based on very specific teaching goals, but highly unusual contexts. The teaching goals relate to a specific technique or concept in the teaching artist's discipline and incorporate an additional interest of the teaching artist's, outside his or her medium. The unusual teaching context (defined by the teaching artist or facilitators) constrains the teaching artist to think about teaching outside of familiar structures and expectations and therefore allows him or her to focus on *what* and *how* to teach. The goal is, within tight creative constraints, to elaborate concrete teaching strategies that can generate novel, exciting and effective curriculum ideas.

The exercise is described for a group of teaching artists, but it can also be easily done alone. If you are working as a group, you can pair off, or have groups of three. Interdisciplinary groups are good, too.

1. Every teaching artist should write down on separate index cards:
 a. One skill or concept in her/his medium that she/he would like to teach. The more specific the skill or concept the better.
 b. One area or question of interest outside her/his discipline. This can be a hobby (furniture restoration), an area of academic or technical inquiry (quantum mechanics), or a work of art (novel, film, painting).
 c. An invented, outlandish teaching context
 i. A place (lifeboat)
 ii. A group of students (four shipwrecked exotic dancers)
 iii. A time frame (thirty days of continuous instructional time)
2. Shuffle the "invented teaching context" cards and have everyone pick one at random.
3. Each group of two or three, or each teaching artist working alone, invents and "sketches" (loosely plans) curriculum using at least one of each of the following (but can choose to combine more than one of each):
 a. Skill or concept in a medium
 b. Area of interest or question outside the medium

 c. Outlandish context

4. After groups or individual teaching artists have had time to explore, invent and sketch curricula, these can be shared, discussed and critiqued both in terms of how they address the outlandish teaching concepts and how they might be translated to real contexts (schools, prisons, etc.).

The following example is taken from an actual workshop in which this exercise was employed. Teaching artist-participants in the workshop created the solutions and rationales. It's worth noting that some of the most innovative and viable solutions came from teaching artists with little teaching experience. This example describes one of many such exercises completed by teaching artists in the workshop, all of which generated a rich collection of ideas and insights for curriculum.

- *Example problem:* Two visual artists are asked to develop a lesson that attempts to teach a range of paint control (from highly controlled to uncontrolled), and the concept of relative size and perception of depth, to a tourist on a train, in two minutes. The artists chose the technique (paint control) and the additional area of interest (size and depth perception as a factor in visual narrative). Other workshop participants assigned the "unconventional" context.

- *Example solution:* The tourist is first asked to mark on a map places he or she would like to go—to plan an itinerary. The tourist is then asked to look outside the train and pick out an object or person. The tourist is asked immediately to construct a narrative about the object or person.

- *Example rationale:* In two minutes the tourist is led through a sequence that moves from a controlled planning (analogous to controlled paint application) to a spontaneous creative response. Simultaneously, there is also a shift in scale from thinking in terms of a map to a distant but actual object or person. The mental and perceptual shifts are meant to simulate analogous shifts the tourist/student can apply in painting.

- *Example of curricular implications, discussed during group critique, that the painting teaching artists and other teaching artists suggested they wished to implement in their teaching:*
 - Related ideas for teaching in the medium
 - Teaching painting techniques, or ranges of technique, by combining work in the medium with exercises in visual and mental observation and analogy
 - Linking specific painting techniques with affective content or narrative function

- Using micro-lessons to stimulate a student's use of a technique in different ways
 - Related ideas for teaching in general
 - Investigation of the idea of learning skills and ideas in very short periods of time—learning moments
 - Investigation of such rapid or sudden learning as the product of longer-term preparation (on the part of teacher and or students), and also as a starting point for additional discovery

EXERCISE 2: Art-making as a curriculum lab

The idea in this type of workshop is to analyze one's own arts practice from the point of view of learning and teaching. The goal is to make concrete connections between one's own expertise and interests as an artist and a person, and ideas about what and how to teach in one's medium and across disciplines. The exercise is described for a group, but one can also do this alone.

- Teaching artists, in mixed or discipline-specific groups, bring in either finished work or work-in-progress from their arts practice, or create new work on the spot. They do this individually or in groups, possibly using creative constraints in order to narrow the technical and conceptual scope of the art-making.
- The teaching artists as a group then observe and analyze the work in depth in order to answer the following questions:
 - What specific skills and concepts of the medium are in evidence in the work and/or in the process that created the work?
 - What additional areas of knowledge and inquiry are present in readings of the work, or in the process that the artist engaged in making it?
 - What curricular ideas can be derived from this analysis?

The following example is from an actual workshop. All the participants were musicians. Many had never taught before, or had not taught in a teaching artist context. Although the example deals primarily with music, this exercise can work in any medium and also for interdisciplinary groups.

- Six working musicians with various levels of teaching experience met for two hours with the goal of developing some new and interesting ideas for their teaching practice. The artists briefly discussed their musical practice as well as areas of interest and experience outside of music.
- Together, the artists then chose one musical skill or concept that they felt

it was important to teach and that they also felt in some degree capable of teaching. The group chose the concept and technique of "pulse" as the fundamental rhythmic feature of a piece of music.

- Together, the artists chose one area of interest outside of music as the subject of thematic investigation in a piece of music. The group chose "Death as narrative," based on one participant's interest in the narratives he observes everyday on the trains, and on a recent event where a man jumped to his death from the train.

- As an additional creative constraint the group chose a single instrument on which all seven of the group (including the facilitator) would compose, improvise and perform. The group chose a large plastic table with a piece of roll-paper on it.

- The group improvised a 6–7-minute collaborative piece of music that attempted to explore the idea of "Death as Narrative" and to make particular use of pulse as a musical dimension.

- The group then discussed the piece with the aims of identifying both musical and thematic threads, identifying questions generated by the piece, and speculating on possible readings of the piece. This led to a more general discussion about the curricular implications of the musical and extra-musical dimensions of the piece. The discussion focused on the following questions:

 • What musical elements of this piece, and the process of its performance, could be taught? How would one teach them? The curricular discussion surfaced teaching ideas about:

 – Polyrhythmic listening
 – Implied pulse versus explicit pulse
 – Working against a pulse
 – Moving in and out of rhythmic phase
 – Use of timbre, dynamics, pitch and note envelope to convey affect
 – Ensemble improvisation
 – Narrative arc in improvised music
 – Abstract and literal intent in music

 • What were the extra-musical curricular implications of this piece and this performance?

 – One of the musicians used the sound of writing with a pen on a piece of paper as a rhythmic and thematic element. This inspired a wide-ranging discussion on the aural/sonic dimension of literary production and its history, from clay tablets to writing on velum to mechanical typewriters, computer keyboards and near-silent touch screens. The discussion suggested several ideas for an interdisci-

plinary investigation that could generate highly original curriculum in music, history and literature.

- The discussion investigated the idea of a specific musical and literary metaphor for life and death. One musician discussed how difficult and nonintuitive rhythms become very intuitive with practice. Another recounted the train-suicide story as a narrative about one man's failed attempt to "learn difficult rhythms in life." This stimulated a number of ideas for fiction, non-fiction and poetry curriculum that might elaborate musical and literary analogies in generative ways.
- There was a fairly rich discussion of the function of electrical pulses in human and animal biology, including heart function regulation and brain function. Several good questions were raised about whether and how one might investigate these metaphorical and physical analogies in ways that could lead to interesting and useful learning in music and biology.

An example structure for curriculum/project planning and writing

Break it down but don't dumb it down

Ideally, the invention and sketching of exciting concrete curriculum ideas should be followed by the translation of these ideas into clear and viable curriculum plans appropriate for a specific teaching context. When planning and writing curricula you should check that you are not deleting or diluting the concepts you identified as important and interesting to you in the inventing and sketching exercises. You do not need to dumb down your idea to fit an educational context. Often, even very complex ideas can be translated for real students in real situations. This can be achieved without losing what is essential, if you take the time to break the ideas down into manageable components. A complex skill or idea can usually be divided into a number of simpler ones.

Speak your own language

Curriculum planning and writing should not be a mechanical or tedious task; it should be artful and interesting. Part of the goal is to translate your idea into a viable plan that you (and perhaps others) can use as a basis for exciting and effective teaching. When you are writing teaching artist curricula, you are also explaining and advocating for the work that is important to you, in language that will be intelligible and compelling to students, teachers, administrators and funders. This language should reflect *your way of thinking and*

working. You do *not* need to adopt edu-speak jargon in order to be understood by teachers and administrators. You simply need to explain what you are doing as a teaching artist and why you are doing it. If your teaching is a kind of art-making, you might think of your written curricula as a combination of an artist statement and a detailed blueprint of the work. Your curricula should be interesting to you and to others. If you communicate simply and clearly what, how and why you teach, your curricula will inform and inspire other teaching artists.

Often, you will have to translate your curricula and lesson plans according to the specific formats, templates, methodologies and vocabularies of arts education organizations, schools and other institutions. You will sometimes have to reference education standards, general rubrics and other criteria. If you begin by planning and writing in your own language and according to your own expertise, it will be a simple thing to translate or adapt your curricula to fit any such requirements without sacrificing what is important to you in your teaching and in your discipline. You should not feel constrained to invent and plan your work in the first place based on criteria and structures that do not relate to your discipline or how you work as an artist. You should plan in your own way and translate and cross-reference after you have clearly articulated your aims and methods for yourself.

This translation process is also a chance to educate organizations, institutions and funders about your way of working as a teaching artist in your medium. Teaching artists needn't be reactive when confronted with the aims and goals of funders and administrators. We should seek real connections to our own educational aims, and where these connections do not exist we should take the initiative to advocate for the expansion and redefinition of program aims and goals.

Where criteria, models and standards do not make sense, you should feel empowered to question them, or to explain to administrators and colleagues why they do not correspond in a real way to what you do. To do so is not to be precious or an idiosyncratic "artist." It is part of our role as teaching artists to develop ways of talking, writing and thinking about specific practice that relate it to our own practice as artists. What makes us useful is that we teach as artists, and when we find opportunities to explain this concretely, we should feel free to do so. Often it is just this sort of discussion that leads to meaningful exchanges about the work among teaching artists and between teaching artists and administrators.

Three reasons to plan in detail

1. Careful, detailed, concrete and rigorous planning prepare the ground for flexibility, spontaneity and revision in the classroom. Such planning is by no means an obstacle to free artistic experimentation by students;

it is what creates the context in which experimentation can take place.

2. If you first plan in detail in your own "language," any mapping to standards or other educational requirements you have to do subsequently will probably be a process of discovering and articulating real connections to such requirements in the work, not one of designing the work around abstract goals that are foreign to the way you think and work.

3. Careful, detailed, concrete and rigorous planning will make it more possible for you to engage in meaningful and deep collaboration with other teaching artists, as well as teachers and administrators.

Put it into words

Teaching artists are faced with a wide variety of models for course, grant and program proposals, and there are a number of generalized models that one might present to them. We like the idea of a simple approach that focuses on the following four questions:

- What will you teach?
- How will you teach it?
- How will you know it worked?
- How will your teaching lead students to be better artists?

This general approach to curriculum writing can be easily adapted for different contexts, audiences and requirements. This model is only a starting point; it can be used to organize your thinking and planning or adapted to your own needs and style. A course/project proposal is a sort of work of art as well as a tool. It documents a course or project plan in ways that can inform and enrich the work of other teaching artists and arts educators, and it should read as something interesting, exciting and thought provoking for both reader and author.

Some other questions to think about when you plan

Curriculum planning and writing is as creative an act as curriculum inventing and sketching, but the focus is different. Here are some additional questions you might consider as you plan your work:

- What will students make?
- What will they learn?
- What do *you* want to learn?
- How structured/open-ended will the project/lesson/session be?
- How directed/free will student work be at various stages of the project?

- How much time do you want students to dedicate to practicing a technique and how much to applying the technique in making original work?
- How much time do you want to spend on general conceptual knowledge and how much on specific technical knowledge?
- Are you trying to teach too much, at the expense of depth and rigor?
- Are you teaching too specifically or too narrowly to allow students scope in the art-making to develop original work that excites them?
- How will you collaborate with teacher(s) or staff?
- Is there enough time and space for students to do *their* work?
- How will you stay out of the way?
- How will you know what happened?
- Will this be fun and interesting for *you*? What will you do if it isn't?

A Framework for Teaching Artist Curriculum and Project Proposals

1. Course/Project Description (approximately one paragraph or 200 words maximum)
 a. Explain what you will teach.
 b. Explain how you will teach it.
 c. Explain what sort of work the students will make, or explain that that will be determined by the students.
 d. Explain why it is important for your medium and, where applicable, other content areas.
 e. Explain why it will be interesting to students.
2. Rationale (approximately 2–3 paragraphs, 400 words maximum)
 a. Explain in greater depth why you are choosing to teach these particular skills and concepts in this way.
 b. Explain in greater depth the importance of teaching these particular skills in your medium.
 c. If applicable, explain why integration of other content areas outside the arts discipline will yield better art-making and better learning in the content area (justify integration).
3. Description of Teaching Context (one paragraph 200–300 words, or bullet points)
 a. Briefly explain who the students are, what their previous experience is, and any unique or specific characteristics or interests of the group that might inform the work.
 b. Briefly describe any collaboration (with teachers, other teaching artists, parents, etc.) that will be a part of the course/project.
 Briefly describe the organizational or institutional context (who is fund-

ing this, who is overseeing it, etc.).

4. Supplies, Equipment, Space (list, as long as needed)
 a. Describe what you will need and where it will come from.
 b. Describe the space you will use and any changes or adaptations you will make to it.
5. Budget (if applicable, one paragraph 100–200 words maximum, or bullet points)
 a. If applicable, describe the overall budget requirements and give a general sense of the major expenditures. A detailed budget that includes materials cost and pay for teaching artist teaching and planning time is best approached as a separate document.
6. General Sequence (no more than five bullet points each chapter)
 a. Briefly outline the entire project in terms of the major events, including planning, exhibition of work, and assessment and evaluation. Give time durations as specifically as possible.
 b. Describe the main learning goals (particularly skills or concepts in the medium) at each stage, and give a general example of the level you expect students to be working at for that stage.
 c. Describe any preparatory work that teachers and/or students will do outside of the course or project itself.
7. Course/Project Plan (Depending on the project and medium, each session can be as short as a one sentence description, or as long as a multipage outline.)
 a. Describe each session in as much detail as possible. Remember that you are by no means obligated to carry out this plan as it is written. In fact, it is likely you will constantly be revising according to conditions and to initiatives that you and the students take spontaneously based on your interests and the work.
 b. The questions below do not have to be addressed at great length, just with great specificity. Often one or two sentences or bullet points are enough for each question.
 c. Exhibitions and performances should be included as sessions.
 d. It is perfectly permissible to have sessions that are not structured, or that anticipate that the students will plan and define structure.
 i. What will you teach in this session?
 1. This is a concrete question and should have concrete answers.
 2. This is a good place to make sure you are not attempting too much.
 ii. What will the students do?
 1. You should have a plan that allows you to account for nearly every minute you are in the classroom (again, this will likely

change a lot—but having the plan will make it much easier to improvise).

 iii. What will you, other teaching artists and/or teachers do?

 1. You might be doing a lot of direct teaching, you might be helping students here and there, or you might be trying to stay out of the way while they work.

 iv. How will you know if you've succeeded in teaching what you wanted to teach?

 1. If you can answer this question clearly for each session, assessing/evaluating the entire project will be easy. Session-by-session assessment should generally be as transparent as possible and as unobtrusive as possible for the students, so that it does not distract from their focus on making their art. Furthermore, it should take little of your time and focus, so that you can relate primarily to the students *as artists*.

 v. How will you modify your plan for subsequent sessions based on this one?

 1. What questions do you have about this session that you will have answers for after it's over?

 2. What space have you allowed to adapt the rest of the project?

8. Assessment/Evaluation Plan (2–3 paragraphs, 500 words maximum, or bullet points)

 a. How will you know what students learned?

 i. You can use a wide variety of assessment means, but they should derive from the specific answers to the question "What will you teach?" If you cannot describe a learning goal and describe how you will teach it, you cannot assess it.

 ii. Careful planning of your own observational assessment in each session

 iii. Assessment can include:

 1. Your casual observation

 2. Informal student comments and discussion with students

 3. Student written feedback

 4. Skills tests

 5. Conceptual and concept-related tests and essays

 6. Formal student interviews

 7. Aesthetic, thematic and technical analysis of student work

 iv. In general, assessment plans should be brief, concrete, and quantitative only where you are focusing on quantifiable skills. Wherever possible, assessment should be seen as an activity separate from the actual art teaching, art learning and art-making, where the emphasis should be on the quality of the work, not the performance of the student per se.

b. How will you and your collaborators learn? (one paragraph, 300 words maximum, or bullet points)

 i. Depending on your style and way of working, you may wish to incorporate formal plans for critiquing your own teaching at various points, or you may wish to outline a more general approach to revising your ideas and course plans in the wake of this particular course or project.

Twenty-three ways to get or make a teaching artist gig

We cannot overstate the importance of doing careful research before approaching organizations and program staff about a gig. Before you call or email *anyone*, do your homework. Know what an organization does, what its emphasis is, how it works, and why it works in the field. Such research will help you to connect with the right people, will make it clear that you are serious, and will also help you avoid pursuing gigs that are not right for you. Showing a potential employer that you have taken the time to inform yourself about an organization's work is particularly important if you do not have much or any teaching experience.

1. Research several arts education organizations that hire teaching artists in your town.
 a. Before you contact them, make sure you know what they do and how they do it.
 b. When you have a clear idea of this, contact the Education Director. Tell her you want to get a better sense of how they work, and also give them a sense of how you work.
 c. Meet with their program people or teaching artists to chat. Always bring a resume—such meetings often double as informal job interviews.
 d. See if any of the organizations feel like places you'd like to work. You might want to meet with them without any specific teaching ideas in mind, or you might want to show up with an idea for a project or program that you'd like to create.
 e. If you are a student, it may be appropriate to intern or volunteer as an assistant teaching artist for a period of time. Don't let yourself be exploited, but don't be afraid to get your foot in the door and learn more about the work by volunteering where appropriate.
2. Research and then contact some arts organizations in your medium in your town. See if they have education programs that hire teaching artists. Meet with their education people and see what happens.
3. Research and then contact some arts organizations in your medium that *don't* have education programs. Propose such a program. Even a very

small, one-person pilot might be of interest, if it relates to how they do their work, or can perhaps help them develop audiences for their work and thus become more a part of the local community.

4. Research and then contact local arts museums, or even science and technology museums that may have arts related collections. Find out if they have educational programs that hire teaching artists. If they don't, consider proposing such a program.

5. Research and then contact your local school board. Find out if they have programs that hire teaching artists directly or through arts organizations. If they don't have such programs, consider proposing one. Check with your local teachers union to make sure teaching artists are not being used as low cost replacements for full-time arts specialists—you don't want to be undercutting existing arts programming or decent wages for teachers.

6. Research and then contact a school directly through a teacher or staff person you know, or by cold calling. Find out if they have any interest in a teaching artist residency or collaboration. Ask if they have worked with teaching artists before. Propose something. Consider writing a grant yourself to support your work. Again, before proceeding check with the local teachers union to confirm that teaching artists are not being used as low cost replacements. If you are going to work in a school that already has someone working in arts programming in your discipline, contact him or her to find out what work is already being done and whether your work will overlap with or undercut it. A conversation like that may lead to interesting and fruitful collaboration.

7. Research and then contact a community center and propose something. Write your own grant, or propose that the community center collaborate with you on writing a grant.

8. Research and then contact your local public library or library system. Most public libraries offer art workshops to teens, and increasing numbers are offering adult arts programming as well. Librarians share information about successful programs with other librarians, and teaching artists can sometimes get steady gigs in multiple libraries. Most libraries have some funding available for one-off classes, or brief series of classes, but they may welcome grant collaboration. In addition, many libraries welcome art displays.

9. Research and then contact a local after-school arts program.

10. Research and then contact a church with youth or adult education programming. Propose something.

11. Take your gear out to a park or street corner. Research the legalities and any safety issues. Try to obtain necessary permits first, or just keep a super-low

profile. Attract passersby, and get them working in your medium.

12. Research and then contact your local park district. Find out if they have summer or after-school programs for youth, or continuing education programs for adults. Propose a course in your medium.

13. Research and then contact local colleges, universities and community colleges that have continuing education programs or just arts programs. See if they will hire you for existing programs, or propose something new.

14. Research and then contact senior centers, adult daycare centers and creative aging programs. Find out if they hire teaching artists. Propose something.

15. Research and then contact local hospitals. Find out if they have in-hospital arts programming for child and adult patients. Propose something.

16. Consider working in prisons or youth correctional facilities. Our colleague, teaching artist Tish Jones, has some suggestions for how to go about this:

 Most prisons or correctional facilities hold a workshop or orientation facilitated by an organization or volunteer. This is followed by a request for a proposal, and there are applications involved to ensure that you are not connected to or related to an inmate. The first step is contacting their program coordinator to submit a proposal for a workshop, which is a very rigorous and sometimes difficult process. Connecting with the city or state is another approach. Many states have what is often called a Juvenile Detention Alternatives Initiative (JDAI) program. Through this program teaching artists can propose a post (or pre) workshop or session for young people who are at risk of reoffending. Having a parole officer (PO) as an advocate also helps; a PO can often recommend programming. You can also simply partner with other organizations, or apply for a grant and design a prison-based program.

17. Research and then contact mental health advocacy groups. Find out about arts programming for the mentally ill, or find out about contexts for which you might be able to propose such programming.

18. Research and then contact disability advocacy groups. Find out about arts programming for the disabled, or find out about contexts for which you might be able to propose such programming.

19. Research and then contact urban or rural social service organizations. Find out about existing arts programming associated with such organizations, or find out about contexts for which you might be able to propose such programming.

20. Contact cultural organizations that serve immigrant, ethnic or neighborhood communities. Find out about existing arts programming asso-

ciated with such organizations, or find out about contexts for which you might be able to propose such programming.

21. Contact local industry, especially industries that have factories that employ large numbers of people in one place. Propose after-work or lunch hour arts programming (yes, it's been done successfully!).

22. Contact local unions. Find out if they have educational programming for adults or young people. Propose something.

23. Some way we haven't thought of here but that *you* will think of.

Ten answers to the question "what should I get paid?"

1. A lot. You're worth it. Art is worth it.

2. Whatever you can get. You're worth it.

3. Do your research. Check with hiring organizations. Ask some local teaching artists.

 a. Try not to settle for less than local teaching artists are getting, and try to get more—that will help them, too. In larger cities the low end of decent is really $40/hour, and $75/hour is more like it. One hundred dollars per hour shouldn't make you feel the least bit greedy. You are probably freelancing, not receiving benefits, and not working anywhere near full time. You're also good at what you do, and what you do is important.

 b. The rates in the previous paragraph are those paid by the most well funded organizations, in large cities, to the most experienced teaching artists with the best resumes. In many places teaching artists are getting as little as $12-15/hour. While this is perhaps shameful, it's also something you can't change by yourself or today. Getting some paid experience and even a low hourly rate may make sense, especially if you don't have too many options or are very new to the work.

4. Always remember that the word "service" does not magically make it okay to pay teaching artists next to nothing.

5. You should get paid for your teaching and also for your prep and documentation time. Many organizations do not pay for the latter, however, so you may have to accept that you won't be paid for some of your work.

6. If you're developing new curriculum, you should try to get paid for that, too.

7. If you are doing the same work as other teaching artists who work for the same organization, you should ideally be paid the same wages they are, regardless of experience. Same work—same pay.

 a. This is, of course, often not the model embraced by employers in this

or any other field. So you may have to accept a pay scale or lower pay based on your lack of experience.

 b. You can negotiate using the argument that strong teaching artist practice is based as much on experience and knowledge in your arts discipline as it is on experience in teaching.

8. You'll have to pick your battles, but pick them!

9. It's okay to work for free as long as you aren't undercutting someone else. Work for free only in a program you developed or proposed, or one in which everyone works for free.

10. Seek union wages with decent benefits. (Some day soon, we hope.)

Six ways to shake up your teaching artist work

As teaching artists we often think of ourselves as people who bring new approaches and experiences to students, teachers, schools, community centers and prisons. Many of us like the idea of pushing pedagogy and student experience beyond convention and what seems "comfortable." We have a sense that out of such novelty, risk, and uncertainty come deeper learning and greater invention. It stands to reason that at least some of the time we should push ourselves in the same way. In that spirit, we offer a list of ideas about how we might "flip the script" of our own practice:

1. **Scare yourself.** If you're the sort of teaching artist who is known for being highly organized and always successful, design a project that you are only 1% sure will be successful and 99% sure will crash and burn. The project should be so exciting, however, that if it *is* successful, it will be *really, really cool*. Chances are your students will radically alter the odds; but even if they don't, the project is likely to result in a spectacular and highly educative "failure."

2. **Play it really safe.** If you are the sort of teaching artist who is always doing the kind of thing described in the previous paragraph, do the opposite: Create a highly structured, clearly defined, very predictable project, the outcome of which seems 99% certain. Undoubtedly your students will introduce many great surprises.

3. **Stir up trouble.** If you are the type of teaching artist who is very careful about the themes, images and language your students use in their work, or in their interactions, or if you are particularly sensitive to school culture and administrator expectations, lighten up. Push your students to subvert some of those expectations and to feel free to examine and portray the full range of human emotion and experience. You may find your students' work more nuanced and sensitive than you expected. You may also find teachers, administrators, funders and parents more

tolerant and sophisticated in their expectations than you anticipated.

4. **Be warm and fuzzy.** If you are the teaching artist who is always fighting the strictures of institutional and self-censorship, who is always on guard against "inauthentic," excessively predictable student work, lighten up. Ask some funders, parents, teachers or administrators what *they* would like to see come out of a project. Then present these expectations as an aesthetic, intellectual or technical challenge to the students. You may discover that in adapting to and interpreting openly expressed limits and expectations, your students find highly innovative solutions. Some of the greatest art ever made was "work for hire."

5. **Ditch the mirror.** Are you heavily into process, reflection, documentation, analysis and action research? Get your head out of your, umm, navel. Drop *all* of that, for a day, a month, or a year and focus on the *art as art*; if applicable, focus on the academic content as the *raw material of art*. This is what most of us do in our own work—why shouldn't our students? You may find that when it's all about the work, and not about evaluating the student or the teaching artist, students engage differently, and you work differently.

6. **Look a little more closely.** Do you cringe at the thought of evaluating the learning that takes place in your classroom or studio? Do you become slightly nauseated at the prospect of writing reflectively about your pedagogy? Does the sight of the word "rubric" feel like an affront to your mystical destiny as a teaching artist? Get over it. If you work with an arts ed organization that encourages reflective practice, try embracing it. If you don't, do a little reading and research and apply it to your work. Examine what's really happening when you teach. Consider that you might actually be able to learn something from what *you* do, and improve how you teach and even how you make art. And if *you* can learn something from what you do, so can the rest of us.

ENDNOTES

1. Hacker, Andrew, "Where Will We Find the Jobs?" *New York Review of Books*, February 24, 2011, 39-41. Head, Simon, "They're Micromanaging Your Every Move," *New York Review of Books*, August 16, 2007, 42-44.
2. Guthrie, R. Dale, *The Nature of Paleolithic Art* (Chicago: University of Chicago Press, 2006).
3. Groopman, Jerome, "Healthcare: Who Knows Best?" *New York Review of Books*, February 11, 2010, http://www.nybooks.com.
4. Ibid.
5. Feynman, Richard, *The Pleasure of Finding Things Out* (Cambridge: Perseus Publishing, 1999), 187.
6. A protocol called *Descriptive Review* originated with the Prospect Archives and

Center for Education and Research in North Bennington, Vermont under the leadership of Patricia F. Carini. It was developed primarily as a tool to help teachers gain greater insight into a particular student's learning by using either of two processes—Descriptive Review of a Child or Descriptive Review of Work. *Descriptive Review* as it has been used and developed by Becca and Barbara in their work in Minnesota and beyond grows out of similar work developed by Steve Seidel of Harvard's Project Zero. Seidel's Collaborative Assessment Conference, in which a teacher presents student work to a group, is distinguished from other protocols that look at student work in that presenting teachers say nothing to explain the work or its context until after the participants go through all the steps in the review process.

7. The *Critical Response Protocol* grows out of work done by artists. It is most closely related in name to the Critical Response Process, a process developed in the early 1990s by teaching artist Liz Lerman, of the Washington, D.C.-based Dance Exchange. Lerman developed the Critical Response Process as a way to dialogue about artistic works-in-progress. She designed it as a structured conversation to help artists move their work to its next stage of development. Many artists and educators have embraced Lerman's Critical Response Process and adapted it for their own discipline.

 The *Critical Response Protocol* as it has been developed and used by Becca and Barbara and their colleagues in Minnesota and beyond builds on the work of Minnesota teacher and poet George Roberts—who in turn learned the process from visual artist Judith Rood. The protocol has been further developed and disseminated by teaching artist Melissa Borgmann-Kiemde in her work with the Juno Collective. According to Roberts, the first four questions of *Critical Response* are designed to be entirely nonjudgmental, which allows respondents to feel some confidence in their own responses almost immediately. They offer the artist important information about what responses/memories/associations/feelings the work produces in the viewer. In addition, the kind of information surfaced by these questions often has little to do with technical accomplishment (unless that is specifically asked for by the artist) but focuses much more on artistic intent and the communication of that intent. Roberts believes this point is incredibly important when working with students whose sense of their own technical skills might cloud the deeper and more important questions of how the work is changing them—as makers and as audience.

8. The *Tuning Protocol* has its origins in the Critical Response Process, a process developed in the early 1990s by teaching artist Liz Lerman, of the Washington, D.C.-based Dance Exchange. Lerman developed her Critical Response Process as a way to dialogue about artistic works-in-progress. She designed it as a structured conversation to help artists move their work to its next stage of development. Many artists and educators have embraced Lerman's Critical Response Process and adapted it for their own discipline. David Allen and Joe McDonald at the Coalition of Essential Schools developed a version that they use primarily in looking closely at exhibitions of learning. Becca and Barbara in their work have adapted the *Tuning Protocol* for use in reflecting on both teacher and student work-in-progress.

9. Portions of this section are adapted from material originally published in *The Teaching Artist Journal* (Routledge/Taylor and Francis) issue 10(1). The examples are taken from workshops Nick facilitated in collaboration with Kate Adams at Marwen Institute; workshops with Nicole Losurdo, Maia Morgan and Cynthia Weiss for the CCAP-organized Teaching Artist Development Studio; and workshops Nick led under the auspices of Columbia College Chicago's Department of Graduate Student Support and Chicago Arts Partnerships in Education.

3

Is My Teaching Working?

ASSESSMENT ON YOUR TERMS

"Is this working?" This is a fundamental question of all art-making and also all teaching. Art-making is a continuous process of evaluation, testing, adjustment and revision. An improvising musician chooses the next note based on what she or he is hearing in the moment, and the choice is a response to what *is* and also what is intended. An architect's evaluation and assessment has to take place mostly before construction even begins—there may be a thousand problems to solve where engineering and aesthetics overlap.

Similarly, any teacher is constantly engaged in assessment of students, material, and self. The evaluation takes place on many different levels—everything from reading a student's body language in the moment to giving thoughtful and rigorous tests to analyzing student work over a long period. Every assessment of the student's learning is also in some way an assessment of the teacher's teaching.

The idea of assessment and evaluation in teaching artist work, like the work itself, is both simple and complex. It is simple because fulfilling assessment criteria of any kind is not the point; art-making is the point. So where assessment methods do not support the latter, we can discard them or ignore them. Or we can at least try to.

Assessment in teaching artist work is complex for two reasons. The first relates to the fact that art-making is a highly subjective activity. By definition, it seeks to express precisely what is most subjective—individual and collective experience. So questions of whether such expression is being accomplished well or successfully are difficult to frame and yield only partial answers. Making, experiencing and interacting with works of art are activities that are often

unquantifiable and even indescribable. Looking at a painting or hearing a piece of music can be a visceral emotional experience, can leave us cold, or can provide pleasure and satisfaction in the way the work leads us to unexpected associations or new visions.

But this does not mean that art defies analysis; on the contrary, art invites, even demands it. Experiencing a work of art is always, in part, an analytical experience, even if it takes place largely in the realm of the unconscious or involves associations and insights that cannot be articulated in language. There is a great deal to be learned by analyzing, evaluating, and experimenting with art in all its psychological, spiritual, cultural, political, aesthetic and historical dimensions. Theoretical analysis and even systematization of artistic disciplines has at various times in history yielded profound and useful insights that have advanced practice. Art is deeply subjective; the media, materials and methods we use to make it are concrete. So while artistic experience may in some ways defy empirical analysis, art-making requires it.

The second reason assessment in teaching artist work can be difficult has to do with the present cultural and political context in which such work is being done, particularly in the United States. A good deal of the advocacy, funding and administration of the work is based on the premise that teaching artist work, and indeed art-making by students, is justified to the degree that it supports specific academic, social, behavioral, economic or institutional outcomes. Instead of being designed to advance the work of helping students to make their art, assessment strategies and outcomes are often constructed, and sometimes even skewed, to justify the work in terms of other priorities.

The current near-mania for assessment among arts education organizations is driven by the funding climate. This is a relatively recent development. Somehow arts education happened for decades without the existence of a specialized field of assessment that is separate from designing, implementing and refining the actual work of teaching in the arts. Private funders and especially public funders, like the U. S. Department of Education, have in recent years placed more emphasis on a kind of mechanical accountability that seeks to show that they are "getting their money's worth" out of the arts education programming they fund. Often this worth is defined in terms that have little or nothing to do with art-making and the learning that always accompanies it. The people designing and implementing assessment in the arts frequently have little or no firsthand knowledge of or experience in the arts disciplines in which they are assessing teaching and learning.

Increasingly, this assessment is based on abstract structures and formulas that are further removed from what is specific and essential about teaching in a given medium. It has become commonplace for arts education organizations and programs to hire "evaluators," who often do not have an arts background and are more usually social scientists, management consultants or specialists of some other kind. These evaluators are charged with determining the value

of teaching and learning in disciplines for which they have little or no frame of reference. Their assessment is based on very general and often dubious social science, educational, organizational or management theory. Assessment strategies in arts education are sometimes even presented as scientific or statistically significant in spite of the fact that they generally include none of the controls, repeatability or rigorous peer review that characterizes genuine scientific and statistical inquiry. Such mischaracterization not only lends authority to unverifiable conclusions, it also often obscures what actually *can* be learned through more transparently subjective, qualitative and synthetic investigation.

This is not to suggest that the social sciences have nothing to offer arts educators. Some very important and insightful work has been done by social scientists on the many ways in which art teaching and learning function within cultural and institutional structures. But it makes little sense to ask a social scientist, much less a management consultant, to analyze *arts* learning from the point of view of development in and of a medium, and still less sense to ask a teaching artist to analyze arts learning through the lens of the social sciences.

This heavy emphasis on a specialized type of assessment that is not firmly grounded in knowledge of the disciplines being taught can be intimidating and confusing to teaching artists, and can be an obstacle to what is most important in our work. Assessment criteria shape curriculum and programs. If as teaching artists we are asked to put non-arts outcomes first, we are faced with deemphasizing our particular expertise as an artist, and therefore deemphasizing exactly what is unique and valuable about teaching artists—that we relate to all students as fellow artists and help them make art. Some teaching artists just assume "that's the gig" and attempt to teach the unteachable. Or maybe we are presuming too much: Perhaps some of us *do* know how to teach creativity as an abstraction—although we haven't seen it done yet. Most teaching artists we know choose to teach their medium anyway but have to face the constant overhead and distraction of somehow demonstrating that they are in fact teaching a list of intangibles that no one seems to be able to clearly define, let alone score on a rubric. Paradoxically, abstract and utilitarian assessment criteria and methods end up obscuring the actual insights that teaching artists and their students can provide into teaching and learning in arts media and other areas of study.

The premise of this chapter is that assessment and evaluation of teaching artist work should closely reflect what teaching artists actually do: teach people to make their own art and make it better. Such assessment should be rooted in an analysis of the specific skills, concepts, and content of a medium and any other area that is under study: How are we teaching these things? Are students learning what we are teaching? Are they learning other things? Are students making art that is varied, original, and interesting for them and for others? What sorts of criteria are we using to make these judgments, and are we tak-

ing the time to teach those criteria to students? If we look closely at these questions together, and if we consider each medium and context with an eye to what is unique and particular, we will undoubtedly also gain some insights into what teaching artist work and art-making mean in a larger context. This is the kind of assessment and evaluation that is an inseparable part of our work, supports the work, and is often organic to teaching artist practice.

But it is inevitable that any teaching artist working in America today will face a wide range of assessment demands, pressures and methods that do not relate directly to the work of art-making. The purpose of this chapter is to help any teaching artist to:

1. Further develop his or her own methods of assessing and refining practice from a variety of perspectives that bear on the teaching, learning and artistic experience and discovery that is teaching artist work.
2. Recognize assessment priorities and methods that do not support the development of practice and:
 a. Where possible, to reframe these in ways that support practice.
 b. Where possible, to explain one's practice and values in terms that satisfy these priorities without obstructing or diluting practice.
 c. Where necessary, to argue against assessment priorities and methods that obstruct sound teaching artist practice.

If you are clear about what and how you teach, it becomes much easier not only to evaluate and develop your teaching, but also to explain to others how and why you teach. Many teaching artist jobs involve criteria such as alignment with education standards, organizational and institutional goals, and non-arts outcomes. Clarity about your own intentions as a teaching artist and your own assessment methods enables you to translate the outcomes that matter to you in a way that makes sense to the organizations and institutions that hire you. Sometimes this involves cross-referencing the specifics of your teaching to the often very general criteria you are asked to address—you can actually give meaning and content to vaguely stated outcomes. At other times it involves reframing criteria and outcomes in ways that relate more realistically or meaningfully to what and how you teach. Rather than design your teaching around external assessment criteria, you can, through a dialog with those who hire you, shape the assessment criteria to better reflect what you actually do.

We believe that the idea of assessment and evaluation needs to be defined both clearly and broadly. We've structured this chapter to help you think about assessment from a variety of perspectives, which, while they may overlap, are also often distinct. The chapter provides tools, ideas and techniques to help you consider and answer these questions about the work that you are doing with students:

1. Does it work for students as artists and learners?
2. Does it work for the goals of the teacher/school/organization?
3. Does it work for you as an artist and teaching artist?
4. Does it work to advance practice in the teaching artist field?
5. Does it work to advance practice in your arts discipline or medium?

We believe that all of these questions can be important and interesting to a teaching artist, but also that these questions have different importance for every teaching artist and in every teaching situation. In approaching each of these questions it helps to be as clear as possible about which assessment criteria and priorities are *our own* and which are not. Our own priorities as teaching artists may often overlap with those of the organizations and institutions within which we work, but they are often not identical and sometimes they even conflict. The more clarity you have about this question, the easier it is to navigate in ways that support your own practice.

We hope this chapter can help you approach these problems and questions on your own terms and in ways that make your work more fun, effective and fulfilling for you and your students.

Most of what is important and effective about teaching artist work cannot be understood in general or quantitative terms. The most useful insights into teaching, learning, student development, and innovation in a medium derive from specific observation and synthetic thought about such observation. Ultimately, it is the teaching artist and his or her students who are best qualified and best placed to make such observations and talk and write about them. We hope that this chapter will also encourage you to develop your own ways of assessing, evaluating and expressing what is important about your practice and in your medium.

ELEVEN GENERAL IDEAS ABOUT ASSESSING TEACHING ARTIST WORK

1. Assessment of teaching artist work begins with the teaching artist and the medium.
 a. Many arts education organizations and institutions look to develop non-medium-specific frames of thinking about teaching and learning, such as "collaboration," "critical thinking," or "engagement." That doesn't mean you have to begin with such frames. Just as your teaching develops out of your expertise and interests, so too can your assessment strategies.
 b. Just as you teach what matters to you in your medium, you should assess based on what matters to you in your medium and as an artist.

What Does Good Teaching Artist Work Look Like?

Recently I visited a photography summer program that takes place in a mostly working class high school here in Chicago.[1] Within moments of walking into the room where a group of students and a teaching artist were working, I had a strong hunch that I was looking at some excellent teaching artistry and art-making. I spent only about half an hour in the room, but everything I saw and heard further confirmed that this was "good" work. I would like to describe, one teaching artist to another, the things I observed that made me think so:

1. **Students were making something that seemed important to them.**
 About fifteen students sat at computer screens, some together, most alone. It was quiet, but not too quiet—people talked and joked a little. But it was clear that almost everyone's focus was on the images displayed on their screen.

2. **The teaching artist seemed to relate to the students as artists.**
 I watched as this young teaching artist moved around the room, mostly doing his own work (preparing to show and talk about some images), but attentive to how the students were progressing. Occasionally he'd stop to look at an image over a student's shoulder. Sometimes he'd comment, sometimes not. If a student asked a question, technical or aesthetic, the teaching artist moved quickly to respond and help, but with a very light touch; as soon as the student was able to move on, the teaching artist moved away. The teaching artist seemed to like and respect the students, but not in an overbearing way.

3. **The students seemed to relate to the teaching artist as an artist.**
 Students seemed willing to ask the teaching artist for advice and ideas, but as far as I could tell, they were more collegial than deferential in their affect. The students appeared to share the same liking and respect for the teaching artist but the personal relationship did not seem to be the main thing—they were at work.

4. **The students seemed to relate to each other as artists.**
 Some were clearly friends; some seemed perhaps from "different crowds" (although it's hard to tell). Students seemed quite comfortable making suggestions and providing advice to each other in much the same way as the teaching artist. I watched as a student only half-jokingly criticized, even disparaged, another student's work. The second student shrugged, and then chuckled, as if the critique was completely natural, and also as if it was not particularly persuasive. It seemed as if, in this context, these students joked, discussed, even argued about the work.

5. **The students were working as intentional and conscious artists, and were enjoying it.**

a. I probably annoyed any number of kids by interrupting them and asking what they were up to. Every one of them answered with an explanation related to technique. A student working in Photoshop with a beautiful image of a very large, strangely shaped piece of ductwork on the roof of the high school said, "I'm working with the contrast on this image to make this part stand out more clearly against the sky. I think that will make it look more weird, which is what I want." Their focus, again, was on making the work, and it was immediately clear that they had some grasp of technique but were also sharpening their technical abilities as a means of controlling their medium. They seemed able to look at their work critically, but were centrally engaged in making the work.

b. When I would ask what students intended with a particular image, or why they made images at all, I got short but interesting and unique answers: "I want people to look at my pictures and not understand them at all at first." "I like it when I look at an image like that, so I want people who look at my images to experience that."

c. I asked several students whether they enjoyed making images, and at least two looked at me as though I were insane.

6. The students were making good art.

a. Okay, so that's the loaded one, right? But not to raise this question is to miss the whole point. If we are not creating a context in which people develop their work, invent, originate and gain more control over their medium, then we are wasting their time. I also think that any ancillary or "portable" learning that happens in the arts happens as a result of a deep engagement with technique and application in a medium, not simply as a result of a superficial "arts experience."

b. I don't think we have to adopt a whole system of aesthetics to talk about what "good work" means. In this room I saw:

i. Variety. Even though many students were working with related themes or prompts, there was tremendous variety in technique and aesthetic. This did not seem to be in any way an extension of the teaching artist's aesthetic. In fact, I had no sense from looking at student work of what the teaching artist's work might look like, or what his focus as an artist might be.

ii. Invention. I saw many images during my brief visit that were novel to me and did not fit aesthetic frames with which I was familiar. I am not familiar enough with photography as a discipline to say whether significant technical or aesthetic experimentation was in play, but my inexpert take was that it was.

iii. Power. Most of the images I saw were interesting to me—some visually, some narratively or associatively, many in multiple ways. Some were very moving. Others were engaging intellectually.

iv. Development. A couple of students showed me older images

alongside the one they were working on. In one case I found the earlier images more compelling, if less crafted, but it was clear that student work was at least partly about evolution and change. The students did not seem stuck on just one idea or approach.

v. Wholeness. In my brief visit, I saw several images that I found so interesting that I'd want to look at them all the time. I knew I'd get something out of seeing them over and over. Of course, they were perhaps to my particular tastes. But it's quite nice, and it seems a privilege, to walk into a studio, student or otherwise, and have that experience.

As I thought later about what I'd seen, about why it seemed so good, it struck me that everything happening in that room appeared to be entirely natural and effortless. It made me wonder, as I often do when I see work like this, why things become so complicated in arts education. Why does simple, good work become fraught with political, territorial, and methodological spats, and mired in jargon-laden administrative swamps? Aren't we just trying to create contexts in which people can learn to make art better, and learn other things through that process?

And then I remembered (again) that we don't operate in a political or social vacuum, and that this "simple, effortless" program that I had the good luck to visit was the result of extremely difficult and dedicated work on the part of a highly skilled and enthusiastic teaching artist and equally skilled and visionary program director who must work tirelessly to fund, organize and guide such a program. What is good and valuable about the work begins with them and leads to some very good art and some powerful young artists. For me, this is the most meaningful assessment of all.

—Nick

Teaching artist work is not just about teaching students to make art; it's about engaging students as artists who develop original work and develop new ways of thinking and working in a medium. These "products" of the work are often what are most exciting to our students and to us as fellow artists, and they should be highly valued in any evaluation of the work.

c. Often the most useful and far-reaching insights are gained by looking at the most specific and detailed dynamics of teaching and learning in an arts discipline. If you can clearly describe what you and your students are doing in the work, you will be able to communicate useful things to other teaching artists and educators. Specificity is everything; what is vague is never profound.

2. Assess in the language of your practice and medium.

Arts education is a field currently awash with jargon: educational jargon, management jargon, cognitive science jargon, and spiritual and self-help jargon. Some of this jargon is useful in the fields from which it derives. Much of it is vapid and empty in any field. It helps no one when we substitute such jargon for clear and specific discussion of the work we do. If you are a sculptor, speak in the language of sculpture. Where that language may be obscure or inaccessible to others, explain it. Don't abandon the language of your discipline. Bring others into it and translate where necessary.

3. Assessment and reflection should lead to conclusions about practice.

 a. The point of assessing teaching and learning in teaching artist work is to refine, develop and strengthen practice. If it becomes too divorced from practice or is seen as an end in itself, it can quickly become sterile in a way that distracts from the actual work. Generating new questions can be a good thing to do, but questions are of limited use if we don't at least try to find answers to them, however partial.

 b. If assessment and evaluation are to serve practice, they must reveal successes as well as failures, strengths as well as weaknesses, clear insights as well as questions to which we do not yet have answers.

4. Be clear, for yourself and others, about the purposes assessment and evaluation are designed to serve.

 a. Many organizations that hire teaching artists devote great resources to advocating for their work and for your work. Often they use research, assessment and evaluation as a key part of this advocacy. Such research may overlap with your needs as a teaching artist, but it also may not. It is important to be clear about this distinction. Some assessment is about explaining the work to funders, some is about teaching artists developing their practice, some is about evaluating student learning and development, and some is about all these things at once. The clearer you are about the purposes of assessment, the more it will be useful to you and to the work.

 b. Assessment and research may be a top priority for the organization that hires you, but this does not mean that it has to be your priority as well. Certainly you will have to provide documentation and other information if that's part of the gig. But in many cases, the heavy emphasis that some organizations place on research and assessment, particularly of non-arts related outcomes, can be a distraction to you and to students. While art-making may be a kind of "inquiry" or research for some artists, constant "data collection," "reflection" and "documentation of process" that are not a natural part of how you or students work in the discipline can quickly turn a real art-making environment into something that feels more like a psych lab. This is

not good for you or for students. Where you need to erect a firewall between the parts of the gig that require you to be a researcher and the parts where you are an artist among artists, you should do so.

5. To assess or evaluate something you need to be able to describe it clearly.

 a. Arts education in America is also awash in vague, often highly mystified and reified notions about the utility or value of arts experience. To some degree this is understandable, given the hostile political and economic climate for the arts and education in general. But that does not change the fact that cognitive scientists, philosophers and artists cannot clearly describe or explain such a vague and contextually dependent concept as, for instance, "creativity." While it may make sense to think and talk about what this concept might be or mean, it makes very little sense to try to assess our teaching based on it and on similarly vague concepts. The fact that something is interesting to talk or think about doesn't make it a useful criterion for assessing the work.

6. In order to assess something quantitatively you need to be able to measure it.

 a. Quantitative assessment can be useful and interesting in any kind of teaching. It provides a certain framework for analysis. But it can be useful only if it seeks to measure what is measurable. Nick can tell you exactly what percentage of his students are using both electronic and acoustic sources in their music. He cannot tell you how much they are using one or the other, because he has not worked out what that means: how often in a song? for what durations? on how many tracks of a multi-tracked recording? It might be useful to investigate such things quantitatively, but unless he does so with some kind of rigor, slapping a number on something is more about making his assessment seem scientific or "true," than it is about actually learning anything.

7. Putting something on a rubric or scoring it with words does not make the assessment "qualitative."

 a. If you are using words like "more" or "less," or phrases like "all the time," or "some of the time," you are doing quantitative assessment. Those are *quantities*.

 b. Often assessment that is constructed to support organizational or institutional goals attempts to measure very abstract outcomes like "critical thinking abilities," "creativity," "collaborative behavior," and "self-esteem."

8. There is nothing wrong with tests.

 a. A well-designed test can serve many useful purposes. It can help organize your teaching and help organize a student's study and learning. It can measure certain types of student progress and the effec-

tiveness of your teaching, particularly in students' use of specific skills or techniques and their understanding of specific concepts.

b. What tests by themselves cannot do is paint a complete and synthetic picture of what is happening aesthetically and educationally in your classroom or studio. That requires critical qualitative reflection, discussion and writing by you and perhaps your students.

9. Assessment designed to support foregone conclusions is not assessment; it's advocacy.

a. Arts education in America is heavily shaped by a constant struggle by arts organizations, schools and individual teaching artists to obtain and maintain funding. This shaping and even deformation has been most heavily expressed in the ways in which arts teaching is evaluated and assessed. It is almost inevitable that in your teaching artist work you will be asked to provide "data" and documentation to support foregone conclusions. These conclusions are often correct and are linked to laudable motives—art is good for kids and does make them smarter! But advocacy that masquerades as research and assessment can be confusing to a teaching artist at best, and at worst can obscure or even suppress real assessment of teaching and learning in which the insights may be more mixed and more complex.

b. The important thing for us as teaching artists is to know the difference between real, critical and honest assessment of our work that is based on a genuine interest in advancing practice and uncritical cheerleading that is about defending the work and raising money. The more clearly we understand this difference, the more we will have at least a shot at reframing the premises of advocacy so that we can all spend less time cheerleading in defense of the work and more time actually learning from the work.

10. Assessment, research and reflection should not distract from or get in the way of art-making.

a. Another unfortunate outcome of the struggle for funding is that assessment and evaluation have progressively invaded the time and space that teaching artists create with students to learn the skills of a medium and make art. We find ourselves videotaping and photographing every move a student makes, filling out reflection forms and asking students to constantly monitor their own process and progress, and reflecting with collaborating teachers and teaching artists more about the collaboration than the actual work. While there may be useful insights to be gained from all of these activities, they can also be a huge distraction from the teaching and making that are at the core of our work.

b. How you choose to deal with the pressure to constantly evaluate yourself and your students, rather than evaluate and engage with the actual work being done, is up to you. Our solution has been to erect something of a firewall in our heads and in the classrooms and studios where we work. This firewall separates our work as teaching artists from our sometimes willing, sometimes reluctant work as "researchers" and advocates for the work. In the studio Nick is an artist and technician among artists and technicians. He is no more focused on reflecting on his "process" than when working with professional musicians in a professional studio. This is not to say that he doesn't think about what he's doing, or doesn't learn new things all the time he's doing it. Rather, he tries to think about *what he's doing*, and not what it might mean to a funder or arts education administrator. The same goes for Becca. She needs to engage students as poets when she is with them and devote their time together to manipulating and playing with language. Too much thinking and talking about what we are learning about being poets too soon, or for one day out of a 3-day residency, does not make sense. We think about that stuff later.

11. Assessment should be synthetic and should make a point.

a. Teaching in any discipline is not a science. Neither is art-making. It engages some of the same ways of thinking about the world that science does, just as the sciences engage all kinds of artistic tools and concepts. But in spite of attempts to give educational and arts education theory a scientific veneer, it seems clear to us that we do not yet know enough about the highly complex and variable dynamics of cognition, much less teaching and learning, to be able to develop systems and models of teaching artist work that can be shown to "work" better than others. This does not mean that we can't develop insight into what works well in a given teaching context, but that useful insights can emerge only from a synthetic, qualitative analysis. Useful writing about teaching artist work often looks more like a description, narrative or argument than a prescription or method. We hope that the way this book is written reflects that.

b. As teaching artists we can think of our assessment and evaluation work artfully, whatever the context. We can maintain a personal viewpoint, one that expresses our own take on what we are doing, what purpose it serves, and how it works or doesn't work. We do not need to pretend to be objective. In fact, we should always be transparent about the fact that our "data" are the data of subjective experience and interested and engaged observation. As artists we should talk about our work, what we learn from it, and why it matters to us.

DOES MY TEACHING WORK FOR STUDENTS?

Assessment: A support to art-making or an obstacle?

In our work planning and writing and teaching curriculum we have to start and end with the student. Where do we want students to end up in terms of their learning in and experience with our art form? Is exposure enough? Do we want them to learn a particular technique? How well? Will they produce a drawing or a poem or a song? What level of work do we think they can achieve? How would we assess their work, both as an outcome of the techniques and content that we taught and as art? Do we assess them as a group overall, or individually?

There is an inherent tension between the assessment of student work and learning in teaching artist work. One of the essential things we bring to schools and other institutions is de-schooling/de-institutionalization of time and space in those places. This means that for the time we are working with students in a classroom, it is not a classroom—it is a studio, stage, workshop, etc. This transformation is necessary for real art-making to happen and is the reason why different types of learning, often deep learning, take place in the contexts that teaching artists create. Excessive, obtrusive, or overly rigid assessment methods are the quickest way to *re-institutionalize* time and space. If the teaching artist lesson or project suddenly becomes focused on evaluating student progress or learning rather than on art-making, we might as well not be there in the first place.

The importance of giving primacy to the creation of a free context in which art-making is the point cannot be overstated. So whenever we are considering an assessment strategy or method, it is worth asking the question: Is this something that one would ever apply to non-student art-making? Would we ask a professional painter to reflect on his or her process in writing after every session in the studio? Would we evaluate a professional musician's degree of "impulse control" as a key indicator of his or her musical development? If the answer is No, we must at least consider the possibility that our method or strategy may in fact be an obstacle to the student art-making that is at the center of what we are trying to achieve.

Assessment as a means of learning things

Sound assessment starts with questions and ends with more questions. It is usually only approximate, not definitive. It measures something at a given point in time, and it is measuring something that is rarely fixed or static. Good assessment is always looking ahead to the next benchmark or possibility. It asks us as teaching artists and it asks students: What's next? This is because learning and making and creating are not processes that simply end. This is

also because the different ways students learn are individual and dependent on many variables. We absorb knowledge and meaning and develop skills in an art form incrementally, in great gulps or sometimes all at once in an intuitive flash. This is not to say that evaluating a given student's work is impossible to do in any meaningful fashion. It just means that if we can, we need to balance our approach and use more than one method over a period of time. The more we can involve students in the conversation the better. And the more specific we can be in our questions and in our search for answers, the easier it becomes to assess whether things are actually working for students.

For example, if we want students to walk away from a dance residency with a basic grasp of the elements of dance (Body, Space, Time, Energy, Action) and an ability to apply them in their own dancing and to recognize these elements in a dance performance, we have to plan carefully—on paper or using a mental model. In this respect assessment is inseparable from curriculum planning.

- We have to name these learning objectives clearly for ourselves and any partnering teacher or artist, including the students. We have to know why they in particular matter to us—does knowing them make you a better dancer? Does knowing them allow you greater fluency in dance? Does knowing them help you better respond to and understand dance as an art form?

- We have to figure out precisely how to teach the skills and knowledge that we named as learning objectives. How will we help students learn and apply the dance elements, and how will students develop their ability to recognize them in performance?

- We have to consider how we want these particular students to express their knowledge. Through their dancing? On a written test? In conversation with us or with each other? A combination of these? This is where our values as teaching artists come into play, and where the values of a school or organization might intersect or work in tension with ours. For instance, we might be satisfied that students can simply dance in ways that show that they have learned and internalized on a physical level the elements of dance. Let's say you were working in partnership with the school's dance specialist. He might have a more vested interest in documenting students' literacy with dance vocabulary, and so he might ask them to identify on paper the elements they recognize in a video clip of a dance performance. By assessing students in both ways, both of you would know whether or not a given student now has a basic grasp of this knowledge, and you could share your assessment strategies and results with each other.

- We have to establish some criteria that tell us whether students have learned what we wanted them to learn in our art form, and to what

degree. This is often the hardest part of assessment, because it asks us to measure qualities of a work of art that may be ineffable, or simply so context-dependent or personal that it seems impossible to separate them into discrete categories or descriptors such as "excellent," or "interesting," or "student shows mastery by. . . ," or "student is still developing this skill as evidenced by. . . ." This does not mean that such efforts are unnecessary or a waste of time. On the contrary, it is often in the assessment phase, and in trying to say aloud or on paper what precisely we are looking for, that we finally understand the nuances and specific qualities that we really wanted to teach in the first place and that help us to better evaluate student work or performance and assign to it a particular level of proficiency or fluency.

- This planning with a particular model of student work in mind, or planning backwards, is a useful structure and is what most schools and institutions employ in their curriculum planning. It can help us be clear and cogent in our approach to teaching and to measuring whether or not something is working in our art form. It also keeps us focused on the student learning and work and gives us points of reference along the way.

Such a planning process can also be problematic if it becomes too rigid and if we become too fixated on specific outcomes, forgetting to step back occasionally to see what else might be happening. If we want students to become better artists, then as part of that process they will inevitably surprise us by working in ways we had not expected, or by creating work that confounds our stated goals of quality or proficiency. Or the students might be floundering or unengaged and creating work that is surprisingly bad or boring. Good curriculum is flexible enough to address these kinds of departures from what we expected, even if it means that what we had originally defined as success might need to be revised.

One other caveat: The fact that something is easy to assess does not necessarily mean that it is worth assessing. As artists we ought to stay focused on assessing things that have a real bearing on the students' ability to make art. This is our particular area of expertise, and it is why we are there in the first place. Sometimes we end up assessing things that are incidental to making art, like the number of entries in a student reflection journal, or students' ability to recite back to us certain terms or concepts used in the art form. In the example about learning the elements of dance, we could measure whether students know all five elements of dance by quizzing them or having them fill out a worksheet. We could find out how many students know them and how many do not pretty quickly. These data might be very useful to a school or district that needs to show student proficiency in meeting standards for literacy in an art form, for instance.

However, if we have determined that expressive and interesting dance uses

one or more of these elements and that our aim is for students to be able to dance in ways that incorporate the elements of dance, then we need to be able to measure the quality of their dancing itself. We need to have decided that what we will be looking for is the creative application of the elements of dance, and we will need to have thought about whether we are interested in isolating those elements in our assessment and evaluative criteria, or whether they are part of the language that we use in describing what we see happening in student work.

Finally, it is important to keep in mind that art-making and learning to work in a medium are dynamic processes that often do not proceed linearly. An artist does not make work or develop a voice or vision in a cumulative sequence of even steps. More often, progress is made dialectically: A dynamic of contradictions or tensions in the medium or in the artist's thinking leads to sudden shifts or qualitative developments. What this means for assessment is that one has to consider carefully what is most important in a given context—student competency with a technique or concept, or the use of techniques and concepts in artistically effective and inventive ways. Sometimes very roughly executed work will contain within it clear signs of a powerful or innovative direction or idea in a medium. It can be the case with any artist that his or her technical capacity lags behind his or her intent or vision. This happens even more often with artists who are new to a medium. We are not saying that idea should take precedence over technique, but that it's important to find a balance that supports and assesses both, with an eye toward encouraging original and successful work, not just technical proficiency.

Assessment structures and tools

The following assessment plan represents one approach to figuring out whether something is working for students. The first example shows how you might measure reaching a very narrow learning goal that may be connected to a longer, more in-depth project or unit. The second example shows how you might measure a learning goal that is broader in scope.

One can tell from the assessment methods and criteria in the following tables—we have used questions, although we could have written them out as declarative sentences in more detailed language describing different levels of proficiency—that this is qualitative assessment and therefore highly subjective. There is nothing wrong with this approach, which simply reflects the subjectivity of judging a work of art in any art form. It is also filtered through our own personal lenses as artists and educators. Our job here is not to oversimplify things, but to try to make our method of qualitative assessment as transparent as possible, so that we are constantly building the capacity of students and collaborating teachers to become more fluent and adept at evaluating work in our particular art form. As a result, students become better artists. This kind

Table 3.1 This sample is based on teaching elementary students over the course of one or two 50-minute lessons.

Learning Goal: What are you going to teach? Why?	How will you teach it?	How will you measure it?	What are your criteria? How will you know if you were and the students were successful?
Students will learn and apply the element of dance we call "action" by using locomotor movement (moving from one place to another) and nonlocomotor movements (moving in one spot).	We will demonstrate and describe locomotor and nonlocomotor actions.	We will observe each small group movement sequence as students are making it and provide immediate feedback or clarification as needed.	Yes or No: Do the students' movement sequences differentiate between locomotor and nonlocomotor movements?
Why? Because the concept of "action" in dance is a fundamental way of understanding and organizing the infinite variety of movements our bodies make. If we can think about some of these movements more systematically, we have more tools to create expressive dance.	We might also look at a video clip of a dance in which these two kinds of action are highlighted and/or clearly contrasted.	When they share their sequence with the large group, we will make a mental note to see whether they are including locomotor and nonlocomotor actions.	How interesting or varied were the movement sequences among the different groups?
	We will consider briefly what happens when everyone is doing locomotor actions at once and when some are and some are not. What happens for the dancers? What happens for the audience?	We will also consider how they are sequencing their actions and what level of expressivity it conveys.	How hard was it for the other students to come up with an idea or title to describe the sequences they observed? What sorts of words did they use to describe the sequences?
	We will ask students in groups of three to come up with a sequence of three movements (one locomotor action and two nonlocomotor actions).	We will do this informally using our subjective judgment, but also ask the other observing students to describe what they see happening and how they might characterize or title such a sequence in terms of the ideas or feelings it conveys.	How interested do students seem in developing their movement sequences further to better fit with how they were described or titled? Or in thinking about ways to move that lie beyond such descriptions?
	We will ask students to respond to each other's work and talk about how the audience response might help the performing students change their current movement sequence.		

Table 3.2 This sample is based on teaching elementary students over the course of six 50-minute lessons.

Learning Goal: What are you going to teach? Why?	How will you teach it?	How will you measure it?	What are your criteria? How will you know if you were and the students were successful?
Students will learn and apply certain elements of dance (Body, Action, Space, Time, Energy) in the context of creating original movement sequences. Why? If we can think about dance as a series of different kinds of movements that operate in concert with and in contrast to each other, and in combinations, we have more tools to create expressive dance.	Over the course of 6 sessions: We will demonstrate, describe and apply different ways of using the elements of dance. We will look at video clips of dance performance in different genres in which these elements of dance are highlighted and/or clearly contrasted. We will discuss the different ideas and feelings that different kinds of movements convey. We will ask students in groups of three to conceive and develop an original sequence for a final sharing, including giving it a title. Along the way we will ask students to respond to each other's work as audience and learn how to use the elements of dance as a means of understanding and analyzing each other's work.	We will observe small group movement sequences as students are making them over the course of the project and provide immediate feedback or clarification as needed. When they share their final sequence with the large group, we will consider the level of expressivity it conveys. We might take written notes so we can reflect later. We will do this informally using our subjective judgment, but also ask the other observing students to describe what they see happening, and how successfully they think the performers conveyed the ideas or feelings behind their title. We might take notes on this conversation too, or ask the partnering teacher to capture it.	How interesting or varied were the movement sequences among the different groups? Did their chosen titles underscore what we saw happening in the movement sequences? How hard was it for the other students to describe and analyze the sequences they observed? Are they using the vocabulary of dance?

of fluency is learned through direct experience, over time and with repeated exposure to different kinds of art-making and artwork. It can be expressed formally with rubrics, checklists or written feedback, or communicated in more informal oral discussion and critique.

Some artists are highly reflective by nature and stop to take notes or make observations during or right after a lesson. Others just know they need to make a change next time. In both cases, the teaching artist is aware that some aspect of the lesson went differently than expected—perhaps less smoothly, or perhaps much better than originally planned. How does an artist know this? By observing students at work, by listening to them, by looking at the work they are making. There is nothing particularly mysterious about this process of assessment, whether it is ongoing or undertaken in a more comprehensive way at the end of a project. It is part of good teaching. You can get better at it. And you can learn new and different methods of evaluating student work so that you have more ways to respond in whatever context you find yourself teaching. Below is a partial list of ways you can assess student work.

Ways that you as an artist can assess student work

1. Observe student work in progress. What do you notice about it? Do the students seem to get the main point you are trying to teach? How can you tell? In some mediums the learning manifests itself right away in what students are making. In others, it might not show up until the end; what you may be assessing along the way is the production process and how efficient or collaborative it is. How informally or formally you approach this aspect of teaching depends on what you need to know and how much time you have overall for the project.
 a. Informal method: Walk around and look at what students are doing. Talk to them. Ask them questions. Observe silently.
 b. Formal method: Make a list of what you want to see in their work and check off who is getting it and who isn't. Record students at work (this is particularly useful in a performance-based medium like theater or dance) and watch the video footage on your own, or with a collaborating teacher. What do you see and hear? How is it going? What do you think they are learning?
2. Have students reflect on their work along the way. Think about points in your lesson where having them stop to consider what they just did or saw their peers doing would help you understand their grasp of a particular concept. Invest as much time as you think a given concept or technique warrants. This is where knowing what really matters to you comes in handy. It will help you figure out what you really must stop and assess, and what you can just let happen. If you notice that a lot of the students'

work is coming up against similar challenges, or could benefit from a nudge in a specific direction, then it makes sense to stop a whole group and ask them to consider their work more critically in the moment.

 a. Informal method: This can be as simple as asking the whole group "What did you notice about what we just did?" or "Why do you think it is important to know X or Y?"

 b. Formal method: Have students look at video footage of themselves at work. Ask them to tell you what they notice and how they think it is going. Ask them what they think they could do differently. Or with a medium like clay, or in drawing or poetry, have students stop working and spend some time looking at each other's work and giving each other feedback. This may be done first as a large group, to model the process, and then in smaller groups or pairs. Give them some specific prompts that align with what you want them to learn and apply. Examples might be: "Describe what you notice about the technique (or use of balance, use of color, etc.) in this work," or "What words stand out?"

 c. As noted earlier in this chapter, there are risks involved with formal and informal student reflection. Where such reflection is primarily about examining one's work in a medium from the point of view of gaining greater control over the art-making, then reflection can be interesting and fun, and it can support the art-making. But if it distracts from or interferes with the students' work in the medium, it can be tedious and can encourage students to spend too much time ruminating on the work rather than doing it.

3. Look at finished student work as art and evaluate it as art. You can conduct an evaluation with the student or students, but you can also spend time looking at their work on your own or with your artist and teacher peers. Don't be afraid to do this, or think that you will hurt students' feelings by evaluating their work. Focus on the work itself. Describe its characteristics and qualities in the terms that you have been teaching. If you have been teaching in a way that is about making art, then a student won't take your feedback personally. Of course, it takes some discipline and practice to create this kind of art-making space, but even adorable kindergarteners who are touchy and tired and cry easily late in the day can handle an honest description and appraisal of their work if you undertake it with seriousness and respect.

 a. Informal method: Observe the student work in exhibition or publication or a sharing or performance. What comes to your mind? How do you respond as a fellow artist? How well is it functioning as art? Or is it remaining more in the realm of assignment at this point (i.e., containing elements of technique or content that you wanted to teach

but that are not applied in a particularly expressive way)? What does that tell you about your teaching?

b. Formal method: Conduct with students an oral or written critique of their final work. If they created more than one piece, ask them to select one; if the work was collaborative or performance-based, have students present the work again or record it for them. Ask students to evaluate their work using criteria that you and they have been working toward in the art form—things like use of a particular technique in the art form and how expertly or efficiently they have applied it. Another criterion might be originality: Is the work surprising in some way? Shocking? Expected or clichéd? Is the student work varied, or is it all similar? Does it reveal your aesthetic, or theirs?

4. Look at student work using a specific process such as "Looking at Student Work."[2] "Looking at Student Work" is a protocol in which one presents student work to a group of fellow artists and/or educators in order to better understand student progress and one's own instructional practice. In this step-by-step process, you as the presenting artist do not provide any information or context concerning the student work until after the group responds to these questions:

a. What do you see or hear? Describe without judgment.

b. What questions does this work raise for you?

c. What do you think students took away in terms of learning in the art form?

d. (Additional prompt: How is the work functioning as art?)

The shared perspective of a group helps the presenter and the group to become more aware of aspects of student work that might otherwise have escaped notice. You can do this kind of review with your collaborators on the lesson or project, or even better, with a group of responders outside of the immediate teaching context. The latter tend to have a fresher perspective and are more able to focus on the work itself rather than on what they might already know about a particular student.

5. Ask students to critique examples of work in your art form that you consider high quality or illustrative of particular techniques that interest you or perhaps even annoy you. Give them a range of work to which they can respond over the duration of a project or course with you. How they respond will allow you to see into their ability to analyze art. This is a critical piece of being an artist; it is partly how we develop an aesthetic sense or awareness. While student response to others' artwork does not convey the whole picture of what they know and do in the art form, it is a window for you into how they make meaning. For them also, it can

be a way to feel how the composition of something leads to a particular response in a particular viewer, reader or audience.

 a. Informal method: Bring numerous examples of work before students and discuss them. Find out what the students notice and think about when they view or read or listen to the work. Find out what they think it is about. Find out whether or not they like it. Group discussions are helpful because they are more likely to surface a range of responses. As teaching artist you can be listening for increased depth and detail in their responses over time, and you can listen for an increased openness or understanding of work that they might initially find strange, boring or irrelevant.

 b. Formal method: Take more time to write down student responses. Use similar prompts to elicit their responses each time you show them a new work. Analyze their vocabulary and the evidence they use to support their conclusions or their judgment about their liking or disliking a given piece. If students are older, try having them write up their thinking. This could be a good writing assignment in collaboration with a classroom teacher. Students could then share their responses with a partner or with the larger group after they had thought about and written out their individual responses.

Some means of student assessment and what they are good for

1. Critique (see Chapter 2 for in-depth discussion of critique methods)
 a. Generate insights into the development and meaning of student work.
 b. Indirectly assess the degree to which students are fluent in certain concepts and language in a discipline.
 c. Assess the degree to which students are able to develop critical distance from their work and make use of responses to their work either by making changes to their work or by deciding not to make changes.
 d. Assess whether students are comfortable relating to each other and to themselves as artists.
 e. In the case of arts integrated work, assess indirectly the degree to which non-arts knowledge and concepts have been assimilated.
2. Discussion, interviews and written reflection about process
 a. Indirectly assess the degree to which students are fluent in certain concepts and language in a discipline.
 b. Generate insights into innovations in process that students may be developing.
 c. Generate insights into how students perceive your role in their work

and learning.

 d. Generate insights into how the educational, social and physical context is affecting their work and learning.

3. Examining student work as art

 a. Indirectly assess the degree to which students are fluent in certain concepts and language in a discipline.

 b. Indirectly assess the use of specific techniques or technical concepts.

 c. Generate insights into the development of students' original voice, vision or technique in a medium.

 d. Generate insights into the degree to which you are communicating technique without limiting technique.

 e. Generate insights into the degree to which you are presenting exemplars and precedents without limiting the development of original approaches and aesthetics.

 f. In the case of arts integrated work, assess indirectly the degree to which non-arts knowledge and concepts have been assimilated.

4. Multiple choice tests

 a. Assess student knowledge of vocabulary or specific technical procedures in a discipline.

 b. Assess student knowledge of factual historical, cultural or other contextual information in a discipline.

 c. In the case of arts integrated work, assess indirectly the degree to which non-arts facts or vocabulary have been assimilated.

5. Essay or other less quantitative tests

 a. Generate insights into students' theoretical and practical ideas about a medium.

 b. Assess a student's ability to think critically and analytically about work in a medium or about works of art.

 c. Assess student knowledge of vocabulary or specific technical procedures in a discipline.

 d. Assess student knowledge of factual historical, cultural or other contextual information in a discipline.

 e. In the case of arts integrated work, assess indirectly the degree to which non-arts facts or vocabulary have been assimilated.

6. Practical tests or proficiency demonstrations

 a. Assess student proficiency in technical skills or specific techniques.

 b. Assess your teaching of technical skills and specific techniques.

 c. Build student proficiency and confidence with technical skills and specific techniques.

DOES MY TEACHING WORK FOR THE TEACHER, SCHOOL, OR ORGANIZATION?

Teaching artists work in all kinds of settings and locations. Some work within a school classroom, some work in after-school programming or for community programs. We work with senior citizens and prisoners, hospital patients, museum-goers, random people on the street. . . . Most of us get hired by someone or by some organization that wants to know whether and how our teaching is "working." Our work rarely happens completely independently of institutions or organizations. Chances are that someone besides us wants to know how well things are going in our classroom or studio. They may even have a fair idea of how they want things to turn out.

In the best case, the goals we set as teaching artists overlap with the goals of our partnering teachers, schools or organizations, or we understand their goals well enough to see how our assessment dovetails with theirs, or they ask us for input to help them name some specific goals as part of the project. Sometimes the goals we set as teaching artists may even conflict with the goals of a program or organization, and we have to find ways to mitigate this tension. We might have to modify or compromise our own way of working. It can be a difficult call to figure out how much one can or should change one's teaching before such changes defeat the very purpose of our work as a teaching artist. However, we should not assume that we can't advocate for what we think is important in our work and even seek to shape a program or organization's assessment priorities in ways that better reflect what is being taught, learned and made.

As teaching artists we know better than anyone, except perhaps the students, exactly what is happening in our classrooms and studios. If the assessment criteria and methods don't make sense, we should feel free to speak up. Sometimes the disconnect is just the result of a lack of detailed knowledge about the work on the part of administrators or evaluators, and a teaching artist's input with regard to assessment is often both helpful and appreciated. The more we know about the culture—political, social and economic—of the places we work, and the more we understand the role we are expected to play, the more we can help to shape the expectations that frame assessment of our work and our students' work.

Does it work for the teacher?

Many teaching artists work in collaboration with classroom teachers. We find ourselves in elementary classrooms or high school classrooms or working alongside specialists at all levels. It's essential for teaching artists to under-

stand that the work of many teachers in public schools, particularly in cities and in poor rural areas, is incredibly demanding. Teachers are under huge pressure to cover a seemingly endless list of subjects and skills, often without sufficient resources and time. "Covering" specified material, meeting the many types of educational standards, and producing good scores on standardized tests are the order of the day, particularly in less wealthy districts. The idea of making time and space for art-making can seem daunting or worse for even the most capable and arts-minded classroom teacher. Effective collaboration between teaching artists and teachers needs to be based on the premise that both parties have specific expertise to share, and that the teaching artist must act as an ally in the teacher's constant struggle to bring greater depth and rigor to the classroom in often very difficult conditions.

Teachers seek to collaborate with teaching artists for a number of reasons. Sometimes they want us simply to come in and teach in our art form. Sometimes they have had no say about our presence. More often, teachers have a particular curricular reason for inviting us into their classroom in the first place. A teacher may want his or her students to:

- Have more exposure to the arts.
- Be more confident writers.
- Work on their fine motor skills.
- Learn how to collaborate with each other in new ways and contexts.
- Explore familiar material in a brand new way through an art form.
- Get better at reflecting on and revising their work.
- Access their imaginations more fully.
- Hone their skills in a particular academic area, such as:
 • Reading comprehension.
 • Pattern recognition.
 • Understanding a complex process in science, for example, how a solid changes to liquid or gas at the molecular level.

Sometimes teachers have specific goals; sometimes they have much more general or vague goals. In any case, our job as teaching artists is to figure out where our art form overlaps with these goals, collaborate as closely as possible to develop curriculum that meaningfully addresses these goals without sacrificing the specific artistic expertise we have to offer, and try to offer meaningful assessment strategies to help evaluate whether students have reached these goals. Where such goals are beyond the scope of our medium or expertise, we need to communicate this clearly to teachers so that they don't expect us to accomplish the impossible or the irrelevant.

To achieve this kind of clarity we need to have the opportunity to ask

teachers at the outset what they want students to walk away with at the end of a project or residency. We need to ask them what success looks like to them. Ask them to define it in very specific terms. If they want students to express themselves creatively, ask them what they think that looks and sounds like. Does it mean that all the work will look different? That students won't get hung up on being right or wrong? That they will work more independently of their teacher and of each other? Ask the teacher how he would assess students' current ability to express themselves creatively in a particular medium. The kind of answer he gives you will help you assess what the teacher already knows about his students and how he thinks about the concept of creative expression in the first place.

Teaching artists want to be relevant and helpful in the classroom. We don't want to be seen as obstructionists or as someone who is wasting students' time. This means that sometimes we end up promising to do things or to fit our work into existing curriculum in ways that are not realistic or that end up diminishing what we can accomplish in our art form. Sometimes we are just interested in the possibility of integrating our art form into new subject areas. The challenge engages us and we see the potential for good stuff to happen. Whatever the case, we need to work alongside the teacher to help him formulate specific goals in language the students understand, goals that are framed in ways that will allow us to gauge the effectiveness of our teaching.

Fifteen questions to ask a teacher at the start of a collaboration

1. How did this collaboration come about? Whose idea was it?
2. What would you like to know about my work and me?
3. Can I ask you about you and your work?
4. What is particularly interesting and important to you in your teaching?
5. What is your interest, if any, in my art form?
6. What are your outside interests or hobbies? Do you make art?
7. What intersections between my discipline and yours would you most like to explore?
8. What would you like your students to get out of this collaboration?
9. What would you like to get out of this collaboration?
10. Are there ways in which this collaboration can make your work as a teacher easier and more fun?
11. Are there ways we can support your curricular goals through actual teaching of my medium and through art-making?
12. What are your students like as individuals? Have they made art in class before? Are you familiar with any of the art they may make elsewhere? What is your sense of them as artists? What is your sense of their tastes?

13. Are there particular thematic limits or prohibitions that apply to student art-making in this class or school?
14. Do you have a preconceived notion about what student work will be like? Is it okay with you if it proves different from what you expect?
15. Do you have any concerns about this collaboration?

Does my teaching work for the school or organization?

Sometimes as teaching artists we end up working for a specific program within a school or for an organization. Conversations about what they expect of you as a teaching artist usually take place before you begin any specific project and usually include information about what the school or organization needs in terms of assessment or documentation of student learning. Some organizations or school districts provide administrative support to teaching artists in the form of facilitators, coaches or project coordinators when you meet with collaborators to plan and reflect. They may also help document the learning, or may have previously established assessment criteria that reflect what they need and value. Such support can be a great benefit and take off your shoulders some of the responsibility to do it all yourself. But as we noted above with teachers, you should spend some time finding out what matters to an organization, and how people in the organization talk about teaching and learning in an art form, before you go about crafting a detailed assessment plan. Ask them some of the questions listed above. Ideally, everyone's ideas align, but in practice collaboration is usually messier, especially if all involved are really interested in learning from each other. Taking the time to build mutual understanding is worth it—even if you ultimately decide that working in a particular way with a given organization is not a good fit for you.

Twelve questions to ask yourself about an organization's or institution's assessment criteria and program goals

1. Do I clearly understand the literal meaning of these criteria?
2. Is it clear what these criteria mean to the organization or institution?
 a. Is it clear what is meant by abstract attributes like "creativity" and "critical thinking?"
 b. Is it clear what is meant by the metrics applied to abstract attributes? (For instance, what does "Students apply critical thinking most of the time" mean?)
3. Should I ask for clarification where criteria or goals are unclear?
4. Do these criteria relate to, or make sense for, my teaching and my discipline?
5. If the criteria don't make sense, should I discuss this with program

administration and try to revise them?

6. Should I just take the criteria as they are and attempt to map the assessment of what I do so that it supports the criteria—i.e., fudge the data?

7. Should I modify my teaching to support external criteria and goals?

8. If I modify my teaching, am I sacrificing what I have to offer in the first place?

9. Are these criteria or goals really in conflict with what I do, or are they just vague?

10. If they are just vague, is it merely a question of giving them content by explaining in the appropriate language what I do and what the students do?

11. Will these criteria and goals get in the way of teaching and learning in my medium, or are they just annoying to think about?

12. Would I be better off not being a part of this project? Might I learn a new way of working that could be useful to me?

Don't be afraid of the standards

If you do teaching artist work in schools, it is likely that you will have to reference state education standards in the arts and possibly in academic subjects as well. The prospect can be intimidating to some teaching artists. THE STANDARDS can seem a bit like golden tablets enshrined in a cave somewhere near the state capitol, and written in an archaic tongue spoken only by EDUCATORS.

In fact, although education standards vary a lot from state to state, they generally need not constitute a major impediment to teaching the way you teach. Most arts standards ar;e quite general and vague; almost anything you do in the arts can be understood as meeting at least several and often many of the criteria in the standards.

Many arts standards are interesting and useful and were compiled by people who know something about teaching in specific disciplines. These standards can be a resource or at least a spur to curricular ideas for teaching artists; they can also provide you with language to describe what you do in terms that make sense to teachers and school administrators. Other standards give strange weight and priority to abstract activities and behaviors like "analysis and evaluation of aesthetic qualities;" such things are often given the same weight as learning the skills of actual art-making. Some standards are so jargon-laden that they are incomprehensible or seem just plain irrelevant or dumb.

There is often a huge disconnect between what exists in the standards and what exists in public schools. Standards may suggest complete, balanced curricula in the arts, or across a "common core," but it is increasingly uncommon

to find a school in any but the wealthiest districts that has the resources and teachers to fully or effectively implement such curricula. For a teaching artist, responding to the standards is often an exercise in cross-referencing what you already teach. This is another case in which your clear articulation of *what* you teach at the planning stage, and clear articulation of your curriculum at the writing stage, can really help. Keep in mind that even if your students' work is primarily about art-making, it may also relate to academic standards. If they are dealing with shapes, patterns, measuring, thinking three-dimensionally, writing, speaking in discussion, in critiques or in presentations, many academic standards may apply, and it is generally to your advantage to document this. This is by no means a hustle. Work in the arts really can engage the full range of human cognition and intellection, and the skills of the artist are applicable and used in different ways in most disciplines. Cross-referencing standards that are not directly related to your artistic goals is simply to recognize and advocate for the fact that it is in actual art-making—not in making art merely as a means to another end—that many different types of learning take place.

The specifics of how to cross-reference your curriculum will vary greatly depending on your discipline and methods. We'll provide an example here from one of Nick's projects in a public high school.

An example of mapping teaching artist work to education standards

The project described here was one I (Nick) did under the auspices of, and with funding from, Chicago Arts Partnerships in Education. It was a collaboration with my friend and colleague Leo Park, the orchestra teacher at Northside College Prep, a public magnet school in Chicago. The project was about as far as one can get from something designed to satisfy state standards, general educational criteria, or even conventional arts education goals. As a musician and recording engineer I saw it develop out of my own curiosity about the relationship between the objective characteristics of music and the construction of taste, as well as my desire to see what a group of high school students would do, think and make in response to a near-absurd musical-technical-conceptual challenge. It also developed from Leo's own curiosity about cross-genre music categorization and from his observation that his students were fascinated by his discussion of how The Music Genome Project informed the software of the Pandora site.

Here is how we described the project in a summary that is part of the documentation we completed for CAPE (a few details are added here for clarity). As you can see, the standards were the farthest things from our minds when we planned this project.

Project Title
"Bad Music Detector: An Experiment"

Who
Music teacher Leo Park, musician/audio engineer Nick Jaffe, and a group
of students in grades 9–12 with no formal musical training.
About the School
Northside College Prep (CPS) is an academic magnet high school. The
students in this unit were participating in a year-long World Music history
class that they chose instead of a performance class. A few of the students
play music outside of school (in bands, for example), but none admitted
to any formal training and most considered themselves "nonartistic" and
"nonmusical." Their work on this project suggested otherwise.

Overview
A group of 9th–12th graders in a class they were taking to avoid music
performance classes was asked to design a "machine to detect bad music."
No other guidance, direction or structure was provided. The students self-
organized into three groups based on their different views of the question.
Over the next nine sessions they built two machines and a mockup of a
third. One machine was ostensibly arbitrary (a response to what the stu-
dents considered the absurd proposition) and involved a robotic sculp-
ture that incorporated functioning headphones, additional electronics,
and a Magic 8 Ball that would pass through the body of the sculpture and
emerge with an answer to the question, "Is this bad music?" One machine
was "social," and made use of a carefully and systematically selected panel
of human "judges" and a randomized polling system. The mockup was
of an "objective" machine that analyzed a range of musical characteris-
tics and dimensions, both quantitative and qualitative, in order to detect
"bad" music. On their own initiative students also completed a "behind-
the-scenes" documentary about the project that included discussion and
commentary on the themes of the project as well as funny and spontane-
ous footage of the students working.

Inquiry

1. Is there such a thing as "bad music?" If so, what defines such music?
2. Is it possible to construct algorithms and design real or virtual machines
 to identify "bad music?"
3. What can be learned about music, culture, technology and musical
 experience through the attempt to design the "machines" mentioned
 above?

Findings

1. "Good" and "bad" are emotional and subjective characterizations by definition.

2. No SOUND is inherently good or bad.

3. It is possible to design real and virtual machines to identify "bad music," provided that the question is understood as complex, human, and to some degree absurd.

4. A great deal can be learned in the attempt to design such machines—perhaps most notably that music is experienced contextually and can be experienced in many subjective and objective dimensions.

As part of the project documentation we were required to list which Illinois state education standards in the arts and other subjects we addressed in this project. What follows are the standards we listed, with explanatory notes in italics that I added for the purposes of this book.

Standards Addressed

Fine Arts

25.A.4 Analyze and evaluate the effective use of elements, principles and expressive qualities in a composition/performance in dance, drama, music and visual arts.

25.A.5 Analyze and evaluate student and professional works for how aesthetic qualities are used to convey intent, expressive ideas and/or meaning.
Students discussed and analyzed a wide variety of music in great detail from many different perspectives. Novel and profound insights about the gestural, rhythmic and harmonic dimensions of music as they relate to context and affect emerged from this discussion and in some spontaneous writings by the students.

25.B.4 Analyze and evaluate similar and distinctive characteristics of works in two or more of the arts that share the same historical period or societal context.
In an attempt to more clearly delineate objective and subjective characteristics of music students made numerous comparisons to, and analyses of, works in other media, especially film and television.

27.A.4a Evaluate how consumer trends in the arts affect the types and styles of art products.

27.B.4a Analyze and classify the distinguishing characteristics of historical and contemporary art works by style, period and culture.
Discussion, debate and design work on the machines often revolved around questions of genre, style and commercial and cultural construction of tastes.

Math

9.A.4a Construct a model of a three-dimensional figure from a two-dimensional pattern.

9.A.4b Make perspective drawings, tessellations and scale drawings, with and without the use of technology.

9.A.5 Use geometric figures and their properties to solve problems in the arts, the physical and life sciences and the building trades, with and without the use of technology.

9.B.5 Construct and use two- and three-dimensional models of objects that have practical applications (e.g., blueprints, topographical maps, scale models).

In constructing the "arbitrary machine" sculpture and the mock-up of an objective machine students used a wide range of design, carpentry, model construction and electronics assembly skills, many of them self-taught "on the job" specifically for the construction of this project.

8.B.5 Use functions including exponential, polynomial, rational, parametric, logarithmic, and trigonometric, to describe numerical relationships.

In designing the mock-up of the "objective machine" students developed a number of trigonometric models of rhythmicity/arrhythmicity in an attempt to quantify the questions "When is a rhythm too irregular to groove?" and "When is a rhythm too regular to groove?"

Science

11.A.4f Using available technology, report, display and defend to an audience conclusions drawn from investigations.

English Language Arts

3.A.5 Produce grammatically correct documents using standard manuscript specifications for a variety of purposes and audiences.

3.C.4b Using available technology, produce compositions and multimedia works for specified audiences.

The students had to regularly report on the progress of their machine design and construction and entertain questions and criticisms from the class. The students also produced a series of written documents and a documentary that explored in depth the themes and questions posed by the project.

It's important to note that neither Leo nor I had any idea what would happen when we posed the challenge of constructing a bad music detector to the class. We did not know in advance which, if any, state standards would

be addressed in the students' work. But because the students engaged fully and enthusiastically with the question and brought depth, inventiveness and ingenuity to the work, and because the project and the machines they constructed were very much their own, they learned many things, generated new and important insights about music, and created three highly unusual and provocative pieces of art.

If your students are really invested in original art-making and you've taught them some concepts and skills that can help generate original work, it is almost guaranteed that they are engaging a wide range of skills that you can cross-reference to the standards.

DOES MY TEACHING WORK FOR ME?

It's become an article of faith in the teaching artist field that working as a teaching artist informs and supports one's own art-making practice. But whether and how such a dynamic plays out can vary greatly from one teaching artist to another. There are teaching artists whose work is very much influenced by their teaching; for others there is little if any cross-pollination. Teaching artist work can make an artist want to run from the classroom to the studio to pursue ideas that came up with students or in the course of teaching. But when it is low paid, time consuming and mired in bureaucratic and political hoop-jumping, it can be alienating and an obstacle to one's arts practice.

The question "Does my teaching work for me?" seems at least as important as any of the other questions addressed in this chapter. If your teaching is not at least indirectly supporting your work as an artist, why do it? If it is not fun, fulfilling and inspiring much of the time, why not take a different day gig? Conversely, if it makes your work and life as an artist materially and artistically rewarding, how might you make it even more so?

The question of what you draw from the work also bears on your students and collaborators. If you are enthusiastic and engaged by the work as an artist, this will translate into enthusiasm and engagement on the part of student artists and colleagues. Conversely, if it's a grind, it will be hard for you to create and teach curriculum that excites and engages students.

The following list of questions is designed to help any teaching artist think through how the work may be affecting his or her work as an artist, and how this impact might be maximized positively. Many of the questions apply to artists who are currently teaching, but they may be useful to consider even if you are not teaching.

Questions about whether your teaching artist work is supporting your arts practice

- Are you having fun?
- If you didn't need any money, and wouldn't be undercutting anyone else, would you be doing this work for free?
- Do you make more work since you've been teaching?
- Is your work different since you've been teaching?
- Is your work better since you've been teaching?
- Does teaching sap your mental and physical energy? Does it increase it? Both?
- Does teaching make you feel more connected as an artist?
- Do your students feel like colleagues of a sort?
- Do you feel you are part of a community of teaching artists?
- Do you even want to feel part of a community of artists or teaching artists?
- Are there things in and around teaching artist work that are alienating to you as an artist?
- Do these things inspire you to make work or change things?
- Do these things make you want to quit teaching artist work?
- Have you met interesting people and made new friends through teaching artist work?
- Have you developed long term artistic, collaborative and social relationships with colleagues and students through this work?
- Is the work actually paying the bills?
- Does this feel good—like you are doing what you love and it's paying the bills too?
- Does this feel oppressive—like you have to do this to pay the bills?
- Does the term "teaching artist" or "professional teaching artist" make you slightly nauseated, or does it just feel funny?
- Can you do the work without identifying yourself by any particular label, or with your own label?
- Do you look forward to teaching?
- Are you anxious about teaching?
- Are you both eager and anxious about teaching?
- Are you learning things about your medium through your teaching?
- Are you learning things about teaching and learning through your teaching?
- Are you learning things about art, people, culture, and the world through your teaching?
- Are you learning things about other disciplines through your teaching?
- Are you learning things about yourself as an artist, thinker, teaching art-

ist, and person through your teaching?

- Do you want to learn anything in particular through your teaching?
- Is teaching making you overthink art-making?
- Do you like to talk or write about your teaching artist work and your students?
- Are you enjoying this book and/or finding it useful?
- Why or why not? (Please tell us—see *Teaching Artist Handbook* contact info in the introduction).

DOES MY TEACHING WORK FOR THE FIELD?

A brand new teaching artist can innovate and advance practice

Teaching artist work is not based on a particular methodology or body of established expertise. As Jim Daichendt's historical essay later in this volume explains, there have been many advances and innovations in art teaching throughout the history of European and American culture. Although teaching artists draw on a range of traditions and precedents, our practice as individuals and collectives is as varied and original as the art we make as artists. To posit a hierarchy of beginning or "emerging" teaching artists who are less effective, inventive or capable than "expert" or "master" teaching artists is problematic in a number of ways. As in teaching, or indeed in any discipline, there are insights and capacities that come only with experience, but these are not decisive. More important to successful teaching artist work is some solid grounding in your discipline (having something to teach), some ideas about how to teach what you know, and an enthusiastic, open and self-critical approach to teaching. Nick says that he did some of his best teaching artist work very early on, before he even knew he was a teaching artist. Artists who have just begun teaching have done some of the strongest and most compelling work we've seen. And while experience can strengthen one's practice, it can also ossify it or even diminish it. In contrast, Becca has seen her teaching grow and strengthen over time as she has become a better poet and increasingly shed her anxiety about being a good teacher. Her ability to be herself in the classroom as a poet has allowed her to be a much better teaching artist. Early on in her career her teaching was stunted by her sense that she had to be just like classroom teachers in order to be a good teaching artist.

Teaching artist work is more akin to art-making than it is to teaching mechanical engineering. Good teaching in either discipline shares certain features, but engineering is a discipline that in most cases requires mastery of a vast store of specialist knowledge before one can consistently and reliably

innovate technique and develop new knowledge. In teaching artist work one is not applying a body of specialist knowledge in "teaching artistry" so much as applying one's expertise and experience in a medium, in a teaching context in which the emphasis is on practice in that medium. Many methodologies have been proposed and applied in this field, but so far none predominates, and with good reason—there is no clear theoretical or methodological frame that fits or systematizes the wide variety of successful practice. No one knows the "best way" to do this work, any more than anyone knows the "best way" to make art. Existing theories and methods have in many cases yielded valuable insights, but it is a great strength of the teaching artist field in the U.S. right now that it is not standardized and not overly professionalized. The hybrid and fluid identity of the teaching artist is key to the vitality and inventiveness of teaching artist practice.

Although the teaching artist practice has been around as long as art, the field in the U.S. has a newness and openness which we hope will remain a defining characteristic. Just as you do not have to study for years to begin work as a teaching artist (you can start right now!), you do not have to have years of experience before what you are seeing, learning and experiencing in your work will matter to others. In fact, it is precisely the voices and insights of newer teaching artists that the field needs in order to develop its particular strengths. These newer teaching artists are in some cases closer to the experience of being a student, and perhaps also to the sense of being "just an artist."

This means that even the newest teaching artist can bring innovation to practice and contribute to the field from day one. Forums for the discussion of practice and informal collectives and organizations of teaching artists are for the most part inclusive and open to teaching artists in all types of practice and at all levels of experience. The *Teaching Artist Journal*, the leading publication of the field, actively encourages new and previously unheard teaching artists to publish about their work and contribute their insights.

It's also important to recognize that the way we think about and do teaching artist work in the U.S. is, for better or worse, profoundly shaped by our cultural, political and economic terrain. The teaching artist works as a hybrid professional from outside schools and institutions in large part because arts teaching as a permanent and stable part of such institutions is increasingly rare. This is not the case in many other countries. In America some teaching artists see their work as closely linked to social and political struggles and causes; in many other countries such struggles and causes largely define the work and the field. Unique aspects of our national terrain have resulted in certain strengths of teaching artist practice, but also in some deformations. Studying, connecting and collaborating with teaching artists across countries, continents and cultures is exciting and enriching. It is also essential if we are to understand our own work in context and advance our thinking and practice not just in art teaching but in art-making. When we think of "the field"

as something we belong to or contribute to, or are just aware of, we should be thinking as broadly and as globally as possible.

We should also remember that the insights that artists gain in teaching have long been of interest and use to many other disciplines. In recent years in the U.S. there has been particular interest in teaching artists' educational insights that derive from their highly active, student-centered approach to teaching. But since artists (teaching artists and student artists) work with a variety of materials, techniques and concepts, often in very experimental ways, there is no limit to the kinds of knowledge and innovation that can come out of teaching artist work. The ways students use digital cameras or audio production software should be of interest to the engineers that develop them. A long-term teaching artist project led by our friend and colleague Mary Hark in Ghana unexpectedly resulted in a highly innovative partnership between biologists and teaching artists that involved the use of an invasive species as the pulp source for fine art paper making.[3] If we think of our field as broad and synthetic, with connections to many ways of thinking and working across numerous disciplines, the possibilities for exchange of ideas and practices are virtually endless.

So when you do your teaching artist work, whether you are (or feel like) a veteran or a novice, consider that the things that you are discovering and inventing may be of great use to the rest of us. That doesn't mean you should feel obligated to share all of your insights—it means only that if you want to share them, many of us will be interested and grateful to know about your work and what you are learning.

Ten questions about how your work is probably useful to the broader field

1. Do you know of anyone teaching exactly the way you teach?
2. What is specific to your teaching?
3. Are you learning things that you think might be useful to other teaching artists?
4. Do you have questions that you would like other teaching artists to address?
5. Have you drawn ideas and methods from other teaching artists?
6. Have you discovered interesting precedents and historical sources that have informed your teaching artist work?
7. Do you have things you'd like to say about the work or the field, but you don't feel you have enough experience or authority to say them? (You do.)
8. Are you working in ways that involve knowledge, materials or practices that are also used in other disciplines and fields?

9. Are you curious about how people teach in your discipline in other regions, countries and cultures? Do you think people elsewhere might be curious about how you teach?

10. Do you rant to yourself or others about things that you think need to be changed in the teaching artist field, in arts education, or in education generally?

Some ways you might share your work with the broader field

- Visit someone else's classroom or program in your city, in another place, in another country or on another continent. Learning about someone else's work is sharing your work
- Organize or join an informal or formal group of teaching artists (in person or online) to share ideas and insights. This might even lead to collaboration, one of the best forms of sharing work
- Organize or join an informal or formal network of teaching artists in a discipline, region, or country, or across countries or continents. The network's focus could be:
 - Shared premises or ideas
 - Ways of working
 - The contexts in which you work
 - Concerns you have about the work or the conditions in which you work
- Organize a formal or informal meeting, discussion, symposium, institute, or happening that is local or international (perhaps via Skype) to:
 - Discuss a question or issue in the work
 - Discuss particular student work and the teaching context it came out of
 - Discuss the conditions in which teaching artists work
- Write about your work:
 - Online
 - Blog
 - Teaching artist discussion sites (ATA listserv, tajaltspace.com, *Teaching Artist Journal* Facebook page)
 - In the *Teaching Artist Journal.*
 - In arts or education journals
 - In journals of professions or disciplines that relate to your work—if you teach kids using botanical skills and knowledge, botanists might like to know about your work
 - Respond to writing by other teaching artists online and in print
 - Write a book. Think you can do better than this? Go ahead and try!

Does My Teaching Work for My Medium or Discipline?[4]

One of the premises of the great modernist art and design school called the Bauhaus was that all human beings are talented—capable of original and powerful expression in any medium given the tools. Modernism also reaffirmed the idea that technique and expressive ability are not the same thing and that therefore children and inexperienced artists are as capable of powerful work as the most experienced practitioners. What the development of technique allows is a greater *range* of artistic expression or solution of creative problems, but it does not guarantee this.

It should also be a premise of teaching artist work that students of all ages are "real" artists and that their work is real art. Fourth graders working entirely on their own in a digital recording studio and having only recently learned some basic skills in audio production have made some of the most original, strange and compelling music that I have ever heard. This music is remarkable not only for its originality and aesthetic power, but also for the way it was made. The methods that a fourth grader in a Chicago public school will stumble on can represent genuine musical and technical innovations. I am thinking of one of a thousand examples I was lucky to experience in my work as a teaching artist: A fourth-grade girl recorded a beat using a popular technique of fist and pencil on desktop. She then applied a dynamic filter effect in the audio production software that resulted in a sound quite different from any I have heard to date—a highly evocative sort of whistling, popcorn-like, rain-spattering beat. The student then combined this with some rhymed verses and fragments about her cousin's high school graduation, versification that combined schoolyard or double-dutch rhythms with a unique affect and phrasing specific to this young artist. The way this beat worked in the context sounds even fresher and more shockingly original to me today than it did when I first heard it nine years ago.

If our students are making original work, then they are also capable of developing new techniques, concepts and even theoretical insights into the media and disciplines in which they work. One of the most powerful things about the Bauhaus and Vkhutemas, the "Soviet Bauhaus" of the 1920s (see Jim Daichendt's historical essay later in this volume), is that although they were teaching institutions, they engaged students as innovators in a wide range of disciplines and fields. The work that students did in the Bauhaus first-year courses and workshops had, in itself, a huge impact on modern design and represented important practical and theoretical advances in art-making and design. There is no reason why we should not view every teaching context with students young and old as a chance to develop new thinking and practice in art. If teaching artists create contexts for real experimentation and provide the tools with which to pursue such experimentation, students will learn things that are of use and of interest not only to them, but to all of us. The joy of such

discoveries is among the most exciting and fulfilling things about teaching artist work.

ENDNOTES

1. Portions of this essay originally appeared in *The Teaching Artist Journal* (Routledge/ Taylor and Francis) issue 9(2). It describes a particular session in The Museum of Contemporary Photography's Picture Me program, which provides intensive training in the medium of photography to 60–80 teens in three Chicago high schools per year. Participating students also take field trips to the MoCP and other cultural institutions, meet with professional artists, and publicly exhibit their work.

 The Senn/Rickover High School Picture Me program mentioned in this essay is presented in partnership with After School Matters with support from Sterling Goodrich, Tobias Emms, and Mary May. The teaching artist is Daniel Shea and the Program Manager is Corinne Rose.

2. *Looking at Student Work* as it is described here grows out of work developed by Steve Seidel of Harvard's Project Zero and has been adopted by many educators around the United States. Seidel's Collaborative Assessment Conference, in which a teacher presents student work to a group, is distinguished from other protocols that look at student work in that presenting teachers say nothing to explain the work or its context until after the participants go through all the steps in the review process. This practice allows observers to keep their understanding of the work at hand separate from what they might know or assume they know about the students. It also allows you as a teaching artist to gather observations about aspects of the work that might otherwise have escaped your notice.

3. For more information about this project see Becca's article "Teaching Artists in Global Contexts: A Consideration of a Papermaking Project in Kumasi, Ghana," *Teaching Artist Journal* 10, no. 1 (2012): 61-69.

4. Note: This section is all Nick.

part II

CONTEXT

Who, What, How, Why and Where (Do We Go from Here?): The Teaching Artist in Context

BARBARA HACKETT COX

WHO MAKES ART? WHY MAKE ART? WHEN, WHERE AND HOW DOES ART-MAKING HAPPEN?

I tried to keep these questions in my mind as I took on this task of talking about teaching artist work, art-making, and where, when and how it happens in the world of arts education. By addressing many of the questions already posed in this book but through the particular lens of my personal experience, I hope to offer a way to better understand the terrain of teaching artist work in the United States over the last thirty years, and also to offer some specific examples of how the different dynamics of this work play out. Arts education is defined in a number of ways. People experience different aspects of it, and everyone brings his or her own perspective to the work. It is easy to get bogged down or lost in generalities when talking about such a huge topic, particularly when the politics of school reform, the arts world and funding enter into the picture. It is easy to lose sight of the importance of making art when we talk about teaching artists and where they fit, given the current trends and fads in arts education.

I thought I would look at it from my own personal experience of 30-plus years in education and try to keep the idea of art-making at the center. I would like to think that I have learned a lot and will continue to learn even more. Writing this kind of handbook with colleagues and for colleagues has only pushed my thinking and opened new vantage points as I continue my own work with artists, arts organizations, and schools. Keeping students (of all ages) and art-making at the center is key!

Over the course of my life I have been a student of the arts, a teacher of the arts and an active administrator and connector of various arts programs. This experience has shaped how I define and support the work of teaching artists.

As I reflect on my first years as a teacher—in public schools in San Francisco, Los Angeles and Oakland, and later New York—I recall programs that were developed by nonprofit organizations such as the Junior League and Young Audiences, programs created to bring culture through mainly classical music performances to elementary and secondary schools. These programs were successful, and theater, dance, and visual art were added to them. Bringing professional artists into schools served two purposes: The students were exposed to "culture," and the artists had another form of employment.

Providing more equitable access to the arts is a laudable goal, and I could certainly see the need for more access to the arts in the elementary schools in which I was teaching. But I also saw how easy it was to dumb down some of those experiences, or worse yet, make the huge assumption that students—in this case, African American students in segregated schools—lacked culture in their lives.

A lot of assumptions are made about arts and culture and about who has culture and who doesn't, particularly when we talk in terms of our K–12 education system. With all of the school reform initiatives I have seen since 1970, it is astounding to still see the racism and cultural bias deeply embedded in schools, in many organizations and in the minds of individuals who say that they want to improve our schools. Early on in my own ignorance about such matters I gravitated to the arts and art makers as a means to better reach and teach the students with whom I was working. It still surprises me when I hear someone talking about the racial achievement gap as if it just happened. And although I do believe that the arts do make a difference in the lives of students, I worry about the way the so-called leaders in the arts education field make claims as though the arts are *the* answer—the silver bullet that will miraculously wipe away the achievement gap.

What if the arts experiences are lame? What if the arts curriculum and content are culturally biased or racist? What about the challenges of doing good arts integration? How effective are the arts if they are watered down so much they lose artistic integrity or are far removed from the art-making? I have seen artists with a strong focus on teaching in an art form produce a clearly positive impact on literacy, only to be pulled so far into the literacy work that they forget that the quality experience they bring in the art form is crucial. When there is quality teaching in the arts, the impact can be profound. But if we diminish the "in the arts" part of the teaching and learning (the art-making), we lose big-time.

I recently attended a board meeting of an agency charged with granting funds for community and school-based arts learning with a focus on cultural, heritage and legacy funding. The board members talked about ways to measure the impact of this new influx of funding. I can't say I was surprised to hear the assumptions made regarding arts, culture and audience and the potential improvement these funds might have on the lives of people who don't have

equitable access to the arts. One board member suggested that they conduct a pre and post survey of low and middle income residents of a predominantly Hmong neighborhood to see if the number of families attending theater performances at a rather large and prestigious arts organization located in another city (approximately twenty miles away) increased as a result of the increased funding to the theater. It didn't occur to anyone on the board that they might also want to consider the fact that there were two Hmong arts organizations within a 4-mile radius of this predominantly Hmong neighborhood that offered their own arts programming for the community which includes Hmong and non-Hmong residents. What about supporting their community-based and school-based work and increasing their audience to include people from across the greater metro area? What about encouraging more cross-cultural collaborations?

What assumptions do we make about the arts, culture and race, particularly as these things relate to student learning? What hidden assumptions and bias surface when we consider bringing culturally relevant learning experiences to our students? What does "culturally relevant" actually mean? Is it a concept that can sometimes lead us to make assumptions that end up limiting what students have access to because we think we are providing them with a "culturally relevant" experience? I once worked with a teacher in an alternative high school for "at-risk" students (more labels!). She mentioned to me that she wanted to provide her students with art experiences that would counteract their "inappropriate life experiences." Inappropriate life experiences? Compared to what, her own? What assumptions were being made and what messages were constantly being sent to the students in that classroom? And who determines what is and is not relevant?

It is a slippery slope to navigate. I think back to one of my early assignments as a classroom teacher, an experience that shaped the way I would explore my own lifelong commitment to teaching and learning. I quickly realized how little my preservice training had prepared me to face the huge responsibility of teaching the thirty-four students in my second-grade classroom. There I was, an idealistic white woman teaching in a segregated school with a predominantly black student population of K–6th-grade students. (The percentage of teachers across the United States who are middle class white women has not changed much since then). I was the sixth teacher assigned to this class and it was only November. As I looked at the textbooks and other resources I had in my classroom, there was something that stood out right away. It didn't matter whether the subject was reading, math or science. My students did not see themselves or people like them in any of the stories and historical content in the school curriculum. Not only were many of the available materials culturally biased and racist, there was little if any content that students found connected to their lives outside of the classroom. The inaccurate and negative portrayals of nonwhite characters and historical figures as well as the total

exclusion of significant events, both past and current, seemed major barriers to student success in the classroom.

Thankfully, I had my own background and experience in the arts to draw on as a way to begin to tackle this problem. Through various arts experiences, I saw ways to bring into the classroom multiple stories and perspectives that connected to the lived experiences of my students as well as stories that provided experiences different from their own. My access to many arts resources became the foundation for much needed alternative curriculum content. I looked to local artists, as well as nationally and internationally renowned artists passing through on tour. Arts organizations, cultural institutions, museums and performance venues were beginning to offer programming for schools and community artist-activists who created after-school arts programming in a variety of settings. Through my work as a field producer for a National Public Radio program I had access to archives of audio/visual recordings of music and arts reflecting a variety of cultural contexts; these recordings served as an excellent introduction to and connection between my students, visiting artists, and community arts programs.

Over the years, my teaching took me to different schools in various communities across the United States. Each setting brought new challenges, and my work with artists and arts organizations continued to evolve. No matter where I was working, increasing access to the arts for students, schools and communities became central to my work.

MY BACKGROUND AS A LEARNER IN THE ARTS

I experienced learning in the arts and about the arts in a variety of ways from a very young age. The public schools I attended in Stockton, California offered art courses throughout the K–12 system. There were offerings in band, orchestra and choral music as well as a range of offerings in the visual arts: sculpture, painting, drawing, clay, etc. In the secondary schools, in addition to the music and visual art offerings, there were some very strong theater programs as well as a smattering of dance programs. Fortunately, strong K–12 arts education programs were quite common across California in the 1950s and 1960s. Unfortunately, this would change by the mid-1970s.

A culturally diverse community in Central California, Stockton offered a number of venues that brought local, national and international dance, theater and music performances to the community. By the time I was a teenager, I had attended numerous live performances by such artists as Duke Ellington, Andrés Segovia, Alvin Ailey Dance, Stevie Wonder and James Brown.

I grew up in a family of professional music, dance, theater and visual artists, so I had the opportunity to see firsthand what it looked like when someone was creating work, performing, practicing and teaching. I learned from

observation of each person's process, which varied greatly depending on the discipline, as well as through structured lessons. I didn't realize my great luck to have practicing artists right in my own family and to have access to formal training through my Aunt Betty's dance studio and theater program and my Uncle Royden's painting and drawing classes, which he taught through a local gallery.

Although my father worked a normal day job all his life, he was also a working musician. Weekends and evenings at our house were full of rehearsals and jam sessions that gave me an extraordinary view of the various ways musicians work—as composers, arrangers, leaders and performers. Lessons for younger musicians didn't happen formally, but lessons were learned. Aspiring musicians knew that our house was a place to learn by observing, listening, talking and at times doing. They could observe the more experienced players working out ideas, and they could also play side by side with them. My father had just a few classes from a local music conservatory under his belt, didn't consider himself a formally trained musician,and never professed to be a music teacher. But he certainly provided the space and the opportunity for a lot of learning to happen, and I learned a great deal about music and teaching in that space, things that served me well when years later I chose teaching as my profession.

Perhaps one of my most memorable experiences was when I got to attend a music clinic held at the University of the Pacific, a private Methodist college boasting a world-renowned music conservatory. Because of my father's membership in the musician's union and his connection to many of the young music teachers and students, I found out that the great Cannonball Adderley, educator, musician, band leader and community activist (his latest recording at that time, "Country Preacher," was connected with Operation Breadbasket, an organization dedicated to improving the economic condition of black communities across the U.S.), would be leading a clinic for college students. It seemed odd that a clinic led by this internationally renowned artist and educator was being held in a Quonset hut located out back, behind the buildings that held the performance hall and music rooms where the conservatory classes and workshops were usually held. In spite of the less than adequate space and equipment, the group played, talked, responded to questions, played some more and engaged in dialog with anyone and everyone who was gathered around. It was an intimate setting, and it felt like I was sitting in on a rehearsal, watching musicians work out some ideas, discuss them with each other, entertain questions, listen to feedback, share openly what they knew and what they didn't know and make their art-making transparent to all present. Every person in the room, no matter their level of experience as a musician or as a listener, felt connected to what was taking place. I learned so much from the various ways that the teaching and learning was happening, including the more specific questions coming from the most experienced musicians (stu-

dents at the conservatory and professional musicians from across the region). It was also a defining moment for me to see artists like Cannonball Adderley and his brother Nat go about their work in such a personal way for a cause that meant a great deal to them.

Years later this experience came back to me and helped me shape my own practice as a classroom teacher and my work bringing teaching artists into arts education programs. Little did I know that this clinic experience would provide the foundation for my own work in arts education—as a teacher, as an arts administrator and as a builder of bridges between artists and educators.

"WHICH ONE'S THE PRESIDENT?"

I received a teaching credential from California State University San Francisco in 1975. I had no idea that this new multiple-subjects credential program, which worked well for me as a general classroom teacher, had reduced requirements for arts preparation courses. This meant fewer arts specialists and less funding for arts education programs. As I entered my first years of teaching, a change in property tax policies in California resulted in deep cuts in public school funding, which in turn led to major setbacks for arts education. Thankfully, I had added to the rich arts learning experiences of my youth with college courses and a wide range of quality arts experiences to which I had access in the communities where I lived and taught: Northern, Southern and Central California. I realized quickly how little my preservice teacher training program had prepared me for the classroom. My own arts experiences became an incredibly valuable resource to draw on as I made my way through my first years of teaching.

It was November of 1978. I had just started my second-ever teaching assignment in a second-grade classroom in South Central Los Angeles. I was the sixth teacher to take the assignment since the beginning of school in September. The entire school attended a performance featuring a brass quintet. The performance was presented by an arts organization that had been founded by the Junior League of Los Angeles in the early 1970s; it was one of the first nonprofit organizations to provide arts education for Los Angeles Public Schools. The 900-plus K–6 students who filled the auditorium weren't very impressed as the members of the brass quintet took turns modeling the sound of their instruments while the group's conductor introduced each instrument by name. The name of each instrument also appeared on the front of each musician's shirt. After a short, not particularly interesting performance the assembly ended. Not only did the performance lack any artistic quality, there was no attempt to connect it to any possible art-making experience for the students. I was quite surprised, perhaps naively so, at the possibility that this might be the extent of the arts resources available to the staff and students.

There didn't appear to be any arts specialists on staff, and there were very few, if any, art and music resources available in each classroom.

As it happened, I had access to a recording and a photograph of President Jimmy Carter standing onstage with drummer Max Roach and trumpeter Dizzy Gillespie as they performed the tune "Salt Peanuts" at the June 1978 Jazz and Jambalaya festival, a tribute to jazz held on the South Lawn of the White House. I posted the photo on the classroom bulletin board and played the recording. The students listened intently and looked at the photo, then asked to know which person in the photo was the President. Here was a teachable moment.[1]

THE QUESTION OF DEFINITIONS:
Arts Education, Arts in Education, Arts Integration, Arts Infused, Learning in and through the Arts, Arts Learning, Interdisciplinary Arts Education. . . .

I have since seen art-making taught in many different places: schools, parks, community centers, arts organizations, museums, cultural centers, street corners, living rooms, neighborhoods, prisons (state, federal, youth authorities, etc.) and health care facilities (hospitals, senior centers).

I have seen art-making taught in a number of ways by amazing teachers and teaching artists who can walk into almost any situation, no matter the space, time frame or audience, and know just where to start and how far to take the work. I have also seen teaching artists and teachers who require a specific space or time frame and who expect that participants have a certain amount of prior knowledge and experience in preparation for the lesson. Both approaches are valid. What is important is that the teaching artist know what she is going to teach and how she is going teach it, and that she be able to articulate clearly what needs to be in place for the art-making to happen.

Let's stop for a moment to consider the ways that the terms "art" and "arts education" might apply in different cultural contexts. In spite of the clear truth that all cultures and peoples make art, perceptions and definitions of what "art" is are still seriously warped by all kinds of colonial, racist and classist attitudes, both popular and institutional, and these attitudes inevitably affect arts education in the United States.

Arts education is typically defined as instruction and experiences in which the arts are treated as separate disciplines. Some may call this "education *in* the arts." Arts integration is defined as instruction in which arts-related concepts and activities are infused into other academic areas. Some may call this "arts infusion" or "education *through* the arts." If you look at arts education research over the past twenty years or so, you can see the influence it has had on trends in arts education programs and arts advocacy. More and more, the emphasis

has been on everything but art-making. It is as if the art-making, which at the outset had captured the interest of many reformers and researchers, got lost in the rhetoric about the power of the arts to teach "twenty-first century skills" and virtually every academic content area other than the arts. The push toward arts-infused curriculum or integration of arts across the curriculum has increasingly meant in practice that the actual learning in the arts is often diminished or almost completely obscured.

In attempts to define arts education two large categories often come up: community-based arts education and school-based arts education—as if the school were somehow separate from the community! Sadly, that is often the case: What happens during the school day is completely separate from what takes place outside of the school day, even when the programming happens after school in the school building.

"Arts learning" is a term that is currently used, particularly in the state arts agency world, to emphasize the need to make "lifelong learning" experiences accessible to a broader audience, from preschool children to seniors. Those experiences can range from exposure to an art form through a performance, exhibit or event to an introduction to, or in-depth exploration of, how to make art in a medium. This broad definition makes sense if it reflects an intention to provide more access to the arts for the population as a whole, but lifelong learning should not be nurtured at the expense of arts access through school-based programs. Unfortunately, in some cases independent teaching artists and public schools are competing for the same arts education funding as larger arts organizations and cultural institutions with teams of development directors and grant writers.

I have seen this battle play out in Minnesota: standards-based arts education in K–12 settings taught by licensed arts specialists vs. community-based arts learning provided by teaching artists and arts organizations. This should not be an either-or situation. Here is what I know: Even if we are talking only about K–12 and serving students in an equitable way, it is a huge job that takes all the resources we can possibly muster. We need teaching artists and arts organizations, arts specialists and classroom teachers who can create opportunities for people to learn about art and to make better art. These things should happen in as many places as possible, not just in K–12 settings, although school is often the one place where students actually have access to the arts. A well supported and thriving arts community is better able to provide quality arts experiences that will enhance school programs, and better able to provide more equitable access to the arts to underserved communities.

In this increasingly diverse world of arts education we must strive harder than ever to create high quality arts learning experiences for *all* students, without regard to the political contexts in which the work arises—or at least, we need to work hard to ensure that such politics do not interfere too much with

the work. That has been my job as arts administrator. How can I help teaching artists access resources and build curriculum that promotes equity for all learners? How can I support the development of resources and curriculum that do not perpetuate baseless stereotypes? How do I help facilitate the kind of learning that uncovers our own hidden assumptions and bias and takes us into deeper understanding of our world? In my experience, the key is *quality* arts experiences led by artists who have developed knowledge and skill in their discipline before they even consider how to teach it.

WHO ARE TEACHING ARTISTS?

Teaching artists can be experienced artists or new practitioners—provided that they know something about their medium and have some ideas. They can be longtime educators, or new to teaching. They might teach skills, techniques and processes explicitly and sequentially, or they might teach mainly by modeling their own process of art-making or performing. A particularly appealing aspect of teaching artist work is that an imaginative, skilled artist with enthusiasm for teaching can immediately contribute to the teaching artist field at a very high level, both as a practitioner and as a thinker.

Teaching artists might be on staff at an arts organization, a presenting organization or a studio or performing arts program in a school or conservatory (public or private). They might be affiliated with groups where they have gone through a selection process (arts councils, state agencies, nonprofit organizations).

Teaching artists create their own artwork in a variety of ways, and what they teach varies with the discipline and context in which they practice. There are numerous ways of working artistically and a variety of places where the work happens. There are also multiple entry points by which artists enter the world of teaching: a performance, an exhibit or event, a residency—either short or more extended—co-teaching (with another artist or teacher) and deep collaborations that might connect an artistic discipline to other subjects, issues and needs. The work might happen in schools during the school day or after school, or in community centers, prisons, health care facilities, museums, galleries, parks, street corners and studios. It might be geared toward pre-kindergarten–12th-grade students, seniors, incarcerated or institutionalized youth or adults or intergenerational participants.

Artists have a long history of taking on the role of teacher, although not always in what might be defined as a "traditional" educational setting. The very ways teaching artists work are pushing all of us to reevaluate hidden assumptions and cultural biases about how arts education is conceived and practiced, and about how education in general is conceived and practiced.

WHAT DO TEACHING ARTISTS TEACH?

Some artists make things and teach others to make things. Some make art or perform and are then able to talk about their work in ways that help audiences understand it differently. Some artists don't want to talk about their work at all. Some perform or create in ways that provide learners with a solid introduction to the creative process—no talking necessary. There are times when we learn by just watching someone perform or create something. Some artists produce an entire body of work that reveals a process to the viewer or listener.

Teaching artists can also help people experience and learn from other artists' work. A teaching artist might explore a work in its historical, social, political or cultural context with students, or she might focus on a particular technical dimension of a work as a way of introducing a technique for students to try out.

Teaching artists put theory about the creative process into practice. Teaching artists can show the range of ways that people can apply a particular technique or theory or knowledge and skill in an art form. Good teaching artists are able to identify specific aspects of their practice and discipline and break down something that is immediately useful to students as they think about making their own work. It can be hard to find language to describe artistic processes and talk about one's work as an artist. Teaching artists often collaborate with other arts educators and coaches to express more clearly what they see as essential in their teaching, and to find the language to explain it and teach it. In this way artists can provide students with a starting point—a language that they can learn and apply, and in which they can become more fluent and creative as they internalize, adapt and reinvent the processes and techniques of a discipline.

Teaching artists who define their work primarily as that of community activists or therapists must first and foremost be artists who are able to share their art form at a high level of sophistication. If artistic competence and quality are not there as a strong foundation supporting therapeutic, social or political goals, attempts to engage art for a social purpose may be ineffective or even counterproductive.

Does one have to be a great artist in order to be a great teaching artist? Not as long as one can recognize strong and original work in a medium, both in exemplars and in one's students' work. What is essential is that the teaching artist be able to break down the processes of a discipline in a way that makes them accessible to students and that encourages their application in original work. Teaching artists can also supplement their own emphases or bridge gaps by collaborating with guest artists who can model exemplary practice and high quality work as they teach or create/perform with students.

HOW DO TEACHING ARTISTS TEACH

Short term residency: Don't underestimate the power of a one shot deal.

Some artists simply demonstrate aspects of what they do, with the intention of teaching about their work as an artist. In my case as a second-grade classroom teacher, I was incorporating the history of jazz into my daily classroom instruction. Jazz recordings provided great examples of the music for my students. Through my evening work in jazz radio, I managed to connect with a number of historically significant masters of jazz, including iconic drummer Max Roach, who offered to come visit my students. Even though he was nervous about being in front of a classroom of second graders, I knew that through a series of lessons beforehand I had created a context for his visit. Students had already heard his recordings and learned something about his contributions to the development of jazz. He demonstrated "Mr. Hi Hat," a drum technique he had learned from drummer Papa Jo Jones, using just a snare drum and hi hat cymbal. He then taught each second grader how to do a paradiddle, one of the rudiments a drummer needs to know. A single 2-hour visit was a significant experience for those students and a catalyst for them to want to learn more.

World-renowned drummer Billy Higgins grew up in South Central Los Angeles and was one of the most recorded jazz drummers ever. He toured extensively, and whether he was in his own community in Los Angeles or in any of the many places he visited around the world, he always found time to share his music with students of all ages. His visits to my classroom, however brief, were as educative and powerful as any teaching artistry. His impact on my own work in education was profound.

Artist residency: Leaving something behind

A couple of years later, my fourth-grade class worked with a visual artist. Throughout the residency she brought in her own drawings, modeled her own techniques on the chalkboard (yes, chalkboard) and broke things down into manageable, incremental steps as she encouraged students to try out each technique along the way. In the first week of the residency her emphasis was not on a final product. She modeled what it looked like to "mess around" with the different techniques and gave students ample time to "mess around" themselves. As their confidence grew, she added further steps, and the students began to make their own work. This was a very challenging class to manage, but the students were completely hooked. The artist suggested I keep the examples she created throughout the residency for the students to reference

after she was gone. I was able to incorporate much of what she taught into my daily program. Long after the residency ended, many of the students continued to "mess around" and make art.

Long-term interdisciplinary projects

A New York State Council on the Arts (NYSCA) grant brought me to New York to develop and coordinate arts education outreach programs for the Jamaica Art Center (a community arts organization in Queens) and the New York City Youth Bureau (a government agency). One of the projects brought theater and visual artists together to develop and implement an intergenerational arts and social studies program connecting neighborhood schools and senior centers located in each of the five boroughs of New York. The artists worked with fourth- and seventh-grade students and seniors investigating the theme of "transportation" in the past, present and future, as seen from the perspective of both the students and the seniors. The artists worked collaboratively within their disciplines to figure out how to access the participants' stories that might surface and find ways to express those stories through oral, written and visual forms.

There were many things for the artists to consider in this project. Most of the seniors had lived much of their lives in the neighborhood. The neighborhoods were experiencing significant economic and demographic changes, which affected their access to various forms of transportation. Many of the students were new to the neighborhood, and they brought a cultural diversity that was new to the seniors. The artists focused first on their art form as they worked with the students and seniors. The theater artists worked on story and narrative: how to access memories, create stories and incorporate the stories of all participants. Particularly with the youth, the stories looked toward the future; this in turn captured the imagination of the seniors. The visual artists introduced multiple of ways of telling stories visually: through drawing, painting, collage, murals, photography and combinations of different forms. As the participants worked with the visual arts materials, the stories developed further. The project concluded with a public exhibit at the New York Transit Museum in Brooklyn Heights. Seniors, students and artists were on hand to share their stories publicly, through the vibrant murals, the written stories and public story telling by seniors and students alike. Intergenerational programs still exist today as a result of the Jamaica Art Center's education programs.

WHERE DO TEACHING ARTISTS TEACH?

Programs or settings in which teaching artists teach can be structured in a number of ways: in school, after school, in a conservatory or studio setting, and in informal and formal settings. As the diversity of programming and con-

texts for learning expands, there are more opportunities for students to gain exposure to, and create in, many different art forms. The role of the teaching artist can vary within the structure of the program and in the environment in which the learning happens. Whatever the setting, teaching artists bring their ways of thinking, seeing, and doing as artists, their knowledge and their experience with their own process of making art. The work of a teaching artist can enhance or deepen a particular aspect of a curriculum being taught in a standards-based arts classroom, or it can serve as a valuable first-time experience in art-making for students and participants.

School-based programs

California Poets in the Schools

In the early 1980s I moved from Los Angeles to Oakland and worked as a substitute teacher in the Oakland Unified School District, where I was introduced to the California Poets in the Schools program. A statewide program started in the mid-1960s, the California Poets in the Schools program brought artists into more than 200 schools across the state. With funding from the California Arts Council, teachers and poets worked primarily with fifth-grade students from ten schools, utilizing writing exercises from the California Heritage Poetry Curriculum along with historical, environmental and arts resources from the Oakland Museum to create a book of student poems. I found the program to be a great instructional guide for teaching writing. With its emphasis on community resources—from the Oakland Museum to the community-based poet-teachers—the program helped me to think about connecting the arts to history, social studies and science and, of course, the local community.

Jazz in the Classroom, 1978–1995

Jazz in the Classroom was a program that I developed and implemented in public schools in Los Angeles, Oakland, New York State, Minnesota and even China. Locally, nationally and internationally renowned jazz artists participated, often connecting jazz performances in the community to K–12 classrooms. Artists participated in a variety of ways—through performances, in workshop settings and in short- and long-term residencies. Artists worked within general classroom settings and in music classrooms.

In November of 1978 I was teaching second grade at La Salle Avenue School in South Central Los Angeles. I was also moonlighting as a jazz radio host for a National Public Radio affiliate, KCRW in Santa Monica. And it hit me: jazz records (yes, vinyl) and album covers with great stories and photos in the liner notes might help me supplement the inadequate curriculum, textbooks and resources I had found in my classroom. The recording of jazz greats

Dizzy Gillespie and Max Roach, the photograph of them with President Jimmy Carter, and a bulletin board full of jazz album covers constituted my first Jazz in the Classroom curriculum experiment.

I'd grown up surrounded by jazz recordings and live music, so I had an understanding of the historical origins of the music; through music I could make connections for my students to a range of cultural, historical and social contexts. I immersed my second graders in music, starting with West African music, and we worked our way to 1978 and Jazz at the White House.

Something was still missing. They were learning about the music, but they weren't really making any music. I wasn't a music teacher and I wasn't a musician. I needed an authentic voice—live and in person would be great. Thanks to my moonlighting in radio, when Max Roach happened to be on tour in Los Angeles, I was able to approach him at the club where he was playing and invite him to my second grade classroom. He was there the next day.

I continued to develop curriculum that addressed learning about the music as well as literacy. More importantly, I was able to connect with more and more musicians, some from right there in the community and others with groups coming through town on tour. Two of the most influential musicians who worked with the Jazz in the Classroom program long term were Don Cherry and Billy Higgins—both had grown up in the neighborhood where my school was located.

In Oakland the program started in one elementary school and eventually spread to six schools throughout the district before expanding into universities and community colleges throughout the Bay Area. Again, authentic voice was key, and the Jazz in the Classroom network was growing into a list of who's who in jazz: Artists such as Max Roach, Pete Escovedo, Billy Higgins, Don Cherry, Charlie Haden, Count Basie, Randy Weston, Wynton Marsalis, Abbey Lincoln, Chico Freeman, Robin Eubanks and Roy Haynes performed, ran workshops and participated in residencies.

I continued to help the program to expand, and eventually a grant brought me and the program to New York, where I was able to implement Jazz in the Classroom through the Jamaica Arts Center in Queens. The program found its way to Binghamton, New York and eventually landed in Minnesota.

As the program evolved, it became clear that long-term partnerships with jazz musicians reinforced the importance of including the authentic voice of artists. There was art-making some of the time, but the major focus was on responding to the performances—seeing someone else make art.

Community-based programs

Many community-based arts programs started with the Works Project Administration (WPA) and other New Deal programs of the 1930s and early 1940s. Some had their impetus in later programs, like the Comprehensive Employ-

ment Training Act (CETA) implemented during the Carter Administration in the late 1970s. Like the WPA, the CETA program put many artists to work on a variety of public and community-based art projects. There are many organizations and programs still around today that emerged from the WPA and CETA programs.

Community arts programs today are often neighborhood-generated. They include such things as murals and public art installations, artists-in-residence programs and bringing art-making into schools and community settings, where they engage community members of all ages in the art-making process. Local, national and international teaching artists teach community members of all ages in a variety of art forms.

In my own experience with community arts programs connected to schools I can point to Billy Higgins. Billy was a major influence on my Jazz in the Classroom program from the very first year. He lived not far from the Los Angeles school where the program started, and it wasn't unusual for me to see Billy strolling across the parking lot toward my classroom with a big duffle bag invariably full of instruments he had collected on one of his many trips to West Africa, China and India. He wanted to share the instruments with the students. When Jazz in the Classroom moved to Oakland and then New York, Billy went out of his way to stay connected to the program wherever it was implemented. And even as the program moved, Billy stayed connected to all of the schools he visited. I saw firsthand how committed he was to strengthening communities through the arts. In 1989 Billy and poet and community arts activist Kamau Daáood cofounded The World Stage, a community-based organization that linked youths with elders by offering performances, workshops and master classes with a focus on African American music, literature and classic and emerging forms of creative expression.

Studio programs

The studio tradition in performing arts means that students learn, practice and hone their own skills and techniques as dancers, musicians and actors. They learn to work within the context of an ensemble in a final performance and as a soloist. Teaching artists who work in many different genres and forms teach in studio settings.

One example is Voice of Culture, a St. Paul, Minnesota dance company founded by dancer Kenna-Camara Cottman, who is also a dance instructor at The St. Paul Conservatory for the Performing Arts, a charter school. Kenna's company is dedicated to preserving the traditions of West African arts and culture through performing and teaching dance and drumming.

Another example is Luna Dance Institute in Oakland, California. Luna Dance Institute's programming has a number of components, including a strong studio component—a Studio Lab program that teaches modern and

creative dance to 5–17-year-olds. In addition, the institute offers a number of outreach programs to schools and the broader community, including a program through the child welfare system for children and parents. There are also professional development resources available for teachers and teaching artists and additional programs offered at libraries and community centers.

A volunteer-run organization in Minnesota, In Progress, recently opened new studios that provide public access to digital art-making tools, including photo and video cameras, computers and software. Volunteers trained through In Progress programs provide instruction and assistance with projects. They also offer workshops and mentorship sessions to the public with a focus on digital story telling. Activities range from open labs, where youth and their families can create digital stories, to professional development sessions on small business development in the field of digital media.

WHY DO TEACHING ARTISTS TEACH?

Why do artists take on the role of teaching artist? There are as many reasons as there are artists. In my work as a teacher, jazz historian in residence, arts administrator and arts education coach, I have worked with artists in many different disciplines, experienced teaching artists, emerging teaching artists and artists who are just beginning to look at teaching as an option to supplement their work as an artist. No matter the discipline in which they work or the contexts in which they might find themselves teaching, artists need to know why they are teaching.

Why do you teach? Why did you choose to teach? Why do you want to teach?

Below are some responses to those questions from artists I have worked with over the past few years.

▼

Nirmala Rajasekar is a world-renowned Carnatic Veena virtuoso and educator of South Indian Music. She teaches on world tours as well as at home in Minnesota in K–12 classrooms (she is affiliated with several teaching artist rosters). She is the founding artistic director of the school Naadha Rasa, where she leads workshops and holds ongoing classes for students who range in age from nine to eighty. When I first met Nirmala, her experience in arts education had been based more on performance for school groups through presenting organizations and for school assemblies. She was in the process of applying to three different roster programs, and through the Artist to Artist network (see below), we worked together on the development of her lesson plans and residency framework. She is a master of both her art form and her teaching practice in K–12 settings. Recently Nirmala was preparing with me to lead a

professional development workshop for teaching artists and music teachers. As I had done once years before, I asked her why she teaches.

> I teach because I have to. This music is an older tradition. It goes from master to student and then back around—the student becomes master. It is a cycle, and it keeps the music alive. Also, when I teach I learn, and teaching takes me into uncharted places where no one has seen me before. Music is my medium of expression; I can say things with music I can't otherwise say. Being from India and living in Minnesota, my music allows me to connect with folks who might see me as different, but through the music it can bring us together. Being an artist is a blessing, and being able to teach others is also a blessing. It is satisfying to see that what you teach makes a difference to somebody.

▼

Peyton Scott Russell is a visual artist who cofounded Juxtaposition Arts, a hands-on visual art and design program for youth located in North Minneapolis, where Peyton grew up. He now works as an independent teaching artist while continuing to work as a muralist and graffiti artist nationally and internationally. Peyton was interested in adapting his community-based and home-school teaching to a school residency model. When I talked to him recently, he was preparing a residency plan for two very different secondary school settings. The first residency would be with four non-arts teachers and would involve five classes in the English and Humanities Department with 9th–12th-grade students. The second residency took place in two 11th-grade studio arts classrooms in a public arts high school. Both residencies were designed to integrate visual arts and literacy. As I worked with Peyton on the design of both residencies, I asked him why he teaches, and why he chose to teach in these different contexts.

> I want to work with both arts students and non-arts students to give them a chance to experiment with and use mixed media in a self-identifying way. I want them to find ways to express something about themselves: personal, or something that relates to peers and/or their community by experimenting with text as an image. I am also interested in my own inquiry around imagery as literacy. When does that begin with children? I want to work with a larger student audience who might not have the skills and experiences in visual art mediums, to provide access to more students. I learn a lot about my own work as an artist from working with both arts and non-arts students.

Peyton also described his own experiences in elementary and middle school

and his love-hate relationship with text. Here are the questions he posed for the students he worked with in the two residencies:

How do we see what we read? What is the difference between seeing and looking? How does my personal experience affect the way I perceive text? How do I visually express/demonstrate what I understand in the text? What does the text say? How does the use of acronyms and phonic spelling in text messaging contribute to an innovative system of communication?

▼

Kristine Sorensen is a media artist who leads the small volunteer-run organization called In Progress. In Progress conducts both in-house and outreach activities that grew out of Kris's work teaching media arts and filmmaking in K–12 schools through residencies and workshops. I first met Kris in 1998, when she was the arts partner in a grant program I coordinated for secondary schools in the Twin Cities in Minnesota. Five years later Kris again served as an artist in residence, this time as part of a new art education partnership program in a small rural school in out-state Minnesota. In 2012, we crossed paths again. This time I tapped into her vast network of media artists—former students of hers from all around the state—who are now teaching artists affiliated with In Progress and who are taking leadership in running its programming. As a means of sharing her work with the coplanners of an upcoming workshop, I asked her to talk about why she started teaching and why it was important to continue working in this way.

It started as a one-person-run digital storytelling program for young people. I started working with schools in the 90s, and for some reason the program seemed to appeal to Native, Latino and Hmong student populations. I was approached to expand the work statewide through community partnerships with public schools, tribal schools and arts and cultural organizations. The program became mobile and adaptable and focused on digital media training and artist mentorships.

A number of young artists who participated in the program created some good work, and when the program ended, they wanted to know how they could take their work further. One particular student, at thirteen or fourteen years old, wanted to not only continue the work, she wondered how she could learn to do what I do—teaching students like her—and the student's curiosity led to what is now a central part of In Progress's practice: teaching students to teach others. Now, in the organization's view—which grew out of the student's thinking—part of being a media artist is being willing to mentor and teach others. Most of the mentors and teachers in the program are former students from the past twenty years. I saw the value of working with students to develop their skills in media first,

and out of that, as they applied the skills, the artistic content developed, which empowered them to develop their own artistic vision and aesthetic.

A List of Additional Reasons Why Artists Teach

1. To perpetuate or keep alive cultural and historical traditions
2. To supplement their income
3. To increase their own skills and develop their own art-making process
4. To share their passion for what they know and can do as an artist
5. To create opportunities for underserved communities to learn to make art
6. To develop capacity for teachers and community organizations to incorporate arts experiences into their classroom and programming
7. Teaching is inherent or intrinsic to their art form or traditional practice.
8. To mentor youth
9. To contribute to, invest in and give back to their community
10. As a form of community activism
11. To make a community a better place to live
12. To provide neighborhood-based arts activities
13. To bring people together
14. To provide students more equitable access to arts learning
15. To help to make school and community settings more interesting
16. To increase student interest in school and improve student achievement
17. To develop audiences
18. To reflect the demographics of the school population and/or the broader community
19. To make visible marginalized art forms and traditional and nontraditional cultural resources
20. To improve and increase career opportunities
21. To extend arts programming to schools and communities lacking arts resources
22. To provide art as therapy in hospitals and community centers

BUILDING A NETWORK OF PRACTICE FOR TEACHING ARTISTS:
Artist to Artist as one model

Teaching artists often work in isolation as visiting or resident artists. Even

though they may have developed methods and strategies for planning and communicating with the teachers and/or administrators with whom they work, unless they are on staff at a school or arts organization, they tend to work very independently. Programs have been developed by institutions, organizations and collectives to provide opportunities for teaching artists to connect with each other and with teachers and program staff to talk about their work and exchange ideas for improving or extending the work. Across the U.S. a number of programs have emerged to address the growing need expressed by many teaching artists for an enhanced community of practice.

Here in the upper Midwest my colleagues and I have made efforts over the years to work with a number of institutions and organizations in support of an artist-driven, collegial and collaborative approach to professional development for teaching artists. This collaborative and informal network, called Artist to Artist, puts artists in a leadership role as they examine their practice, share the variety of ways they are working as teaching artists and share what they know or need to know about the field.

Artist to Artist was developed originally in response to the needs of artists who wanted to improve their teaching practice. A few years ago, in my role as a coordinator of arts education professional development programs, I was approached by a number of artists, with varied levels of experience as professional artists and as teaching artists, who wanted to articulate what they intuitively teach in their discipline so that they could communicate better with teachers and arts education program administrators. In many cases, artists found that they needed to look first at their art-making process and break it down into more visible and concrete steps, so that they could teach well while maintaining the integrity of the art and art-making process.

Artist to Artist developed into a network that connected with arts organizations across the state to provide training and professional development for teaching artists. The network serves a dual role. First, it provides a means for teaching artists to collaborate in articulating what is essential to their teaching and their curriculum design. Second, it offers opportunities for arts education providers to learn from practicing artists and explore new ways to deepen arts learning experiences for students. In the Artist to Artist network I work with artists and arts organizations in group settings or one-on-one, depending on the particular need of the group or individual. My work includes helping people plan a program or residency, develop a lesson plan, coach a collaborative planning session with teachers or help people address challenging issues that arise in their work.

Members of the network have also made a major effort to increase the number of artists of color, American Indian artists and artists of underrepresented art forms or art forms that did not fit within the narrow categorization and labeling often associated with arts education programs. We did this by intentionally involving a diverse group of teaching artists, inviting them to meetings

and sessions and offering them space, time and, where possible, a stipend to connect with each other as they present their work, ideas and questions.

In Artist to Artist events and workshops I have seen a mix of emerging and experienced teaching artists ask each other some important generative questions: What do you do in your art form? Why do you choose to teach? How do you teach what you do? What does it look like when you are making art? What does it look like when you are teaching students to make art? How do you rejuvenate your own work? Does the process of teaching what you do as an artist make you a better artist? If so, how? These questions have led to some great discussions and have consistently demonstrated to all of us how important it is to provide opportunities for this kind of dialog.

One of the principles emphasized in the Artist to Artist framework is that authentic learning *in* the arts is the foundation for creating meaningful arts integration in the classroom. Artist to Artist provides a context in which teaching artists can continuously question and expand the definition of what teaching artists do; it also allows a wider variety of teaching artists to be brought into the work. Such a diversity of perspectives and experiences enriches the conversation about the support and mutual understanding it takes for artists and educators to collaborate in innovative and nontraditional ways, or in ways that may lie outside the conventions prescribed by established arts education organizations, institutions and leaders.

In practice, members usually meet to experience an artist's lesson firsthand and then describe what they experienced using a facilitated reflection protocol. This demystifies and makes visible the often intuitive and extremely complex aspects of teaching by helping participants clearly identify and name what takes place in a given lesson. The process informs the practice of both the presenting and responding artists. Other Artist to Artist meetings have focused on a particular teaching artist program or resource and provided a way for participants to discuss the work in question and relate it to their own experience and practice.

Since 2002 Artist to Artist has continued to build a cadre of experienced and emerging teaching artists who work in the context of what we describe as a "critical friends group," a supportive group of practitioners who look at the work critically with the aim of advancing practice. Leadership of the network has expanded, and many of the teaching artists in the network now serve as "translators," facilitators and mentors to emerging teaching artists. It remains an informal but effective collective of individuals supported by a number of organizations and agencies.

In the past few years, other groups around the United States—many looking for a viable, practical professional development model for their teaching artists—have worked with members of the network directly in their own settings or have created their own network, borrowing the structure of Artist to Artist. Artist to Artist can best be described as collegial, peer-to-peer and

grounded in the actual teaching practice of teaching artists. It has flourished precisely because it is *not* run by any one organization, nor is it dominated by a philosophy of any kind. It is focused on actual work, not on vague ideas about collaboration or partnership, or on foregone conclusions about the meaning of arts education. The range of teaching and work presented to colleagues is wide; the use of facilitated discussion through protocols (usually Descriptive Review or a Tuning[2]) offers just enough structure for a meaningful dialog, no matter what the subject.

BUILDING YOUR OWN COMMUNITY OF PRACTICE

From my own work I know that carving out a space where teaching artists can come together and talk is not easy, especially when so many work independently. But I also know that a few isolated teaching artists could set up a network similar to Artist to Artist. All they need is to come together (in person or even via Skype or videoconference) with a particular focus. If you have a specific lesson that you want to improve, or if you are encountering a particular challenge in your work as a teaching artist, chances are that other teaching artists are in a similar situation. You can agree to meet and examine one person's work—this kind of focus helps in the dialog; if you allow everyone to experience and respond to the work, then all participants come away with new ideas and questions.

As a member of the Editorial Board of the *Teaching Artist Journal*, and coordinator and participant in the Artist to Artist design team meetings that Becca and I convene for the Resource Exchange section of the journal, I know firsthand the power of meeting to talk about and better understand teaching artist practice with the goal of publishing the work for a wider audience. We are interested in taking work that gets overlooked, or happens at the margins of arts education, and making it more visible. We hope that this book provides some stimulus in that direction. You can respond to this book or to the work of your colleagues in the pages of the *Teaching Artist Journal*, online at tajaltspace.com, or at teachingartisthandbook.com. If we are going to improve teaching artist practice, then we need to hear *all* voices.

ENDNOTES

1. The White House Historical Association. *White House Sketches.* http://www.whha.org/whha_history/white-house-stories/president-carter-jazz-festival.html
2. *Descriptive Review* as we practice it in Artist to Artist consists of three main questions: 1. What did you notice/observe? 2. What questions does this raise? 3. What do you think the artist wanted you to take away from this lesson? Followed by a fourth question: 4. How did it feel as a learner? *Descriptive Review* originated with

the Prospect Archives and Center for Education and Research in North Bennington, Vermont under the leadership of Patricia F. Carini. It was developed primarily as a tool to help teachers gain greater insight into a particular student's learning by using either of two processes—Descriptive Review of a Child or Descriptive Review of Work. It is based on the premise that no two people observing the same event or work will see the same thing. The shared perspective of a group helps the group itself or a presenter to become more aware of aspects of a work or lesson that might otherwise have escaped notice.

The *Tuning Protocol* as we practice it in Artist to Artist consists of three main parts: 1. Warm feedback: What was strong about the work? What did you like? 2. Cool feedback: Where are there gaps or confusions? 3. Hard feedback: Where are there larger, structural issues or problems with the work? It has its origins in the Critical Response Process, a process developed in the early 1990s by teaching artist Liz Lerman of the Washington, D.C.-based Dance Exchange. Lerman designed it as a structured conversation to help artists move their work to the next stage of its development. Many artists and educators have embraced Lerman's Critical Response Process and adapted it for their own discipline. David Allen and Joe McDonald at the Coalition of Essential Schools developed a version that they use primarily in looking closely at exhibitions of learning. We use the *Tuning Protocol* in Artist to Artist to help an artist push his or her lesson forward. The *Tuning Protocol* assumes that the presenter or presenters want to improve the work in question and that the participants will deliver thoughtful, substantive feedback.

A Brief, Broad History of the Teaching Artist

G. JAMES DAICHENDT

INTRODUCTION:
Teaching artist as innovator

In a sense teaching artists have existed as long as humans have been making art. The earliest preserved cave art shows evidence of artists practicing their renderings and exploring particular artistic and thematic problems across multiple drawings, and of adolescents working alongside children.[1] Art-making, by its nature, is an activity that can be learned only by doing. So even as artists have always taught techniques and concepts, they have also worked alongside students as fellow artists. It is this same hybridity and spanning of teaching/learning and making that characterizes teaching artist practice today.

This essay is an attempt to put the recent emergence of the particular teaching artist identity, profession and movement in the U.S. into a broader historical context. I hope it will be both useful and thought provoking to teaching artists. It is far from exhaustive; rather it is a brief and selective survey and an invitation and provocation to further study.

This essay does advance an argument: that the history of the teaching artist can be understood as a history of the attempt to unite the theory and practice of art-making through a teaching approach that overlaps with art-making and is, in itself, a kind of artistic and creative process. In this sense the teaching artist, historical or modern, is not a special case or unique identity, but a reflection of the hybridity of art-making itself, and the dual role of all artists as makers and communicators.

The American phenomenon of the teaching artist is an exciting development in art education that continues to innovate learning and teaching art in a variety of contexts. The current teaching artist movement represents many

progressive philosophies and a fundamental change in traditional classroom art education. It also has an intellectual heritage that dates back to progressive schools like the Bauhaus, which in turn showed similarities to the workshop mentality that characterized art teaching during the medieval era.

Despite the recent emergence of a more visible teaching artist field in the U.S., the foundational elements of this work draw upon a long history of artists applying their professional and specialized knowledge. The teaching artist represents a unique combination of art practice and education that plays out both inside and outside traditional paradigms of education. Teaching artists have a distinct place in the history of art education based upon their professional identity and their primary role as practicing artists. From private studios and public school classrooms to large performing arts centers and museums, teaching artists had a considerable impact on American education over the last century and have a growing impact in this one.

There are as many types of teaching artists as there are types of artists. Teaching artists also work beyond the context of schools: in libraries, youth centers, prisons, hospitals and nursing homes. The potential reach of the teaching artist is limitless—important to consider, as the history and development of the teaching artist is closely connected to the roles of the artist in both formal and informal contexts. These artists who are not restricted to a particular type of art-making context apply their experience, practices, processes and interest in learning across a wide range of educational, community, cultural and institutional areas. The rise of the teaching artist has been and continues to be a fundamental aspect of art education and a key component in the development of some of the most successful teaching philosophies and methodologies to date. As teaching artists break barriers, the many pedagogies they enact continue to represent some of the most innovative practices of artists in the public sphere.

Teaching artists work in music, drama, and the literary arts and in a virtually infinite number of specialties in the visual arts and other media—almost any kind of art-making has its teaching artists. I've emphasized the history of visual art because this is my area of expertise, but this means that there are gaps in this history, particularly with regard to the teaching of writing in the twentieth century. I hope that the general trends described are useful in giving the reader a sense of the larger developments across disciplines. It's also the case that many teaching artists work outside traditional teaching contexts, and their work has at times provided a catalyst for social and political change. In this essay I have highlighted many individuals and movements in teaching artist work, but I have had to omit many more.

This essay also focuses mainly on Classical, European and American traditions in the arts and deals predominantly with the visual arts. This emphasis reflects the author's particular expertise and the fact that, for better or worse, the theory, ideology and practice of the teaching of art in America, and there-

fore the history of the teaching artist field in America, has been shaped heavily by European traditions. However, it is by no means an indication that the vast range of traditions and practices outside this sphere are less important, less innovative or less relevant to teaching artist work. American art and art practice have been profoundly shaped by indigenous cultures, as well as non-European immigrant and colonial ones. What defines American art, music and culture as distinctly American is largely the result of the cultural contributions of African slaves and their descendants, American Indians, Spanish, Mexican and Mestizo cultures of the Southwest and the many European and non-European immigrations that have shaped this country's history.

It should also be understood that the contributions and innovations of marginalized peoples and cultures to American arts education were and are important to arts practice and arts education practice in general, and not only as features of a particular tradition. For instance, in the decades following their forcible removal from ancestral lands in Southern Appalachia to Arkansas in the 1830s, the Cherokee Nation established one of the most advanced and comprehensive systems of public schooling on the continent. This period also saw the rapid development and spread of an innovative written Cherokee language and its application to the chronicling of traditional Cherokee oral traditions, as well as to new literature and journalism. Such important developments should be studied for the light they shed on how Cherokee culture has shaped American culture, and how Cherokee educational and literary innovations have contributed to our broader understanding and practice of education and literacy.

Similarly, the near-absence of women in the annals of art history and the history of arts education until the twentieth century reflects not a dearth of their contributions but significant weaknesses and gaps in our institutions and intellectual traditions. A deeper examination of the material reasons for such gaps is essential if we are to develop more rigorous and meaningful scholarship in the history of arts education. Such scholarship can help advance teaching artist practice that promotes social equality for women and the oppressed. Women's relative marginalization in European and American art history overlaps with the marginalization of artistic activities that were typically associated with women's work, such as quilting and fiber arts, and with the artistic output of other oppressed populations—like the practice of African-American quilters in the United States or many American Indian artistic and craft traditions.

We are currently witnessing a vibrant and exciting rediscovery of many of these enduring traditions and media in teaching artist practice. Nevertheless, it is important to recognize the limitations of this short history in this area, particularly in an era in which many non-European traditions and arts practices are playing an ever greater role in teaching artist work. The intent here is not to provide a comprehensive history but to give the reader a sense of the depth and breadth of the concepts, people, and movements that have informed

and influenced current teaching artist practice in the U.S.—the intellectual and artistic heritage of the American teaching artist.

Another goal of this essay is to contribute to the larger discussion of how teaching artists define themselves and their field. Erickson values art education histories as a means of understanding the origins of terms and setting a foundation for future research questions.[2] There is of course no objective history and no one history of anything; any history is part of a much larger narrative that involves many voices.[3] Histories of art education can serve as an initiation into the field of art education and can create a sense of belonging and clarification of ideas. The knowledge and understanding gained through the study of past work can feed our consciousness as we formulate new questions about current and future practice of teaching artistry.[4]

THE ARTS IN THE CLASSICAL MODEL OF EDUCATION

In the Classical era the idea of the "professional artist" was very much alive. While the term "artist" may not have existed as in its current senses, the special knowledge and skills associated with artistic training in music, drama and the visual arts were learned disciplines and as such were based on rules and theories that could be taught and transferred to younger generations.[5] The Greek term *mousike* referred to any of the arts and sciences that fell under the influences of the muses.[6] Today it has a much narrower meaning as music, but the broader classical sense of the word points to the great importance that was accorded to the arts in classical Greek society. The cultural consensus in this period was that education, at least for males of the upper classes, should tend toward a balanced physical, moral, intellectual and aesthetic training and development. A heavy emphasis on teaching and learning in the arts is reflected in the many creative and technical feats of the Classical era.

Formal and aristocratic education was differentiated from the education offered to women and manual laborers. In the case of upper class women, the home was the site of education in the domestic arts, which sometimes included crafts. For the working classes a family workshop was often the center of informal teaching and learning in the arts and trades. For instance, sculptors usually emerged from a family tradition and were generally trained by a parent or relative rather than in a formal school. Dramatic actors in classical Greece have a particular relevance to our contemporary understanding of teaching artist work in the sense that their craft was often practiced in the public sphere to great cultural and political effect. Drama was a kind of public practice and indirect teaching of the discipline of theater. While not much is known about specific art education methods of the Classical era and in other ancient civilizations, we do know that artistic products were held in high esteem, and in

subsequent epochs Classical Greek artistic culture is consistently associated with a commitment to craftsmanship in the arts.

The Romans did not entirely embrace this emphasis on the arts as a central and organizing focus of learning. While the Greeks admired music and considered it important to an educated and civilized person, the Romans did not share this admiration. The Roman imperial period was characterized by a decline in the arts in general. Some individuals taught and continued Greek ideas in teaching craft, but in much smaller numbers. This is evidenced especially by the dwindling number of art products that were created. As Roman tastes changed and interest in the arts waned, arts practice in the Empire fell out of favor and the cultural importance of artists and craftsmen decreased in the later Roman period.

MEDIEVAL GROWTH AND EXPERTISE

The transition from the fall of the Roman Empire to the Middle Ages in the beginning of the 4th century marked a significant change in the Western world. The collapse of central political and economic organization led to a decline in trade and travel, and production in and support for the arts in Europe and the western Mediterranean. Paradoxically, the Christian church both suppressed pagan art and simultaneously facilitated learning and art-making. Scholarship, art, and literature were all affiliated with the work of monasteries, but "[t]he artisans, who, as the heirs of the old Roman craftsmen, were still plentiful enough in the towns, worked within very modest limits until the revival of urban economy."[7] The issues of importance for teaching artists (or more appropriately, artisans, because the term "artist" did not exist in the contemporary sense) revolved around the truth of the Gospel, a concept that linked worldview, professional practice and teaching. Monasteries became small cultural hubs of creativity, much like workshops, where art was produced in a range of mediums and dealt with religious themes, but also with Classical historical, literary, geographic and proto-scientific themes. Religious iconography in particular was a means by which monastic and other artisans taught illiterate believers through the imagery they created. Early medieval manuscripts and art objects often combined secular and religious themes with various cultural traditions in a single work. The Franks Casket, an ornate chest made in seventh century Anglo-Saxon England, includes Christian, Roman historical and Germanic pagan images, as well as runic, Anglo-Saxon and Latin inscriptions. Despite later representations of the Middle Ages as a period of narrowly Christian religious art-making and teaching, cultural inclusion is typical of art-making, and therefore art teaching, during this period.

The term "Middle Ages" is generally applied to the period from the fifth century to the fourteenth century, and it was this era that witnessed the growth

of formal, institutionalized education. Grammar schools and universities became firmly established, but so too did music schools and art/craft workshops, as specialized practice in various disciplines was refined. The church, as well as secular powers, founded universities that made it possible to pursue specialized study; by 1500 there were seventy-nine universities in Europe.[8] The medieval university sought to graduate experts in such fields as medicine, law, nd religion. This was a professional system of education that varied according to context, but these schools required fees, were available to the wealthy and were associated with the developing commercial classes rather than the aristocracy.

Educational and artistic developments in Europe did not happen in isolation. Islamic and Arabic influences—in particular in Islamic Spain, throughout the Mediterranean world and across Europe—played a central role in the development of many academic, technical and artistic disciplines. Arabic texts and scholarship in mathematics, science and medical disciplines, as well as the translation and study of classical texts, were key to shaping European culture. The highly organized educational systems and a wide range of artistic and architectural practices of the Islamic world also deeply influenced European educational and artistic practice. Islamic Spain, Al-Andalus, between the eighth and fifteenth centuries C.E. was characterized by a particularly inclusive cultural environment in which Muslim, Jewish and Christian intellectual and artistic practices intersected and flourished across a range of disciplines with the support of aristocratic patronage.

Parallel to the growth of the university in Europe in this period, the apprentice system practiced by the craft guilds developed into a sophisticated and powerful political institution for business and trade. The arts were disciplines that existed primarily outside the academic context and were mainly associated with artisanship and manual labor. The craftsmen and artists of the Middle Ages progressed through a system that in theory prepared apprentices to be masters. The Craft Guild was an important construct for artists and craftsmen. In the apprentice system, the master, who was the head of the guild, trained younger or less experienced craftsmen and artists. Or as Raleigh writes, ". . . the teaching of art was no more than the imitation of a master craftsman who had perfected an acceptable imitative and iconographic style."[9] This learning process involved working professionals training future professionals.

Arts pedagogy was not highly developed in the guild system, and to the degree it existed it was likely not a complex affair. The political benefits of guilds kept them in power for hundreds of years and maintained this emphasis on the arts as manual trades. The pedagogically and artistically stifling effects of the guild system were one reason for the emergence of art academies and a search for alternative educational means for artists in the Renaissance.[10] However, the actual production in the arts in both the monastic and guild

contexts was often highly sophisticated and culturally and intellectually multilayered; historical and archaeological evidence suggests that the products of such skilled artisanship were highly valued.

THE RENAISSANCE AND THE BIRTH OF THE TEACHING ARTIST

The Italian Renaissance is one of the most important and essential developments in the history of teaching artists. The period witnessed heightened importance of the idea of the "artist as genius" and an intellectual acknowledgment of artistic work that forever changed the way we understand what artists do and how we engage their work. "The new Renaissance ideas in the arts were controversial and aggressively supported—which inevitably led those who championed them into teaching."[11] As artists sought new opportunities to learn their disciplines, new institutions were established where art could be engaged and taught. It was during this period that the arts became subjects of study in conservatories, art academies and eventually universities. Supporters of art academies believed that the fine arts were first and foremost an intellectual discipline in which method played an important but subordinate part. Painting—along with grammar, rhetoric, dialectics, arithmetic, geometry, astronomy and music—was considered a branch of the liberal arts rather than a mechanical art.[12] Renaissance academies and conservatories represented an opening up of opportunities for secular training in the arts and became centers of teaching and learning in the arts. Contemporary fine arts academies and conservatories have their roots in the Renaissance.

This transition, in which artists became more than simply a collection of professional practitioners in media, did not happen overnight but gradually, beginning in the late medieval era and continuing into the Renaissance. From the fourteenth to the sixteenth century students continued to become professional artists under masters in specific fields. However, during this period new artist clubs and academies arose for those who sought an education beyond grinding the guild master's pigments or working under the patronage of religious organizations. Artist clubs were also centers of discourse: along with members of the upper classes, painters, sculptors and musicians frequented the clubs to discuss issues related to music and poetry.[13] This secular development in artistic practice was directly connected with the emerging emphasis on humanism and its attendant philosophy of education focusing on classical studies. This new focus made education in the arts more available than before and remained a central component of teaching models in the coming centuries. The arts benefited greatly as this renewed focus created a context where schools acknowledged literature, aesthetics, poetry and drama as important subjects. In the previous period these aspects of education had been

considered unimportant or minor, or had been altogether ignored as fields of study and practice. Artistic methods were refined over time and eventually became knowledge bases for all the arts. The following centuries witnessed the great impact of the Italian Renaissance as humanistic ideas spread throughout Europe through formalized education.

THE ENLIGHTENMENT AND THE IMPACT OF SCIENCE ON THE ARTS

The Enlightenment period saw a wider understanding of secular culture, rather than the church, as the center of the world. In the seventeenth century, empirical systems of gathering knowledge and learning became more prevalent as the basis of education. The concepts and language of science gained ground among the commercial, urban and ruling classes, and the arts became politicized in a new way with the development of national consciousness, centralized national monarchies and a growing commercial and industrial class. Art became associated with luxury and came to represent power, culture and glory. "Grandeur" became a key dimension of artistic production, and nowhere was it better manipulated than in French art education, where the enforcement of specific technical standards and institutional power were commonplace. Political-artistic authority was felt at every level through the provision of artistic opportunities to the advantaged, the preservation of artistic traditions and the influence of professional success as a driver of arts education.[14]

The French Academy and the many schools influenced by this institution set about organizing the theories and doctrines of the past into a fixed curriculum. The teachers were highly accomplished masters, the very best in their fields, and academy positions were held in high esteem. One could not gain or maintain a position in the academy without a professional practice of the highest caliber.

This academic model of art education was and still is a double-edged sword. The increased standing of teaching artists legitimized the study and production of art but also limited the possibilities for teaching and learning that might break from tradition. The emergence of the modern university and art school meant that advanced education was more available to certain social classes, but it also centralized political and theoretical frameworks of that education. To become an expert in the arts one now had to be educated at one of these centers of learning and teaching, which became the legitimizing agencies for musicians, actors and visual artists. This emphasis on excellence in a creative discipline became part of being a teaching artist and also became linked with the idea of professionalization. Possession of degrees and association with institutions and formal education became important parts of determining competence in a field. In order to attain professional status, painters

had to have attended an academy and musicians a noted conservancy; actors had to have trained with and belong to an influential drama association.

This narrow path to success in the arts necessarily excluded women. Exclusion was due to institutional, cultural and political limitations rather than individual ones. To take just one example, Linda Nochlin cites the historical lack of male nude models for women art students. Access to male nude models for drawing and painting was the foundation of the nineteenth century Academy education, and entrance to and success in the Academy was the only path to a successful career in art. This sort of marginalization plays out repeatedly in the history of arts education, and it is only relatively recently that teaching artists and institutions have adopted a wide enough range of pedagogies to allow greater access to arts education for women.[15]

Simultaneously with the higher level of art education offered by academies and conservatories, the eighteenth and early nineteenth centuries saw the beginnings of government-sponsored art education in French and British public schools and one of the earliest efforts to democratize art education. Its originators were social reformers who sought to increase the influence of the commercial class and raise aesthetic standards nationally. Many schools in England recruited artists to start teaching within these publicly funded schools. As artists were trained to teach art, the field of art education developed as a new subject of study that offered art teachers more than just a disciplinary specialty. It was a common assumption in the United States during this period that artists who had trained in a European academy or conservatory were of a higher quality and had more to offer the potential art student. This period saw the emergence of several individuals who are noteworthy for their innovative artistic and educational methods, and they make instructive case studies in the history of teaching artists.

GEORGE WALLIS:
Designing a New Way to Teach

George Wallis was in many ways a typical nineteenth century English artist, designer and teacher. A product of a local design school, he was very highly regarded for his painting and his efforts in the community. However, it was his progressive views on education that led him to depart from the standard curriculum proposed by the Government Schools of Design, a bureaucratic institution that determined the standards and expectations imposed on British design schools.[16]

Rather than administer a one-size-fits-all teaching scheme—which had been the norm, Wallis individualized and customized his teaching based upon the location of the school and the needs of local industry. Because each local economy was different, and different industries required different types of

design, Wallis developed creative design lessons that equipped his students for design work based on general principles rather than having his students copy forms (a strategy used to train artists and designers for hundreds of years). In Wallis's view this spark of ingenuity was an expression of the fact that his artistic identity, professional experience and artistic process were essential to his understanding of the proper way to teach. Originality was of great importance in Wallis's pedagogy. While master at Manchester School of Design (his second post), he designed his own course for advanced students; in the course he would demonstrate a design principle and then ask students to create an original design based upon the principle modeled.

Wallis called himself an artist-educator before a term like teaching artist existed, and his teaching methods were very different from those of his predecessors. His students were much more effectively prepared for professional work, because they had worked on their own original designs and experienced the creative process of a designer. However, such innovative methods were not always smiled upon, and Wallis ran into many roadblocks during his career. The central administration of the Government Schools of Design in London did not always understand his unique curriculum, which differed greatly from the curriculum in use in other English schools.

George Wallis's historical significance is two-fold: He elaborated the idea of the artist-teacher in his writings before this hybrid identity became a contested issue in twentieth-century art education, and he was a major contributor to the art education landscape of the nineteenth century.

WILLIAM MORRIS AND THE ARTS AND CRAFTS MOVEMENT

The Arts and Crafts Movement was a design philosophy that had its origins in England of the 1860s and spread to the United States in the early twentieth century. It was later revived in the United States by proponents like Arthur Wesley Dow, another noteworthy teaching artist.[17] The movement was a reaction to late nineteenth-century industrial design that was typically low quality and full of superfluous decorative elements. Proponents of the movement sought better craftsmanship and applied the artistic processes of traditional handicrafts to the creation of commercial products. Industry was taking a toll on the environment and was characterized by terrible working conditions. Arts and Crafts movement adherents feared that the growth of industry would also lead to the eradication of traditional handicrafts. The movement championed traditional artisanship and simple, high quality, handmade designs. The handmade objects the movement produced breathed new life into what had become sterile and anachronistic fields of fabric, furniture, and wallpaper design. Much more than an artistic development, it was also a political and

social reform philosophy that sought to create well made products for everyone and return to medieval, romantic and egalitarian ideals in art, design and social life.

William Morris is the most notable proponent of the Arts and Crafts movement. In 1861 Morris cofounded Morris, Marshall, Faulkner and Co. (later Morris and Co.), a firm that favored handicraft production. He sought inspiration from nature in his work and evoked a return to medieval ways of thinking about art-making and education. Morris's firm's products included furniture, stained glass, tapestry and wallpaper.[18] Morris was a committed artisan and craftsman whose teaching developed in conjunction with his efforts to spread his counter-cultural and radical philosophy.[19] Several craft guilds were formed during this period in an attempt to revive medieval guild values and training methods. These included Morris's own Century Guild, established in 1882, as well as the Kelmscott Press, a publishing company he founded with the aim of producing handmade books using fifteenth-century methods. The development of these institutions influenced both Morris's artistic production and his teaching.

Romanticism gained strength during the Industrial Revolution, in part as a revolt against the intellectual and industrial changes of the time, and Morris's views were very much in this mold.[20] Historian Michael Curtis describes the frustration that the artists of the Romantic period felt in an environment they could not control or influence: "The romantics looked back to the past; in particular, they rediscovered the Middle Ages and Medieval Christianity, considering them the pinnacle of inspiration and beauty.[21] Ultimately, Morris's hopes of uniting the quality and artisanship of handicrafts with availability to the masses proved utopian. His simple and beautiful designs were more expensive than industrial products because they required more time and resources to produce. However, the energy around the Arts and Crafts movement spurred the emergence of craft education in British schools and colleges and, later, in the United States. The declining influence of the Arts and Crafts movement also marked the beginning of the Bauhaus, which had a similar goal of developing high quality, simply designed products that would be affordable to working people but sought to realize that goal by closely connecting artists and the methods of industry. Out of the Arts and Crafts Movement and the Bauhaus there emerged an emphasis on the relationship between design and creativity, and quality of life. These became deeply intertwined with modernist views of arts education and, ultimately, teaching artist practice.

WALTER GROPIUS AND THE BAUHAUS

In the late nineteenth century the influence and political clout of academic institutions weakened as new methods of artistic production were spurred on

by social, political and philosophical changes. These were driven in turn by technological changes. The Bauhaus arose out of the waves of these changes and remains one of the most influential schools of art ever created. The artists, architects, designers and performers associated with the German school had a huge impact on American education and culture that persists to this day. The architectural aesthetic and the progressive ideologies at schools like Black Mountain College and the structure of art education in the American university system are a direct outgrowth of many of the philosophical views expounded by Bauhaus founder Walter Gropius and the many instructors and students who made up the Bauhaus in its short-lived existence between 1919 and 1933 (the movement underwent a brief revival in Chicago as the New Bauhaus, 1937–1945).

Fredrick Logan referred to Walter Gropius as one of the most important artist-teachers or teaching artists in the history of art education.[22] Historian James Elkins considers Gropius the most important influence on contemporary art instruction.[23] Gropius's training as a professional architect guided and shaped his design of the Bauhaus, its curriculum and, by extension, the educational structure of the modern art school.

A central characteristic of the Bauhaus was its embrace of new technologies.[24] The school's stated goal was to overcome the division between art and craft as well as the growing schism between art and industry. This was an unusual viewpoint at the time and was the foundation of a curriculum in which all students worked with a wide range of materials, including wood, fibers and concrete. A highly attuned teaching artist, Gropius used many of his architectural skills to bridge the divides between new and old methods and materials, and to promote the idea of architecture as the most integrative and synthetic of artistic practices. Gropius often used the metaphor of a bridge to highlight the practical realization of his vision to connect resources and philosophies; a bridge even served as a key architectural feature of the layout of the school.[25]

Initially frustrated by his own education in the field of architecture, Gropius sought to create an environment that prepared students to utilize the technologies of the future. The outdated education he had received was not fit for the new technologies offered by the professional and industrial landscape. In the Bauhaus's famous first-year curriculum students concentrated on exploring a wide range of materials and techniques in all their sensory and functional characteristics. The student work that emerged from the first-year workshops remains a stunning body of art and design deeply rooted in new and highly inventive approaches to materials.[26] The openness and the focus on student-driven exploration across many mediums that typified the Bauhaus workshops are echoed in the work of many contemporary teaching artists.

Gropius's architectural training provided a unique perspective that informed not only his views on teaching but also the governance of the

school.[27] The subsequent hiring of additional teaching artists to work within the school was part of an impulse to develop a nexus of original thinking that would push aesthetic and technical boundaries. Gropius sought to place at the center of the school's curricular goals the elaboration of a common language of design, a language that would allow the artist/designer to move forward in expression and creation. Gropius placed great emphasis on cooperation between the artist and the technician as a key factor in progressing beyond the historic disconnect between the form and function of industrial products.[28] The varied philosophies of education and approaches practiced by the diverse faculty of the Bauhaus contributed to the complex pedagogical goals of Gropius's school.

The Bauhaus curriculum was developed and implemented by a number of teaching artists, including Johannes Itten, Josef Albers, Wassily Kandinsky, Paul Klee, Oskar Schemmer and Joost Schmidt, a group that did not necessarily agree with one another or with Gropius.[29] In spite of shared general emphases there was no official teaching plan at the Bauhaus, and throughout its existence the curriculum changed direction in response to new issues. The many theories of art and education that emerged from the school eventually migrated to the United States, as members of the Bauhaus and other progressive arts educators fled fascism and war in Europe and accepted positions in American institutions, such as Harvard University (Walter Gropius, Marcel Breuer, Sigfried Giedion), Yale University (Joseph Albers), the Illinois Institute of Technology (Mies van der Rohe), Massachusetts Institute of Technology (Gyorgy Kepes) and Black Mountain College (Joseph Albers, who taught there before he joined the faculty at Yale). The combination and embrace of design and artistic processes by faculty at the Bauhaus allowed for greater depth in their teaching of art and resulted in a curriculum that genuinely reflected contemporary artistic and design practice.

The Bauhaus also saw an important revival in 1937 in Chicago as the New Bauhaus (later called the IIT Design Institute at the Illinois Institute of Technology) under the direction of Moholy-Nagy. The New Bauhaus continued and in some ways extended the curricular emphasis and ethos of the German school and had a profound impact on American arts education in the postwar period. Its faculty included such innovators as John Cage, Buckminster Fuller, and photographers Harry Callahan and Aaron Siskind, under whose leadership "street practice" and the visual thesis became a central part of the photography curriculum that was widely adopted elsewhere in the field.

Bauhaus theories and practices contributed much to teaching artist practice in a larger, historic sense. The school's emphasis on the reuniting of art and craft, the universality of talent and the human purposes of art and design prefigured the emphasis on universal arts access that characterizes the work of many contemporary teaching artists. The Bauhaus's highly integrative practices—students not only studied all arts disciplines but also did work in math-

ematics, the sciences and other fields—shaped many of the more progressive ideas behind current arts integration practice.

VKHUTEMAS AND THE MODERN TEACHING ARTIST

Vkhutemas (a Russian acronym for "Higher Art and Technical Studios") was a state-sponsored art and technical school that existed in the Soviet Union from 1920 to 1930. The school was renowned for its focus on the study of space and geometry and its association with the avant-garde modern art movements of Constructivism, Rationalism and Suprematism. Major figures in the Russian and then Soviet Avant-garde such as Kazimir Malevich, El Lissitsky, Varvara Stepanova and Aleksander Rodchenko served on the Vkhutemas faculty at various times or were instrumental in the development of the school. The teaching artists who worked within Vkhutemas brought their modernist and revolutionary politics, philosophies and theory into the classroom and workshops, where the borders between teaching and art-making often blurred.

Vkhutemas had a foundation and a disposition towards art and design that were similar to those of the Bauhaus, but they were more rigorously theoretical and attempted an even more direct alignment with industrial practice. The school came into being in the wake of the October Revolution, from the merger of two older art and design schools. Its purpose was to prepare artists with advanced skills to serve industrial and cultural production as well as teachers and managers in artistic and technical-artistic fields. The first-year curriculum completed by all students aimed to provide theoretical and practical training across disciplines in general problems such as "color on the plane," "form through color," and "volume in space." An emphasis on science and mathematics was a major feature of the training.[30] Ultimately, the school's failure to integrate artists with industry and the emerging Stalinist bureaucracy's repression of progressive and avant-garde movements in the arts led to Vkhutemas's closure in 1930.[31]

Like the Bauhaus, Vkhutemas was the site of an explosion of practical and theoretical innovation across many disciplines, and the school's influence on design and art education extended far beyond the borders of the USSR and the period of the school's existence. The fact that several avant-garde art movements were centered there points to an intense synergy of professional work across disciplines. Aleksander Rodchenko, a founder of constructivism and ardent supporter of the Bolshevik Revolution, was a key figure in advancing at Vkhutemas the idea of a new artistic profession, that of the "artist-constructor," who could bring a wide range of artistic and technical skills to bear in making "useful objects" and serving the needs of the new society and humanity.

Another notable teaching artist working within the Vkhutemas was Kazimir Malevich. Malevich, known for his geometry-based abstract paint-

ings, joined the staff at the Vkhutemas in 1925. Like many Vkhutemas faculty, Malevich blurred the lines between his artistic activities and his teaching responsibilities; his artist identity was always present in his teaching, and his philosophies of art-making directly affected the way he taught. Malevich was not new to teaching. He had been a faculty member and, eventually, director of the Vitebsk Popular Art School, and had sought to engage his students in both theory and practice throughout his teaching career.

Although Vkhutemas was short-lived, it was a place where teaching artists could thrive in an atmosphere of experimentation and freedom. The school came into being in the context of a revolution, civil war and desperate famine and poverty. Art for art's sake was low on the list of priorities of the new Soviet state; many artists put their skills and talents to work in a wide range of social and industrial efforts with the hope of ushering in a new epoch of social equality. Leading figures such as Rodchenko and the writer Maxim Gorky worked along with legions of lesser known painters, writers and musicians in literacy campaigns, initiatives to promote cultural equality for national minorities and women and military and economic campaigns in defense of the revolution.

The diverse faculty of the Vkhutemas propagated many early modernist approaches to areas such as product design and architecture and set a standard of malleability as students and faculty moved fluidly among the specializations available in the curriculum.[32] The faculty was similarly multidisciplinary; Rodchenko, for example, taught painting, metalworking and woodworking. This dynamic approach to art teaching set the stage for a number of conceptual ideas about art education that re-emerged in late twentieth-century art education.[33] At both the Bauhaus and Vkhutemas the mentoring relationship between faculty and students had more in common with apprenticeship than with an academic professor-student paradigm. Both schools were profoundly experimental in that they encouraged teaching artists to experiment freely not only with artistic and technical theory and practice but also with their pedagogy in ways that erased formal distinctions between teaching and making. We find echoes of such experimentation in teaching artist work today.

THE HIGHS AND LOWS OF PRIMARY AND SECONDARY ART EDUCATION IN THE U.S.

The history of art education in the United States is one of varying rationales.[34] The justifications for offering art classes shifted from decade to decade as the population grew and the goals of education changed. Prior to World War I art education in the United States was associated with industrial design training. After the 1920s, the industrial design emphasis of most art pedagogy faded, because industry no longer required these skills to the former extent. The arts would now be taught for cultural purposes, creativity, nationalistic purposes,

leisure and self-expression, a changing rationale that Davis views as a strength of art education as the field continued to rethink its boundaries.[35]

In the eighteenth century Benjamin Franklin was an early advocate for the study of art.[36] However, art was not introduced into American public schools until the early part of the nineteenth century. Before 1870 art education was largely considered an extra, frill or benefit taught by a volunteer, yet it did exist.[37] From the 1820s to the 1860s, the study of art was introduced slowly into schools in major cities along the East Coast and in the Midwest and certainly did not have wide support.

After 1870 art education became a curricular subject in most major cities. Drawing was introduced in the public schools of Massachusetts, where it was viewed as contributing to the development of industry. Educators took their cues from design schools in England, and the preparation of technical skills and the development of the eye became primary concerns. Walter Smith was particularly influential in this regard. A former art teacher in England, Smith brought with him to the U.S. an interest in design education as it applied to industry.[38] Industry-centered philosophies dominated art education until the end of the nineteenth century. Interestingly, music was also adopted as a subject in Boston Public Schools in 1838 on the premise that students would benefit morally, intellectually and physically from music study.[39] The main arguments for early adoption of arts education were based to a large degree on admiring emulation of European standards and concepts.[40] The arts slowly came to be understood in the U.S. as part of the training of an educated person, but a utilitarian undercurrent persisted that suggested that music and visual art education developed fine motor skills that were seen as essential to the preparation of future industrial workers.

The time between 1870 and 1917 witnessed considerable growth of public schools in the United States.[41] Population increased dramatically from the larger cities to the plains, where one-room schoolhouses were widespread. To meet this growth, teacher training schools also multiplied. There was a heavy demand for trained teachers; the professions of teacher, superintendent, principal and director (along with education as a discipline) became more established and visible and were associated with higher status and salaries than in the past.[42]

At the beginning of this period art was taught by the principal teacher and did not warrant a specialist. The high demand for and scarcity of teachers led to the establishment of education programs to prepare schoolteachers who could teach reading, writing, math and history. However, teacher colleges also prepared teachers who were not artists to teach art. "The idea that an art teacher might require a different form of training than an artist was a radical notion . . . that art could be taught by anyone but an artist was a radical notion in the history of ideas."[43]

Changes in cultural life and artistic experience also affected arts education

practice. Professional orchestras, bands, art academies and concerts became more widespread in the U.S. in the late nineteenth and early twentieth centuries. This growth, along with new alternatives for enjoying artistic production (radio, records and increasingly available art books), changed expectations for art education. Historically, the quality of art education in a given culture is closely linked to the availability of artistic resources. Through the many channels of artistic production and popular consumption, professional artists act as formal and informal educators for the culture at large and mediate and facilitate meaningful relationships with art. This has been no less the case over the past century in the U.S.

In the same period education in the U.S. was shaped by a series of movements: the child study movement, the social efficiency movement, the nature movement, the progressive movement,and the manual training movement.[44] These movements in education incorporated a wide range of views on art in education—from "art for art's sake" to the view that art education should serve the needs of industry.[45] In spite of this range of disparate views, the education movements and their theories collectively were significant factors in shaping teaching artist practice in the early twentieth century. Educational theory increasingly led art teachers to accord greater significance to student artwork and to place a greater emphasis on the knowledge that artists use in their practice. More systematic theories of art education came onto the scene as philosophers like John Dewey and artists like Arthur Wesley Dow and Franz Cizek advocated for a central role for art-making in education. The teaching of art in American schools was also profoundly shaped by the evolution of modern art education. As schools like the Bauhaus and Vkhutemas eradicated the older traditions of the more conservative Academy, elements of these progressive institutions caught on in public education in the U.S., although often decades later.

THE RADICAL NOTION OF THE TEACHING ARTIST

Around the turn of the twentieth century the established paradigms in American public education were challenged by progressive educational theory. The following decades included growth and an increased American presence in world politics, including World War I (1917–1918). Amid this growth, an early group of teaching artists emerged in the 1920s and the decades following that maintained many progressive ideals associated with the philosophies of John Dewey and the child art movement. These influential teachers included Victor D'Amico, Natalie Robinson Cole, Florence Cane, Peppino Mangravite, and Marion Richardson (British). These teaching artists felt that maintaining an active practice in a studio discipline was an important component in their teaching. In essence, they felt that their perspective as artists placed them in a much stronger position to facilitate learning as they engaged students in

artistic process. The questions, problems and choices of art-making require an intimate relationship with the ideas and materials from which one's work is constructed; as working artists, these teaching artists felt they were better able to recognize the contours of a student's relationship with concepts and materials when they, too, were immersed in them. Their emphasis on the "affinity between the activity of the artist and the graphic expression of the child" also had a lasting impact on the notion of the teaching artist.[46] This marked a significant step in art education, because prior to this era the qualifications necessary to become an art teacher in American schools were not strict, and it was not uncommon to have non-specialists teaching the visual arts.

Victor D'Amico held a strong belief that the child was an artist, yet differed from an adult artist. D'Amico's curriculum was based on the premise that children should recognize and reflect on their own experience as a source of artistic inspiration. After students developed their ideas, technique and instruction could be introduced based upon the young student's development and maturity and according to his or her needs and interests. D'Amico's curriculum clearly demonstrated that he placed great importance on the individual child as artist and on learning art by making art. In an article titled "Art Education Today: Millennium or Mirage?" D'Amico expressed concern about the dehumanization of the child in the American educational establishment.[47] His role as a teacher of young artists was to encourage them to break from this establishment.

Florence Cane was another of the best known teaching artists of the midtwentieth century. Her philosophy was similar to D'Amico's but differed in her application.[48] Cane drew upon many modernist principles in the visual arts. She advocated drawing from the imagination and painting with the nondominant hand. Both Cane and D'Amico stressed creativity as central in their teaching and demonstrated the importance of art-based knowledge in ways that greatly influenced arts education and teaching artist practice.

THE SETTLEMENT HOUSE MOVEMENT AND NEW DEAL INITIATIVES

The modern teaching artist may be best known for working in contexts outside school walls. The settlement house movement was an early example of community arts education that was used to aid the transition of immigrants into the workforce. A social movement with roots in England, the initiative provided education and social services to populations in specific areas of poverty. The first American settlement house was founded in 1886 in New York City. In 1889 Hull-House (the best known settlement house) was founded in Chicago by public intellectual and activist Jane Addams and her partner Ellen Gates Starr. By 1890 there were over 400 settlement houses in the United States. The teaching artists at Hull-House offered courses in art history and

studio art, in addition to many social services to help immigrants acclimate and ease their cultural transition. The arts were thought to be an essential part of human development and inquiry, and the progressive ideologies carried forward by teaching artists in these contexts worked for the purposes of political and social change. It's also interesting to note that women managed many of the positions within the settlement houses at a time when they were excluded from the professional world. The social mission of art education continues to be an important component and dimension of both teaching artist practice and cultural understanding of the benefits of art education. Booth noted that school-based programs have never been able to include all young people in arts experiences; this was a key reason that teaching artists became important actors in socially driven agendas, such as providing greater social, economic and racial equality in arts access.[49] The extreme and historic race and class segregation of American public schooling has made arts equity and access a particularly compelling motivation for many teaching artists in the past and today.

Beginning in 1933 a series of massive public works and economic stimulus programs were undertaken by the Federal Government under the aegis of the Works Progress Administration (WPA) in response to the economic crisis occasioned by the worldwide Depression. The WPA included a series of programs known as Federal One, which were aimed at putting unemployed artists back to work on federal projects. Through such projects as the Federal Theatre Project and the Negro Theatre Project, the Federal Arts Project and the Federal Music Project, tens of thousands of artists undertook well funded public and studio art projects that transformed cultural life and influenced art-making and teaching in America for decades to come.

In spite of government censorship the relatively progressive atmosphere within the WPA arts programs made possible a surprisingly wide range of political and social expression, as well as the inclusion of black, immigrant and women artists in a period in which such artists faced tremendous discrimination and marginalization. Among the thousands of artists and writers who participated were many who went on to become highly influential figures and in some cases important teaching artists and educators: Jacob Lawrence, Diego Rivera, Philip Guston, Berenice Abbot, Mark Rothko, Nelson Algren, Ralph Ellison, Zora Neale Hurston and John Cheever, to name a few. The WPA arts programs had a tremendous impact on American cultural life.

This impact of the WPA arts programs on the evolution of teaching artist work in the U.S. cannot be overstated. The programs' emphasis on public and community art and local implementation gave artists a new and different kind of visibility in both urban and rural communities. Painters could be seen painting signs and murals as part of public works construction; writers fanned out across the South to interview thousands of former slaves in an historic effort to document first-person accounts of slavery; and actors, writers

and directors of the Federal and Negro Theatre Projects staged classical, new and avant-garde productions in a wide variety of communities and venues. Noted community arts advocates and arts educators Arlene Goldbard and Don Adams wrote:

> Hundreds of teachers were employed by the Art Teaching Division in settlement houses and community centers; in the New York City area alone, an estimated 50,000 children and adults participated in classes each week. The FAP also set up and staffed 100 arts centers in 22 states; these included galleries, classrooms and community workshops and served an estimated eight million people. These local centers also received some $825,000 in local support; some survive to this day.[50]

The experiences and models of community and more democratized arts access, both in teaching and consumption, have had a deep and many-layered influence on teaching artist thought and practice up to the present.

THE TEACHING ARTIST IN HIGHER EDUCATION

The WPA arts programs also played an important indirect role in shaping some of the more innovative arts education initiatives in higher education. As the New Deal programs wound down and war production ramped up in the early 1940s, many WPA artists found jobs in schools and universities, and some played important roles in the evolution of progressive, Bauhaus- and Vkhutemas-like curricula at art schools such as Tyler in Philadelphia and the University of Iowa. Teachers and professors at these institutions were often animated by the same experimental and progressive social aims that were widespread among WPA artists.[51]

The teaching artist field in the U.S. has also been shaped significantly by progressive institutions that allowed for space and experimentation in their teaching, such as Black Mountain College, by universities that hired visiting artists to broaden students' perspectives and by private grade schools. This history contrasts with the simultaneous emergence of public school art education, which sought to define and organize art education into curricula that could be systematized and replicated. As had been the case in Europe, in the U.S. the earliest teaching artists based their practice on traditional academic models that were hegemonic in American higher education from the late eighteenth century to the early twentieth century.

Art Colleges and Academies that followed the European tradition were established along the East Coast. Referring to these early schools, Logan states, "Pioneer artist-teachers, including William Morris Hunt, Thomas Eakins, William Merritt Chase, and Frank Duveneck, were creating a more serious pro-

fessional art education. . . ."[52] These early art professors are often referred to as teaching artists or artist-teachers because they brought a higher level of artistic training and accomplishment to the classroom than many of their American peers. "Their European training had been better, much broader, and at the same time sounder than the timid scholasticism"—a characteristic that applied to their artistic production and teaching alike.[53]

University art departments developed more slowly in the United States than they had in Europe during this period, and they initially offered art education courses as a component of what was considered a well-rounded education rather than as a focus. After World War II former servicemen and women flooded college campuses because of the G.I. Bill. Art, Music, and Drama Departments were overflowing with students, and many new programs were developed and expanded to accommodate the growing enrollment. Before this boom visiting artist-in-residence programs had been effectively used as a strategy to recruit well known experts to art faculties. This strategy was also used in the 1930s to promote music education and was later adopted by visual art departments before art departments became a common fixture in the second half of the twentieth century.[54] Teaching artists in academia opened the door to the hiring of full-time faculty and accelerated curricular developments that brought full-fledged art departments to many college campuses.

EMERGENCE OF THE MODERN TEACHING ARTIST

Arts education in the 1950s and 1960s was shaped by both the political and social repression of McCarthyism and the cultural ferment that first emerged during the early years of the Civil Rights Movement. Noted arts educator and teaching artist advocate Eric Booth has observed that at the core of the mission of the modern teaching artist is the desire to train more artists and the democratic impulse to include everyone.[55] This has been and continues to be an important core value of the teaching artist field. But this impulse did not exist in a vacuum and did not evolve without a struggle against more restrictive or exclusionary approaches that limited arts education to the preparation of specialists. In the postwar period some of this struggle played out on the terrain of higher education.

As previously noted, Black Mountain College is one of the institutions that broke the mold of academic training in the arts in the United States. Established in 1933 (and eventually closed in 1957), the college sought to serve as a liberal arts school with the arts at the center of the curriculum. Many artists were attracted to the idea of studying, visiting or teaching there. Notable faculty included artists in a range of disciplines; they included visual artists like Cy Twombly and Robert Rauschenberg, musicians and composers like John Cage and dancers such as Merce Cunningham.

John Cage's work and thought epitomize many of the modern theories that inform teaching artist work. His professional practice was open to a wide variety of influences, from Eastern philosophy to dance, and the same ideas that shaped his art-making were central to his teaching. Although he composed, performed and created a wide variety of music and sound pieces through many processes, Cage is perhaps most widely known for his composition titled 4´33´´, in which musicians sit silently with their instruments and turn the pages of Cage's blank score without playing a single note for the duration of four minutes and thirty-three seconds. Cage's experimental creative process was extended through the happenings he staged at the college with his students, one of many ways in which he blurred and even erased the lines between art teaching and art-making. It is precisely this kind of freedom and experimentation that is often obliterated in schools as the arts become professionalized and standardized as academic subjects in elementary schools, high schools and colleges. In one sense it is the impulse to reclaim this freedom to combine teaching and making, and the freedom to experiment, that explains the birth of the freelance teaching artist and of teaching artist organizations that operate outside the strictures imposed by institutions.

Over the course of the last century there has been a shift from a technique-centered approach to arts teaching toward curricula that value theory more than ever before. Goldwater describes a decline in drawing education in the midst of incredible growth in art education offerings.[56] The nineteenth-century notion of the technique-based teaching artist had evolved in the twentieth century toward an increased emphasis on language and theory as dimensions of art teaching and art-making. Thus it is not uncommon for contemporary American teaching artists to articulate their practice as artists and teachers with reference to concepts such as social pluralism and with a critical stance with regard to accepted traditions. Many teaching artists find it essential to understand the many histories of objects, peoples, contexts, perspectives and cultures as a prerequisite for engaging these contexts or subjects in a meaningful fashion. The Bauhaus and Vkhutemas experiments further suggest the possibility that social purpose and artistic theory and practice can be united through the exploration of the principles and possibilities of materials and media.

THE SEVENTIES AND CETA:
A Limited Revival of Public Arts

The economic crisis of the 1970s, recession in the 1980s and the persistent poverty and racial inequality of the past two decades have had a disastrous impact on arts education in public schools. Partly in response to the social upheavals of the Civil Rights Movement and the Vietnam War the Sixties and Seventies saw a limited renewal of social spending by states and the federal

government, and this included some expansion of public funding for the arts. The National Endowment for the Arts (NEA) was created in 1965 to offer support and funding to artistic projects of significance or excellence. An organization that has been tossed about like a political football in recent years, the NEA was also responsible for establishing the Artists-in-Schools Program, which brought teaching artists into schools in the 1970s. The program established an influential and lasting model of short-term residencies in which artists modeled their work and processes for students and engaged students in discussion. In many places field trips to plays, concerts, and museums became regular features of public school education. These initiatives expressed a continuing evolution of the idea that a range of experience in the arts is part of a well-rounded education.

The 1970s also saw a smaller scale (relative to the massive WPA) but significant revival of federally funded employment initiatives under the umbrella of CETA (Comprehensive Employment Act). Through CETA-funded local initiatives thousands of artists received jobs and local and community arts projects received funding, often in contexts where teaching was a central component of the work. Painters worked on murals in schools and housing projects, writers compiled oral histories of communities and many community arts organizations and theatre companies were launched with the help of CETA funding. As Arlene Goldbard explained:

> There is scarcely a U.S. community artist who was around in the mid-1970s who did not either hold a CETA job or work directly with someone who did. Most community-based groups in the United States dating from that time were launched on their labor-intensive path with CETA support. The way many community artists speak about the experience evokes Stuart Davis's comments on the WPA: that the public employment of artists was a foretaste of a "new and better day for art in this country." But in this era of privatization, in the U.S. as in most industrialized nations, it's off the menu now.[57]

Even before this period of a limited revival of public arts and privately funded arts programming the hiring of teaching artists for short-term residencies in schools and for work within cultural institutions came under fire, as some arts educators questioned whether teaching artists were a detriment to, or a significant step forward for arts education.[58] Many arts educators even bemoaned the growing trend.[59] Questions were raised about whether the dual roles of teacher and artist were in conflict with one another, and whether art education should be broader than the narrow artist-specific emphasis an artist might bring to curriculum. There was even some specific opposition to the use of the terms "teaching artist" and "artist-teacher."

Eric Booth describes a few of the common tensions that have existed historically between art teachers working in schools and teaching artists:

> There was some tension in implementing these expanding and new programs, as non-school administrators and artists were often poor partners with in-school arts teachers—often disinterested [sic] in the life of the arts in the schools they visited, and sometimes even arrogantly disrespectful of the heroic and essential lifeline the "arts specialists" provided. These tensions have diminished over decades, with occasional re-eruptions whenever delicate balances are dislodged by circumstance or insensitive individuals. Some consistent underlying fears/angers that crack open under stress are: (for teachers) that teaching artists are a cheap way to replace "real" arts learning programs and full time teachers, and that teaching artists come in, stir things up that are not supportive of the ongoing work in the school and then disappear; and (for teaching artists) that school programs are old-fashioned and dull, not good enough to turn on the young, and that arts specialists are unable or unwilling to engage students ambitiously and creatively. There were also nascent tensions between teaching artists and the arts institution administrations that employed them, to the degree that one faculty formed an official union, organized under the United Federation of Teachers.[60]

Since many teaching artists work as freelancers, schools and institutions have at times exploited the tension between teaching artists and arts specialists. School districts sometimes see teaching artists as inexpensive replacements for full-time art teachers, and arts organizations that hire teaching artists have not provided proper benefits or salaries for these artists. Increasingly, teaching artists have sought to change this situation and have resisted being used this way. The first example was a strike by teaching artists that took place in 2006, when the musician teaching artists of Midori and Friends Foundation, members of the American Federation of Musicians Local 802 in New York City, struck for eight weeks and won wage, pension and benefit concessions.[61] Such efforts by teaching artists to fight for better pay and benefits point the way to more trusting and lasting collaborations with in-school art teachers on the basis of a shared interest in quality arts education for all students and decent working conditions for teachers, teaching artists and students alike. The continuing presence of both full-time arts specialists and teaching artists in schools also opens up the possibility that arts specialists will be afforded time and space for their own work as artists, and teaching artists will be provided more access to stable employment, should they seek it.

THE 1980S TO THE PRESENT:
Is Art-making Still at the Center?

Recent developments in teaching artist work have taken place in a context of declining participation in arts education. As arts educator and researcher Nick Rabkin explains:

> [After] a century of steady growth in schools and out, there has been a significant decline in the proportion of American children who have taken classes or lessons in the arts. In 1930, less than one quarter of 18-year-olds had taken any classes or lessons in any art form. By 1982, that figure had risen 180 percent to nearly two thirds of 18-year-olds. But by 2008, it had dropped below half again.
>
> Art education among white children is down only slightly since 1982. But the decline has been precipitous for African American and Latino children. They have absorbed nearly the entire decline.[62]

During the Reagan years the White House-sponsored report *A Nation at Risk* kicked off a conservative "education reform" movement and, with it, cuts to arts programming in urban public schools. Desegregation efforts in the 1970s had begun to narrow the "achievement gap" (really a resources gap caused by segregation), but the 1980s and 1990s saw a reversal of many of these efforts, along with a deindustrialization that hit black and Latino workers particularly hard. The resources gap in public schooling began to widen again and has continued to do so.

In the 1990s conservative political pressures led the NEA to all but abandon direct funding of artists. Ironically, even as the NEA essentially repressed or censored previously publicly funded art-making, the shift in the agency's funding priorities led to some new funding for arts education that was viewed as a "safer," less controversial alternative. The 1990s were also a decade of a new kind of institutionalization of the arts in public schools; administrators began to treat the arts like other subjects in a context of increasing emphasis on assessment and "accountability" across the curriculum. This development has had a profound effect on how art is taught and how art teaching is understood in the U.S. During this period National Standards were established for visual art, dance, drama and music, and additional standards for assessment became a reality.

Discipline Based Art Education (DBAE) became a popular model of art education. DBAE was supported by the Getty Center for Education in the Arts and was adopted by thousands of teachers over the course of ten years at universities and schools throughout the United States. The DBAE philosophy divided the subject of visual arts into four skill sets or subdisciplines: studio,

aesthetics, art history and art criticism. A similar organization was advocated for Music and Drama. This model represented a further shift away from an approach that would closely link art teaching with expressive art-making and toward a more conceptual approach.[63] But this shift was also about systematizing art teaching so that it could be measured according to current assessment methods. Standardized curricula would supposedly deal in more easily identifiable and therefore much more assessable outcomes. Unfortunately, the creative process was not placed at the center of such curricula but was relegated to one-fourth of the prescribed curriculum. It was this underemphasis on art-making that made the model eventually unsuccessful. Ultimately, DBAE's ". . . inflated instrumentalism was rejected in favor of a justification that features art's inherent values."[64] In 1997 the Getty Trust stopped funding the project, and it survives only through the efforts of a few committed proponents.[65]

In contrast to DBAE, the Reggio Emilia approach to arts education emphasizes the creative process as crucial not only to arts learning but also to early childhood development. Reggio Emilia refers to the city in central Italy where a particular educational philosophy and model for early childhood and primary education has been the centerpiece of public school curricula. The philosophy and school system were developed in the years immediately after World War II, amid the devastation and scarcity in the villages of the region. Educator and psychologist Loris Malaguzzi collaborated with local parents to create an innovative system of public schooling based on a flexible approach to student-driven learning in which teachers are less directive and instead act as co-learners who support and help to organize student inquiry. Malaguzzi drew on the insights of educational theorists like Vygotsky, Bruner, Dewey and Piaget but placed a particular emphasis on the humanity and autonomy of children and the importance of the environment (both built and natural) as a learning context. Work in the arts plays a central role in Reggio Emilia pedagogy. Students, often in the context of long-term projects of their own devising, are encouraged to engage in symbolic representation through visual arts, writing, sculpture and drama. Student art-making is very evident in the contemporary curriculum and in the numerous exhibits and books that have emerged from the Reggio Emilia system.

The Reggio Emilia approach and philosophy struck a chord with many American arts educators and teaching artists in the 1990s, and its influence has endured over the past decade. Reggio Emilia curriculum is both child-centered and emergent.[66] This essentially means that the teachers set broad goals, but curriculum itself is shaped by the children's ideas, thinking and learning processes. The curriculum undergoes constant change based upon these observations and interactions with the students. Many art teachers and teaching artists are particularly interested in this philosophy of teaching because of the emergent possibilities. Young children naturally and spontane-

ously engage the arts, and a number of authors cite student interest in talking about art and an awareness of art in their lives.[67] This way of thinking about art teaching as a process of student inquiry and spontaneous engagement has emerged as a consistent feature of many twenty-first-century teaching artist practices.

Hickman extends this idea of instilling arts interactions in the curricula of all disciplines when he writes, "[S]chools, should in my view be modeled on the best practice of successful art and design teachers."[68] His argument values aesthetic experiences, and he sees the aesthetic concerns artists have in the studio as a valid model for learning in the classroom. According to Hickman, both making and engaging with works of art are essential human qualities and part of creating aesthetic significance. The construction of learning environments and teaching practice are in themselves creative and artful activities, which is to say, they are art.

In spite of many progressive innovations in teaching artist theory and practice in recent years, a range of political, economic and institutional pressures have shaped and in some cases deformed the contemporary landscape of American art education. In the current context of scarcity a variety of trends in art education have intersected. In-school art education has shifted its emphasis from teaching skills and techniques to include a much broader interest in creativity in general. Increasingly, arts education curricula are designed primarily to serve learning in other subjects. "Transferability" of the skills learned in art-making has been used with the best of intentions to argue for the importance of the arts in schools, but ultimately such arguments have undermined a broader and deeper understanding of the specific educational and social importance of giving students access to the skills, ideas and experiences that surround art-making.

The teaching artist continues to react to this changing landscape. Extreme economic inequality and racial segregation plague American public education and other public institutions, including prisons, community centers and hospitals. Many teaching artists work, often by choice, in the most underfunded and unequal schools and institutions, often to provide arts teaching in places where it either never existed or has been removed as a regular option. Recent federal education policy has been characterized by a punitive and scapegoating response to the effects of the grotesque underfunding of urban public schools. Funding is tied to test scores, and students, families, teachers and unions are blamed for the inevitable damage done by segregation and underfunding. Teaching in the arts is constantly questioned and portrayed by many policy makers as an unnecessary luxury. Much arts advocacy in recent years has focused on attempts to correlate arts learning with test scores in academic subjects (correlations which by and large are difficult to prove in any scientific sense) instead of emphasizing and celebrating the many ancillary outcomes of working and learning in the

arts, such as the development of visual-spatial abilities and the important skills of self-criticism, reflection and experimentation, all of which emerge as one develops tools with which to work as an artist.[69]

THE FUTURE OF THE TEACHING ARTIST

In this essay I argue that artistic practice and successful teaching in the arts are inseparable. In order to effectively communicate or transmit the implicit and explicit skills and concepts of an arts discipline a teacher has to be dynamically immersed in these skills through an ongoing artistic process. Active and dynamic knowledge of one's discipline has been a hallmark of the most progressive forms of arts teaching historically and is at the center of the particular contribution of teaching artists to both artistic and educational practice.

Another key characteristic of teaching artist work is the dynamic through which the teaching artist is able to relate to students as fellow artists, equals, co-learners and perhaps at times direct collaborators in the making of art, the discovery of artistic and technical insights and the making of meaning. This dynamic of identification also requires that the "teacher" *be* an artist, and it is among the most important things that teaching artists have to contribute to the contexts in which they teach today; in the U.S. in particular, a vast array of dehumanizing curricular, political and economic factors in schools, prisons, hospitals and aging facilities work to narrow and minimize students', inmates', patients' and seniors' agency as learners and creators. By relating to students as fellow artists, teaching artists play a role, even in minor instances, in making time and space for students to connect with a timeless and fundamental activity through which we enact our humanity and communicate with each other. It's also important to note that as American art education has become increasingly removed from the many worlds of arts practice, teaching artists play an increasingly vital role as cultural connectors.

Since the arts vary dramatically in scope and creative process and allow for an infinite variety of expression, there is no limit to the progressive and innovative methods that teaching artists can develop and facilitate in the classroom and other teaching contexts. As I've discussed in this essay, there is something of a repeating historical cycle by which teaching artists of various epochs have renewed arts teaching and arts practice. At times this process has taken place within progressive and unusual institutional contexts in which teaching artists have redefined themselves. But there has also been a consistent thread in which teaching artists have taken advantage of their hybrid and non-institutional identity to bring the innovations of arts practice into schools and other contexts from the outside. This working from the margins—coming into institutions

from the outside—is particularly evident in the practice of many contemporary American teaching artists. That practice helps create time and space not only for art-making but also for intellectual and technical inquiry and depth for students, classroom teachers and others in schools and institutions that are increasingly driven by superficial, rote and boring curricula.

To facilitate a creative atmosphere a teaching artist typically must develop his or her own unique methods. In recent years the field has been characterized by a greater focus on educational philosophy and theory, and many contemporary teaching artists are increasingly conscious of their views and more capable of clearly articulating their goals, artistic and pedagogical choices and methodologies. Teaching artists do not follow one formula in their teaching any more than they do in their art-making; they seek to apply both artistic and educational insights to suit their students, their medium and the social and cultural contexts in which they teach.

The historical view also suggests that teaching artists are innovators in both teaching and artistic practice precisely because they work from a way of thinking and making that emphasizes the inseparability of the two. At the foundation of the teaching artist history is an ongoing creative practice that contributes to the curriculum, priorities, identity, values and processes of teaching and making art. Teaching artists understand the world differently, understand educational problems through their own artistic activity and play an active and nimbly adaptable role in educating the future.

ENDNOTES

1. R. Dale Guthrie, *The Nature of Paleolithic Art* (Chicago: University of Chicago Press, 2006).
2. M. Erickson, "An Historical Explanation of the Schism between Research and Practice in Art Education," *Studies in Art Education* 20, no. 2 (1979): 5–13.
3. K. A. Hamblen, "An Art Education Chronology: A Process of Selection and Interpretation," *Studies in Art Education* 26, no. 2 (1984): 111–20.
4. Erickson, "An Historical Explanation of the Schism."
5. Francesco Cordasco, *A Brief History of Education* (Totowa, NJ: Rowman and Littlefield, 1987). Paul Oskar Kristeller, "The Modern System of the Arts: A Study in the History of Aesthetics, Part I," *Journal of the History of Ideas* 12, no. 4 (1951): 496–527.
6. Arthur Efland, *A History of Art Education: Intellectual and Social Currents in Teaching the Visual Arts* (New York: Teachers College Press, 1990).
7. Arnold Hauser, *The Social History of Art: Volume One* (New York: Alfred A. Knopf, 1951), 175.
8. Cordasco, *A Brief History of Education.*
9. H.P. Raleigh, "The Artist-Teacher: Paradox of Education," *Art Journal* 31, no. 4 (1972): 421.
10. Carl Goldstein, *Teaching Art: Academies and Schools from Vasari to Albers* (Cam-

bridge: Cambridge University Press, 1996).

11. T.B. Hess, "Some Academic Questions," in *The Academy: Five Centuries of Grandeur and Misery, from the Carracci to Mao Tse-tung*, ed. T. B. Hess and John Ashbery (New York: Macmillan, 1967), 9.

12. Mary Ann Stankiewicz, "So What: Interpretation in Art Education History," in *Art Education Historical Methodology: An Insider's Guide to Doing and Using*, ed. P. Smith (Reston, VA: Seminar for Research in Art Education, 1995), 53-61.

13. Goldstein, *Teaching Art*.

14. John Milner, *The Studios of Paris* (New Haven, CT: Yale University Press, 1988).

15. Linda Nochlin, "Why Have There Been No Great Women Artists?" in *Women, Art, and Power and Other Essays* (New York: Harper & Row, 1988), 145-178.

16. G. James Daichendt, "George Wallis: The Original Artist-Teacher," *Teaching Artist Journal* 7, no. 4 (2009): 219–26.

17. Arthur Wesley Dow, *Composition: A Series of Exercises in Art Structure for the Use of Students and Teachers* (New York: Doubleday, Page and Co.,1926).

18. Goldstein, *Teaching Art*. William Lethaby, *William Morris As Artist: A Lecture Delivered at the South Kensington Museum on 4th March 1926* (London: Godfrey Rubens, 2007).

19. R. Yeomans, "The Foundation Course of Victor Pasmore and Richard Hamilton 1954–1966" (PhD diss., University of London, Institute of Education, 1987).

20. Michael Curtis, *The Great Political Theories*, vol. 2 (New York: Avon Books, 1962).

21. Ibid., 76.

22. Frederick M. Logan, *Growth of Art in American Schools* (New York: Harper and Brothers, 1955).

23. James Elkins, *Why Art Cannot Be Taught* (Chicago: University of Illinois Press, 2001).

24. Walter Gropius, *The New Architecture and the Bauhaus*. (Boston: Charles T. Branford Co., n.d.).

25. G. James Daichendt, "The Bauhaus Artist-Teacher: Walter Gropius's Philosophy of Art Education," *Teaching Artist Journal* 8, no. 3 (2010): 157–64.

26. László Moholy-Nagy, *The New Vision: Fundamentals of Bauhaus Design, Painting, Sculpture and Architecture* (Mineola, NY: Dover Publications, 1938).

27. Rainer K. Wick, *Teaching at the Bauhaus* (Ostfildern, Germany: Hatje Cantz, 2000).

28. Daichendt, "The Bauhaus Artist-Teacher," 157–64.

29. Wick, *Teaching at the Bauhaus*.

30. Patricia Railing, "The Idea of Construction As the Creative Principle in the Russian Avant-garde," *Leonardo* 28, no. 3 (1995): 193–202.

31. Victor Margolin, *The Struggle for Utopia: Rodchenko, Lissitzky, Moholy-Nagy, 1917–1946* (Chicago: University of Chicago Press, 1997).

32. Ibid.

33. Ibid.

34. Efland, *A History of Art Education*.

35. Efland, *A History of Art Education*. Jessica Davis, *Framing Art As Education: The Octopus Has a Good Day* (New York: Teachers College Press, 2005).

36. Benjamin Franklin, *Proposals Relating to the Education of Youth in Pennsylvania* (Philadelphia, PA: Franklin and Hall, 1749).

37. J. S. Keel, "Research Review: The History of Art Education," *Studies in Art Education*, 4, no. 2 (1963): 45–51.

38. Ibid.

39. G. N. Heller, "Music Education History: A Short, Selective Bibliography," *Music Educators Journal* 74, no. 4 (1987): 24–26.
40. Ibid.
41. Logan, *Growth of Art in American Schools*.
42. Ibid.
43. Efland, *A History of Art Education*, 108.
44. Ibid.
45. W. G. Whitford, "Brief History of Art Education in the United States," *The Elementary School Journal* 24, no. 2 (1923): 109–15.
46. Efland, *A History of Art Education*, 196.
47. Victor D'Amico, "Art Education Today: Millennium or Mirage?" *Art Education* 19, no. 5 (1966): 27–32.
48. Mary Ann Stankiewicz, *Roots of Art Education* (Worcester, MA: Davis, 2001).
49. Eric Booth, *The History of Teaching Artistry*, unpublished document, 2010.
50. Don Adams, and Arlene Goldbard, "New Deal Cultural Programs: Experiments in Cultural Democracy," Webster's World of Cultural Democracy, http://www.wwcd.org/policy/US/newdeal.html. This gives a concise and insightful overview of the WPA programs and their impact.
51. Sarai Sherman, personal communication, December 25, 2011.
52. Logan, *Growth of Art in American Schools*, 54-55.
53. Ibid., 54.
54. G. James Daichendt, *Artist-Scholar: Reflections on Writing and Research* (Bristol, UK: Intellect Books, 2011).
55. Booth, *The History of Teaching Artistry*.
56. R.J. Goldwater, "The Teaching of Art in the Colleges of the United States," *College Art Journal* 2, no. 4 (1943): 3–31.
57. Arlene Goldbard, *New Creative Community: The Art of Cultural Development* (Oakland, CA: New Village Press, 2006).
58. W. McCracken, "Artist-teacher: A Symptom of Growth in Art Education," *Art Education* 12, no. 9 (1959): 4–5.
59. M. Day, "Artist-Teacher: A Problematic Model for Art Education," *Journal of Aesthetic Education*, 20, no. 4 (1986): 38–42. Vincent Lanier, "Affectation and Art Education," *Art Education* 12, no. 7 (1959): 10, 21. N. Orsini, "The Dilemma of the Artist-Teacher," *Art Journal* 32, no. 3 (1973): 299–300.
60. Booth, *The History of Teaching Artistry*, 7.
61. Summer Smith, "Teaching Artists Strike for Justice," *Allegro*, 106, no. 2, February, 2006, http://www.local802afm.org/2006/02/teaching-artists-strike-for-justice/.
62. Nick Rabkin, "Teaching Artists and the Future of Education," *Teaching Artist Journal* 10, no. 1 (2012): 5–14.
63. W. Dwaine Greer, "Developments in Discipline-Based Art Education (DBAE): From Art Education Toward Arts Education," *Studies in Art Education* 34, no. 2 (1993): 91–101.
64. Ralph A. Smith, "The DBAE Literature Project," National Arts Education Association, DBAE Bibliography, http://ed.arte.gov.tw/uploadfile/periodical/902_0203_0615.pdf (1999): 12.
65. S. M. Dobbs, *Learning In and Through the Arts: A Guide to Discipline-Based Art Education* (Los Angeles: The J. Paul Getty Trust, 1998).
66. M. Schiller, "Reggio Emilia: A Focus on Emergent Curriculum and Art," *Art Education* 48, no. 3 (1995): 45–50.

67. Terry Barrett, "Criticizing Art with Children," in *Art Education: Elementary*, ed. A. Johnson (Reston, VA: National Art Education Association, 1992), 115-29. Michael Parsons, Michael, *How We Understand Art* (New York: Cambridge, 1987).
68. Richard Hickman, *Why We Make Art And Why It Is Taught* (Bristol, UK: Intellect Books, 2005), 145.
69. Ellen Winner, "Art for Our Sake: School Arts Classes Matter More Than Ever—But Not for the Reasons You Think," *Boston Globe*, September 2, 2007, http://www.boston.com.

References

Note: This bibliography only refers to Jim Daicherdt's essay

Adams, Don and Arlene Goldbard. "New Deal Cultural Programs: Experiments in Cultural Democracy." Webster's World of Cultural Democracy. http://www.wwcd.org/policy/US/newdeal.html.

Barrett, Terry. "Criticizing Art with Children." In *Art Education: Elementary*, edited by A. Johnson, 115–29. Reston, VA: National Art Education Association, 1992.

Booth, Eric. *The History of Teaching Artistry*. Unpublished document. 2010.

Cordasco, Francesco. *A Brief History of Education*. Totowa, NJ: Rowman and Littlefield, 1987.

Curtis, Michael. *The Great Political Theories: Volume 2*. New York: Avon Books, 1962.

Daichendt, G. James. "George Wallis: The Original Artist-Teacher." *Teaching Artist Journal* 7, no. 4 (2009): 219–26.

———. *Artist-Teacher: A Philosophy for Creating and Teaching*. Bristol, UK: Intellect Books, 2010.

———. "The Bauhaus Artist-Teacher: Walter Gropius's Philosophy of Art Education." *Teaching Artist Journal* 8, no. 3 (2010): 157–64.

———. *Artist-Scholar: Reflections on Writing and Research*. Bristol, UK: Intellect Books, 2011.

D'Amico, Victor. "Art Education Today: Millennium or Mirage?" *Art Education* 19, no. 5 (1966): 27–32.

Davis, Jessica. *Framing Art As Education: The Octopus Has a Good Day*. New York: Teachers College Press, 2005.

Day, M. "Artist-Teacher: A Problematic Model for Art Education." *Journal of Aesthetic Education* 20, no. 4 (1986): 38–42.

Dow, Arthur Wesley. *Composition: A Series of Exercises in Art Structure for the Use of Students and Teachers*. New York: Doubleday, Page and Co., 1926.

Dobbs, S.M., *Learning In and Through the Arts: A Guide to Discipline-Based Art Education*. Los Angeles: The J. Paul Getty Trust, 1998.

Efland, Arthur. *A History of Art Education: Intellectual and Social Currents in Teaching the Visual Arts*. New York: Teachers College Press, 1990.

Elkins, James. *Why Art Cannot Be Taught*. Chicago: University of Illinois Press, 2001.

Erickson, M. "An Historical Explanation of the Schism between Research and Practice in Art Education." *Studies in Art Education* 20, no. 2 (1979): 5–13.

Emery, Lee. *Teaching Art in a Postmodern World*. Altona, Australia: Common Ground Publishing, 2002.

Franklin, Benjamin. *Proposals Relating to the Education of Youth in Pennsylvania*. Philadelphia, PA: Franklin and Hall, 1749.

Frost, S. E. *Basic Teachings of the Great Philosophers*. New York: Anchor Books, 1989.

Goldbard, Arlene. *New Creative Community: The Art of Cultural Development*. Oakland, CA: New Village Press, 2006.

Goldstein, Carl. *Teaching Art: Academies and Schools from Vasari to Albers*. Cambridge: Cambridge University Press, 1996.

Goldwater, R. J. "The Teaching of Art in the Colleges of the United States." *College Art Journal* 2, no. 4 (1943): 3–31.

Greer, W. Dwaine. "Developments in Discipline-Based Art Education (DBAE): From Art Education toward Arts Education." *Studies in Art Education* 34, no. 2 (1993): 91–101.

Gropius, Walter. *The New Architecture and the Bauhaus*. Boston: Charles T. Branford Co., n.d.

Hamblen, K. A. "An Art Education Chronology: A Process of Selection and Interpretation." *Studies in Art Education* 26, no. 2 (1984): 111–20.

Hauser, Arnold. *The Social History of Art: Volume One*. New York: Alfred A. Knopf, 1951.

Heller, G. N. "Music Education History: A Short, Selective Bibliography." *Music Educators Journal* 74, no. 4 (1987): 24–26.

Hess, T. B. "Some Academic Questions." In *The Academy: Five Centuries of Grandeur and Misery, from the Carracci to Mao Tse-tung*, edited by T. B. Hess and John Ashbery, 8–18. New York: Macmillan, 1967.

Hickman, Richard. *Why We Make Art and Why It Is Taught*. Bristol, UK: Intellect Books, 2005.

Keel, J. S. "Research Review: The History of Art Education." *Studies in Art Education* 4, no. 2 (1963), 45–51.

Kristeller, Paul Oskar. "The Modern System of the Arts: A Study in the History of Aesthetics, Part I." *Journal of the History of Ideas* 12, no. 4 (1951): 496–527.

Lanier, Vincent. "Affectation and Art Education." *Art Education* 12, no. 7 (1959): 10–21.

Lethaby, William. *William Morris As Artist: A Lecture Delivered at the South Kensington Museum on 4th March 1926*. London: Godfrey Rubens, 2007.

Logan, Frederick M. *Growth of Art in American Schools*. New York: Harper and Brothers, 1955.

Margolin, Victor. *The Struggle for Utopia: Rodchenko, Lissitzky, Moholy-Nagy, 1917–1946*. Chicago: University of Chicago Press, 1997.

McCracken, W. "Artist-teacher: A Symptom of Growth in Art Education." *Art Education* 12, no. 9 (1959): 4–5.

Milner, John. *The Studios of Paris*. New Haven, CT: Yale University Press, 1988.

Moholy-Nagy, László. *The New Vision: Fundamentals of Bauhaus Design, Painting, Sculpture and Architecture*. Mineola, NY: Dover Publications, 1938.

Nochlin, Linda. "Why Have There Been No Great Women Artists?" In *Women, Art, and Power and Other Essays*, 145–178. New York: Harper & Row, 1988.

Olivas, Yvonne. "Conflict: Local and Global." In *Rethinking Contemporary Art and Multicultural Education*, edited by E. Joo and J. Keehn II, 383–387. New York: Routledge, 2011.

Orsini, N. "The Dilemma of the Artist-Teacher." *Art Journal* 32, no. 3 (1973), 299–300.

Parsons, Michael. *How We Understand Art*. New York: Cambridge, 1987.

Rabkin, Nick. "Teaching Artists and the Future of Education." *Teaching Artist Journal* 10, no. 1 (2012): 5–14.

Railing, Patricia. "The Idea of Construction As the Creative Principle in the Russian Avant-garde." *Leonardo* 28, no. 3 (1995): 193–202.

Raleigh, H. P. "The Artist-Teacher: Paradox of Education." *Art Journal* 31, no. 4 (1972): 421–424.

Reagan, Timothy. *Non-western Educational Traditions: Alternative Approaches to Educational Thought and Practice*, second edition. Mahwah, NJ: Lawrence Erlbaum Associates, 2000.

Schiller, M. "Reggio Emilia: A Focus on Emergent Curriculum and Art." *Art Education* 48, no. 3 (1995): 45–50.

Smith, Ralph A. "The DBAE Literature Project." National Arts Education Association. DBAE Bibliography. http://ed.arte.gov.tw/uploadfile/periodical/902_0203_0615.pdf (1999): 12.

Smith, Summer. "Teaching Artists Strike for Justice," *Allegro*. 106, no. 2 (February, 2006). http://www.local802afm.org/2006/02/teaching-artists-strike-for-justice/.

Stankiewicz, Mary Ann. "So What: Interpretation in Art Education History." In *Art Education Historical Methodology: An Insider's Guide to Doing and Using*, edited by P. Smith, 53–61. Reston, VA: Seminar for Research in Art Education, 1995.

———. *Roots of Art Education*. Worcester, MA: Davis, 2001.

Whitford, W. G. "Brief History of Art Education in the United States." *The Elementary School Journal* 24, no. 2 (1923): 109–15.

Wick, Rainer. K. *Teaching at the Bauhaus*. Ostfildern, Germany: Hatje Cantz, 2000.

Winner, Ellen. "Art for Our Sake: School Arts Classes Matter More Than Ever—But Not for the Reasons You Think." *Boston Globe,* September 2, 2007. http://www.boston.com.

Yeomans, R. "The Foundation Course of Victor Pasmore and Richard Hamilton 1954–1966." PhD diss., University of London, Institute of Education, 1987.

Index

118, 139, 152, 154–155, 162
Cunningham, Merce, 220